ART IN THE CLASSROOM

D0921955

ART IN THE CLASSROOM

An Integrated Approach to Teaching Art
in Canadian Elementary and Middle Schools

IRENE RUSSELL NAESTED
Mount Royal College

HARCOURT
BRACE
CANADA

Harcourt Brace & Company, Canada

Toronto Montreal Fort Worth New York Orlando
Philadelphia San Diego London Sydney Tokyo

Copyright © 1998
Harcourt Brace & Company Canada, Ltd.
All rights reserved

No part of this publication may be reproduced or transmitted in any form or by any means, electronic or mechanical, including photocopy, recording, or any information storage and retrieval system, without permission in writing from the publisher.

Requests for permission to make copies of any part of the work should be mailed to: Permissions, College Division, Harcourt Brace & Company, Canada, 55 Horner Avenue, Toronto, Ontario M8Z 4X6.

Every reasonable effort has been made to acquire permission for copyright material used in this text, and to acknowledge all such indebtedness accurately. Any errors and omissions called to the publisherís attention will be corrected in future printings.

Canadian Cataloguing in Publication Data
Naested, Irene Mae
 Art in the classroom : an integrated approach to teaching art in Canadian elementary and middle schools

Includes bibliographical references and index.

ISBN 0-7747-3357-8

1. Art – Study and teaching (Elementary).
2. Interdisciplinary approach in education. I. Title.

N350.N33 1998 373.5 C97-931165-9

Acquisitions Editor: Joanna Cotton
Senior Developmental Editor: Laura Paterson Pratt
Production Editor: Stacey Roderick
Production Co-ordinator: Sheila Barry
Assistant Production Co-ordinator: Shalini Babbar

Copy Editor: Gail Marsden
Cover Design: Avril Orloff
Interior Design: Avril Orloff
Typesetting and Assembly: Avril Orloff
Technical Art: Avril Orloff
Printing and Binding: Transcontinental Printing Inc.
Cover Art: Mark Beenham, age 11

This book was printed in Canada.

 2 3 4 5 02 01 00 99 98

PREFACE

Art in the Classroom: An Integrated Approach to Teaching Art in Canadian Elementary and Middle Schools is designed to encourage instructors to give a larger place to art in the general education of children. Art education should be a vital component of their development, well-being, and learning. Through art activities, children learn to express their ideas in a physical form. They develop the skills of planning, gathering materials, and implementing their ideas. Art activities also allow children to investigate questions and problems in a variety of ways, and open the door for application of skills from one subject to another.

When subjects are taught separately in the school curricula, students often have difficulty transferring what they learn from one subject to another. The relationship between subjects may not be obvious to them. This book advocates a more holistic approach to integrating art with other curricula, so students will learn to make the connections. It will show you how the contents of one discipline can be used to enrich another. You will discover ways to integrate art with other disciplines such as social studies, language arts, mathematics, and science, as well as drama, dance, and music.

You may be concerned that by integrating subjects they will lose their integrity, or that concepts and skills will be lost, watered down, or poorly presented. To avoid these situations, at least one teacher in the teaching team should be an art subject specialist, or have good knowledge of art education, when you undertake to integrate art with other subjects.

Art education encourages greater understanding of personal heritage and cross-cultural awareness. Canada is often described as a cultural mosaic, and we are fortunate to have this kind of rich artistic heritage. To successfully integrate an appreciation of the arts of different cultures, you need an understanding of art concepts, vocabulary, media and methods, art appreciation, and lesson and unit planning. You will find reference to the multicultural nature of our country throughout the book, along with ideas for ways you can integrate these cultural and artistic influences in your teaching practices.

ABOUT THE BOOK

Educators and researchers, not convinced that the traditional separate-subject teaching is the best method, have been looking for better ways of organizing curricula and connecting learning for children in the schools. Many of these ideas are presented in Chapter 1. They include not only the term "integration," which often organizes curriculum around central themes, topics, and concepts with the use of concept maps, but also such terms as "interdisciplinary and cross-curricular planning," "integrative curriculum," and "generative curriculum planning." All of these methods of organizing curricula have a common goal of helping students to integrate learning, to make connections, and to make learning meaningful and personal.

The integration of art and art experiences into the school curricula has an historical base. The educational theory and practice of Dewey, the Montessori and Waldorf schools, and the

grouping of courses under the heading of humanities, contribute to some of the philosophies and ideas behind integrating art. These theories are discussed in Chapter 2.

Art education develops symbol systems, aesthetic awareness, and various avenues of communication and expression. Evaluation, assessment, and reporting to parents, as well as the celebration of learning are also part of the learning and teaching plan. These issues are presented in Chapters 3 and 4.

Chapter 5 offers an introduction to the language and basic concepts you should know when leading art activities.

Part Two, "Media and Methods" covers basic information on not only the "How to" but also the "Why?" of art production. Drawing; painting; printmaking and fabric arts; sculpture and ceramics; and illustration, photography, and video and computers are discussed in separate chapters.

Part Three, "Integrating Art into the School Curricula," makes natural connections between art and other school subjects: language arts, social studies, science, math, the fine arts of drama, dance and music. Art education also addresses individual learning styles, abilities, and the learners' special needs. The final chapter gives you a brief survey of the history of art.

The Appendices at the back of the book provide lists of materials and resources.

The suggested project ideas, methods of course integration, and use of materials can be used with various age groups and student needs. If your own art background is limited, or if the physical resources in your classroom are scarce, this book will help you learn how to teach art in your primary or elementary classroom. If you have a background in art, or even if you are an art specialist, I hope that after reading this text, in whole or in part, you will be provoked to reflect or inquire into your own teaching and learning practices in art education. Suggestions for keeping a reflective journal are given with the "Reflection" questions at the end of each chapter.

●●●●●●
Acknowledgements

Reviews: John Emerson, University of Toronto; Anna Kindler, University of British Columbia; Bernard Schwartz, University of Alberta; and William Zuk, University of Victoria

Lori Temeycke and her students at University Elementary

Debra Carlson and her students at Strathcona Tweedsmire School

Irene Grabner, Paul Zabos, and their students at Pearson School

Paula Steinberg and her daughter, Jordhynn Guy

Gaye McVean, Isabelle Hunt-Johnson, and Tyler Johnson

Robyn Cochrane, Sandra Niedermier, Judith Hart, and the students at Milton Williams Creative Arts School

Karen Burford and her students at Queen Elizabeth

Christopher White and Emily Keough

BASP (Before and After School Program) Hillhurst, Sunnyside Community Association, staff and students

Cathy Dunsmore, Mrs. Fisher, Jane Hambly and Rick Gillespie, and the students at Glamorgan Elementary

Louise Russell
Fraser and Emma Young
Jesper, Thomas, and Maureen

A NOTE FROM THE PUBLISHER

Thank you for selecting *Art in the Classroom: An Integrated Approach to Teaching Art in Canadian Elementary and Middle Schools* by Irene Russell Naested. The author and publisher have devoted considerable time to the careful development of this book. We appreciate your recognition of this effort and accomplishment.

We want to hear what you think about *Art in the Classroom*. Please take a few minutes to fill in the stamped reader reply card at the back of the book. Your comments and suggestions will be valuable to us as we prepare new editions and other books.

BRIEF CONTENTS

PART ONE **ART EDUCATION IN ELEMENTARY AND MIDDLE SCHOOLS** 1

CHAPTER 1 Introduction to Art Integration 3

CHAPTER 2 Art in the School Curricula 20

CHAPTER 3 Learning Styles and the Artistic Process 41

CHAPTER 4 Planning for Learning, Teaching, and Assessment 58

CHAPTER 5 Fundamentals of Design and Art Appreciation 86

PART TWO **MEDIA AND METHODS** 105

CHAPTER 6 Drawing 107

CHAPTER 7 Painting 127

CHAPTER 8 Printmaking, Fabric Arts, and Jewellery 140

CHAPTER 9 Sculpture and Ceramics 156

CHAPTER 10 Illustration, Photography, Video, and Computers 178

PART THREE **INTEGRATING ART INTO THE SCHOOL CURRICULA** 195

CHAPTER 11 Integrating Art with Language Arts and Social Studies 197

CHAPTER 12 Integrating Art with Science and Math 217

CHAPTER 13 Integrating Visual Art with Music, Drama, Dance, and the Study of Cultures 241

CHAPTER 14 Art for Students with Special Needs 262

CHAPTER 15 A Brief Survey of Art History 274

APPENDIX A Materials and Resources 301

APPENDIX B Dyeing 306

APPENDIX C Visual Art Magazines 310

APPENDIX D Children's Books on Art and Artists 311

CREDITS 317

INDEX 319

CONTENTS

PART ONE	**ART EDUCATION IN ELEMENTARY AND MIDDLE SCHOOLS**	**1**
CHAPTER 1	**INTRODUCTION TO ART INTEGRATION**	**3**
	Introduction	3
	The Benefits of Art Education	3
	Why Integrate Art with Other Curricula?	4
	Research Base for Integration of Curricula	5
	The Interdisciplinary Concept Model	6
	Integrative Curriculum	8
	The Kaleidoscope Curriculum Organizer	9
	Fogarty's Ten Ways to Integrate Curriculum	9
	The Generative Curriculum	10
	Inquiry-Based Curriculum	11
	Arts Integration: The Study of a Culture	14
	Summary	17
	Reflection	17
	Bibliography	18
CHAPTER 2	**ART IN THE SCHOOL CURRICULA**	**20**
	Introduction	20
	The Place of the Arts in Society	20
	The Development of Communication Systems	22
	Sounds	23
	Gestures	23
	Words	23
	Numbers	23
	Images	23
	Art Education in the Schools	24
	What about Integrating Art into the Curriculum?	28
	A Brief History of Art Integration	29
	Experimentalism	29
	Progressive Education	30
	Montessori Schools	30
	The Waldorf Program	31
	Humanities	32
	Integrating Art with Other Disciplines	32
	Levels of Art Integration	32
	Art Education as Central	32

Art as a Moderate Influence 34
Detrimental Integration of Art 35
Summary 37
Reflection 37
Bibliography 38

CHAPTER 3 **LEARNING STYLES AND THE ARTISTIC PROCESS** **41**
Introduction 41
Developmental Stages in Children's Art 42
The Infant 42
Ages Two to Four — Preschool 42
Ages Five to Eight 44
Ages Nine to Eleven 45
Ages Twelve to Fourteen 47
Learning Styles 48
Viktor Lowenfeld 48
David Kolb 49
Anthony Gregorc 49
Dunn and Dunn 49
Miers and Briggs 50
Right-Left Brain Theory 50
Bernice McCarthy 51
Howard Gardner 52
A Synthesis of Learning Styles 54
Summary 55
Reflection 56
Bibliography 56

CHAPTER 4 **PLANNING FOR LEARNING, TEACHING, AND ASSESSMENT** **58**
Introduction 58
Planning an Integrated Art Program 58
Characteristics of a Good Teacher 59
A Creative Learning Environment 60
Techniques for Planning Subject Integration 62
Forming a Teaching Team 63
Brainstorming 63
Mind-Mapping 63
Elements of an Integrated Program 64
Motivational Devices 66
Memory 66
Imagination 66
Real Experiences 67
Relaxation and Visualization 67

Technology 67
Peer Teaching 68
The Right Questions 68
Independent Study 68
Learning Centres 69
Cooperative Learning 69
 Informal Groups 69
 Brainstorming Groups 69
 Response Discussion 70
 Representative Groups 70
 Sharing Circles 70
Unit and Lesson Planning 71
Planning for Assessment 75
 Checklists 77
 The Portfolio 78
 Journals 79
 Exhibition and Celebration 79
 Student Self-Assessment 80
Reporting 80
 Reporting to Parents 80
Advocacy for the Arts 82
Summary 82
Reflection 83
Bibliography 83

CHAPTER 5 **FUNDAMENTALS OF DESIGN AND ART APPRECIATION** **86**

Introduction 86
Elements of Composition 87
 Colour 87
 The Colour Wheel 87
 Colour Intensity 88
 Tone or Value 88
 Colour Harmonies, or Schemes 88
 After-Image 89
 Line 89
 Texture 90
 Shape and Form 91
Principles of Composition 92
Creating the Illusion of Depth 95
Learning to Appreciate Art 96
 Viewing and Talking about Art 96
 Biographical Information 97

Description 97
Analysis 98
Interpretation 98
Judgement 99
Art Appreciation Projects and Events 99
Field Trips and Gallery Tours 99
What Happens Next? 99
Comparing Artists 99
Written Correspondence 100
The Critic or Curator 100
Art Catalogue 100
Art Videos 100
Inside the Landscape 100
Guest Artist 100
Artist in Residence 101
Mystery Search 101
Classroom Gallery 101
Summary 101
Reflection 102
Classroom Projects 102
Bibliography 103

PART TWO **MEDIA AND METHODS** **105**

CHAPTER 6 **DRAWING** **107**

Introduction 107
Teaching Drawing 108
Making Marks — Tools and Surfaces 108
Motivation 109
Observation 109
Making Expressive Lines 110
Collaborative Drawings 112
Drawing Techniques 113
Gesture 113
Mass 113
Contour 114
Cross-Hatching 114
Combining Techniques 115
Linear Perspective 115
Variations on Drawing 117
Nonrealistic Rendering 117
Illustration 121

Figure Drawing and Portraiture 122
Nature Study 122
 Colour 123
 Texture 123
 Colour and Value 123
 Shape and Colour 124
 Shape and Texture 124
 General Observation I 124
 General Observation II 124
Summary 124
Reflection 125
Classroom Projects 125
Bibliography 126

CHAPTER 7 **PAINTING** **127**
Introduction 127
Approaches to Painting 127
 Painting to Illustrate 127
 Understanding Self and the Emotions 128
 Painting Memories 129
 Figures and Portraits 129
 Art History 130
 Learning through Painting 130
 Tools and Materials 130
 Surfaces 130
 Colour Media 131
Painting Techniques 132
 Collage 135
 Pointers for Successful Collages 135
 Collage Projects 136
 Montage and Decoupage 136
 Mandala and Kaleidoscopes 137
Summary 138
Reflection 138
Classroom Projects 138
Bibliography 139

CHAPTER 8 **PRINTMAKING, FABRIC ARTS, AND JEWELLERY** **140**
Introduction 140
Printmaking 141
 Methods of Printmaking 141
 Printmaking in the Elementary Classroom 142

Relief Printmaking 142
Rubbings or Frottages 143
Stamp Printing 143
Block Printing 143
Monoprinting 143
Stencil and Screen Printing 144
Embossing, Collograph, and Etching 144
Fabric Arts and Jewellery 145
Fabric Making 145
Weaving 145
Weaving in the Classroom 146
Fabric Decoration 147
Batik and Tie-Dye 147
Exploring Other Fabric Arts 150
Jewellery 151
Trophies, Medals, and Medallions 152
Hats and Headdresses 153
Summary 154
Reflection 154
Classroom Projects 154
Bibliography 155

CHAPTER 9 SCULPTURE AND CERAMICS 156
Introduction 156
Sculpture 156
Sculpture in the Elementary Classroom 157
Materials 157
Paper 157
Papier-Mâché 159
Papier-Mâché Pulp 159
Plaster 160
Wire 160
Fabric — Soft Sculpture 160
Mobiles, Stabiles, and Kinetic Sculpture 161
Assemblages, Environments, and Installations 162
Masks and Puppets 162
Dioramas 164
Ceramics 164
The Origins of Functional Pottery 165
What Is Clay? 166
Clay in the Elementary Classroom 166
Introducing Clay 167

Clay Tools 167
Forming Clay 169
Functional Pottery 169
Clay Relief and Sculpture 170
Finishing Clay Work 171
Firing Clay 172
Digging Clay 172
A Teacher's Story 174
Summary 175
Reflection 175
Classroom Projects 175
Bibliography 176
Films 177

CHAPTER 10 ILLUSTRATION, PHOTOGRAPHY, VIDEO, AND COMPUTERS 178
Introduction 178
Illustration 178
Advertising 178
Poster Making 179
Lettering 180
Calligraphy 180
Bookmaking 180
Constructing Books 182
Photography 182
Making Slides and Overheads 182
Slides 182
Overheads 183
The Pinhole Camera 183
Pinhole Camera Construction 184
Photograms 184
Developing 185
Sun Images 185
Animation and Video 186
Animation 186
Flip Books 186
Thaumatrope 187
Computer Animation 187
Storyboards 187
Video Cameras 188
Making Films 188
Technology and Art 189
Computers and Art 189
The Computer and Symbolic Space 190

Art Laserdiscs 190
The Computer as a Teaching Tool 191
Summary 191
Reflection 191
Classroom Projects 192
Bibliography 192

PART THREE INTEGRATING ART INTO THE SCHOOL CURRICULA 195

CHAPTER 11 INTEGRATING ART WITH LANGUAGE ARTS
AND SOCIAL STUDIES 197

Introduction 197
Art and the Language Arts Curriculum 198
Themes and Ideas for Art and Language Arts Integration 200
Who Am I? 200
Poetry 200
Cartoon Strips 202
Problem Solving 202
Animals 203
Stories and Myths 204
Art and the Social Studies Curriculum 204
Me and My World 205
Architecture 205
History and Culture 206
Early Canadian History 210
Understanding "Culture" 210
Cultural Communities 211
Geography 211
Newspapers 212
Create Your Own Culture 214
Summary 214
Reflection 214
Classroom Projects 215
Bibliography 215

CHAPTER 12 INTEGRATING ART WITH SCIENCE AND MATH 217

Introduction 217
Art and the Science Curriculum 218
Conceptual Themes 218
The Human Body 220
The Seasons 220
Fall 220

Winter 221
Spring and Summer 221
Planning Field Trips 222
Maps and Map Making 223
Ecology and Conservation 224
Studying Soil 224
Animals 225
Sketchbook Assignment for a Zoo Field Trip 225
Making Footprints 225
Camouflage 226
Birds 226
Sea Life 227
Insects, Butterflies, and Moths 228
Amphibians and Reptiles 229
Dinosaurs 229
Plant Life 229
Trees 230
Paper Making 231
Physics 232
Northern Lights 232
Art and the Math Curriculum 232
Time 234
Size and Proportion 234
Recording 234
Currency 235
Numbers 235
Classification 235
Comparing and Matching 235
Patterns 236
Tessellations 236
Shapes 236
Perimeters 237
Summary 238
Reflection 238
Classroom Projects 238
Bibliography 239

CHAPTER 13 INTEGRATING VISUAL ART WITH MUSIC, DRAMA, DANCE,
 AND THE STUDY OF CULTURES 241

Introduction 241
Art and Music 242
Elements of Music 246

Rhythm 246
Texture 246
Form 246
Expression 246
Music Integration 246
Making Musical Instruments 247
Art and Drama 248
Puppets and Masks 250
Backdrops, Scenery, and Props 250
Art, Dance, and Movement 251
Children and Dance 252
Elements of Dance 252
Creative Dance 252
Folk Dancing 253
Art and the Study of Culture 253
High Art 254
Religious Art 255
Folk Art 255
Ethnographic or "Primitive" Art 255
Popular Art` 256
Architecture 256
Functional Art 256
Body Adornment 256
Patriotic Art 256
Advertising Art 257
Communication Art 257
Military Art 257
Sports Art 257
Summary 258
Reflection 258
Classroom Projects 259
Bibliography 259

CHAPTER 14 ART FOR STUDENTS WITH SPECIAL NEEDS **262**

Introduction 262
Understanding Students with Special Needs 263
Students with Physical Challenges 263
Students with Special Learning Needs 264
Students Who Have Special Talents 266
Gender Differences 267
Teaching Students of Diverse Cultures and Languages 267
Special Activities 270

Summary 271
Reflection 271
Classroom Projects 272
Bibliography 272

Chapter 15 **A Brief Survey of Art History** **274**

Introduction 274
Art Around the World 274
The Art of Early Humans 274
Egypt 276
India 276
China 276
Japan 277
Africa 279
Islamic Art 280
Ancient Greece and Rome 280
European Art before 1800 280
Major Western Art Movements from 1800–1980 281
Impressionism 282
Neo-Impressionism 282
Post-Impressionism 282
Cubism 283
Futurism 283
Dada 283
Expressionism 283
Constructivism 284
Surrealism 284
Abstract Expressionism 284
Pop Art 285
Minimalism 285
Op Art 285
Kinetic Art 285
Performance Art 286
Recent Trends in Art 286
Neo-Expressionism 286
Multimedia Art 286
Postmodernism 287
Women and Art 287
The Art of the First Nations 288
Early Canadian Artists 289
The Era of the Group of Seven 290
Contemporary Canadian Artists 292

An Integrated Unit of Study: Trees in Art 294
Summary .. 296
Reflection ... 296
Classroom Projects .. 297
Bibliography .. 297
 Videos .. 300
 Laserdisc Information/Catalogue Sources 300

APPENDIX A MATERIALS AND RESOURCES **301**

APPENDIX B DYEING **306**

APPENDIX C VISUAL ART MAGAZINES **310**

APPENDIX D CHILDREN'S BOOKS ON ART AND ARTISTS **311**

CREDITS **317**

INDEX **319**

PART·ONE

Art Education in Elementary and Middle Schools

···········

Introduction to Art Integration

● ● ● ● ● ●
Introduction

Drawing pictures, symbols, and signs and making three-dimensional objects have been a natural part of human activities since prehistoric times. Cave drawings in southwestern France and the Venus figurines found throughout Europe tell us something about our early ancestors' creative work. Much later, in our own country, the images created by our aboriginal people stand out as symbolic representations of their relationship with their environment.

This ability to create, which separates humans from other animals, is essential for the development of culture. Art is a part of our efforts to understand ourselves and our world, and it provides communication systems as natural as language. By drawing on what is natural to humans, art education becomes a meaningful way of providing for children's social, emotional, intellectual, and personal development.

The purpose of integrating art into the school curricula is to help students make connections in their learning experiences and engage them within their special learning styles. Teachers can assist students in making these connections within subjects and across subject lines, and to connect new learning to what they already know.

This chapter discusses the value of art education in the development and schooling of children, the research behind the rational for integrating subjects, and the use of reflective journals.

● ● ● ● ● ●
The Benefits of Art Education

Our natural environment is made up of images, sounds, smells, movements, animals and plants, and human life forms. Many of us fail to actually see what is around us, or we are blinded by stereotypical ideas and images, such as yellow round suns and popsicle-shaped green trees. The environment we humans construct is also dense with visual stimulation and sounds.

Art education helps students become more perceptive of their environment and other people, and helps them communicate with greater ability and confidence. Students should be encouraged to observe and to gather information through all their senses to heighten their awareness of what is around them.

Through art education, children can become aesthetically critical of the structures humans have created. Students become appreciative and sensitive to the natural environment and learn to respect and care for our ecosystem.

As part of art education, children gain understanding of other cultures and discover their own cultural heritage, along with discovering contemporary art.

Traditionally, teaching and learning practices have stressed reading and writing, and calculating numbers, but children also need broad avenues of personal expression and

BOX 1.1 WHEN I WAS A CHILD

When I was a child, I played as a child.
When I became a student,
I was encouraged to put away my childish ways,

And decipher meaning from the world through word and number.
When I became a teacher,
I rediscovered the values of play,
And other ways to experience and learn.

communication that are not limited to words and numbers. Words and numbers alone cannot fulfil the human need to understand the personal and cultural nature of thoughts and feelings. Without artistic expression and aesthetic experience, a society lacks vitality and the depth of the human spirit.

• • • • • •
Why Integrate Art with Other Curricula?

Most public schools teach subjects separately, a method that fragments students' learning. However, an increasing number of educators have become advocates for more integrated, interdisciplinary educational philosophy and curricula (Nielsen, 1989). "More and more educators are coming to realize that one of the fundamental problems in schools is the 'separate subject' approach to knowledge and skills" (Beane, 1992, p. 46).

The primary reason for you to integrate curricula is to bring various aspects of the students' separate subject learning into a meaningful association. Content, knowledge, and understanding can be drawn from one discipline and used to enrich and apply to another. Through integration, students can understand, for example, the relationship between a country's geography, its history — political events, cultural changes — and its literature and visual art. Such motivational strategies as audio-visual aids, field trips, guest speakers, materials, and equipment are a part of the success of the planned learning and teaching experiences. (Chapter 4 presents planning and assessment strategies.)

Art teachers and teachers of other subjects often fear that by integrating subjects the areas of study will lose their identity or that concepts and skills will be lost or poorly presented. However, with a holistic approach teachers can draw content from one discipline and use it to enrich another, rather than stripping down any one subject.

These are some practical reasons why integrating art education is a valuable approach. Integrating art with other subjects:

- Stimulates images and enhances student learning by involving the student visually, physically, and emotionally.
- Connects course content, concepts, and skills.
- Makes the most of time and can allow for sustained work periods during the school day.
- Addresses multiple intelligences or learning styles of the students.
- Develops alternative avenues for expression that are not limited to words and numbers.

- Connects the art class with the outside world: television, advertising, dress/costume, architecture, city-planning, the natural environment, and other cultures.
- Opens alternative approaches for learning, teaching, and communication.

Jane Schmalholz Garritson (1979) summed up well some basic reasons for integrating curriculum.

> Why integrate curriculum? There are several reasons. The preschool child approaches living and learning as an inseparable whole. Then he goes to school and often finds science, math, language arts, social studies, and the arts taught as entirely separate entities. Each is presented as an end in itself although the essence of daily living is their constant interchange. The child may come to regard the subject areas, when presented in 40-minute modules, as unnatural and so far removed from each other and from his own involvements that he is unable to connect what he learns in school with his needs and activities outside school. He begins to separate school (learning) from the real world (living). This schism widens with time and by high school, unable to handle both, he may opt for the real world and drop out (p. vii).

Integrated learning and teaching reflects "real" work in the "real" world. As Garritson so clearly states, students discover that in the traditional school system of segregated subjects real work happens outside of school. And real work is interactive and is dependent on many facets of learning and understanding. Real jobs require a great deal of transferability of skills and abilities, and many educators believe that holistic approaches to learning unify knowledge and support a greater understanding that cannot be obtained by studying parts separately.

Perkins (1991) proposed that if students are to understand what is taught, to put information into new relationships, to interpret, generalize and apply knowledge, then connections must be made. Students make connections much more readily when subjects that have been artificially partitioned are integrated. As Tanner and Tanner (1980) maintained, "…perhaps the most damaging results of breaking down the curriculum into minute particles is that it must, of necessity, lead away from an understanding of the unity of all knowledge" (p. 337).

• • • • • •
Research Base for Integration of Curricula

The goal of education presumably has always been to help students understand the world around them as a whole. But the amount of information to be taught led educators to divide it into separate discipline areas.

The separate-subject curriculum was, traditionally, linear with a definite beginning, middle, and end. A nonlinear curriculum is more like a mind-map or sphere, with no beginning or end, but the continual addition of connections, like spokes in a wheel or a spider's web. This nonlinear method of curriculum organization has many variations and few definitive answers as to how to "do it right." The main concern is planning for learning that connects or unites, whether it be focused on themes, specific programs, or within the context of a "real-life" project. This approach involves the integration of concepts, skills, and content across curricular areas (Palmer, 1991).

Since learning takes place inside students, they must relate each subject, experience, and piece of information to their previous learning, to their personal lives, and to the world around them. According to Means (1992), a teacher can choose to aid the learning in this process by providing a curriculum that "expects meaning in relationships, in content and in experience" (p. 15).

The Interdisciplinary Concept Model

The principal aim of integration or interdisciplinary instruction is to present learners with an opportunity to discover relationships that go beyond separate disciplines and that bind together different aspects of our world in some systematic manner (Borich, 1992). In Chapter 2, the educational philosophies of Dewey, Montessori, and Steiner are presented as forerunners to integrated, interdisciplinary learning and teaching.

In the last ten years, many education researchers have written on the topic of integration. However, even earlier, Benjamin Bloom, a leading U.S. educator whose research formed the basis for the successful Headstart Program in the United States, encouraged the development of curricula based on integrative threads. He defined these threads as the ideas, problems, methods, or devices that unite or relate more than one separate learning experience.

> Bloom suggested three possible sources for these integrative threads: (1) major ideas, topics, or theories within disciplines; (2) major problems whose solutions require the use of a variety of subject matter and methods; and (3) methods of thinking, of inquiry or of study specific to various disciplines (Nielsen, 1989, p. 20).

P. Dessel also wrote about integration in 1958, referring to "The meaning and significance of integration." Dessel said that even though our minds have a tendency to organize and generalize, we still need to encourage and assist this tendency, and that "Structures which nurture these sense-making arrangements within each learner's mind need to be provided by the curriculum" (Harter and Gehrke, 1989, p. 13).

Ten years later, in 1968, D. Ausubel recommended that teachers use "advanced organizers" when planning the integration of information. "The purpose of these advanced organizers is to help explain new material by helping the learner relate the information to previously learned concepts" (Nielsen, 1989, p. 20).

Eisner (1991a) also supported integration of the arts and other subjects, "as long as the values of art are not diminished in the process" (p. 19).

Educators and researchers in education have used many terms over the years to describe curriculum planning, learning, and teaching — "interdisciplinary," "cross-curricular," "integrative," "inquiry method," "generative curriculum." These approaches have a broader scope than the traditional segregated subject, direct-teaching method, and many more curriculum organizers or models are being developed or refined to assist educators in planning for learning that is connected. "Genuine learning involves interaction with the environment in such a way that what we experience becomes integrated into our system of meanings" (Beane, 1991, p. 9). Few educators agree on the definition and use of these models, and what they look like. However, they

have many similarities and all attempt to integrate learning — to make learning more meaningful and real for the student.

> An integrative, interdisciplinary curriculum can provide students with a global view of learning and can teach them skills necessary for the transference of knowledge gained in one area to a variety of other areas or problem situations (Nielsen, 1989, p. 20).

A number of researchers and educators have contributed their ideas and thinking in the area of curriculum organizers. Box 1.2 lists names of educators you might want to investigate.

According to Whinery and Faircloth (1994), some curriculum theorists distinguish between "interdisciplinary instruction which draws upon the disciplines for content, and an integrated curriculum which draws upon the needs, interests and questions" (p. 31) students have about their personal world and the larger world. Jacobs and Borland (1986) developed the "Interdisciplinary Concept Model" in which "Students can grow enormously by taking a traditional subject area and looking at it through more complex perspectives" (Jacobs, 1989, p. 54) (see Figure 1.1). Jacobs was reticent to use other terms and definitions previously developed by educators, which include "cross-disciplinary," "multidisciplinary," "pluridisciplinary," and "transdisciplinary." She chose to use the term "interdisciplinary" and defines it as: "A knowledge view and curriculum approach that consciously applies methodology and language from more than one discipline to examine a central theme, issue, problem, topic or experience" (p. 8). The central aim of this model is to focus the discipline perspectives on the investigation of a target theme, issue, or problem, such as revelation, humour, flight, or world hunger (Jacobs, 1989).

BOX 1.2 EDUCATORS IN THE FIELD OF CURRICULUM ORGANIZERS

Dr. Heidi Hayes Jacobs is a professor at Teachers College, Columbia University in New York.

Dr. John Clarke of the University of Vermont teaches reading and curriculum design in secondary education.

Dr. Russell M. Ange teaches methods and curriculum at the University of Vermont.

Gordon F. Vars is Professor of Education, Teacher Development and Curriculum Studies at Kent State University in Ohio.

Dr. James A. Beane teaches at National-Louise University in Madison, Wisconsin.

Dr. M. Elizabeth Nielsen is an assistant professor in the Department of Special Education at the College of Education, University of New Mexico.

Nathalie J. Gehrike is an associate professor in the Department of Curriculum and Instruction, College of Education, University of Washington, Seattle.

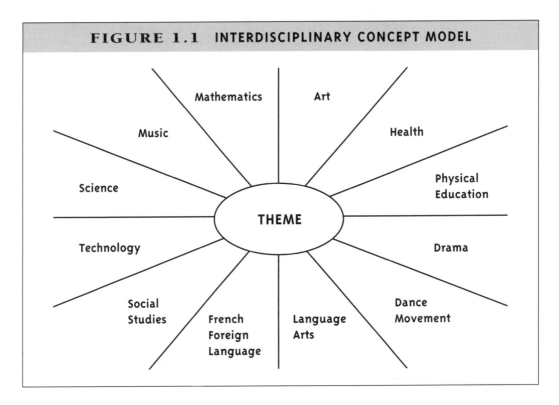

FIGURE 1.1 INTERDISCIPLINARY CONCEPT MODEL

Jacobs presented a systematic approach, or framework, for the development of interdisciplinary units. She suggested teachers begin by selecting an organizing centre, which acts as a focus for curriculum development. The topic can be a theme, subject area, event, issue, or problem, but she also cautions that the "organizing centre should neither be so general and all-encompassing that it is beyond the scope of a definitive investigation, nor should it be so narrow that it restricts the parameters of study" (p. 54). Each spoke in the web is a discipline area representing standard school subjects. Conceptual topics such as observations, patterns, light, revolution, humour, flight, pioneers, the future, or world hunger could become an organizing centre and students could participate in the selection of topics. Furthermore, Jacobs believed there will always be subject-specific skills that resist integration, that are definitely worth teaching, and that may be taught best in a conventional setting.

INTEGRATIVE CURRICULUM

Beane (1993) described the integrative curriculum as one that goes beyond the subject-centred and multidisciplinary approaches. "An integrative curriculum works off the idea that genuine learning occurs as people 'integrate' experiences and insights into their scheme of meanings. Moreover, the most significant experiences are those tied to exploring questions and concerns people have about themselves and their world" (p. 18).

The integrative curriculum does not abandon all of the knowledge and skills that have been traditionally defined within disciplines, but "works with an integrated view of knowledge in the

context of questions and concerns that are identified in collaboration with young people" (p. 18). These might include problem solving, critical analysis, ethics, valuing, and question posing.

Nielsen (1989) considered the first step in the development of an integrative curriculum to be the selection of a method for unifying the separate pieces of information in a manner consistent with the use of broad, global themes. These themes would become focal points as a start to thematic webbing in which related topics and their accompanying activities would be connected. Beane (1993) encouraged educators "to set aside the tendency to jam the concept of an integrative curriculum into the categories of our present subject-centred structures" (p. 23). Vars (1991) suggested the integrative curriculum is the ultimate in student-centred integrated learning in which teacher and students develop units of study, and "jointly decide on specific questions for study, how the unit will be carried out and how student progress will be evaluated" (p. 9).

THE KALEIDOSCOPE CURRICULUM ORGANIZER

Harter and Gehrke (1989) discussed a curriculum organizer that engenders integrative behaviour modelled after the kaleidoscope. The learner is at the centre surrounded by six structural formats that can be used to integrate learning experiences. They include:

1. Topics — Subject, theme or heading, including such examples as "A Trip Around the World," "The Age of the Dinosaur," "The Dark Ages," "The Renaissance."
2. Concepts — An idea of a class of objects: describing human motivations, states of mind, relations, and aspirations. Concepts are often used as organizers within subject areas.
3. Great Ideas — Important generalizations or propositions that tend to be more value laden than the other organizers. Examples include: "all people are created equal, behaviour is a function of the interaction between a person and the environment (B=PxE), and knowledge is power" (Harter and Gehrke, 1989, p. 16).
4. Life Problems — Common questions, problems, dilemmas, predicaments, and issues faced by human beings. Environmental issues and questions like "How may human beings best deal with declining natural resources? and How may we preserve our individual freedoms?" (p. 16) are examples.
5. Mind Constructs — Processes of the mind that can be based on J. P. Guilford's Structure of the Intellect Model with five operations of the mind: evaluation, convergent production, divergent production, memory, and cognition. "These operations are carried out to result in products of units, classes, relations, systems, transformations, and implications" (p. 16).
6. Disciplines — A department of knowledge, pointing out the similarities and differences among models of thinking used in each discipline.

Harter and Gehrke cautioned (1989) that any curriculum can eventually fall into disrepair. Whichever organizer is chosen — one of the six described or organizing structures yet unnamed — educators must constantly re-examine to ensure their choice promotes integration.

FOGARTY'S TEN WAYS TO INTEGRATE CURRICULUM

Fogarty (1991) described ten ways to integrate curriculum. He believed these ten models could give educators a solid foundation for designing curricula that help students make valuable

connections while learning. These models include: the fragmented, connected, nested, sequenced, shared, webbed, threaded, integrated, immersed, and networked models.

1. **Fragmented Model** — "The traditional design for organizing the curriculum" (p. 61).
2. **Connected Model** — Although the disciplines remain separate, this model maintains a focus on making connections within each subject area, and relating ideas within the discipline.
3. **Nested Model** — "Takes advantage of natural combinations. For example, the study of the circulatory system targets concepts of systems, as well as facts and understandings about the circulatory system in particular" (p. 62) and also targets the thinking skills of cause and effect.
4. **Sequenced Model** — The arranging of topics from different disciplines so that similar units coincide, for example, the study of *Charlotte's Web* in language arts with a science unit on spiders.
5. **Shared Model** — The "overlapping of concepts from two distinct disciplines as organizing elements" (p. 62). What concepts or similar skills do the units in the different disciplines share?
6. **Webbed Model** — Using a "theme to integrate subject matter," (p. 63) such as inventions. This theme could lead to the study of simple machines in science, and to reading and writing about inventors, and designing and building models in art classes.
7. **Threaded Model** — Weaves together thinking skills, study skills, graphic organizers — a multiple-intelligences approach to learning through all disciplines. For example, the project or problem could include an analysis component in each content area.
8. **Integrated Model** — "Interdisciplinary topics are rearranged around overlapping concepts and emergent patterns and designs. This model blends the four major disciplines by finding in them the overlapping skills, concepts and attitudes" (p. 64). An example would be the concept of argument and evidence in math, science, language arts, and social studies.
9. **Immersed Model** — The integration takes place within the learners, with little or no outside intervention. The learner filters content through personal interest and expertise.
10. **Networked Model** — Learners direct the integration process as they reach out within and across their areas of specialization.

Fogarty (1991) concluded by stating "These models are just beginnings. Teachers should go on to invent their own designs for integrating the curricula. The process never ends" (p. 65).

The Generative Curriculum

Similar to the interdisciplinary and integrated curriculum planning approach is the generative curriculum. Generative curriculum is considered by some educators (Fisher and Cordeiro, 1994; Laminack and Lawing, 1994) to be a more creative, intuitive approach in which the curriculum planning becomes a natural, dynamic collaboration of the teacher and students. Topics, themes, and concepts are also used in a generative curriculum. However, the students' interests remain

at the centre of the inquiry since knowledge is a constructive act, making meaning and building from what learners already know. Fisher and Cordeiro (1994) believed that "using a generative focus enables teachers and children to create personal paths of inquiry even within the pre-scribed curriculum" (p. 3).

INQUIRY-BASED CURRICULUM

According to Clarke and Agne (1997), "Inquiry teaching puts students in the position of researchers, asking and answering questions about information that may range far beyond the boundaries of a single discipline" (p. 30). Students show their conceptual and factual under-standing by constructing personally meaningful "yet plausible answers to the key focusing ques-tions" (p. 32), and their answers can be expressed in a variety of forms, including personal interviews, graphic representations, models and concept maps, images, and essays.

Short and Burke (1996) examined inquiry-based curriculum. The most common meaning of this form of learning centres on the students engaging in research on their own topics or ques-tions. Short and Burke agreed that the thematic-units approaches are more interesting and engaging for students than segregated subject teaching, but such topics as "dinosaurs" or "the study of China" were often aimed at specific facts and concepts. Even though "students no longer memorized facts; instead they gathered facts and engaged in activities that we planned for them" (p. 99). However, inquiry is a process of both problem posing and problem solving — of immersing one's self in a topic and having time to explore to find questions that are significant to the learner and then investigating those questions. Specific questions grow out of exploration, and not the other way around. The following are two examples that Short and Burke used to illustrate a shift from thematic units to inquiry methods.

Teacher #1 taught a thematic unit on oceans to first graders. She pulled together science experiments, sea shells, art activities, movies, and books and led her students through a series of activities in which all the students participated. At the end, students were asked to choose a sea creature to research and then they collected facts into fish-shaped books.

Teacher #2 pulled together resources as did teacher #1, but she began the inquiry on oceans with a field trip. Children were asked to bring resources from home and to share what they already knew about oceans from their own experiences. Resource centres were developed. In class discussions, students shared their explorations and questions, which were recorded on a chart. Later, questions were selected that were most significant to the students. Groups presented their research and what they learned to their peers, in a variety of ways — charts, diagrams, jour-nals, and graphs. The difference between inquiry and thematic curriculum planning is that, "Inquiry involves not only building curriculum from students but also negotiating curriculum with students" (Short and Burke, 1996, p. 102).

Research conducted by Aschbacher (1991), Shavelson & Baxter, (1992), and Richmond and Striley (1994) indicated: "that a curriculum unit in which the subjects are integrated and instruc-tional techniques are used that involve students in interactive learning, problem solving, critical thinking, and independent thought and action can lead to high levels of thinking and meaning-ful learning" (Borich, 1992, p. 194).

BOX 1.3 BRAINSTORMING A TOPIC — HARMONY

HARMONY

ART

After a short brainstorming session considering the topic of harmony and the provincial curriculum for Grade 5, a group of Calgary teachers planning for the Creative Arts School came up with the following list of connections. More ideas were added and refined. What could be added or changed? How can these ideas be developed into a generative curriculum or learning connections for the students? Consider these questions, keeping in mind there is no one right answer or one way to teach and learn.

- Expression to illustrate and create, harmony vs. disharmony
- Harmony in colour schemes and design principles, unity and pattern, tessellations, mandalas
- Reflection on and appreciation of works from various cultures and environments
- Balance in 2-d and 3-d, mobiles
- Harmony is an integral and essential element common to all art forms
- Focus questions: How does a person's experiences influence his/her art?
 How does a person's art reflect the harmony within themselves?
 What are the reasons for creating art?
 Compare how the principles of harmony and balance are used in dance, visual arts, music, or literature.
 Apply the principles of weight, balance and gravity to a project (science, math, dance, art, etc.).

What is harmony (beauty) and who determines the standards?
When is it preferable to employ imbalance, conflict, disharmony, tension, change, excitement, suspense, or interest in a composition?
What is harmony and why must the artist be concerned with it?

MUSIC

- Harmony vs. disharmony, rhythm, melody, form
- Expression in musical traditions considering the above in European and eastern, modern vs. classical
- Make musical instruments, shapes for percussion, environmental influences
- Sounds from the environment — animals, etc.
- Identify and describe the elements of unity and variety on tension and release in folk ballads and other traditions

DANCE/DRAMA/PHYSICAL EDUCATION

- Introduce movement, shapes, motion, gears, parts, how each part is moving, flow of movement, balance, machine building, storytelling through movement, animals and nature, symmetry, unity, cooperation, rhythmic gymnastics, circle dances, cultural influences
- How does a dance communicate harmony — feeling, an idea, theme, or emotion?
- Is balance an important part of harmony?

(continued)

(continued)

LANGUAGE ARTS

- Talking, reading, and writing; constructing the meaning of harmony; feelings and understandings
- Word flow, grammatical structure, sentences
- Making associations and connections, things working together, relationships
- Conflicts — natural and man-made, human vs. environment
- Novel study, poetry — freestyle, lyric, Haiku — on harmony and unity themes

HEALTH

- Harmony in self-awareness and acceptance, in relationships and relating to others, with peers and school
- Creating a community of learners — positive school climate
- Growing up healthy, nutrition and exercise, physical fitness, harmony in your body
- How does harmony apply to a healthylife style?

- Life careers and self-understanding

MATHEMATICS

- Symmetry, tessellations, measurement, graphing, geometry, patterns
- Data management, collect, record, organize, display, interpret
- Applying the principles of weight, balance, and gravity to science and math.

SCIENCE

- Harmony in nature, ecosystems, wetlands, plants and animals, interrelationships and conservation
- Interrelationships, gears, machines and pulleys.

SOCIAL STUDIES

- Harmony and Canada's links, interaction with people, geography, and community living in harmony
- Early Canada, cooperation, conflict, bilingualism

Panaritis (1995) identified key ingredients for success of interdisciplinary teaching and learning. They include: time to learn, plan, implement, and evaluate resources; rewards for participants; committed teachers; and patience and flexibility. In his article "Beyond Brainstorming: Planning a Successful Interdisciplinary Program," he pointed out that schools

> must rid themselves of the tendency to think of interdisciplinary education as a finite set of discrete skills instead of as the ongoing and wide-ranging process it truly is. If success did not require a great deal more than learning how to brainstorm, to choose a theme, or to formulate guiding questions, then certainly the idea would have taken hold in schools long ago, and the odds of creating viable interdisciplinary programs would be substantially improved (Panaritis, 1995, p. 628).

This argument holds equally true for all of the integrated, connecting, inquiry-based curriculum planning models presented here. Whichever curriculum organizers are used — a form of one described or organizing structures yet unnamed — educators should constantly re-examine and evaluate their learning and teaching.

Arts Integration: The Study of a Culture

The study of a culture by rote memorization has little meaning. However, exploring the life of a people, which includes their art, gives life to learning and develops understanding of beliefs, practices, and artistic heritage. Social studies curricula at various grade levels include the study of a particular country or culture. However, often cultures are studied in isolation, without the arts, which have always been a part of human life.

Because of the expressive nature of the arts, they unite cultures with very different traits and experiences. For example, the folk dances with their variations are common in different cultures and are a part of celebrations around the world. The visual arts, music (choral and instrumental), drama, and dance and movement all transmit the heritage and culture of a people, their spirit, and their thoughts and feelings. Students cannot really learn about a country or culture without discovering the arts of the people.

Integrated learning is based on a constructivist view of how we assemble knowledge of ourselves and the world — bits of information that commonly make up school courses can only be learned to the extent that they connect to what the student already knows and provide an opportunity for further elaboration (Clarke and Agne, 1997). In other words, a constructivist approach means that students construct, or build, one layer of meaning on another. By integrating courses of study, isolated subjects fade into the background and the broad aspects of the curricula can come into meaningful association. This holistic approach to learning and teaching provides experiences that unify knowledge and enhance understanding.

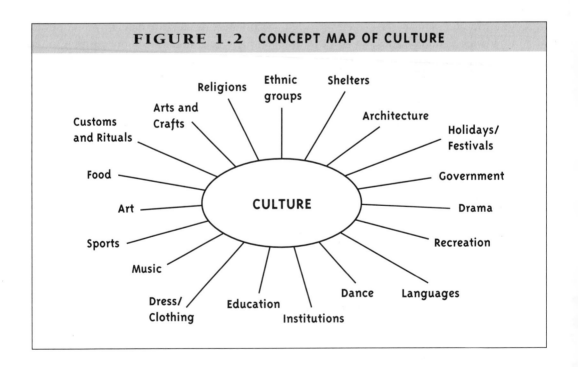

FIGURE 1.2 CONCEPT MAP OF CULTURE

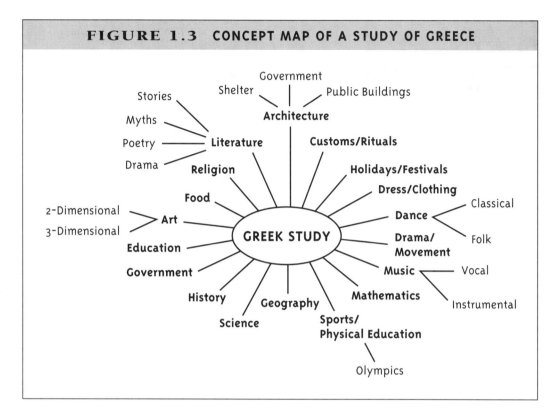

FIGURE 1.3 CONCEPT MAP OF A STUDY OF GREECE

What follows is an account of an integrated curriculum study with students in Grades 5 and 6, a study based on the concepts in the preceding paragraphs. Through this study, students learned to communicate and express their understandings through use of their multisensory abilities, and to understand a culture at the aesthetic level. (This is a shortened edited account, first published in Naested, (1993).

The study of Greece was a designated topic for the elementary curriculum. Elementary teachers, a teacher-librarian, and fine and performing arts specialists in art, drama, dance, and music collaborated in teams to create an educational experience for their students about Greece — the birthplace of western civilization, government, science, mathematics, education, architecture, and the fine and performing arts. The course of study was organized around essential questions and culminated in a public exhibition and performance.

Students formulated questions and then began their research. "They read, looked at pictures, slides, filmstrips, listened to music, drew pictures, and developed models. They each became experts on some aspect of the theme," (p. 86) and they learned to collaborate with other students and exchange information.

Part of the process was to decide what the final presentation of their learning would be because this decision affected their research, the expertise they required, and the time and materials needed.

The students' investigation led them to problems of mathematics, politics, astronomy,

BOX 1.4 A TEACHER'S STORY

Integrated holistic learning is like a picture puzzle.
Little is understood when the pieces are studied separately.
When the pieces are put together, the picture becomes complete.
The landscape of information fits together.
Then understanding — even "eureka" — happens.

architecture, mythology, science, government, the Olympics, and of course, art, dance, drama, and music. In their study of music, for example, they learned that the people living on the eastern side of the Mediterranean have similar music and use similar instruments. The ancient Greeks used a lyre and an aulos, which is a double reed instrument. The students used instruments that sounded similar to these ancient instruments — a recorder and autoharp. The students also learned that the diatonic scales include tones that have Greek names (Dorian mode, Ionian mode, and so on) and they discovered from which parts of Greece these names came. In this case, learning about Greek music led students to learning about the geography and tribes of the country.

The correlation of subjects helped the students develop awareness of the relationship and connection between disciplines. When they were not working on their Greek research questions in the library, the art room, the classroom, or the science lab, they were learning songs and dances of Greece. Covering the material required by the curriculum was not a constraint, and students were able to take the time they needed for their investigation.

They created their own plays based on a Greek myth or character developed with the drama teacher. All the students chose to be a particular god, goddess, monster or other mythical creature, integrating especially art and drama for the planned evening celebration. Students created symbols and costumes in the art room illustrating the nature of their characters. They illustrated Greek myths using coloured paper, pen and ink, pastels, clay, papier-mâché, or paint. They created relief murals and Greek pottery.

Obviously, the teachers who participated did not believe in the myth that learning can be guaranteed if instruction is delivered systematically, one small piece at a time, with frequent tests. They operated on the premise that knowledge must solve a problem or provoke inquiry if it is to seem relevant, and teachers must equip students to keep questioning. Asking questions as a way of organizing content served to strengthen students' sense of their own authority over content. They, themselves, designed the questions and the tasks that became their final presentation, which was a demonstration of what they learned and in itself a more vital learning experience than undergoing a "trial by question."

Because the teachers believed that students do not learn in order to keep the learning to themselves, but they learn in order to share, the final part of the project was an exhibition. The exhibition was in two parts: a classroom presentation of the investigation and a public performance in the evening. The students used a variety of media in the classroom presentations:

overheads, maps in two-dimensions and relief, models, posters, puppets, music, writings, artifacts, dance, plays, and artistic creations — whatever was needed to explain their investigation. The exhibition challenged students to show off not merely their knowledge, but their initiative and problem solving as well. After the classroom presentation, the students wrote a project evaluation of their work and the work of their fellow classmates.

The study ended in an evening of celebration, a Greek Festival. For this event, the students dressed as Greek gods, goddesses, and mythical creatures. They performed their student-developed plays using the props and backdrops they had designed. They sang, played musical instruments, and danced. Parents and relatives filled the gymnasium to capacity. Art works and the humanities projects from the class presentations were displayed in the main hallways, with student creators standing by to answer questions. After the performance, guests and performers were served baklava, a Greek dessert made of phyllo pastry with honey and nuts, along with a lemon drink.

Through experiencing in many different ways the arts and ideas of Greece, the teachers, the students, and their parents developed a greater understanding of the culture. For the students, the multi-sensory modes of gathering information, of expression and communication resulted in integrated, holistic learning.

• • • • • •
Summary

Integrating art education into the school curriculum means that students can experience holistic learning. As a result of research over the years, a number of models for integrated learning have been developed, including the Interdisciplinary Concept Model, the Integrative Curriculum, the Kaleidoscopic Organizer, Integrated Curriculum Models, the Generative Curriculum, and the Inquiry-Based Curriculum.

This chapter has provided an example of integrated learning through a teacher's story of how a group of classroom teachers developed an integrated unit based on the study of Greece.

REFLECTION

❶ What is your personal response to the idea of integrating art education? What questions do you have?

❷ How might you incorporate or integrate art experiences in your daily teaching?

❸ Research further the methods of integrating learning mentioned in this chapter, particularly any of the methods that interest you most.

❹ Compare the students' learning experiences if they had studied Greece in the traditional way — through, say, a history and a geography lesson — with the experience of learning described in this chapter.

❺ What do you perceive as the strengths of the teachers in the teacher's story in this chapter?

❻ Join art education organizations to benefit from their publications and conferences. Members are notified about their conferences and receive their journals.

The Canadian Society for Education Through Art, CSEA National Office, 3186 Newbound Court, Malton, Ontario, L4T 1R9. This is a nonprofit society, founded in 1955 for the advancement of education through art.

An American organization:
The National Art Education Association (NAEA), 1916 Association Drive, Reston, Virginia, 22091.

An international organization:
International Society for Education Through Art (INSEA), P.O. Box 1109, 6801 BC Arnhem, The Netherlands.

In addition to the organizations listed above, there are also provincial (and state) art teacher organizations. Contact your local teachers' association for the addresses.

BIBLIOGRAPHY

Beane, J. (1993). Problems and possibilities for an integrative curriculum. *Middle School Journal,* September, pp. 18–23.

Beane, J. (1992). Creating an integrative curriculum: Making the connections. *NASSP Bulletin,* November, pp. 46–54.

Beane, J.(1991). The middle school: The natural home of integrated curriculum. *Educational Leadership,* October, pp. 9–13.

Beane, J. (1990). Rethinking the middle school curriculum. *Middle School Journal,* May, pp. 1–5.

Bloom, B. (1958). Ideas, problems, and methods of inquiry. In N. Hanry, ed., *Yearbook of the National Society for the Study of Education: The Integration of Education Experiences,* part 3, vol. 57. Chicago: Chicago University Press, pp. 84–104.

Borich, G. (1992). *Effective Teaching Methods.* Second edition. Englewood Cliffs, NJ: Merrill/ Prentice Hall.

Burnaford, G., J. Beane, and B. Brodhagen (1994). *Middle School Journal,* November, pp. 5–13.

Canadian Society for Education Through Art (n.d.). *Visual Art Education and You.* CSEA National Office, 3186 Newbound Court, Malton, Ontario, L4T 1R9.

Clarke, J. and R. Agne (1997). *Interdisciplinary High School Teaching. Strategies for Integrated Learning.* Boston: Allyn and Bacon.

Corporate Council on Education (n.d.) Employability skills profile: The critical skills required of the Canadian workforce. Ottawa: The Conference Board of Canada.

Down, A. and R. Mitchell (1993). Shooting for the moon: Standards for the arts. *Educational Leadership.* 50 (5), 32–35.

Eisner, E. (1993). The education of vision. *Educational Horizons,* Winter, 81–85.

Eisner, E. (1991a). Structure and magic in discipline-based art education. In David Thistlewood, Ed., *Critical Studies in Art and Design Education.* Portsmouth, NH: Heinemann, 14–26.

Eisner, E. (1991b). What really counts in schools. *Educational Leadership,* February, pp. 10–17.

Fisher, B. and P. Cordeiro (1994). Generating curriculum: building a shared curriculum. *Primary Voices.* 2 (3), August, pp. 2–7.

Fogarty, R. (1991). Ten ways to integrate curriculum. *Educational Leadership,* October, pp. 61–65.

Glickman, C. (1991). Pretending not to know what we know. *Educational Leadership,* May, pp. 4–10.

Harter, P. and Gehrke, N. (1989). Curriculum kaleidoscope of alternatives. *Educational Horizons,* Fall, pp. 12–17.

Jacobs, H. (1991). Planning for curriculum integration. *Educational Leadership,* pp. 27–28.

Jacobs, H. (1989). *Interdisciplinary Curriculum: Design and Implementation.* Alexandria, VA: Association for Supervision and Curriculum Development.

Jacobs, H. and J. Borland (1986). The interdisciplinary concept model: Theory and practice. *Gifted Child Quarterly.* 30(4), Fall. pp. 159–63.

Kleiman, G. (1991). Mathematics across the curriculum. *Educational Leadership.* October, pp. 48–51.

Laminack, L. and S. Lawing (1994). Building a generative curriculum. *Primary Voices K-6.* 2 (3), August, pp. 8–18.

List, L. (1982). *Music, Art, and Drama Experiences for the Elementary Curriculum.* New York: Teachers College Press.

Logan, L. and V. Logan (1971). *Design for Creative Teaching.* Toronto: McGraw-Hill.

Means, S. (1992). The interrelated curriculum. In J. Jenkins and D. Tanner, eds., *Restructuring for an Interdisciplinary Curriculum.* Reston, VA: National Association of Secondary School Principals.

Naested, I. (1993). Towards the forgotten thoughtfulness. In R. Shute and S. Gibb, eds., *Students of Thought: Personal Journeys.* Calgary: Detselig Enterprises Ltd., pp. 75–88.

Nielsen, M. E. (1989). Integrative learning for young children: A thematic approach. *Educational Horizons,* Fall, pp. 18–24.

Noddings, N. (1995). A morally defensible mission for schools in the 21st century. *Phi Delta Kappan,* January, pp. 365–68.

Palmer, J. (1991). Planning wheels turn curriculum around. *Educational Leadership,* October, pp. 57–60.

Panaritis, P. (1995). Beyond brainstorming: Planning a successful interdisciplinary program. *Phi Delta Kappan,* April, pp. 623–28.

Parsons, L. (1990). *Response Journals.* New York: Pembrooke Publishers, Ltd.

Perkins, D. (1991). Educating for insight. *Educational Leadership,* October, pp. 4–8.

Prawat, R. (1993). The value of ideas: problems versus possibilities in learning. *Educational Researcher,* August–September, pp. 5–15.

Schmalholz Garritson, J. (1979). *Childarts: Integrating Curriculum through the Arts.* Menlo Park, CA: Addison Wesley.

Short, K. and C. Burke (1996). Examining our beliefs and practices through inquiry. *Language Arts,* Vol. 73. February, pp. 97–104.

Spillane, R. (1987). Arts education is not a frill. *Updating School Board Policies.* 18 (8), pp. 1–5.

Tanner, D. and L. Tanner (1980). *Curriculum Development: Theory into Practice,* Second Edition. New York: Macmillan.

Thomas, G. (1992). Learning for the 21st century. *Thrust for Educational Leadership.* 22 (2), pp. 8–12.

Vars, G. (1991). Integrated curriculum in historical perspective. *Educational Leadership,* October, pp. 14–15.

Werner, P. (1990). Implication for movement. In W. Moody, ed., *Artistic Intelligences: Implications for Education.* New York: Teachers College Press.

Whinery, B. and C. Faircloth (1994). The change process and interdisciplinary teaching. *Middle School Journal,* November, pp. 31–34.

CHAPTER 2

Art in the School Curricula

Introduction

Art is a part of every culture. Whether or not art thrives in a culture depends on whether creative expression is valued at all levels of society. The priority our society has given art in our schools has varied from time to time; nevertheless, we have a long history of including art concepts and materials in students' learning activities.

In this chapter, we look at communication systems — visual art is one of these — and we discuss how art can be integrated into a system of education. Integrating art dates back to many educators and theorists. Dewey, Montessori, and Steiner are three who included art experiences in their educational philosophy. The course integration of language and social studies (and sometimes the arts), called the humanities, is another form of organization. Although one can find situations in which attempts at integrating art in the school curricula become detrimental to learning about art, there are a number of ways and degrees, or levels, of successfully integrating art into the school curricula.

The Place of the Arts in Society

In traditional societies the arts, rituals, and ceremonies were an integral part of educating and socializing the children in cultural expectations, history, and current thought. These societies did not have a separate part of their cultural life called "art" — it was simply a part of their daily life.

Modern western societies appear to have forgotten the reasons for, and value of, educating the young in the arts. In fact, it is unfortunate that in our own time we see a trend toward thinking of art education as unnecessary, and even a "frill," which, of course, could not be further from the truth.

We would do well to learn from traditional societies that confirmed the individual's place in society through rituals, rites of initiation, and provision of an ideological framework with well-defined roles and tasks. In our complex society, full of conflict and ambiguity, adolescents have the terrifying task of identifying a coherent set of values in which to invest their energies and self-confidence, and against which to test their own meandering selves. (The Arts, Education and Americans Panel, 1987, p.93). Through the arts, our young people can gain a sense of themselves and explore their relationship to society.

In its art, a culture demonstrates what makes it distinct from and similar to other cultures. By incorporating the arts into daily experience, humans can communicate and understand, not only their own thoughts and feelings, but the thoughts and feelings of others. The study of the arts of the past and present can help clarify, as well as preserve, the artistic heritage and the essence of history.

20

BOX 2.1 WHY ARTS EDUCATION?

The arts are a natural form of expression.

- "It is just as natural for the young child to paint and draw as it is to laugh and cry, make mud pies, or romp on the lawn . . . In an atmosphere of encouragement he discovers, experiments, creates, and becomes his best creative self" (Logan and Logan, 1971, p. 149).

Art is a nonverbal language.

- The art of children is a symbol system that emerges from early scribbling. Art is both a fundamental and distinctive way of knowing. Children need opportunities to think in images.

Art documents life.

- Art captures and immortalizes life's moments and experiences. "The ability of the artist to perceive aspects of life often unobserved or hidden and his skills in transforming these qualities into art forms makes it possible for the viewer to share the experience of the artist" (Logan and Logan, 1971, p. 149).

Art teaches problem solving.

- "The artist is faced with making selections, rejections, decisions, in terms of a keenly developed sensitivity to the elements involved in design, form shape, and harmony of colour, line, and movement . . . He must be able to select, modify, and organize them into some coherent whole" (Logan and Logan, 1971, p. 149).

Art is creative expression.

- To express in a creative, innovative manner, one must be aware of one's inner and outer world. A creative expression reflects the artist's experiences, observations and understandings. According to Herberholz and Alexander (1985), "When creative expression remains passive, it is usually because of self-doubts, anxiety, lack of knowledge or skill in visualizing" (p.5).

Art develops powers of observation.

- Researchers have observed that artists characteristically have well-developed powers of observation, are sensitive to visual and physiological stimuli, creating a relationship between the artist and the environment.

Art provides an emotional outlet.

- "Art offers opportunities for constructive involvement with emotions . . . His work may reveal the impact of an emotional response to a specific event, situation, or personal experience" (Logan and Logan, 1971, p. 149).

Art helps to develop self-esteem.

- Early creative expression through art fosters a sense of accomplishment that enhances self-esteem and control of one's environment. Children learn to use not only their heads but also their hands and their hearts!

Art offers risk-taking opportunity.

- Art experiences offer the children opportunities to explore solutions to problems that have more than one

(continued)

(continued)

right answer. Contemporary society demands that people take risks and adapt to change. Children learn " . . . by testing their limits in a new environment: by acting, by failing, by succeeding, and then by reflecting on their actions individually and with others who have similar experiences" (Sternberg, 1993, p. 27).

• Art experiences offer the children opportunities to explore solutions to problems that have more than one

Art develops divergent thinking.

• The arts encourage divergent thinking (higher order thinking), not reliance on rote memory or one correct answer. From the moment of the idea, inspiration or artistic impulse, the children imagine, recall, see, think, search, formulate concepts, solve problems, choose media, revise and produce visual images of their own perceptions, emotions, thoughts and feelings.

Art motivates students.

• Children's involvement in the arts has a positive effect on their attitude and

motivation toward learning. The students have control of their environment — the media they use. They become active learners in an activity-based environment.

Art develops aesthetic judgement.

• Through the arts, students acquire aesthetic judgement, which enhances daily life and affects individual choices as well as impacting group decisions concerning the human environment.

Art helps children develop skills.

• The arts assist in the development of the kind of skills that students need and employers value. The Conference Board of Canada's *Employability Skills Profile: What are Employers Looking For?* (1991) states that Canadian employers need people who can communicate, who think critically and can solve problems, who are adaptable and can work well with others in a team approach. These are the kinds of skills integral to creating, viewing, interpreting, evaluating and discussing art.

••••••
The Development of Communication Systems

The arts are based on symbolic thought, which combines sensation, feeling, and reason to create objects and performances. The creation of symbols is one way humans organize experience in order to understand and communicate it.

The arts develop important communication systems through words, images, numbers, gestures, and sounds. These are the five basic symbol systems that humans use to understand and communicate. Unfortunately, our western educational system places greater emphasis on word and number. As a teacher, your challenge lies in adjusting this emphasis by including all five of the symbol systems in your learning and teaching.

SOUNDS

Sounds are the sensations perceived by our sense of hearing. For our ancient ancestors, the human heartbeat probably inspired the use of the rhythm of the voice and the beat of hands and objects against various surfaces. The drum with its distinct beat, along with other instruments, was developed by humans as a way of communicating. The sounds could be put together to make pleasant, rhythmic music — the flow of strong and weak sounds followed by silence. These sounds and rhythms helped to create a sense of well-being, or to stimulate adrenaline before a hunt, or a battle, or even mating.

GESTURES

Gestures are the use of the movements of limbs and body as a means of expression to emphasize an idea, sentiment, or attitude. Body movement became a way for early humans to communicate such thoughts and feelings as fear, anger, and dominance, or affection, acceptance, and understanding. Body gestures and hand signals, or sign language, were used before words were developed to communicate to members inside the community, as well as outside. Dance became a form of storytelling and a demonstration or enhancement of power over, or respect for, animals and spiritual beings.

WORDS

A word is a speech sound or series of sounds that communicates a meaning. Words were developed from the noises made from the vocal chords, throat, and cavities of the head, which became commonly known by the members of a cultural group.

A word is also a written or printed character (letter), or combination of characters, which represent a spoken word. These characters were derived from images that told a story, through pictographic images such as the Chinese and Egyptian hieroglyphics (a system of writing mainly in pictorial characters). These characters or alphabets are grouped together to represent a sound or series of sounds.

NUMBERS

Numbers are different from word forms in that they denote reference to one or more than one, and belong to a mathematical system. Humans developed verbal and written numbers after they used fingers, pebbles, shells, and sticks. Early humans counted things that were of some value to them.

IMAGES

Early in their history, humans created images. The body was probably the first "object" of visual artistic expression. The first humans collected things that attracted their attention, such as shiny pebbles, or shells, and used them to adorn their body, head, and hair. Body painting and tattoos were also used as adornment, probably even before jewellery. The art of jewellery-making derives from altering and adding to the pebbles, shells, and other cherished objects to be worn on, or attached to, the body or clothing.

Cave walls, such as those in the Lascaux Caves in southern France, contain some of the earliest paintings. The inhabitants of these caves created visual images using berries and earth to depict scenes of animals and significant events.

Every culture developed distinct clothing, jewellery or clothing adornment, group totems, or distinctive decoration of their habitat. Images and artifacts were created for a variety of reasons: spiritual observances, recognition of status and rank, or purely for decorative purposes.

Early humans created abstract designs and animal images on pottery, baskets, tools, and weapons, which they derived from representational images that evolved over generations.

Lynne List (1982) describes language and communication systems this way:

> If language is a vehicle for expression, then the arts must be considered as language since they, just as mathematics and oral and written language, have a syntax, a grammar, and an architecture of organization. Each of the artistic symbol systems informs and assists in forming the mind. It is through them that one inquires. In addition, illiteracy in any of the major systems represents a deprivation of some kind of understanding. A description of a flower or a song provides one way to convey what the flower or song is like. A picture of the flower or seeing the sheet music provides a second way. Sniffing the aroma of the flower or listening to the song played provides a third way. Each method provides for a segment of the total from its own vantage point (p. 2).

• • • • • •
Art Education in the Schools

Historically, the value that art education has been given in the schools has depended on the ideas about education and the demands on the schools at a given time. In fact, the position of art education in public schools has often been precarious, especially when schools have been attacked for not meeting the needs of society or business. Periodically business groups, especially, have been quick to criticize education for not adequately educating their young citizens. As a result, the media promote various slogans such as "getting back to the basics" and "no frills education." Of course, some people stick by the time-worn description of basic education as the three Rs of reading, (w)riting and (a)rithmetic.

Unfortunately, education in the arts has not always been considered part of basic education. From time to time numerous public incentives have been used to make our students achieve higher scores on standardized tests than those of whatever country appeared to have a competitive leading edge on educating their children. This was the case, for example, with the Soviet Union in the late 1950s after the Sputnik spaceship launch to the moon, and with Japan in the late 1980s and early 1990s, primarily in the areas of science and mathematics.

Although there are always those educators who see the arts as basic to education and as an essential part of our society, other segments of our population do not see the arts as an area in which students can get "real" jobs after they've completed their formal studies.

As already suggested, the goals in art education have altered over the years to accommodate societal shifts. The most dramatic change was from "mechanical imitation" as an emphasis in the art program to "free expression" in the mid 1940s. Research in art education before 1950 was

BOX 2.2 ON SCHOOL

He always wanted to explain things
But no one cared.
So he drew.
Sometimes he would draw,
and it wasn't anything.
He wanted to carve it in stone
or write it in the sky,
and it would be only him and the sky and
the things inside him that needed saying.
It was after that he drew the picture.
It was a beautiful picture.
He kept it under his pillow
and would let no one else see it.
He would look at it every night
and think about it.
When it was very dark and his eyes were
 closed,
he could still see it.
When he started school,
he brought it with him,
not to show anyone,
just to have it along like a friend.
It was funny about school.
He sat at a square, brown desk,
like all the other square, brow desks.
He thought it should be red.
And his room was a square, brown room,
like all the other rooms.
It was tight and close and stiff.
He hated to hold the pencil and chalk,
his arms stiff, his feet flat on the floor,

stiff,
the teacher watching and watching.
She came and spoke to him.
She told him to wear a tie,
like all the other boys.
He said he didn't like them.
She said it didn't matter!
After that, they drew.
He drew all yellow.
It was the way he felt about the morning.
And it was beautiful.
The teacher came and smiled at him.
"What's this?" She said. "Why don't you
draw something like Ken's drawing?
Isn't that beautiful?"
After that his mother bought him a tie,
And he always drew airplanes and
 rocketships
like everyone else.
And he threw the old picture away.
And he lay alone looking at the sky,
it was big and blue and all of everything,
but he wasn't anymore.
He was square inside and brown,
and his hands were stiff.
He was like everyone else.
The things inside that needed saying
didn't need it anymore.
It had stopped pushing.
It was crushed.
Stiff.
Like everyone else.

Source: Author unknown. Written by a high-school senior — two weeks before committing suicide.

rare and sporadic, but after this era many investigators studied creativity even though their terms were often not examined critically, or the definitions were ambiguous.

Over time, the North American public drew a separation between arts and academics, and began to value them differently as well. The public forgot that the arts has an academic, discipline base (Werner, 1990). By the late 1960s leaders in art education in Canada and the United

States recognized that specific learning experiences must provide for the realization of four objectives in the art program.

1. The development of visual and perceptual discrimination skills.
2. The making of art — the development of skills in manipulating tools, equipment, and media used in making art.
3. The study of works of art — the understanding of the role of art in society; an appreciation for a wide variety of visual art forms; and understanding how art records the achievements, beliefs, and values of people across time and place.
4. The critical evaluation of art products — the ability to respond to works of art using vocabulary, historical and visual/tactile information, and knowledge of art media and its influence on the viewer.

"Discipline Based Art Education" became an important term, especially in the United States. The philosophical roots probably came with the education reform movements in the early 1960s. Programs were designed to "academicize" the art lesson in order to make it measurable. According to MacGregor (1989), "Along with student accountability, teacher accountability for the program should be demonstrated. In the past, art teachers have often been responsible to no one but themselves (p. 27)." The content of DBAE encompassed three disciplines: art making, art history, and art criticism. This last discipline included identifying, interpreting, and evaluating works of art, and aesthetics — investigating issues and questions concerning the nature and values of art. The advocates of DBAE wanted art education to be a part of every student's education.

There are several reasons why art should be included in the general education curriculum. Dobbs (1989) listed four:

1. Art teaches about civilization and human achievement in the works of art, architecture, and design.
2. Art teaches effective communication — the exchange and understanding of ideas, values, and feelings that are represented nonverbally in visual images. The visual arts can be used to create new knowledge, inform opinion, and convey human emotion.
3. Art encourages creativity and the ability to solve problems.
4. Art teaches the act of choosing based upon examination and judgement rather than impulse and emotion.

According to Eisner (1991), a structural option in the design of DBAE is the boundary strength between art and other subjects.

> One way to design an art curriculum is to differentiate it clearly from everything else that is taught . . . Here the integrity of the subject is maintained by protecting it from dilution with other subjects: art is not meant to serve as handmaiden to the social studies or the language arts (p. 18).

However, another curriculum design minimizes the curriculum boundaries, making connections between subjects and fostering integration, "An option that imaginative curriculum planners can pursue" (Eisner, 1991, p. 19).

FIGURE 2.1 CONCEPT MAP OF LIFE SKILLS DEVELOPED THROUGH THE ARTS

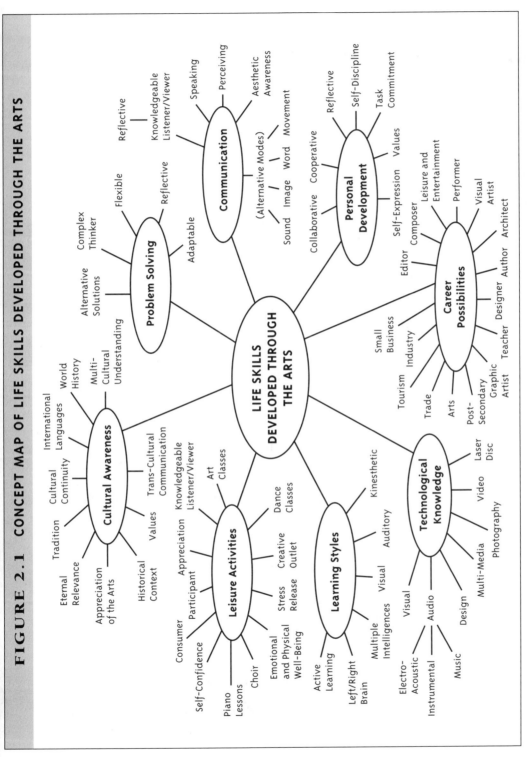

Source: Naested, I. and P. Dormian. (August 1996). From a collaborative brainstorming session, Mount Royal College, Calgary, AB.

• • • • • •
What about Integrating Art into the Curriculum?

The concept of the comprehensive school with course specialization was introduced into North American public education early in the twentieth century. This traditional method of educating children, which applies the principles of specialization, segregates subjects.

There are at least four reasons why some schools prefer to continue the practice of segregating subjects rather than integrating learning: the tradition of educational practice affords security; the time required to plan and teach integrated units of study; the fear of watering down the curriculum or not covering the required subjects; and the practice of external standardized testing, imposed by political pressure or political groups.

Tightly structured classroom activities might make a teacher feel secure. But just because an educator feels in control — and the classroom is quiet and orderly — does not mean learning is taking place. Of course, sometimes when students are at work the classroom will be quiet. But students who are active, who have a dynamic learning situation, do not necessarily create chaos. Integrated, collaborative, and team-taught classes of cooperative learning — students working in sharing groups — provide an atmosphere for a kind of learning that cannot take place in the traditional classroom setting. However, some educators feel too insecure to work in this kind of dynamic situation. Perhaps a part of their discomfort arises from the myth that learning can be guaranteed if instruction is delivered systematically, one piece of information at a time. Strategies based on this false idea do not fit into integrated, dynamic learning.

To initiate an integrated classroom, more planning time is required in the beginning, especially for planning a team-teaching arrangement. However, working with other teachers provides opportunities for mutual sharing of expertise and experiences. In the process, your own learning expands and builds to enrich your teaching and your interaction with students.

Perhaps more class time is also required in an integrated system — one must question the quality of an education system in which students cannot be allowed the time they need for a given learning experience. There is no question that sustained, multisensory learning activities, such as artistic expression, do require unpressured time. Multisensory art experiences make use of the human body's sensory ability to acquire and communicate information, ideas, thoughts, and feelings. This kind of learning calls into action total involvement of mind and body in exploration and problem solving. Is this not what learning is about?

Art educators may question how art concepts, values, skills, and content can be integrated with other subjects while still maintaining the inherent virtues and integrity of the art education curriculum. The fear of watering down the art program or presenting art concepts inadequately in an integrated system is valid, particularly when integration is not clearly understood and not properly carried out. Eisner (1991) stated:

> The integration of one subject with others is not without potential costs. When integration is aimed at, the special features of a subject are often compromised in the process . . . Yet, I do recognize that any approach has its trade-offs. I value integration, coherence and unity. I would urge that connections between

the arts and other subjects be made when they can, as long as the values of art are not diminished in the process (p. 19).

However, the challenge for teachers is to give themselves the resources and training they need for integrated teaching. At the same time, they also need to feel comfortable in exploring the arts and artistic expression, and become knowledgeable in the discipline of art education.

The kind of learning being described in these pages does not lend itself to prescriptive evaluation. In other words, this dynamic kind of learning is not easily measured by traditional methods of evaluation such as multiple-choice tests, filling in the one right answer, and other forms of regurgitation of facts. Art explorations do not have, and should not have, one right answer; instead, this type of investigation results in varied solutions and open-ended conclusions. Different, nontraditional kinds of evaluation must be used in integrated learning — measurement that must be developed appropriate to the situation.

• • • • • •
A Brief History of Art Integration

In 1879, John Smith published art lessons for elementary and normal school. These lessons included copying as training for the hand and eye. The use of colour was (unfortunately) discouraged until the students were older and received more "advanced lessons." The students were also discouraged from adding any imaginative elements to their drawing, but were to draw exactly what they observed. However, between 1910 and 1920 the word "art" replaced "drawing" in the art curricula to broaden the scope of students' work. Three major divisions of art were established: fine arts, industrial arts, and art in daily living.

During the period from 1891 to 1903 experimental psychologists began to study children. The child-study movement explored children's drawings and their use of colour in an effort to understand child development. These studies on children and their art were significant steps in acknowledging the importance of art, and setting the direction of art education in public elementary education. Including art in the school curriculum was given further recognition by three educators — John Dewey, Maria Montessori, and George Steiner (founder of the Waldorf School). All three of these educators included art experiences in their theory and practice.

EXPERIMENTALISM

Early in the 1900s, Arthur Dow attacked contemporary practices in art education. He believed schools should teach composition and aesthetics rather than teaching drawing simply through copying, which he saw as a mechanical process — he wanted art education to include art appreciation.

Following on the heels of Dow, the integration of art with other subject areas received major impetus during the child-study movement, called Experimentalism, and continued throughout the Progressive Education Movement, which was based on the philosophy of American philosopher and educator, John Dewey (1859–1952). Dewey declared that educational methods excluded the imagination and did not touch emotions and desires. He advocated that schools should replace the arid regime of drill and practice with spontaneous discovery and the kind

of learning that incites excitement. His vision implied a new conception of teaching and learning — a desire to develop (through the schools) the creative intelligence of children.

The curriculum in schools that adopted Experimentalism was, indeed, experimental in that students were given freedom to explore and develop projects in areas of interest through real-world situations. Students' learning focused on problem solving, which took precedence over memorization, and included field trips and hands-on experiences.

Progressive Education

John Dewey's philosophy of learning and teaching influenced the formation, in 1919, of the Progressive Education Association (PEA). This movement encouraged the teacher to be a guide, and students to be self-governing in a climate that encouraged self-expression and freedom of movement in an enriched physical environment providing access to materials (Clark and Cutler, 1990). The Progressives were committed to the natural development of children, and they valued the arts as an integral part of the education system.

Today, reformers also have this picture of instruction in which learning is viewed as an active process of constructing and reconstructing knowledge. Teaching and learning practices use the arts to perceive, understand and communicate what is learned, thought, and imagined. Teachers become guides to inquiry, helping students learn how to construct knowledge, which is seen as fluid and open-ended.

Montessori Schools

Maria Montessori (1870–1952) was the first woman in Italy to receive a medical degree (1894). She worked as a psychiatrist with "retarded" children and, as a result of this experience, she developed her theories on education. She opened the first Montessori school, called "Children's House," in 1907 for normal children ages three to eight. Montessori understood the imagination and creative powers of children — a main principle of Montessori schools was that education must help children to develop their personalities in accordance with their nature and potential.

Self-directed learning — including activity-based instruction and learning through motor activities to develop cognitive skills and abilities — is at the heart of the Montessori approach. Children's inclination to be self-directed in their activities is encouraged and respected, and teachers are trained to observe each child and record their observations.

Montessori's concept of auto-education means simply that children teach themselves through exercises in which they use appropriate materials. "A three-part (motor, sensory, intellectual) sequence of materials and activities enables the child to teach himself in a prepared environment under the observation of a specially trained 'directress' " (Orem, 1974, p. 50).

Montessori understood that children are imaginative and creative and therefore she incorporated drama, music, design, drawing, painting, clay, and other artistic media into daily learning experiences. She believed that children's imagination could best be developed by sensory education, training, and observation. "According to her, imagination is developed from reality-impressions received from the environment, thus the need for training in perceiving the environment" (Orem, 1974, p. 46).

The environment, including the aesthetics of the school and classrooms, was given great importance and had special significance for the inner-city and underprivileged students. Not only was the school considered a cultural environment but the children were given opportunities to become familiar with their own culture, as well as enlarge their cultural horizon.

> Dr. Montessori recognized that a child begins learning the moment he enters the world. She was awed by the strength of the child's innate urge to learn. In creating her Children's Houses, she endeavoured to establish an environment in which this vital urge would be nurtured and protected (Orem, R., 1974, p. 15).

Montessori emphasized the development of positive self-image through children's work and real accomplishments. She believed that how much and how well people learn throughout life is determined largely by their experiences during their early years.

THE WALDORF PROGRAM

The thinking of Rudolf Steiner (1861–1925), an Austrian philosopher, is the basis of the many Waldorf schools around the world. According to Miller (1986), Waldorf schools do not fragment the curriculum, but integrate activities around the arts. At the elementary level a kinaesthetic, activity approach to intellectual subjects is used to encourage children's emotional involvement in learning, an approach that leads to developing knowledge and skill as Ogletree (1975) explained.

> Young children have primarily an imaginative consciousness and their thinking takes place in pictorial, mental representations, and they learn best by doing. For this reason every effort is made to present the subject matter motorically and artistically. In this sense art is not an isolated subject but is a pervasive media which gives meaning to every subject . . . (p. 3).

Teachers in the Waldorf School emphasize fairy tales, myths, and fables to stimulate children's imaginations in their elementary school years. Art, music and drama, games, and gymnastic exercises are also integrated into the lessons (Miller, 1988). The pupils enjoy the experience of doing, of creating with their hands, of body movement and expression, of drawing and writing even before they learn to read. "Waldorf pupils learn in much the same way artists think out their materials, through imagination and feeling, through story and drama, colour and shape, movement and interplay" (Reinsmith, 1989, p. 85).

Steiner understood that just as the universe is an integrated whole, so should the curriculum interweave and connect all subjects. "Nothing is isolated or in a vacuum; every part is part of a whole . . . pupils are moved to sense the whole in every part they investigate" (Reinsmith, 1989, p. 84).

The arts and practical skills play an essential part in the educational process throughout the grades in Waldorf schools. The arts are not considered luxuries, but fundamental to human growth and development. According to Barnes (1991), "When the Waldorf curriculum is carried through successfully, the whole human being — head, heart, and hands — has truly been educated" (p. 54).

HUMANITIES

Historically, the teaching of humanities was a branch of learning encompassing the study of humankind and culture. In schools today, this branch of education is taught in an interdisciplinary manner. Often the course of studies is team taught and focuses on a thematic approach.

Humanities combine the study of social studies and language arts or English and occasionally one or more of the fine arts subjects, generally visual arts. The purpose is to provide students with opportunities to develop critical thinking, writing and discussion skills, to improve students' analytic and critical judgment, and to allow students to deal in depth with complex, interdisciplinary issues.

The connection with visual arts in this program can take various forms. The planned humanities program might weave the study of art history with social studies and historical literature themes and concepts; for example, a study of people versus the environment by exploring the art and writing of early Canadian pioneers.

Another model might incorporate visual arts materials, and concepts and skills development, in the presentation of learning. The outcome or presentation could take the form of posters, collages, books, pamphlets, videos, cartoons, hand-drawn flip books, video or computer animation, or illustration of poems, stories, situations or social issues.

• • • • • •
Integrating Art with Other Disciplines

Art education underlies most other learning, particularly in the elementary years. Art is a language system that enhances awareness, understanding, expression, and communication. It encourages multiple ways of perceiving, gaining information, and delivering or communicating thoughts, feelings, and ideas. Art grows and develops within a social context and an integrated approach means that students perceive art as culturally, historically, and geographically relevant.

LEVELS OF ART INTEGRATION

The levels of integration of art in the curriculum can vary depending on the expertise of the teachers — their knowledge, skills, and understanding. The level of integration in study units also depends on whether teachers are able to articulate the concepts of art through discussion, demonstration, or in lesson objectives.

Art Education as Central

A program in which art education is the focus maintains its integrity of concepts, values, content and skills, and is taught by an art specialist. This level of integration may be considered traditional, for it preserves the course as a distinct, separate subject. In this situation, the curriculum is differentiated clearly from everything else that is taught. "Here the integrity of the subject is maintained by protecting it from dilution with other subjects" (Eisner, 1991, p. 18).

You can adapt this course distinction and encourage integration by sharing curricular concepts, themes, or skills with other disciplines as a first step in connecting learning and teaching for the students and teachers. Further, art education can easily be used as a basis for integrating

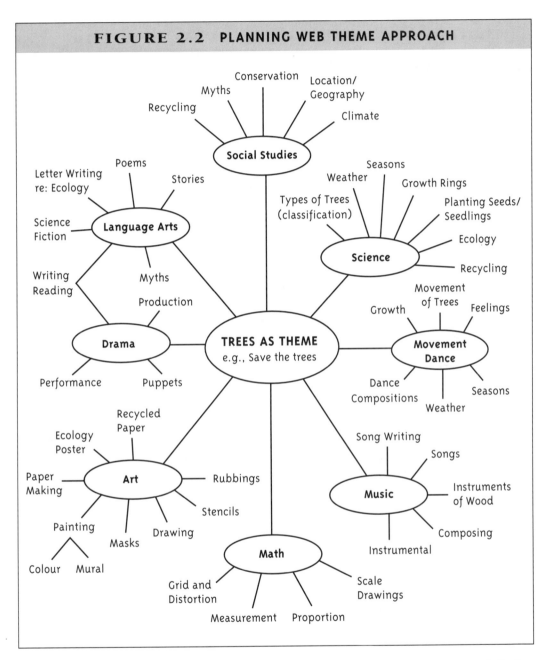

FIGURE 2.2 PLANNING WEB THEME APPROACH

the total school curriculum in which other subject areas provide themes or common skills that can be addressed in the art program.

One example of integration might be to use the theme of Canadian Art History during Canada's early exploration by Europeans (in a particular time and region). Through this approach, students can learn about the artists, their life and work, the geography and social

FIGURE 2.3 CONCEPT MAP OF TREES AS AN ART THEME

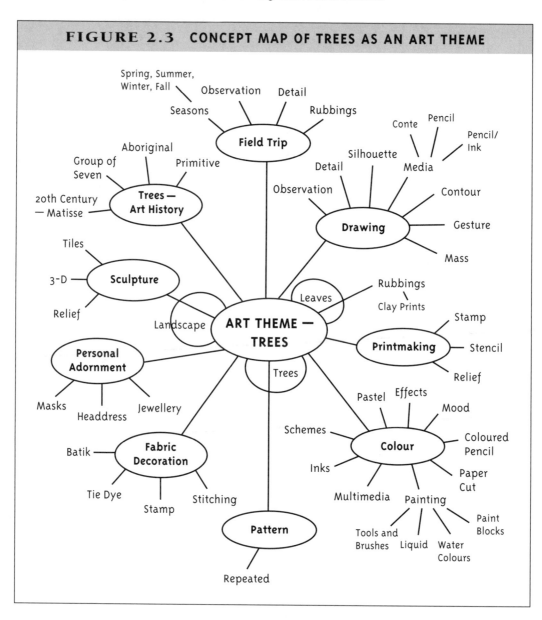

structure, problems, and lifestyle at that time in history. Field trips can be arranged to the local art museum; students can discuss original works, prints, slides, and other visuals. The works can be interpreted in written or in artistic forms, such as story books, poems, paintings, wall murals, or prints. Art concepts and skills would reinforce all learning and teaching.

Art as a Moderate Influence

In a program of "moderate" integration, the purpose of art in the overall learning outcome is to support the other subject areas — for example, developing a backdrop for a play or performance

designed by the students. In this case, art skills, concepts, values, or content are acknowledged by the teacher, but these are not the main focus. The primary difference between a central and moderate focus is the emphasis the teacher places on the art concepts, values, content, or skills.

Detrimental Integration of Art

Art integration becomes detrimental to learning when it is used in a way that impedes or impairs the understanding, concepts, skills, and values of art. Generally, the damage is done inadvertently by well-meaning teachers who have little experience with art. These teachers lack understanding of what constitutes the elements, principles, and values of a good art program.

When an activity is called "art" simply because it requires the use of what a teacher thinks are art materials, or when art skills and understanding are not addressed in the lessons and when stereotypical images are used or encouraged, the result is a crippling of the students' imaginations.

Colouring photocopies of work-sheets, adult-prepared images, and outlined pre-drawings is not art and is detrimental to the students' understanding of art and their creative ability. An assignment of filling in pre-drawn images not created by the student damages self-expression and undermines self-confidence in artistic expression.

The same detrimental effect occurs when, for an art lesson, a teacher asks students to create collages by cutting and pasting images from magazines or newspapers to illustrate thoughts, feelings, stories, or social issues. Often students have not been given the opportunity to learn design elements and principles that would help them produce a significant, meaningful, and powerful piece of art because teachers may lack an understanding of these elements and principles and therefore are unable to assist and instruct the students. Further, the teachers, and therefore the students, may lack the understanding and importance of the use of collage in the history of art. (Collage history, media, and methods are discussed in Chapter 7.) The story, "The Little Boy" (Box 2.3), describes the detrimental effect of so-called art experiences assigned by teachers without an understanding of the creative process of art.

BOX 2.3 THE LITTLE BOY

Once a little boy went to school.
He was quite a little boy,
And it was quite a big school.
But when the little boy
Found that *he* could go to his room
By walking right in from the door outside,
He was happy and the school did not
 seem quite
 so big any more.

One morning when the little boy had
 been in school awhile,

The teacher said, "Today we are going
 to make a picture."
"Good!" thought the little boy. He liked
 to make pictures.
He could make all kinds.
Lions and tigers. Chickens and cows.
 Trains and boats —
And he took out his box of crayons and
 began to draw;

But the teacher said, "Wait, it is not time
 to begin."

(continued)

(continued)

And she waited until everyone looked
 ready.
"Now," said the teacher. "We are going
 to make flowers."

"Good!" thought the little boy. He liked
 to make flowers.
And he began to make beautiful ones
With his pink and orange and blue
 crayons.
But the teacher said, "Wait! And *I will
show you how.*"
and it was red with a green stem.
"There," said the teacher. "Now you may
 begin."

The little boy looked at the teacher's
 flower.
Then he looked at his own flower.
He liked his flower better than the
 teacher's.
But he did not say this.
He just turned his paper over and made
 a flower
like the teacher's.
It was red, with a green stem.

On another day when the little boy had
 opened
The door from the outside all by himself,
the teacher said:
Today we are going to make something
 with clay."

"Good!" thought the little boy. He liked
 clay.
But the teacher said, "Wait. It is not time
 to begin."
And she waited until everyone looked
 ready,

"Now," said the teacher. "We are going
 to make a dish."

"Good!" thought the little boy. He liked
 to make dishes.
And he began to make some that were
 all shapes and sizes.
"But," the teacher said, "Wait, and I will
 show you how."
And she showed everyone how to make
 one deep dish.
"There," said the teacher. "Now you may
 begin."

The little boy looked at the teacher's dish.
Then he looked at his own.
He liked his dishes better than the
 teacher's
But he did not say this.
He just rolled his clay into a ball again.
And made a dish like the teacher's.
It was a deep dish.

And pretty soon the little boy
Learned to wait
and to watch,
And to make things just like the teacher.
And pretty soon
He didn't make things of his own
 anymore.

Then it happened that the little boy and
 his family
Moved to another house in another city.
And the little boy had to go to another
 school.
This school was even bigger than the
 other one.
And there was no door from outside to
 his room.

(continued)

(continued)

He had to go up some big steps,
And walk down a long hall to get to his
 room.

And the very first day he was there the
 teacher said,
"Today we are going to make a picture."
"Good!" thought the little boy.

And he waited for the teacher to tell him
 what to do.
But the teacher didn't say anything.
She just walked around the room.
When she came to the little boy
She said, "Don't you want to make a
 picture?"

"Yes," said the little boy, "What are we
 going to make?"

I don't know until you make it," said
 the teacher.

"How shall I make it?" asked the little
 boy.

"Why, any way you like," said the
 teacher.
"If everyone made the same picture, and
 used the same colors,
how would I know who made what, and
 which was which?"

"I don't know," said the little boy.

And he began to make a red flower with
 a green stem.

Source: Helen Buckley. (May, 1979). The Little Boy. *The Needle — R.* Niagara Falls: Niagara Penninsula Needle
Arts Guild.

• • • • • •
Summary

This chapter discussed the place of art in society, and offered a description of art as one of the communication systems of society. A brief history of art integration was presented with a description of Experimentalism, the Progressive Education Movement, Montessori schools, the Waldorf program, and the humanities.

We discussed the levels of art integration in a school curriculum, and described the outcome of instruction when teachers lack understanding of art.

REFLECTION

❶ Have you been in a Montessori school, or a classroom that adopted Montessori principles? What sensory experiences did the children have? If you have never been in a Montessori school, try to imagine the children's multisensory learning experiences.

❷ Use your library to read about Maria Montessori's life and work. How can you as a teacher use her philosophy in your work?

❸ Form a discussion group and brainstorm possible themes, issues, or concepts that might serve as a focal point for an integrated unit of study. Consider "big questions" such as harmony, self in society, balance and imbalance, conflict and cooperation, and connections and commonalities between cultures and societies.

❹ In the teacher's story on studying Greece as described in Chapter 1, what is the level of art integration in the unit of studies? What factors could have increased or decreased the level?

❺ Choose one theme, issue, or concept and develop a mind-map to visualize the various subject areas.

❻ The topic of integration in education and levels of integration of art with other subjects was introduced. As a student (teacher or parent of a student) in primary or secondary school can you recall an incident when your teacher or teachers organized the learning and teaching in an integrated manner? What are your thoughts on this experience? Was art involved and what level of integration did art take in the process?

❼ Are there times when art should be maintained as a segregated, distinct discipline? How, when, and why?

BIBLIOGRAPHY

Aschbacker, P. (1991). Humanitas: A thematic curriculum. *Educational Leadership,* October, p. 16.

Barnes, H. (1991). Learning that grows with the learner: An introduction to Waldorf education. *Educational Leadership,* October, pp. 52–54.

Baskwill, J. (1990). *Connections: A Child's Natural Learning Tool.* Toronto: Scholastic.

Beane, J. (1992). Problems and possibilities for an integrative curriculum. *Middle School Journal,* September, pp. 18–23.

Beane, J. (1991). The middle school: The natural home of integrated curriculum. *Educational Leadership,* 49 (2), October.

Brandt, R. (1991). On interdiciplinary curriculum: A conversation with Heidi Hayes Jacobs. *Educational Leadership,* Vol. 49 (2), October, pp. 24–26.

Brophy, J. and J. Alleman. (1991). A caveat: Curriculum integration isn't always a good idea. *Educational Leadership,* 49 (2), October, p. 66.

Brown, R. (1989). Testing and thoughtfulness. *Educational Leadership,* 7, pp. 31–33.

Brown, R. (1988). Barriers to thoughtfulness. *The Council for Basic Education,* April, pp. 4–7.

Brown, R. (1987). Who is accountable for thoughtfulness? *Teacher Testing,* September, pp. 49–52.

Buckley, H. (1979). "The Little Boy." *The Needle-R.* Niagara Falls: Niagara Peninsula Needle Arts Guild, May.

Clark, B. (1986). *Optimizing Learning: The Integrative Education Model in the Classroom.* Columbus: Merril Publishing Company.

Clark, R. (1993). Nurturing art education: The efficacy of integrated arts curricula. *Canadian Review of Art Education,* 22 (1), pp. 1–16.

Clark, C. and B. Cutler. (1990). *Teaching: An Introduction.* San Diego: Harcourt Brace Jovanovich.

Dillon, J. (1983). *Teaching and the Art of Questioning.* Bloomington, Ind.: Phi Delta Kappa, Educational Foundation. The coalition of essential schools. *Horace.* Vol. 6, No. 3, March.

Dobbs (1989). Discipline-based art education: Some questions and answers. *NASSP Bulletin,* May, pp. 7–13.

Drake, S. (1991). How our team dissolved the boundaries. *Educational Leadership,* October, pp. 20–22.

Eisner, E. (1991). Structure and magic in discipline-based art education. In D. Thistlewood, ed. *Critical Studies in Art and Design Education.* Portsmouth, NH: Heinemann.

Eisner, E. (1972). *Educating Artistic Vision.* New York: Macmillan Publishing Co. Inc.

Ewens, T. (1986). *Discipline in Art Education: An Interdisciplinary Symposium.* Rhode Island: Rhode Island School of Design.

Fogarty, R. (1991). Ten ways to integrate curriculum. *Educational Leadership,* October, pp. 61–65.

Fogarty, R. (1991). *The Mindful School: How to Integrate the Curricula.* Palatine, IL: IRI/Skylight Publishing, Inc.

Fowler, C.B. (1988). *Can We Rescue the Arts for America's Children? Coming to Our Senses Ten Years Later.* New York: American Council for the Arts.

Gardner, H. (1995). Reflections on multiple intelligences, myths and messages. *Phi Delta Kappan,* November, pp. 200–209.

Herberholz, D. and Alexander, K. (1985). *Developing Artistic and Perceptual Awareness: Art Practices in the Elementary Classroom.* Dubuque, IA: Wm C. Brown Publisher.

Jacobs, H. (1991). Planning for integration. *Educational Leadership,* October, pp. 27–28.

Jacobs, H. (ed.) (1989). *Interdisciplinary Curriculum: Design and Implementation.* Alexandria, VA.: Association for Supervision and Curriculum Development.

Jacobs, H. (1989). The interdisciplinary concept model: A step-by-step approach for developing integrated units of study. In H. Jacobs, ed. *Interdisciplinary Curriculum: Design and Implementation.* Alexandria, VA: ASCD, pp. 53–65.

Jenkins, J. and D. Tanner. (1992). *Restructuring for an Interdisciplinary Curriculum.* Reston, VA: National Association of Secondary School Principals.

Lazear, D. (1992). *Teaching for Multiple Intelligences.* Bloomington, IN: Phi Delta Kappa Educational Foundation.

Lazear, D. (1991). *Seven Ways of Knowing: Teaching for Multiple Intelligences.* Palatine, IL: Skylight Publishing.

Lillard, P. (1972). *Montessori. A Modern Approach.* New York: Schocken Books.

List, L. (1982). *Music, Art, and Drama Experiences for the Elementary Curriculum.* New York: Teacher's College Press.

Logan, L. and Logan, V. (1971). *Design for Creative Teaching.* Toronto: McGraw-Hill.

MacGregor, R. (1989). DBAE at the secondary level: Compounding primary gains. *NASSP Bulletin,* May, pp. 23–29.

McFee, J. and Degge, R. (1977). *Art, Culture and Environment: A Catalyst for Teaching.* Belmont, CA: Wadsworth.

Manning, M., G. Manning, and R. Long. (1994). *Theme Immersion: Inquiry-Based Curriculum in Elementary and Middle Schools.* Portsmouth, NH: Heinemann.

Miller, J. (1988). *The Holistic Curriculum.* Toronto: OISE Press.

Miller, J. (1986). Atomism, pragmatism, holism. *Journal of Curriculum and Supervision,* Spring, pp. 175–96.

Montessori, Jr., M. (1976). *Education for Human Development: Understanding Montessori.* New York: Schocken Books.

Naested, I. (1993). Educational Innovations at Lester B. Pearson High School, in Calgary, Alberta, Canada. Unpublished dissertation. Provo, UT: Brigham Young University.

Naested, I. (1993). Towards the forgotten thoughtfulness. In Shute, R. and S. Gibb, *Students of Thought: Personal Journeys.* Calgary: Detselig Enterprises Ltd. pp. 75–88.

Ogletree, E. (1975). *Waldorf Schools: A Child-Centred System.* Paper. U.S. Department of Health, Education and Welfare. National Institute of Education.

Orem, R. (1974). *Montessori. Her Method and the Movement. What You Need to Know.* New York: G. P. Putnam's Sons.

Perkins, D. (1991). Educating for insight. *Educational Leadership,* October, pp. 4–8.

Perkins, D. (1988). Art as an occasion of intelligence. *Educational Leadership,* January, pp. 36–43.

Project Zero, Interdisciplinary Research Group, Harvard Graduate School of Education, 323 Longfellow Hall, Cambridge, Ma. 02138.

Province of British Columbia. (1990). *Intermediate Program.* Educational Programs. Ministry of Education, Parliament Building, Victoria, BC.

Reinsmith, W. (1989). The whole in every part: Seiner and Waldorf schooling. *The Educational Forum,* Fall, pp. 79–89.

Saskatchewan Education, Training and Employment. (1991). *Arts Education: a Curriculum Guide for Grades 1–9.* Humanities Branch, Curriculum and Instruction Division, Saskatchewan Education, September.

Schmalholz Garritson, J. (1979). *Childarts: Integrating Curriculum through the Arts.* Menlo Park, CA: Addison-Wesley.

Shoemaker, B. (1989). Integrative education. A curriculum for the twenty-first century. *Oregon School Study Council Bulletin,* October.

Shute, R. and S. Gibb. (1993). *Students of thought: Personal Journeys.* Calgary: Detselig Enterprise Ltd.

Sizer, T. (1984). *Horace's Compromise. The Dilemma of the American High School.* Boston: Houghton-Mifflin.

Smith, F. (1990). *To Think.* New York: Teachers College Press.

Smith, F. (1986). *Insult to Intelligence: The Bureaucratic Invasion of our Classroom.* Arbor House, New York: U.S. Library of Congress.

Sternberg, R. (1993). Intelligence is more than I.Q.: The practical side of intelligence. *The Journal of Cooperative Education.* Cooperative Education Association. Winter XXVIII (2), pp. 6–17.

Tanner, D. and L. Tanner. (1980). *Curriculum Development: Theory into Practice.* Second Edition. New York: Macmillan.

Tchudi, S. (1991). *Travels Across the Curriculum: Models for Interdisciplinary Learning.* Richmond Hill, ON.: Scholastic.

Vars, G. (1991). Integrated curriculum in historical perspective. *Educational Leadership,* October, pp. 14–15.

Werner, P. (1990). Implications for movement. In Moody, W., ed., *Artistic Intelligences: Implications for Education.* New York: Teacher's College Press.

Werner, P., N. Sins, and L. Debusch. (1989). Creating with Art, Music and Movement. *Runner,* Summer.

Wiggins, G. (1989). Teaching to the (authentic) test. *Educational Leadership,* 46 (7), pp. 41–47.

Willis, S. (1995). Refocusing the curriculum, making interdisciplinary efforts work. *ASCD Education Update.* Association for Supervision and Curriculum Development, January, 37 (1).

Willis, S. (1994). Teaching across disciplines, interest remains high despite concerns over coverage. *ASCD Education Update:* Association for Supervision and Curriculum Development, December, 36 (10).

Learning Styles and the Artistic Process

CHAPTER 3

• • • • • •
Introduction

Imagine you are visiting a classroom of second graders who just returned from a walk in a park where they observed people feeding Canada geese bread crumbs near a sign which read "Please don't feed the wildlife." This event resulted in a classroom discussion about social responsibilities and taking care of animals. After some time the teacher brought the discussion to a close and suggested that the students recount their experience using paints and writing.

As you observe the children, you learn very quickly that each one has a different response to the same situation. In other words, children have a variety of different learning styles. Getting to know the children in your class, including their developmental abilities, is one of your major tasks for effective teaching.

All children are special and are at varying stages in their physical, intellectual, emotional, social, and artistic development. Their abilities in using art materials depend on their development and interests and learning styles.

According to Armstrong (1987), "All children are gifted. Every child is a unique human being — a very special person" (p. 12). Armstrong also acknowledged John Goodlad's project that surveyed 1000 classrooms and discovered that children were not given opportunities to exercise the vast proportion of the part of the brain that is used for learning through building, drawing, performing, role playing, and making things. "The part of the brain that thrives on worksheets and teacher lectures probably takes up less than 1 percent of the total available learning" (Armstrong, 1987, p. 12).

Understanding students' stages of development and learning styles will help you when you develop a program of studies so that the lessons meet children's individual needs.

This chapter introduces the developmental stages of children as they apply to art education, and provides you with a background on educators who have conducted research related to children's learning styles.

FIGURE 3.1
DEVELOPMENTAL STAGES IN CHILDREN'S ART

Ages 12 – 14 years

Ages 9 – 11 years

Ages 5 – 8 years

Ages 2 – 4 years

The Infant

• • • • • •
Developmental Stages in Children's Art

Children all pass through the same stages in their development, but the pace of their development varies. For example, two young children of an identical age might be at different stages in their ability to use a pencil. Rhoda Kellogg (1970), who collected and classified children's art work, was one of the first educators to study children's drawings from the perspective of their stages of development. She discovered that children in almost every country in the world begin drawing at about the same time and show a similarity in developmental patterns. Because the ages of children vary in each of the stages, the progression as detailed in this section should be interpreted as a frame of reference rather than a rigid pattern.

THE INFANT

Whether they are born into an urban industrialized society, a preliterate tribal culture, or a nomadic desert group, children all go through the same stages as they come to discover the nature of objects, the actions that can be performed upon them, and the ways that these objects relate to one another (Oat and Hurwitz, 1984, p. 17).

At first, infants' movements and behaviour are based on reflexes, and as they grow and develop through their sensory experiences, they gradually learn that they can direct their movements to interact with objects. For this reason, infants need interesting environments indoors and out; stimulus might be in the form of brightly coloured mobiles and wall pictures inside, and a variety of smells, colours, and objects to handle outside.

The beginning of art for an individual is this early contact with the environment through seeing, smelling, grasping, tasting, and touching. Nurturing adults share their world with the infant through sounds, smells, images, movements, and words. These sensory experiences are essential for an infant's development and understanding of the world and human culture. According to Oat and Hurwitz (1984), knowledge of the basic temporal, spatial, and causal relationships that govern objects is generally acquired by the age of eighteen months.

As young children develop their motor abilities and learn to crawl and walk, their environment expands and the sensory experiences become more complex. By that time, play has become children's way of developing their motor, sensory, cultural, and intellectual abilities. Obviously, children begin to play long before they learn to communicate effectively with words. Through play they imitate, interpret, and organize human experiences.

AGES TWO TO FOUR — PRESCHOOL

Children aged two to four years are often said to be in the manipulative stage. The abilities of children in this stage vary depending on the opportunities they have had to manipulate objects and materials. At this stage, children use all their senses to discover the unique qualities of any material they use. They also begin making random marks on paper. At first the scribbling is uncontrolled, but the experience gives children satisfaction.

Children begin repeating patterns and the scribbles often change into forms that resemble geometric shapes, suns, mandalas, or sun faces. Rowe (1987) divides the scribble stage into

PHOTO 3.1 Sensory experiences are essential for an infant's development and understanding of the world and human culture.

disorganized scribbling, when children start to control their movements with drawing materials; controlled scribbling and variable scribbling, when children learn to vary the way in which they use the materials; and finally, named scribbling. At this point children begin to name the forms they put together and tell stories about what they are doing. In other words, at this stage they are able to begin articulating concepts and feelings and can render visual images of absent objects or people.

This level is known as the symbolic stage — lines and shapes become body parts and large heads have stick arms, and then legs. In their drawings, children use only those body parts important to their expression, and there is usually no relationship between colour and the object. As they develop, children give torsos to their human-like figures, along with more physical details, for example a belly button and fingers.

Unfortunately, once children are in school, they generally are allowed little time to play, manipulate paint, colour, line, sand, or clay. Through the arts, children become active learners — well-designed art experiences allow for the various learning styles of children.

EXHIBIT 3.1
Disorganized scribble

EXHIBIT 3.2
Controlled scribble

EXHIBIT 3.3
Named scribble

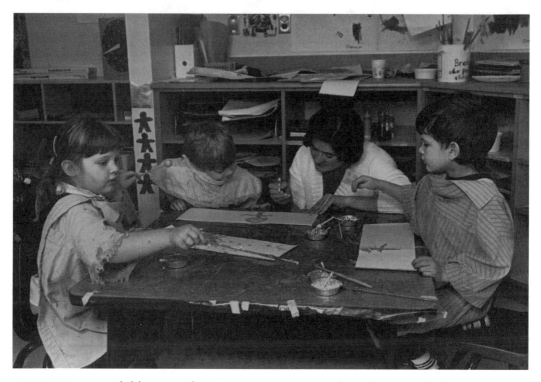

PHOTO 3.2 Children use their art to communicate their ideas and feelings.

AGES FIVE TO EIGHT

Children at this age learn best by interacting with people and concrete objects through first-hand experience and by trying to solve real problems. As they become interested in peers and activities outside their immediate family, their awareness of the similarities and differences between themselves and others grows (Kantrowitz and Wingert, 1989).

At this stage, children can create lengthy stories and tunes, along with their variations — dances and gestural sequences. Their works have gone beyond single elements to assume a scene-like quality (Oat and Hurwitz, 1984).

As children develop, they understand the relationship between their art and their world. They use their art to communicate their ideas and feelings and to express what they know, not necessarily what they can actually see. For example, in a picture of a garden, they might draw potatoes or carrots under the ground. Also, their pictures are often divided into ground, air, and sky.

Children in the early stages, often make colour choices based on stereotyped notions of the proper colours of things, for example, blue sky and green grass. According to Oat and Hurwitz (1984), whether children's drawings at this stage reflect the universal factors of earlier years or the cultural influences of the school years depends on the intrusion of the culture on the children — child care or early schooling — and the rate of their individual development.

With instruction and access to art materials, school-age children can learn to mix colours

and they also become interested in subtle uses of colour to portray the weather, the seasons, and moods of people. Activities that encourage children to observe their natural and constructed environment foster their visual awareness, so teachers should develop strategies that encourage the children to make visual studies based on careful observation and recall. They will produce richer visual imagery following these activities, but do not expect representational accuracy.

Children in the early elementary grades enjoy using imaginary themes and situations for artistic inspiration. Poems and stories continue to be valuable sources of motivation, but you should encourage the children to create their own images. Colouring books, stencilled images such as Easter bunnies, Halloween pumpkins, and Thanksgiving turkeys should NOT be given to children to colour or be used as images for them to reproduce.

AGES NINE TO ELEVEN

Pre-adolescents or preteens are well socialized and cultured individuals. Children at this stage show little tolerance for work that is not literal and realistically drawn. They attempt to incorporate detail into their images, which relate to their immediate experience. They learn how to focus on one perspective and overlap images to conceal invisible parts — for example, drawing one side of a car without showing the wheels that are not visible from that side. At the same time, their colour choices become more subtle and expressive.

In the past it was common for boys to portray cars, machinery, and "he-men" or superheroes and for girls to draw landscapes, flowers, and pretty girls — responses to the culture of the time. With your guidance, you can help students move away from gender-stereotyped themes and images. There is no reason why boys would not enjoy drawing flowers and birds, and girls airplanes and boats.

EXHIBIT 3.4 Age 5

EXHIBIT 3.5 Age 8

EXHIBIT 3.6 Age 10

As pre-adolescent children enter puberty, rapid body changes sometimes lead them to feel insecure, and their self-confidence is affected. Their lack of self-confidence may reach a "crisis of confidence" when it comes to creating art, particularly when their ideas do not match their skills in creating the visual forms if they have only a faint memory of what the image looks like. This is the point when pre-adolescents might truly believe "I can't draw." Lowenfeld and Brittain (1964) describe this crisis. "Crisis means passing from one stage to another under great difficulty . . . Since adolescence is considered a stage in the development of human beings, this crisis is connected with the difficulties of passing from one developmental stage to another" (p. 252).

EXHIBIT 3.7 Age 11

Observation or directly perceiving the object is one way to restore the pre-adolescent's confidence and to overcome deficiencies in depicting the objects. For instance, if a student attempts to draw a horse and cannot get the legs "just right," direct her or him to pictures of horses in varying positions found in books, slides, and videos, or even to live horses.

Topics that interest children at this level are birds, animals, sports, planes, monsters, mysteries, science-fiction themes, and prehistoric beings, especially dinosaurs. To stimulate their imagination, children can be encouraged to imagine creatures that combine parts of people and machines or parts of machines and animals.

Selective studies of size, shape, colour, and spatial relationships can be introduced at this level. Do not stress the use of perspective unless a student specifically asks for help in this area. Stories, poems, or myths from various cultures (expressively read by guests, if possible in traditional costume) can offer stimulation for making art, especially when mood, feeling, and atmosphere are discussed.

EXHIBIT 3.8 Age 12

Ages Twelve to Fourteen

Students in early adolescence and early teens have a keen interest in creating representational art based on direct observation and memory; the appeal of any subject will depend on their ability to identify with it. Some children aged twelve to fourteen may view monster themes as juvenile but are intrigued by science-fiction stories and myths. They are able to think on a much more abstract plane, to construct and test theories, "unlike the pre-teenager who has tolerance only for realism, the adolescent can explore illusionistic, abstract and other non-representational forms" (Oat and Hurwitz, 1984, p. 27).

Encourage personal symbolic imagery. Themes based on opposites like love and hate, innocence and guilt, success and failure may inspire personal exploration of issues that affect early teens as well as social commentaries on poverty, loneliness, and popularity.

Some students in their early teens lack confidence and easily become discouraged and embarrassed by their own shortcomings. However,

EXHIBIT 3.9 Age 14

they are usually willing to put forth their best effort to become competent in art, providing they are encouraged and see improvement in their work. If students are confident in their drawing of a particular subject matter — cars or people — encourage them to portray these subjects in different ways. You might assign a series of studies on a single theme with variations in the use of colour, figure-ground relationships, proportions (exaggerated, simplified, or distorted) and in various media (painting, clay sculpture).

••••••
Learning Styles

Educators and psychologists have done much research on learning styles and have developed theories on the subject over the years. According to Sternberg (1994), "A style is a preferred way of using one's abilities. It is not in itself an ability but rather a preference" (p. 35). Hence, various styles are not good or bad, only different.

Educators' theories influence the way they teach children and, generally, teachers teach the way they themselves learn best. For this reason you need to develop an awareness of different approaches in teaching. No single instruction process can provide for all learners. Not all children learn the same way. Appreciation and tolerance for differences in learning styles helps create learning environments that meet the needs of each learner. Several theories of learning styles are listed in this section. A synthesis of these theories and how they relate to art education follows.

Viktor Lowenfeld

Viktor Lowenfeld and W. Lambert Brittain (1964) identified two types of learners, the visual and the haptic — those who observe through tactile experiences. They differentiated these two types, both by the attitude toward the process and by the end product.

People described as visual learners first gain understanding of things from their appearance. Initially they see the whole, then the details and parts. Lowenfeld and Brittain (1964) described their process:

> This visual penetration deals mainly with two factors: first, with the analysis of the characteristics of shape and structure of the object itself; and second, with the changing effects of these shapes and structures determined by light, shadow, color, atmosphere, and distance. Observing details is not always a sign of visual-mindedness; it can be an indication of good memory as well as of subjective interest in these details (p. 261).

People who are haptic observe mainly through muscular sensations, kinaesthetic experiences, and touch sensations. The word "haptic" comes from the Greek word, "hapitkos," meaning able to lay hold of (p. 280). Lowenfeld discovered that haptic persons do not transform kinaesthetic and tactile experiences into visual ones, but attribute emotional value according to size — a big building is more important than a small one. Expressionism is a form of art that incorporates expression, feelings, and subjective processes into one. These elements also make up the haptic experience.

Lowenfeld suggested that teachers be aware of these two types of learners and present lessons and motivational material that include haptic sensations as well as visual experiences.

DAVID KOLB

David Kolb was responsible for much of the early learning-style research and he influenced the theories of such educators as Bernice McCarthy and Anthony Gregorc. Kolb identified four learning style types: the diverger, assimilator, converger, and accommodator.

1. The diverger can see a variety of possibilities and organizes them into a whole. He or she is often artistic, likes people, and is good at brainstorming.
2. The assimilator uses inductive reasoning, can devise theoretical models, and synthesizes information.
3. The converger likes right and wrong answers, uses deductive reasoning, and is more comfortable with things than with humans.
4. The accommodator is the doer and risk taker, who solves problems by trial and error and tends to be impatient. (Gruener and ter Borg, 1986).

ANTHONY GREGORC

Anthony Gregorc identified four types of learners: abstract sequential, abstract random, concrete sequential, and concrete random. He believed that learners perform better and at a higher cognitive level when taught and given projects and assignments that are compatible with their learning style (Gregorc, 1985).

1. Abstract sequential learners are generally logical, analytic, convergent thinkers. They like to discuss and debate. They appreciate teachers who structure the lessons in sequential steps and maintain order in the classroom.
2. Abstract random learners are generally sensitive to feelings and atmosphere and appreciate freedom from rules and guidelines. They are usually holistic in their learning and work best on hands-on, multisensory activities.
3. Concrete sequential learners generally have good memories, like order and logical sequence to directions and prefer a quiet, predictable environment.
4. Concrete random learners are practical but are also risk takers. They prefer teachers who are facilitators to their learning, and rich environments that are flexible and full of stimuli, with guidelines rather than rules.

DUNN AND DUNN

Dunn and Dunn (1978) identified three types of learners: visual, auditory, and kinaesthetic. The visual learner learns by seeing; the auditory by hearing the spoken word; and the kinaesthetic student learns best through physical activity and direct involvement.

Dunn and Dunn identified twenty-one elements that affect the individual students' learning styles. They have been divided into five categories.

1. Environmental: sound, light, temperature, design.
2. Emotional: motivation, persistence, responsibility, structure.
3. Sociological: peers, self, pair, team, adult, varied.
4. Physiological: perception, intake, time, mobility.
5. Psychological: impulsive-reflective, analytic-global, left brain-right brain.

Dunn and Dunn also believed that although teachers teach the way they learn, most can respond to differences in learning styles by careful planning. They suggested that teachers design their classroom for multifaceted learning environments or approaches, including multisensory instruction (Gruener and ter Borg, 1986).

MIERS AND BRIGGS

Miers and Briggs identified eight learning preferences.

1. "Extroverts" are people who act and communicate. They learn best through psychomotor activity and enjoy working in groups.
2. "Introverts" are people who think and reflect and learn best by working alone reading and reasoning; they need time for internal processing.
3. People who are the "Sensing Types" apply experience to problems after careful observation and understanding. They learn best by going step-by step and tend to have practical interests.
4. The "Intuitive Types" are individuals who use hunches and intuitions and apply ingenuity to problems. They are most successful in tasks that call for the grasping of general concepts and verbal fluency.
5. People who are "Thinking Types" are creative with impersonal or objective data. They appreciate logical organization of knowledge in a structured classroom.
6. The "Feeling Types" are people who are creative with personal data and learn through personal relationships.
7. People who are the "Judging Types" work in a steady, orderly way and need formalized instruction with structured tasks. They are methodical, cautious workers who seek closure in their work.
8. The "Perceptive Types" work in flexible ways and are risk takers who follow their impulses. They like informal problem solving and discovery tasks (Gruener and ter Borg, 1986).

RIGHT-LEFT BRAIN THEORY

The right-left brain theory was developed through brain research of patients with partial paralysis, and through surgery on patients with psychological disorders. Researchers discovered that the human brain was made up primarily of two hemispheres: the left controls language and language-related capabilities, including verbal and analytic abilities (word and number); the right functions in a non-verbal, intuitive way. According to Brooks (1978):

> In normal right-handed adults the left hemisphere is specialized for verbal, logical, linear, and sequential tasks which are abstract and time related. It is the brain's language centre for verbal and mathematical tasks. The right hemisphere is specialized for visual, spatial, metaphorical, and intuitive tasks. It processes non-verbal information and is responsible for visual imagery and imagination (p. 2).

Betty Edwards (1979, 1986) adapted this theory and developed drawing units. According to Edwards "the right brain perceives — processes visual information — in the way one needs

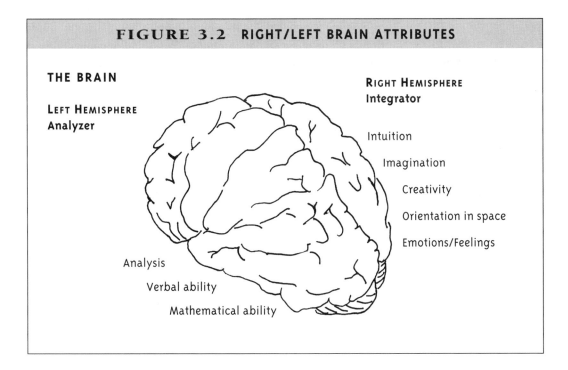

FIGURE 3.2 RIGHT/LEFT BRAIN ATTRIBUTES

THE BRAIN

LEFT HEMISPHERE
Analyzer

RIGHT HEMISPHERE
Integrator

Intuition

Imagination

Creativity

Orientation in space

Emotions/Feelings

Analysis

Verbal ability

Mathematical ability

to see in order to draw, and that the left brain perceives in ways that seem to interfere in draw-ing" (p. 32). Furthermore, " . . . most of our educational system has been designed to cultivate the verbal, rational, on-time left hemisphere, while half of the brain of every student is virtually neglected" (p. 36) and "the emphasis of our culture is so strongly slanted toward rewarding left-brain skills that we are surely losing a very large proportion of the potential ability of the other halves of our children's brains" (1979, p. 37).

Teaching and assessment practices in most schools do not pay adequate attention to the right brain; generally, the abilities of the left brain are recognized. There should be a greater emphasis on arts education for children in order to develop both sides of the brain.

In her books, Edwards describes activities that teachers can introduce to help students dis-cover whether they are left- or right-brain dominant. The drawing projects throughout the book will help students develop their drawing ability and encourage practice instead of the defeatist attitudes of "I can't draw!"

BERNICE MCCARTHY

Bernice McCarthy (1980) developed the 4MAT Model of learning styles. Style 1 learners are what she called Innovative Learners; Style 2 are Analytic Learners; Style 3 are Common Sense Learn-ers; and Style 4 are Dynamic Learners.

1. Style 1, or Innovative Learners, ask "why?"; they need to be involved personally and learn by listening and sharing ideas. They perceive information concretely and process it reflec-tively. They are idea-related, imaginative people.

2. Style 2, or Analytic Learners, ask "what?"; they perceive information abstractly, think ideas through, and process ideas and information reflectively. Their strengths are in creating concepts and models.

3. Style 3, or Common Sense Learners, ask "how?"; they need to know how things work and they learn by testing theories. They perceive information abstractly and process it actively. Their strength lies in practical application of ideas.

4. Style 4, or Dynamic Learners, ask "what if?"; they learn by trial and error, self-discovery, and taking risks. They are active in their learning, test experience, and carry out their plans.

HOWARD GARDNER

Howard Gardner defined intelligence as the "ability to solve problems or to fashion product, to make something that is valued in at least one culture . . . making something, making a work of art, a poem, a symphony; running an organization; teaching a class — these are uses of intelligence" (1990, p. 16).

Gardner believed that these forms of intelligences have been ignored by psychologists because they are difficult to measure, and because they take the focus off the elements that constitute success in our schools. Formal tests that require children to answer questions orally, fill in blanks, or do paper and pencil tasks tend to favour students who are linguistic, logical or mathematical, and discriminate against students who are strong in other intelligences (Armstrong, 1987).

Gardner describes seven intelligences and is researching an eighth. The seven include: linguistic, logical/mathematical, spatial, bodily/kinesthetic, musical, interpersonal, and intrapersonal. Armstrong's book (1987), *In Their Own Way,* describes various attributes that parents and teachers can watch for in order to identify their children's or students' special intelligences. He also discusses ways parents and teachers can help strengthen students' abilities in all the intelligences. However, these categories of intelligence should not be rigidly interpreted — no person's intelligence is 100 percent one type.

1. Linguistic intelligence is the ability to think in words and to use language to express complex meanings. This form of intelligence is evident in authors, poets, journalists, speakers, and newscasters. The students gifted in this area have highly developed auditory skills, enjoy playing with the sound of languages; they like to write, spin tall tales, tell jokes and stories, and play word games (Armstrong, 1987).

2. Logical/mathematical intelligence is the ability to calculate, quantify, consider propositions and hypotheses, and carry out complex mathematical operations. This intelligence is evident in scientists, mathematicians, accountants, engineers, and computer programmers. "Students strong in this form of intelligence think conceptually" (Armstrong, 1987, p. 20); they love brain teasers and logical puzzles.

3. Spatial intelligence is the capacity to think in three-dimensional terms. It enables a person to perceive external and internal imagery, and to recreate, transform, or modify images, to navigate oneself and objects through space, and to produce or decode graphic information. This form of intelligence is evident in sailors, pilots, sculptors, painters, and architects. These students think in images, love mazes or jigsaw puzzles, and spend their free time drawing, designing, building, and inventing.

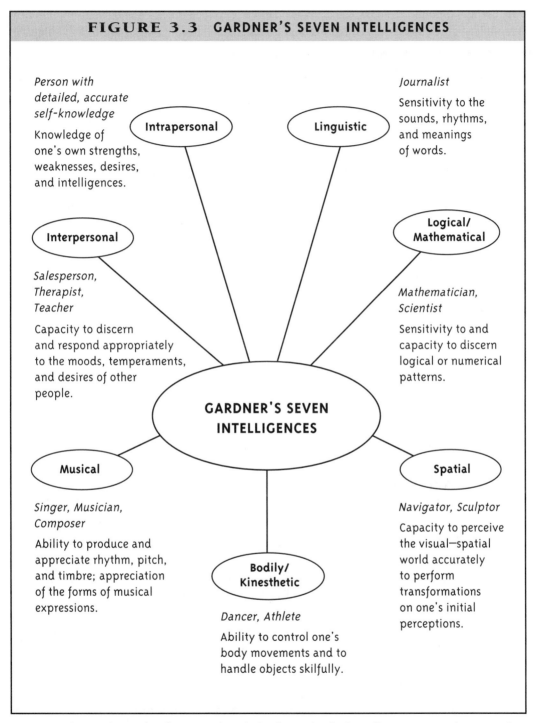

FIGURE 3.3 GARDNER'S SEVEN INTELLIGENCES

Person with detailed, accurate self-knowledge

Knowledge of one's own strengths, weaknesses, desires, and intelligences.

Intrapersonal

Linguistic

Journalist

Sensitivity to the sounds, rhythms, and meanings of words.

Interpersonal

Salesperson, Therapist, Teacher

Capacity to discern and respond appropriately to the moods, temperaments, and desires of other people.

Logical/ Mathematical

Mathematician, Scientist

Sensitivity to and capacity to discern logical or numerical patterns.

GARDNER'S SEVEN INTELLIGENCES

Musical

Singer, Musician, Composer

Ability to produce and appreciate rhythm, pitch, and timbre; appreciation of the forms of musical expressions.

Bodily/ Kinesthetic

Dancer, Athlete

Ability to control one's body movements and to handle objects skilfully.

Spatial

Navigator, Sculptor

Capacity to perceive the visual–spatial world accurately to perform transformations on one's initial perceptions.

Source: Based on Gardner, H. (1983). *Frames of Mind: The Theory of Multiple Intelligences.* New York: Basic Books; and Gardner, H. (1988). Beyond the IQ: Education and human development. *National Forum,* 68(2), 4–7.

4. Bodily/kinesthetic intelligence enables one to manipulate objects and to fine-tune physical skills. Athletes, dancers, surgeons, and craftspeople often have this kind of intelligence. These students squirm in their seats, "process knowledge through bodily sensations," (Armstrong, 1987, p. 22) have good athletic abilities and fine-motor co-ordination. They "can excel in typing, drawing, fixing things, sewing" (p. 22) and other crafts, and cleverly mimic people's mannerisms.

5. Musical intelligence is demonstrated in those with a sensitivity to pitch, melody, rhythm, and tone. It is evident in composers, conductors, musicians, critics, instrument makers, as well as in sensitive listeners. These students often sing, hum, or whistle tunes quietly to themselves, have strong opinions about music, and are "sensitive to nonverbal sound in the environment." (p. 22)

6. Interpersonal intelligence is the capacity to understand and interact effectively with others. This form of intelligence is evident in those who are successful teachers, social workers, actors, or politicians. These students socialize a great deal at school, are the organizers or leaders, or have the ability to influence the actions of others. They pick up on other people's feelings and intentions, may be seen to have "street smarts," and enjoy playing group games.

7. Intrapersonal intelligence is the ability to self-analyze and use this knowledge in planning and directing one's life. Students with strong intrapersonal intelligence, according to Armstrong (1987), tend to shy away from group activities. They are aware of their feelings and ideas and may keep a diary or have ongoing personal projects and hobbies.

Gardner does not believe that any of the intelligences are inherently artistic or nonartistic. However, some of the implications of Gardner's theory are that "intelligences singularly or in combination can be put to artistic uses. They can be used to create or to understand artistic works, to work with artistic symbol systems, to create artistic meanings" (1990, p. 20).

A SYNTHESIS OF LEARNING STYLES

Research in education and theories of learning and teaching are not a pure science, with only one right theory or answer. However, everyone has a preferred learning style. The nature of the individual and the way the child was nurtured by the parents and teachers, as well as the environment, are also believed to affect learning styles.

Educators do not know categorically how a person learns or what should be taught. Nor do they know the best practices of teaching, for learning theories are just that — theories. If all were known about learning and teaching, the public, parents, politicians, and educators would have little to debate. What researchers do understand is that when children are taught through methods that complement their learning characteristics, motivation and achievement increase.

After surveying the learning theories, we can see that these principles of learning emerge consistently throughout:

- Learning is developmental. Therefore, teachers must be sensitive to students' developmental stages to create a comfortable, nonthreatening learning environment.

- Students learn in different ways. How researchers categorize these ways vary, but all teachers should be aware of learning differences and accommodate these differences.
- Teachers must motivate students to be active learners.
- Students are captivated, or become intrinsically motivated, in different ways by different things.
- Students learn best when they are allowed to take control of, and make, their own decisions. Open ended projects (with guidance) and meaningful, relevant assignments are the most successful.
- Students learn by seeing, touching, manipulating, and interacting with natural and constructed objects and people.

These principles on learning styles were also acknowledged in this Chinese proverb: "I hear and I forget, I see and I remember, I do and I understand."

Learning through the arts is made up of the "doing" and "understanding" in this proverb. The arts can encompass a wide array of learning styles. No single instructional process provides optimal learning for all.

Frank Smith (1990) wrote about thinking and learning in his book, *To Think*. He described the process of learning as a creation instead of just the acquisition of information.

> The view is current, in scientific research and popular educational theorizing, that the brain is an information-processing device, functioning only under the pressure of immediate circumstances to seek, organize, retrieve, and utilize information. Learning is regarded as the acquisition of information; memory, its recovery; and thinking, its manipulation. This narrow and ugly metaphor, taken directly from contemporary electronic technology, regards the brain as a kind of computer, a device for performing a limited set of predetermined operations on data. But this is not what the brain is, or what it does.
>
> The brain is more like an artist than a machine. It constantly creates realities, actual and imaginary; it examines alternatives, spins stories, and thrives on experience. The brain picks up huge amounts of "information" on our journey through life, but only incidentally, the way our shoes pick up mud when we walk through the woods. Knowledge is a byproduct of experience, and experience is what thinking makes possible (p. 12).

••••••
Summary

This chapter discussed the developmental stages children go through as they grow. The rate of children's development varies, but all children pass through the same stages.

We also provided a brief overview of learning theories developed by Viktor Lowenfeld, David Kolb, Anthony Gregorc, Dunn and Dunn, Miers and Briggs, Bernice McCarthy, and Howard Gardner, as well as the right-brain, left-brain theory. Understanding these theories is useful for teachers as they plan curricula so that they are able to teach in a way that meets the needs of students.

REFLECTION

❶ How do you think learning about the stages of child development is relevant to learning about teaching art?

❷ How would you describe your learning style? Write down what you think about it, and then complete several learning-style inventories. Do you agree with the results? Why? How does your learning style affect the way you learn, teach, and interact with others?

❸ A number of learning styles were discussed briefly in this chapter. Choose several of these that have particular interest for you and do further research on them.

❹ There are many more learning theorists not mentioned in this chapter. They include such authors as Thorndike, Skinner, Rensoulli (Active and Passive Learners), and social reconstructionists or behaviourists. Research these theorists and compare their ideas. Are these theories relevant to teaching an integrated program?

❺ Make a list of the characteristics of the child who tends to be haptic. What would be this child's preference of subject matter, manner of representation, use of colour, and use of proportion? Plan a lesson that would emphasize nonvisual responses.

❻ Given that children have different learning styles or preferences, why is art education an essential aspect of education?

BIBLIOGRAPHY

Armstrong, T. (1987). *In Their Own Way. Discovering and Encouraging Your Child's Personal Learning Style.* Los Angeles: Jeremy P. Tarcher, Inc.

Atack, S. (1980). *Art Activities for the Handicapped.* London: A Condor Book, Souvenir Press (E & A) Ltd.

Brooks, R. (1978). *The Relationship between Piagetian Cognitive Development and Cerebral Cognitive Asymmetry.* E.R.I.C. Document.

Curriculum Enrichment Advisory Committee. (1981). *Enrichment and Gifted Education Resource Book.* Province of British Columbia, Ministry of Education, Curriculum Development Branch.

Dunn, R. and K. Dunn. (1978). *Teaching Students Through Their Individual Learning Styles: A Practical Approach.* Reston, VA: Prentice-Hall.

D'Zamko, M. and W. Hedges. (1985). *Helping Exceptional Students Succeed in the Regular Classroom.* West Nyack, NY: Parker Publishing Company, Inc.

Edwards, B. (1986). *Drawing on the Artist Within: A Guide to Innovation, Invention, Imagination, and Creativity.* New York: Simon and Schuster.

Edwards, B. (1979). *Drawing on the Right Side of the Brain: A Course in Enhancing Creativity and Artistic Confidence.* Los Angeles: J. P. Tarcher, Inc.

Gardner, H. (1990). Multiple intelligences: implications for art and creativity. In W. Moody, ed., *Artistic Intelligences: Implications for Education.* New York: Teachers College Press.

Gregorc, A. (1985). *Inside Styles, Beyond the Basics.* Columbia, CT: Gregorc Associates, Inc.

Gruener, M. and L. ter Borg. (1986). *Student-Centred Education: A Guide to Understanding and Accommodating Learning Styles.* Second Edition. Calgary: Calgary Board of Education.

Hurwitz, A. (1983). *The Gifted and Talented in Art: A Guide to Program Planning.* Worcester, MA: Davis Publications, Inc.

Kantrowitz, B. and P. Wingert. (1989). How kids learn. *Newsweek,* April, pp. 50–56.

Kellogg, R. (1970). *Analyzing Children's Art.* California: Mayfield Publishing Company.

Law, B. (1990). *More than Just Surviving Handbook: E.S.L. for Every Classroom Teacher.* Winnipeg: Pegius Pubs. Inc.

Logan, L. and V. Logan. (1971). *Design for Creative Teaching.* Toronto: McGraw-Hill.

Lowenfeld, V. and W. Brittain. (1964). *Creative and Mental Growth.* Fourth Edition. New York: The Macmillan Company.

Lueptow, L. (1984). *Adolescent Sex Roles and Social Change.* New York: Columbia University Press.

Madeja, S. (editor), (1983). *Gifted and Talented in Art Education.* Reston, VA: National Art Education Association.

McCarthy, B. (1980). *The 4Mat System: Teaching to Learning Styles Using the Right-Left Mode Techniques.* Oak Brook, IL: Excel, Inc.

Moody, W. (1990). *Artistic Intelligences: Implications for Education.* New York: Teachers College Press.

Oat, R. and A. Hurwitz. (1984). *Art in Education: An International Perspective.* University Park, PA: The Pennsylvania State University Press.

Rowe, G. (1987). *Guiding Young Artists: Curriculum Ideas for Teachers.* Melbourne, Australia: Oxford University Press.

Shakespeare, R. (1975). *The Psychology of Handicap.* London: Methuen & Co. Ltd.

Smith, F. (1990). *To Think.* New York: Teachers College Press.

Sternberg, R. (1994). Allowing for thinking styles. *Educational Leadership,* November, pp. 36–40.

Szirom, R. and S. Dyson. (1987). *Greater Expectations: A Source Book for Working with Girls and Young Women.* New York: Learning Development Aids.

Triplett-Brady, S. (1992). ADHD (attention deficit hyperactive disorder). *Teaching Today,* Sept/Oct.

Planning for Learning, Teaching, and Assessment

Introduction

Teaching without planning is like building a house without a blueprint. Your house might have rooms either too small or too big, and your walls might crack. In the case of your teaching, your materials might be inadequate or disorganized, and your students might lack direction and motivation.

As a teacher, you must make an endless number of decisions about your work. How will you lay out the classroom? How will each area be used? How will you begin each day? What will be the focus of your teaching? How will you develop your lesson plans so that they include the curriculum requirements in your province? How will you structure each teaching unit so that you are well prepared without becoming rigid? One could go on and on asking questions that relate to planning a school year.

Thinking through these kinds of questions and answering them is what planning is about. This chapter can help you in discovering the many aspects of planning for integration and evaluation.

Planning an Integrated Art Program

Imagine a classroom learning session that is so powerful that many students still remember it with almost total recall twenty years later. When these students begin to think about this session, the memory becomes vivid, and they actually appear to be reliving it (Bloom, 1981, p. 193). This experience can be termed a "peak learning" experience, and according to Bloom the study of these learning experiences should reveal the conditions essential for creating them.

> Such peak experiences are the rare moments in which an individual has a feeling of the highest level of happiness and fulfilment When a student could recall a learning situation with great vividness, his description indicated that he was almost totally involved in the situation at the time it occurred (Bloom, 1981, p. 194).

Is it possible that more of these powerful moments of learning could become part of daily classroom experience? By including in your planning, activities that call upon most of the five senses (i.e., sight, sound, smell, touch, and taste), you will increase the possibilities that your students will have these memorable peak experiences.

BOX 4.1 GETTING TO KNOW YOUR STUDENTS

When planning a unit of study consider the following questions:

- Does it honour the students' interest? Will they be interested in the topic?
- Does it invite them to learn? Will the learning experience *engage* the students to learn, and not *force* them?
- Is it congruent with the way students learn?
- Will the learning experience be meaningful to the students?
- Does it provide active participation?
- What would the students be learning?
- Does it provide possibilities for in-depth investigation, or is it superficial?
- Does it balance collaborative and independent student activities?
- Does it address different intelligences?
- Does it respond to diverse learning styles?
- Does the theme/question relate to students' prior knowledge?
- Does it allow students to make choices?
- Are students engaged in a variety of learning experiences?
- Is the learning experience open-ended enough so that the outcome reflects the individuality of the student?
- Does it encourage students to take ownership for their own learning?
- Does it promote higher level thinking?
- Does it help students see relationships among disciplines?
- Does it heighten interest in a topic?
- Do the challenges match the skill levels and abilities of the students?
- Are there time restraints, and are they realistic for the project or investigation?
- Does the learning experience assist students to think in a much broader range than before?
- Will the learning experience be worthwhile and develop students' abilities to communicate, think, care, and act?

CHARACTERISTICS OF A GOOD TEACHER

Art teachers need the same qualities that are characteristic of any other good teachers. Having a reasonable degree of self-confidence (i.e., believing in themselves and their abilities) is a basic requirement for good teachers. Besides believing in themselves, teachers must also have faith in their students, and respect them and be interested in them, not just for what they produce, but for who they are. In fact, teachers must have enough interest in their students to get to know them well enough to know what can be expected of them. "Whether or not children are challenged or overwhelmed in the classroom depends on how well you as teachers know your students" (Leonetti, 1980, p. 44).

The following list suggests qualities that you need for successful teaching.

- Competence in your work, and confidence in your ability to teach art to children.
- Enthusiasm and warmth in relating to children.

- Sound organizational skills in lesson planning for art — knowing what supplies, equipment, spaces, and motivational material you will need.
- Good communication skills, verbally and visually. Much can be transmitted using the body. Develop your verbal skills as well as your non-verbal communication through eye contact, facial expressions, and body posture.
- The ability to work in collaboration with students, parents, and colleagues.
- Curiosity and flexibility, with a commitment to life-long learning.
- The skills to access information with the use of technology. Students need attention, help, direction, and material in an art program.
- A sense of humour, and the ability to take pleasure in your work and in the students. Teaching is serious business, but being able to laugh at yourself and to see the humour in situations goes a long way to reduce stress.

Good art teachers develop their interests in art outside of the classroom. Become familiar with art materials so you can assist students. What better way to enrich your teaching than visiting artists in their studios and looking at art in galleries and museums? Read art magazines to keep in touch with contemporary art. Preview videos on art methods and artists.

Consider taking an evening drawing course, or a course in art history. Start an art resource file of your own for ideas on teaching and clippings about artists. Talk to other teachers about teaching art and join a local, provincial, national, or international art teachers professional group. Join your local art museum or gallery.

Teachers who are interested enough to experience art outside the classroom not only enrich their own lives, but their students' lives as well.

A Creative Learning Environment

What makes a classroom a place where students feel comfortable and confident enough to try something new and to explore? You, the teacher, are the one who creates this kind of environment. Your personality — who you are — and your attitude toward children, and the kind of environment you create are the primary factors that determine whether children learn successfully.

A climate in which students feel accepted and welcome means fewer behaviourial problems. Of course, there are always some students who, because of disturbing situations at home or because of other distressing experiences might have difficulty coping with school. Individual attention and conversation with students often helps them to deal with their stress and upheaval.

Most students respond eagerly in a classroom that has been made into a stimulating place, visually and kinesthetically. For example, you can bring a variety of potted plants into the room, along with displays related to the seasons. You can display art posters and two-dimensional student work on tack boards or bulletin boards, and change the display frequently to keep the wall interesting. Devise a good way to also display three-dimensional work, especially when the visuals illustrate topics of investigation.

Still-life objects can be used to discover or observe texture, colour, line, value, and shape through touching and seeing. Found objects — such as small engine or machine parts, potted plants, dried and silk flowers and grasses, rocks, driftwood, branches, sea shells, animal bones

and skulls, scraps of fabric, ribbons, old shoes, boots, and hats — can be collected in the classroom for students to observe and handle. The list is endless (a start to a collectibles list has been included in the appendix on pages 304–305). These items can become rich sources of visual and tactile stimulation and imagery. Parents and students can often donate items, and you can brainstorm with your students to make a list of items to collect that would be useful not only to look at and touch but also to use as art tools, such as old forks and knives and margarine containers.

The arrangement — the way areas are set up for specific purposes or activity centres — and the type of furniture both have an impact on the classroom environment. Regular routines and transitions are also a part of classroom management and affect the atmosphere in the room. Your students need to know what is expected of them, and should be included in discussions about procedures, seating arrangements, care of tools and equipment, and other procedures. Whatever procedures you choose, be consistent in basic routines, because children need consistency to feel secure.

Classroom supplies, equipment, and materials should be well organized and available when students need them. Students should understand procedures for cleaning up tools and storing materials. When you plan how to use your classroom space, remember to take into account space for drying and storing student work. Allowing enough time for clean-up goes a long way to ensure that students work together well in such transitions as preparing for a lunch break or going home at the end of the day.

PHOTO 4.1 Students respond eagerly in a classroom that has been made into a stimulating place, visually and kinesthetically.

BOX 4.2 TIPS FOR COURSE INTEGRATION PLANNING

The following are some points to consider when planning to integrate art into school curricula. To begin with start small — a whole curriculum organization around a single theme can be overwhelming. Ease into integrated studies, holistic learning won't happen overnight. Further suggestions:

- Create mind-maps: graphically organize, brainstorm ideas, or create a curriculum "wall" where all main themes in the various subjects are presented.
- Take inventory of what has already been done at the school or district level.
- Avoid "force fitting" instruction around a theme.
- Discipline integrity: maintain course integrity.
- Attend to the four parent art disciplines (DBAE) of studio production, criticism, history, aesthetics.
- Is each subject area part of the greater whole, contributing to and building upon other subjects and/or concepts?
- Reflect on the changes made — ask why it makes sense, don't just "buy into" an idea.
- Be careful not to make a "three-ring circus" of it. If the effort is exhausting, teachers will not try again.
- Collect information, research, read, discuss, and view.
- Do the teachers need further skills, knowledge, or understanding in an area?
- Do the students need further skills, knowledge, or understanding in an area?
- How might teachers encourage students' engagement in the learning experience?
- How might the teachers facilitate student exploration in the learning experience?
- Is there integrity for each/all subjects that are integrated in the learning experience?
- Is there opportunity for students to develop understanding that transcends the boundaries of subjects?
- Is there mutual benefit for the subjects that are being integrated in the learning experience?
- Are there significant connections to be made between the learning experience and its relevance to the community beyond the classroom?
- Is academic rigor sacrificed on the altar of curriculum integration?

TECHNIQUES FOR PLANNING SUBJECT INTEGRATION

How you go about planning is determined, of course, by whether you are working as an individual classroom teacher or in a team of teachers. Whatever your situation, an integrated unit or even a yearly curriculum is planned with a focus on learning objectives, or outcomes, and concepts, or themes. If you are working with a team, your strategies become more complex, and at the same time, more stimulating. Working as a team gives you the experience of collaborating in brainstorming, creating mind-maps, and gathering your resources.

Forming a Teaching Team

The working process in team teaching is very different from that of the individual classroom teacher. As an only teacher, you have sole responsibility for the students. When you share the responsibility, you add another level of interaction — the classroom dynamic evolves in a different way — and the expertise of each person adds another dimension. A substantial time commitment from each person is required for planning, along with flexibility in approach and techniques, and the willingness to try new methods. "A more powerful fused curriculum develops when two teachers from different subject areas get together to exploit the connections that exist between their related areas" (Clarke and Agne, 1997, p. 48).

The heart of an integrated program is the subject expertise of the teachers on the team. Each team member should be competent in teaching at least one of the subjects to be integrated. Thorough knowledge of a subject, and the possibilities for teaching that particular material, makes the concept of integration less difficult and more conceivable, particularly in the beginning.

Cooperation and collaboration are an integral part of team teaching. Collaboration takes time, and a teaching team must have a regular time for planning to be able to co-ordinate the integrated course of study.

Experienced team teachers emphasize, especially, the need for flexibility when teaming or integrating for the first time, or with new team members. New attempts at learning, teaching, and teaming require adaptable people willing to take risks, who are able to change tactics or even discard plans when necessary. There is no one "right way" of doing things. You must be able to share ideas, trust team members, and be open and responsive to spontaneous, unusual, and unique ideas and suggestions.

Brainstorming

Brainstorming, or free association of ideas, is a useful technique in planning an integrated unit of study. It allows ideas to flow freely and helps you overcome thought barriers that might be carried over from a traditional, segregated curriculum. The rules of brainstorming are simple: no idea is ruled out or criticized, and no one person dominates or editorializes the suggestions. Lists of ideas often result from brainstorming, but "mind-maps" or "thinking-webs" provide a visual representation more consistent with the brainstorming process.

Mind-Mapping

A mind-map is an organizational sketch of ideas or parts of a whole. It is a circular planning web that becomes a useful tool for curriculum planning, and sometimes is used to summarize a brainstorming session. The advantage of a mind-map is that it allows for one idea to evolve into another, through combination or association.

If your brainstorming resulted in a list of ideas rather than a thinking web, you might decide to choose one or two of the ideas from the list to become the centre or starting point for a mind-map or web. The centre could be a concept, theme, issue, or event, and the other parts could include skills, course content, and activities.

In lesson planning, after you have identified the elements of instruction, you can decide what the initiating activity will include. This initiating activity is crucial to the success of the

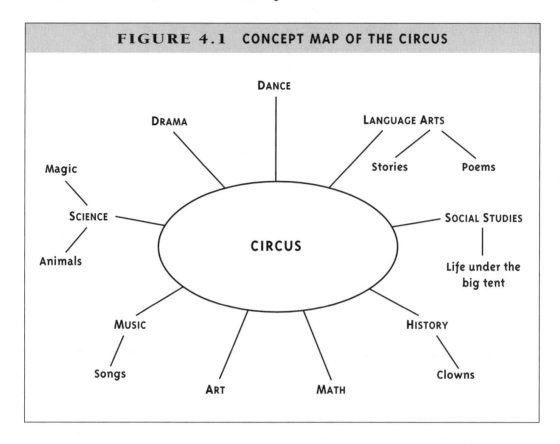

FIGURE 4.1 CONCEPT MAP OF THE CIRCUS

integrated program and could take many forms. It can include several motivating activities such as field trips, films, community visitors, or discussions.

All presentations, experiences, or lessons have a purpose within the program of studies as pictured in your mind-map: lesson objectives, activity flow, materials (resources, books, art materials, and equipment), and approximate time. Location, classroom set-up, and sharing of space are also part of the planning.

Clarke and Agne (1997, p. 48) made a useful scheduling suggestion. "When teachers can recruit the same students for their classes and arrange the schedule so they teach 'back-to-back' periods, they gain a block of time to focus on linkages," making connections and integrating the unit of study. However, Panaritis (1995) suggested that teachers should not be driven by their model for it won't always fit. Don't contrive lessons just to satisfy a rigid curriculum framework.

ELEMENTS OF AN INTEGRATED PROGRAM

A successfully integrated art program includes planning for at least five areas: the learning atmosphere of the classroom; motivational devices; appropriate assessment tools; knowledge of the subject areas; and a general plan for the art program for the year.

The learning atmosphere of the classroom depends, to a large extent, on the relationship between teacher and student and how well the teachers know their students, the teachers' expertise in subject areas, and the use of management skills to organize the classroom and materials. In presenting lessons, motivational devices should create anticipation and captivate attention and engage students in creative problem-solving tasks. Appropriate assessment tools will determine how well students have fulfilled objectives. When planning a topic, or theme, intended for integration with other subjects, you need at least a general knowledge of the subject areas. Teaming up with other teachers who have expertise outside your own area has numerous benefits.

It is also essential that you have at least a general plan of the art program for the year, to ensure that students gain experience, knowledge, and understanding of:

- The reasons for making art.
- Art making using various materials.
- The place of art in history and societies.
- Art appreciation from various times in history and cultures.
- The use of the senses for observation and information gathering.
- Art as a means of communication.
- The integration of art into other courses of study.
- The vocabulary of art.
- The value of viewing the constructed environment and advertisements with a critical eye.

BOX 4.3 ELEMENTS OF ART EXPERIENCES

Integrated units of study can encompass the elements of art in such a way that students experience a richness that is lacking in a traditional approach to learning.

When planning art experiences for children the lessons should include one or more of the following elements:

- A connection with real-life experiences.
- A connection and integration of art experiences with other courses of study.
- Continuity from one art lesson to another.
- Lesson outcomes that allow for personal interpretation and problem solving.
- The experience of various art materials and techniques (and combinations of them) throughout the course of studies in art.
- Adequate motivation for the art activity; the "make whatever you like" approach often lacks potential for creativity and serious art production.
- Use of appropriate motivation, lessons, and materials for the age or developmental stage of the students.
- Cultural understanding and appreciation of art from another era and other cultures.

••••••
Motivational Devices

Motivation, incentive, impetus, spark, stimulus, catalyst — these are all words that describe what moves students to take part in problem solving, learning, or doing. Creative experiences do not happen in a void, nor does learning. Therefore, when you have planned your lesson objectives and outcomes, it's time to plan what motivational devices you will use, because motivation is an ingredient of active learning.

Joanne Whitmore (1980) believed that motivation is an interaction between the students and their learning, doing, and problem-solving that increases self-esteem or preserves self-concept, but that there are many destroyers of positive motivation, such as anxiety. Students can become anxious when they perceive they might fail, and in that case, anxiety can also destroy their motivation, as can criticism or conditional acceptance. You should attempt to provide opportunities and direction for growth with realistic attainable goals for all your students. Praise appropriately, but avoid overuse of praise.

You can consider a variety of motivational devices: calling on students' memory or imagination and using experiential and oral experiences. You might also consider incorporating relaxation and visualization experiences, technology, peer teaching, or high order questioning techniques, as well as developing independent study situations, learning centres, learning groups, or sharing circles into your lesson planning.

MEMORY

Children enjoy recounting experiences and memories. When you get to know your students, and you are alert to what they say, you can encourage them to use their memory as a stimulus for artistic experiences. For example, if a child mentions a memory of a severe thunderstorm, you can lead the conversation into talking about storms — and perhaps even an investigation of thunder and lightning — and the result could well be vivid paintings of memories of storms.

Stories or discussion can arouse mental images, and music and smells can also call up memory. However, if the students are not familiar with a subject, the visual images they will create will be weak because they will likely lack detail. For example, a student who has lived in Saskatchewan and has never travelled to the coast would not have visual recall of the ocean. At the same time, never underestimate the power of the creative imagination when children make art, even on topics that might not be totally familiar.

IMAGINATION

The imagination is a wonderful, creative part of students out of which they invent and develop artistic expression. The imagination is not something that works in isolation, but uses memory and experience to combine images and ideas that are seen, thought, or experienced.

You can stimulate imagination through storytelling, poetry, music, discussion, questioning, simulated games, role playing, dramatic improvisation, guided imagery, and visualization. Encouraging the combination of ideas and images is often successful. For example, through discussion and visuals you can motivate students to create their own mythical creature — part

animal or amphibian, part human. But students must first become familiar with real animals through observation and realistic rendering, and then they can invent others by synthesizing the different elements of what they know.

REAL EXPERIENCES

A touch of real-life experiences can be brought into the classroom in the form of found or still-life objects. Inviting visitors to the classroom is an enriching experience — community members, local artists, representatives of cultural groups in ethnic costume, and even family pets, if appropriate. Visuals, such as posters and carefully selected videos, can also bring richness to the lesson and motivate the creative process.

Field trips to galleries or zoos, demonstrations, investigative projects, and hands-on activities provide real-life experiences. Many researchers believe that we learn less when we read than we do when we see and hear. The greatest amount of learning and retention happens when we have a first-hand experience or when we teach what we know to others.

RELAXATION AND VISUALIZATION

Most people know about the benefit of setting aside time to block out stressful thoughts and activities, to focus on an inner calm, and to do some relaxation exercises. Children can also benefit from relaxation exercises, especially if these become a natural part of their school experience. Drama teachers often use relaxation and visualization techniques to help students focus, and the same techniques can be used in the art room.

The best approach is to have students lie on individual mats with space between them in a dimly lit room (keeping in mind that some children might be afraid of the dark). If that is not possible, take students through relaxation and visualization exercises while they sit in their chairs with their feet flat on the floor and their hands down at their sides. Dim the light in the room at least partially and play soothing music. A good relaxation exercise is to have your students tighten and relax the muscles, going from the body extremes to the body centre (arms and legs to the stomach). Visualization can be encouraged with verbally guided imagery. Ask students to act out situations in their minds — like a walk along the beach or through the woods — noting specific sights, smells, and sounds. Students can develop rich images through these visualization exercises.

TECHNOLOGY

Projected visuals from slides, filmstrips, videos, films, overhead projectors, opaque projectors, laser disks, and computers can bring images to life for the students. The images can be observed, discussed, magnified, distorted, moved and grouped, or transformed to enhance an understanding of art elements.

Audio tapes that create mood or capture animal or human sounds, as well as instrumental or vocal music can be used to encourage visual images related to a main lesson theme. For example, students can listen to animal sounds when studying animals; and they can listen to sounds of buildings under construction and vehicle noises if the urban environment or development is a central theme.

The ordinary chalkboard or whiteboard can be used to illustrate, diagram, or sketch sequence steps and mind-web ideas. Magnifying glasses, microscopes, view finders, and mirrors can also be used to assist in the process of viewing and creating.

PEER TEACHING

Because students have a variety of experiences and abilities, along with a wide range of interests, they can learn a great deal from each other through peer teaching, coaching, tutoring, hands-on assistance, or presenting and exhibiting their work. Take advantage of student expertise by encouraging students to share what they know with others, or explain a process to one student and have her or him teach others.

THE RIGHT QUESTIONS

The primary purpose of questioning is to promote thinking. Educators and students need to go beyond searching for one right answer or working on problems with only one route to a solution. Poor questioning techniques can inhibit creative problem solving and risk taking. Furthermore, students need help and practice in forming and refining questions, and they need to be rewarded for asking good questions. Benjamin Bloom categorized a hierarchy of six levels of learning or intellectual functioning: knowledge, comprehension, application, analysis, synthesis, and evaluation. Questions can be formed that address each level and vary in complexity from simple factual recall to complex evaluation. Higher order activities help students understand and remember information and ideas.

- Knowledge questions require students to recall or recognize information. Students might be asked to label, identify, recite, define, memorize, or name.
- Comprehension questions ask students to translate, interpret, illustrate, express, transform, rearrange, and restate.
- Application questions ask students to transfer and use data and principles to complete a new problem, to apply, modify, paint, sketch, change, produce, and discover.
- Analysis questions ask students to break down data to analyze, compare, distinguish, perceive, select, describe, diagram, and differentiate.
- Synthesis questions require students to integrate and combine ideas to produce new products, plans, or proposals, to design, modify, create, construct, redesign, revise, symbolize, or translate.
- Evaluation questions ask students to appraise information or solutions, to consider, criticize, critique, evaluate, judge, justify, summarize, and recommend (Riles, 1981)

INDEPENDENT STUDY

Independent or individual study is an alternative teaching strategy that promotes independence and provides the opportunity for topic investigation beyond the regular curriculum. It also varies the pace and the opportunity to follow up on special interests. However, such a program requires careful planning and personal guidance of individual students. Independent study offers its greatest promise when it is part of a team-teaching program that allows for flexible use of time and the integration of curricula content.

LEARNING CENTRES

Learning centres are sometimes also called activity centres. You can use these centres to encourage independent learning or individualized instruction related to a specific theme or topic. Students use a centre to investigate selected areas of study — for example, a centre on rocks — with the teacher acting as a guide or facilitator, rather than a director or "teller of truths." The centre can be used as part of an integrated unit of study or as an enrichment investigation. Students should be oriented as to how the centre operates: the centre's learning objective, directions for use, and resource material for research, investigation, and project assignment.

COOPERATIVE LEARNING

Cooperative, or collaborative, learning is a motivational option that works well with integrated study. There are many benefits to forming students into groups for discussion or research: to provide an immediate forum to talk through ideas; to encourage peer support for learning; to help each other learn through consultation; to gain a diversity of perspectives or insights; to provide a class forum for discussion; to encourage reflection; to understand relevance of information and ideas; to learn through purposeful talk. Students learn and practice cooperative skills as they study and explore subject matter together (Clarke, Wideman, Eadie, 1990).

Cooperative, small-group learning works best when students work in positive interdependence and in small heterogeneous groups in which every student is individually accountable as a member of the group. Students learn and practice cooperative skills as they study, explore, and create together.

You can group your students according to a variety of purposes: interest and peer groups — students self-select their group; randomly selected groups; ability groups; and teacher-selected groups. The potential of cooperative learning for improving instruction in multilingual and academically heterogeneous classrooms is enormous. It creates a forum for students to peer-teach, and through teaching they learn.

Informal Groups

The purpose of an informal group is to provide students with an immediate forum for talking. You can create these groups by asking students to turn to classmates seated closest to them and "put their heads together."

You can also form the groups at the beginning of a lesson as a way of encouraging students' participation. For example, if the unit of study is on Greek art, have students share what they already know about this topic. Group discussion can be used to assess current knowledge, to provide a forum to raise questions, and to generate interest on a new topic. At the end of the class, you can form student groups to summarize or review the lesson, to analyze the information, or to brainstorm new questions (Clarke, Wideman, and Eadie, 1990).

Brainstorming Groups

Brainstorming is a useful way of generating a large number of ideas for discussion and evaluation. Guidelines are: no evaluation of ideas until later; quantity is more important than quality; expand on others' ideas; and record all ideas.

You can start your students on brainstorming by posing a question and they should generate and record a list of ideas. After the brainstorming, ask a question to assist the students in sorting or evaluating their list of ideas (Clarke, Wideman, and Eadie, 1990). For example, have them categorize the ideas that might be most possible, most desirable, most or least likely, or some other classifications. Just as teachers create mind-maps from brainstorming, so students can be taught to summarize brainstorming.

Response Discussion

Response discussions provide opportunity for students in small groups to respond personally to an idea, event, issue, or topic. These discussions enable the students to air their views and to feel "heard." You can use these groups to respond to a video or article. Here are some guidelines:

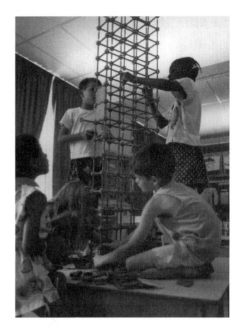

PHOTO 4.2 Students learn and practice cooperative skills as they study, explore, and create together.

- Assign students to "home" groups and ask each group to discuss their immediate response after viewing a video or reading an article.
- Ask questions to explore the video.
- Have students with the same question meet to form exploration groups.
- Ask home groups to meet and report on their discussion of key points while in the exploration group.
- Have home groups develop a poster or image that symbolizes their discussion on the questions or have them write individually in their journals to express their own point of view in light of the shared perspectives and discussions.

Representative Groups

Representative groups are made up of one member from each group. The primary purpose of representative groups is to provide a forum for discussion on the work of groups within the class and provide a manageable way for all groups to make their work public. (Clarke, Wideman, and Eadie, 1990).

Sharing Circles

There are various forms of sharing or talking circles — students are seated in a circle either on a carpet, floor, stools or chairs; seated around a table or tables; or seated at desks positioned in a large circle. You can use sharing to introduce a lesson for discussion, or at the end of the class as part of the lesson closure. You can make circles, which provide an intimate method of sharing learning, a regular component of your class.

Fishbowl sharing is slightly different from the sharing circle in that individuals who are to share are seated in a circle, with others seated outside the circle. One empty chair can be included in the circle for any member outside the fishbowl who wants to make a contribution to the discussion — the student leaves the fishbowl after making her or his point. Fishbowl sharing groups can be formed based on a common question or interest or research topic.

• • • • • •
Unit and Lesson Planning

Unit and lesson plans come in a variety of formats. Unit planning can be done yearly, seasonally, or thematically and can be integrated with other school subjects. One lesson can continue throughout several class periods. Certain elements should be included in all lessons, as outlined below.

- **Lesson Objective** What is the purpose or goal of the lesson, and what is to be achieved by the end of the unit of study? What should the student learn in the lesson?
- **Lesson Introduction** How do you want to introduce the lesson — demonstrate, discuss, display, introduce visuals or guest speakers, questions?
- **Motivational Devices** What stimulation or motivational devices will you use to arouse student interest in the lesson — visuals, audio-visuals, guests, or group discussions?
- **Lesson Preparation** What do you need to do to prepare for the lesson — rearrange tables and chairs, reserve audio-visual equipment, bring in samples or demonstration objects?

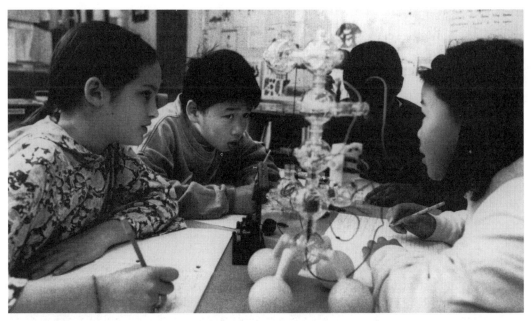

PHOTO 4.3 Sharing circles provide an intimate method of sharing learning.

BOX 4.4 SAMPLE LESSON PLAN FORMAT

Class/Group: _____ Date: _____

Title: _____

Lesson Objectives:

Resources:

Instructional Strategies:

Materials:

Procedure:

Assessment:

Process Evaluation:

Product Evaluation:

Lesson Assessment/ Follow-up/ Reflection:

- **Instructional Strategies** How will the lesson or unit of studies be presented to the students — direct teaching, team teaching, peer teaching, collaborative learning, self-directed learning, learning centres, or discovery learning? Will questioning strategies or generative questions be used to motivate the students?
- **Materials** What materials will the students need — tools, pencils, brushes, newspaper to cover table tops, materials for clean-up (such as sponges and water containers)?
- **Lesson Procedure** What will the students be doing after the introduction of the lesson? Do students have access to materials and do they know how they should be used or handled?
- **Lesson Closure** What amount of time will you need for lesson closure, including storing materials and artwork? What method will you use for summarizing what happened during the lesson and what will be happening in the next session — discussion, sharing circle?
- **Lesson Evaluation** The evaluation consists of two parts. One is the evaluation of the students' work as it relates to your objectives and expectations; the second has to do with your teaching procedures: How successful was the lesson and what could have been done to improve it? What worked well? Did the outcome of the lesson link to the objective?

You might change aspects of your original lesson because of student response or other factors; keep a record of these in a notebook so you can adapt future class plans. You might want to discuss the lesson with your students to gain greater understanding of the success of a lesson. What were the plusses, minuses, or interesting aspects of the lesson? Were the resources valuable in motivating the students, or would other resources have been more effective? Was the topic appropriate? Did the topic integrate with other subjects? Was the demonstration clearly presented? What should have been done differently?

> Did the lesson elicit interest, curiosity, a desire to respond creatively? . . . by continually learning, as we experiment with new teaching ideas, we avoid becoming trapped in a repetitive routine (Szekely, 1988, p. 133).

- **Follow-up** Keeping in mind your previous lesson, what do you want to include in the next lesson? What needs to be reintroduced or reviewed?

BOX 4.5 SAMPLE LESSON PLAN

LESSON PLAN
THE CONSTRUCTED ENVIRONMENT — LEVEL 1

LESSON OBJECTIVES

The students will:
- become visually aware of detail in the constructed environment
- understand the elements of art
- become aware of visual images in daily life

Resources:
- Reference books on architecture and buildings, artworks and reproductions, visual images, photographs
- Poems, stories, songs, children's stories, and illustrations
- The constructed environment in the community

Instructional Strategies:
- Cooperative groups will be formed to discuss the topic. What the students already know.
- The students will report back to the whole class their understanding of the topic.
- Teacher will reinforce or include essential information that has been missed or misinformed.
- Students will be given a list of items/architectural features to look for on their tour around the neighbourhood and will share their findings with their classmates.

(continued)

(continued)

Materials:
- Lists, questionnaire
- Pencils, cardboard boxes, paint, paper, glue
- Plasticine
- Found material, natural and man-made

Procedure:
- Observe the constructed environment in the school community.
- Explore the elements of art, line, texture, pattern, shape, colour, contrast, etc.
- Research aspects of construction.
- Research various design influences.
- View various constructions, visit construction sites.
- Photograph community historical buildings.
- Discuss use of buildings and design and construction influences.
- Design a building for a specific purpose.
- Construct models using various media.

Assessment:
Process evaluation:
- Student contributions to group process and project
- Student reflections on art experiences
- Progress over time, use of time
- Anecdotal records
- Checklist on observed behaviour

Product evaluation:
- Craftsmanship/care and attention to detail
- Completion/display/presentation
- Innovative ideas

Integration:
Social Studies/Language Arts
- Origins of architectural design/details
- Construction material
- Public buildings, their design and use
- Demographics
- Population density of the area investigated
- Occupations of constituents

(continued)

> *(continued)*
>
> - Business vs. residential
> - Interview and write stories about the residents
> - (For further integration ideas refer to Chapter 10.)
>
> *Science and Mathematics*
> - Demographics, population distribution graphs
> - Scale drawings of buildings/streets
> - Proportion of green areas as opposed to concrete
> - Insulation materials and properties
> - Construction material
> - (For further integration ideas refer to Chapter 11.)
>
> *Health/Physical Education*
> - Recreation facilities and use

• • • • • •
Planning for Assessment

Evaluation is the process through which you can observe changes in your students in response to your teaching. Ultimately, as a guide in assessment, you should use students' growth and learning, not just the artwork they produce (Deighton, 1971). Your assessment process can serve as a guide to help students toward self-evaluation, to consider others' ideas, to weigh opinions, and to increase understanding of art and the use of art materials.

> Children need opportunities not only to acquire the skills of impression, but also the skills of expression ... When a teacher gives a class of students the same words to spell, the pedagogical end-in-view is uniformity of outcome ... When that same teacher asks children to write a creative story, or paint a landscape, or choreograph a dance, or compose a piece of music, the last thing the teacher wants is uniformity of outcome. What the teacher seeks is heterogeneity, diversity, idiosyncrasy, works that attest to the distinctive ways in which individual children see, feel, and imagine (Eisner, E. 1991).

Traditionally, assessment of students' artworks has not been given priority, partly because of the belief that art was not important enough to require assessment. The arts provide students with opportunities for a genuine sharing of ideas and abilities without the threat of mark competition. Since the arts have been free of assessment, the focus was on nurturing creative potential as expressed through experimentation, creative problem solving, and an individualistic artistic statement or product. However, this does not mean that arts education was not, or should not be, accountable.

BOX 4.6 ASSESSMENT AND CELEBRATION

ASSESSMENT
- ❑ evaluation tools
- ❑ critical thinking questions
- ❑ high order questioning
- ❑ rote memory testing
- ❑ reflective journal
- ❑ peer teaching
- ❑ critique
- ❑ observation
- ❑ checklist
- ❑ performance outcomes
- ❑ portfolio
- ❑ peer assessment
- ❑ artist/teacher assessment

- ❑ questioning, discussion, debate
- ❑ student self-assessment
- ❑ student led conferences

CELEBRATION
- ❑ presentation
- ❑ performance
- ❑ display
- ❑ sharing circles
- ❑ discussion and questioning
- ❑ video/video-portfolio
- ❑ audience
- ❑ peer/parent/professional/teacher/ community

Eisner believed that when teachers do not evaluate children's art it is educationally irresponsible. Education is goal-directed to bring about desired change, and therefore teachers are responsible to determine whether the educational experience is contributing or hampering this change or growth in art (Cartwright, 1989).

When using or creating assessment tools, consider these questions:

- How can students transform information into understanding and then show what they know?
- How might students and teachers be involved in the presentation of learning?
- What ways will the learning experience be evaluated?
- How will students be assessed to see what they have learned?
- What ways can be used to assess the quality of student work?
- Do the products reflect the individuality of the creator?
- Does the evaluation tool give students informative feedback?

There are various assessment tools — from simple checklists to portfolio development and presentation — for tracking or record keeping, but you should not rely on just one method. Leonetti believed that "No single assessment instrument of any kind should be used as the total criterion for determining a child's learning profile" (1980, p. 45).

Szekely stated:

A teacher's simple judgment that a work is of high quality does not say anything about the value for the student of the work or the experience of making it. The aim should always be to help students learn to evaluate their own work . . . Once a work is completed, they are able to describe it, assess it, and compare it with previous efforts (1988, p. 142).

BOX 4.7 OUTCOME-BASED ASSESSMENT IN ART

- **Self-Directed Learner**
Effort and involvement (demonstrates perseverance and persistence).

- **Knowledgeable Communicator**
Demonstrates the ability to communicate through the production of visual works. Able to articulate the processes that led to producing the work.
 Skill development in the handling of tools and material for artistic expression. Able to discuss works of art, using the appropriate vocabulary of art.

- **Complex Thinker**
Demonstrates inventive and innovative ideas. Explores methods of artistic expression. Takes the idea beyond the simple or ordinary.

- **Quality Producer**
Creates products that reflect craftsmanship. Artworks taken to the ultimate level of completion. Artworks are prepared for exhibition.

- **Collaborative Worker**
Assists co-artists. Demonstrates empathy and consideration.
 Communicates interactively: listens effectively and builds on others' ideas. Generously shares ideas and insights with others.
 Maintains respect for the tools, work space and equipment, and artworks of others.

- **Community Contributor**
Demonstrates knowledge about his or her diverse communities.
 Understands the place of the arts in society and culture.
 Respects self and others.
 Reflects on the role of community contributor in maintaining or enhancing the aesthetics of the natural and man-made environment.
 Becomes involved in opportunities to exhibit and celebrate the arts.

CHECKLISTS

Checklists are usually in the form of a statement and are checked off, by the teacher or student, when the student has performed a specific task. Checklists can also be created with columns with space to check off indications: satisfactory, incomplete, needs more work; or well done, satisfactory, incomplete. Lists can be developed that are general and appropriate for all art lessons, or made specific for certain lessons or use of materials.

The following are the areas of student work to consider in developing checklists.

- Skill in handling and controlling tools and materials.
- Inventive ideas and use of the imagination.
- Experimentation with tools and materials.
- Ability to create pictorial space, perspective, depth.

- Ability to mix colours.
- Skill in using line and colour for expression.
- Capacity to concentrate on work in progress.
- Degree of effort and involvement.
- Respect for tools and equipment.
- Ability to put away equipment and artwork in appropriate places.
- Respect for the rights of others.
- Contribution to class discussions.

THE PORTFOLIO

A portfolio is more than just a container full of "stuff." It should be a systematic and organized collection of a student's work in different media, presented in a way that shows that person's knowledge, skills, attitudes, abilities, and passions and demonstrates his or her own history of learning. Through the portfolio, teachers and students can assess and guide learning so that it becomes a tool to be used as a continuous, on-going process; thus, assessment becomes a reflective collaboration for the teacher, student, and parent.

Students' portfolios are used by educators in the evaluation process, but developing artists also rely on their portfolios to demonstrate achievements. In the broader educational forum, the portfolio is an expanded vehicle of assessment in which a variety of indicators of learning are gathered across many situations before, during, and after instruction.

BOX 4.8 SAMPLE EVALUATION OBSERVATION CHECKLIST

EVALUATION OBSERVATION CHECKLIST

Student's Name: _____ Date: _____

1. Contributes ideas	❏ OFTEN	❏ SOMETIMES	❏ SELDOM
2. Develops one aspect in detail	❏ OFTEN	❏ SOMETIMES	❏ SELDOM
3. Transfers knowledge of the theme	❏ OFTEN	❏ SOMETIMES	❏ SELDOM
4. Explores several ideas	❏ OFTEN	❏ SOMETIMES	❏ SELDOM
5. Takes risks with the new	❏ OFTEN	❏ SOMETIMES	❏ SELDOM
6. Demonstrates commitment	❏ OFTEN	❏ SOMETIMES	❏ SELDOM
7. Challenges self	❏ OFTEN	❏ SOMETIMES	❏ SELDOM
8. Describes what worked and what didn't	❏ OFTEN	❏ SOMETIMES	❏ SELDOM
9. Identifies what to change	❏ OFTEN	❏ SOMETIMES	❏ SELDOM
10. Expresses personal meaning	❏ OFTEN	❏ SOMETIMES	❏ SELDOM
11. Displays concentration	❏ OFTEN	❏ SOMETIMES	❏ SELDOM
12. Discusses why choices were made	❏ OFTEN	❏ SOMETIMES	❏ SELDOM
13. Works cooperatively	❏ OFTEN	❏ SOMETIMES	❏ SELDOM

(continued)

(continued)			
14. Works independently	☐ OFTEN	☐ SOMETIMES	☐ SELDOM
15. Shares materials independently	☐ OFTEN	☐ SOMETIMES	☐ SELDOM
16. Uses materials confidently	☐ OFTEN	☐ SOMETIMES	☐ SELDOM
17. Shows frustration	☐ OFTEN	☐ SOMETIMES	☐ SELDOM
18. Seeks help	☐ OFTEN	☐ SOMETIMES	☐ SELDOM
19. Displays perseverance	☐ OFTEN	☐ SOMETIMES	☐ SELDOM
20. Others . . .	☐ OFTEN	☐ SOMETIMES	☐ SELDOM

Written Comment:

JOURNALS

Students can keep a sketchbook, journal, or learning log for class notes, preparatory drawings, ideas worth investigating, pictures, photocopies, poems, thoughts, and research on artists.

Szekely listed many possibilities for student record books: diary, observation, experimental or doodle book; special trips, movements to choreograph, future-plan book; media notebooks with photographs, tape recordings, films or ideas, photocopies; environmental sampler, such as a collection of leaves, poetic observations; and theme books based on one idea, for example the study of trees (1988, pp. 120–21). These possibilities can be combined into one journal or a sketchbook of ideas, thoughts, information, and reflection. Student journals can give you an understanding of students, their work habits and thought processes, and can become one of your assessment tools.

EXHIBITION AND CELEBRATION

The process of having students look at their work, and then make selections for an exhibition can be a learning experience and a useful means of assessment, and it can become a source of excitement and pleasure in students' accomplishments. Finished art pieces should be valued — they can serve as clues in making decisions about future works, and reveal indications of growth and skills development.

Your students might want to decide whether to have an exhibition as an informal display in the classroom or whether to plan a public exhibit in the school or community and invite their family and friends.

Most students enjoy showing what they have done; and certainly, including some form of celebration with an exhibit demonstrates that you as teacher, and the school, and the community — if you have a public exhibit — value students' accomplishments. If you have a community newspaper in your area, perhaps you could suggest an article about the exhibition and your art integration program. Local media attention adds to students' sense of pride in their work.

BOX 4.9 SAMPLE STUDENT SELF-EVALUATION

STUDENT SELF-EVALUATION

Name: _____

Date: _____

Project description: _____

1. The most interesting thing about this project that I did was . . .
2. The main problem that I had to solve while working on this project was . . .
3. I solved the problem by . . .
4. The things I learned while trying to solve the problem were . . .

STUDENT SELF-ASSESSMENT

Sometimes students are their most ruthless critics. Nevertheless, a student self-assessment process can be a good learning experience. You can provide checklists for the students to use, or you can develop a questionnaire, or simply have them write comments in the form of an anecdotal report based on class discussion about self-evaluation.

• • • • • •
Reporting

Anecdotal report cards, statements of what students are doing, can take a great deal of teacher time, but parents and students appreciate teachers' efforts and thoroughness in providing detailed reports. The reporting process should include individual discussions between the teacher and student and a review of journals or idea books and portfolios.

Students' progress reports should include details of what they learned, their involvement and effort, commitment, class participation, and respect for others. You should also report on your students' skill development in handling tools and materials, respect and care of tools and equipment (including clean-up), innovative ideas through creative problem solving and risk taking, and the quality of the final projects.

REPORTING TO PARENTS

You can communicate your students' progress to their parents in a variety of ways to help them understand and appreciate their children. Educate parents not to rely solely on number, letter, or percentage grades, because these do not tell what the students have learned or accomplished. "Encourage an emphasis on what the child can do and has successfully achieved" (Beesey and Davie, 1994, p. 135).

BOX 4.10 EVALUATION

EVALUATION OF PROCESS:

The evaluation of the process of students working:
- Checklists of observable processes
- Checklist of personal and inter-personal abilities
- Checklist of work and clean-up habits
- Checklist of cooperative behaviour
- Anecdotal records of process
- Videotapes of process
- Audio recordings of process
- Process portfolio of projects
- Student self-assessment of process
- Peer-assessment of process
- Teacher evaluation of process
- Student process journal
- Project planner, sketchbook
- Time-line organization

- Resource and research list to complete project

EVALUATION OF PRODUCT:

The evaluation of the completed student project:
- Checklists of observable attributes of project
- Anecdotal report of the completed projects
- Paper and pencil tests, short answer
- Selection of the best work
- Portfolio
- Statement of intent of artwork
- Formal presentation — audio/visual
- Individual, group, class critique
- Student-led conference
- Parent/student/teacher conference
- External art critic
- Juried show

Plan parent-student-teacher conferences or interviews to be pleasant experiences. Discuss what the students do well and how they have improved in their work and behaviour. Ask the students to discuss how they might improve their habits. You might consider videotaping your students at work as a way of emphasizing the process and not just the product.

Invite students to be a part of the parent-teacher conference to make it a celebration of learning — you might even allow the students to lead the meeting. Student-led conferences provide opportunities for participation in reporting their progress to their parents, guardians, or other adults. The students can select and present, with your assistance or guidance, a collection of work they feel demonstrates their learning and achievement over a specific period of time.

To help the children feel prepared for the conference, have them select specific art pieces, and then role-play with each other — one child presenting to another who plays the role of a supportive parent. Your students can practise their presentations to their parents with you, including their reflections on the assignments and projects: what was learned and how they felt about the process and what they accomplished. "Help students prepare an action plan they can follow through the next term that addresses their goals, established at the conference" (Beesey and Davie, 1994, p. 135).

• • • • • •
Advocacy for the Arts

Arts educators, along with many other individuals inside and outside the school system, know the value of arts education. Nevertheless, teachers in the field of the arts have a responsibility to promote arts education in the public school system. If you develop an expertise in art or arts education, which includes not only art but also drama, dance, and music, others will be more likely to listen to you. As an arts educator, you can participate in professional organizations and attend and help develop workshops, lectures, and courses to raise the awareness of the place of the arts in the community.

Students also become advocates for the arts when they share their accomplishments and learning with people in the community. As well, students can participate in promoting art exhibits, organizing gallery displays of student work, and inviting artists into the school, along with exhibits of their work.

Parents, as well as your colleagues, will be more likely to support art education when they discover how valuable the course of studies is in building self-confidence and encouraging self-expression, as well as developing connections with other learning. Send home an outline of the unit of study, including the objective of the lessons. Include a parent-reflection sheet requesting parent responses and feedback.

Celebrations, exhibitions, and displays of artworks in the school hallways, cafeteria, library, offices, and even in neighbourhood businesses can become a form of advocacy for arts education. If a local business accepts a display of student work, also post a statement of purpose or outcome to give viewers an understanding of the learning process.

Put on an annual art event or feature an art month. For publicity, organize a phoning network among the students and parents. Have the students design and make invitations, and include notices in the school newsletter. Always put up displays during parent-teacher conferences and other events in the school. Talk about your art program with your colleagues and your administrators, and place artworks in their rooms and offices. Be visible, verbal, and enthusiastic about your students' accomplishments. Advertise in the school and community newsletters, in parent and community groups, and with local merchants and businesses. Be aware of what is happening with your provincial department of education and respond in writing to politicians when you believe something adverse might be happening to arts education. Encourage other teachers and parents to do likewise.

Emphasize the importance of not only visual art but all the arts for the total education and development of the students.

• • • • • •
Summary

Careful planning for your teaching will ensure that you can offer good learning experiences for your students. If you intend to integrate art with other subjects, and if you are team teaching, spend adequate time planning to provide a solid base for what happens in the classroom.

You as a teacher need an expertise in your subject area along with an understanding of your students. You will also need to give attention to the learning environment, classroom organization, and motivational devices that you can use to introduce a unit of study.

Assessment should be taken seriously — teachers have a variety of assessment tools available to evaluate the program and students' progress.

Working as an advocate for the arts is a part of your teaching responsibilities. You can promote your art program through discussion with others in the education system, through exhibitions of students' work in the community, and through the students themselves.

REFLECTION

❶ What qualities do you have that will help you to become a good teacher? What qualities do you feel you need to develop?

❷ Think through your own ideas about team teaching. How can this way of teaching benefit students?

❸ Investigate cooperative learning groups. Develop a unit of studies in which cooperative learning groups can be formed. Develop initiating activities, objectives of the unit of study, grouping of the students, and the expected outcomes of the lesson.

❹ Describe how you might use cooperative learning groups in an integrated lesson.

❺ How would you use learning centres in your classroom?

❻ Develop and practise various questioning techniques on a specific theme, topic, or lesson for an integrated unit of study.

❼ How can you take measures to ensure diversity of outcomes of an integrated lesson, and at the same time maintain consistency of excellence and success for all students?

❽ What might be the benefits of developing and maintaining a student portfolio? What are the benefits for the students, for the teachers, and for the parents?

❾ Develop a lesson along with a checklist for record keeping and tracking of a student's progress and work.

❿ Develop a student self-assessment tool.

⓫ Research art organizations at the local, provincial, national (Canadian Society of Education through Art and others), and international (National Art Education Association) levels. Join one or more of these organizations.

⓬ Start your own resource file of art lessons, ideas, media, and other resources — where to buy art materials, videos, films, and other visuals.

BIBLIOGRAPHY

Barrett, M. (1979). Art Education, A Strategy for Course Design. London: Heinemann Educational Books.

Beattie, D. (1991). The feasibility of standardized performance assessment in the visual arts: Lessons from the Dutch model. *Studies in Art Education.* Reston, VA: National Art Education Association. 34 (1), Fall, pp. 6–17.

Beesey, C. and L. Davie. (1994). *Teacher's Resource Book, Level 2 (3–4).* Toronto: Gage Educational Publishing Company.

Bloom, B. (1981). *All Our Children Learning: A Primer for Parents, Teachers and Other Educators.* New York: McGraw-Hill.

Cartwright, P. (1989). Assessment and examination in arts education: Teachers talking. pp. 283–93. In M. Ross, ed., *The Claims of Feeling: Readings in Aesthetic Education.* London: The Falmer Press.

Clark, G., E. Zimmerman, and M. Zurmuehlen. (1987). *Understanding Art Testing: Past Influences, Norman C. Meier's Contributions, Present Concerns, and Future Possibilities.* Reston, VA: National Art Education Association.

Clarke, J. and R. Agne. (1997). *Interdisciplinary High School Teaching: Strategies for Integrated Learning.* Boston: Allyn and Bacon.

Clarke, J., R. Wideman, S. Eadie. (1990). *Together We Learn.* Scarborough, ON: Prentice-Hall Canada.

Deighton, L. (1971). *The Encyclopedia of Education.* Volume 1. USA: The MacMillan Company and The Free Press, pp. 291–92.

Eisner, E. (1991). What really counts in schools. *Educational Leadership,* February, pp. 10–17.

Herberholz, B. and L. Hanson. (1985). *Early Childhood Art.* Third Edition. Dubuque, IA: Wm. C. Brown Publishers.

Herberholz, D. (1964). *Developing Artistic and Perceptual Awareness.* Dubuque, IA: Wm. C. Brown Publishers.

Herberholz, D. and K. Alexander. (1985). *Developing Artistic and Perceptual Awareness, Art Practice in the Elementary Classroom.* Dubuque, IA: Wm. C. Brown Publishers.

Herberholz, D. and B. Herberholz. (1990). *Artworks for Elementary Teachers, Developing Artistic and Perceptual Awareness.* Sixth Edition. Dubuque, IA: Wm. C. Brown Publishers.

Hurwitz, A. and M. Day. (1991). *Children and Their Art, Methods for the Elementary School.* Fifth Edition. Fort Worth: Harcourt Brace Jovanovich College Publishers.

Jones, C. (1993) *Parents are Teachers Too.* Charlotte, VT: Williamson Publishing Co.

Lasky, L. and R. Mukerji. (1980). *Art Basics for Young Children.* Washington, D.C.: The National Association for the Education of Young Children.

Leonetti, R. (1980). *Self-concept and the School Child.* New York: Philosophical Library.

MacGregor, R. (1977). *Art Plus.* Toronto: McGraw-Hill Ryerson.

Mattil, E. and B. Marzan. (1981). *Meaning in Children's Art. Projects for Teachers.* Englewood Cliffs, NJ: Prentice-Hall.

Michael, J. (1983). *Art and Adolescence, Teaching Art at the Secondary Level.* New York: Teachers College Press.

Naested, I. (1993). *Educational Innovation at Lester B. Pearson High School, Calgary, Alberta, Canada.* Unpublished dissertation, Provo, UT: Brigham Young University.

Panaritis, P. (1995). Beyond brainstorming: Planning a successful interdisciplinary program. *Phi Delta Kappan,* April, pp. 623–28.

Richardson, J. (1986). *Art: The Way It Is.* Third Edition. Englewood Cliffs, NJ: Prentice-Hall.

Riles, W. (1981). *Arts for the Gifted and Talented, Grades One through Six.* Department of Education. Sacramento, CA: Publication Sales.

Romey, W. (1980). *Teaching Gifted and Talented in the Science Classroom.* Washington, D.C.: National Education Association.

Schirrmacher, R. (1993). *Art and Creative Development for Young Children.* Second Edition. New York: Delmar Publishers Inc.

Sefkow, P. and H. Berger. (1981). *All Children Create: Levels 4–6. An Elementary Art Curriculum.* Holmes Beach, FL: Learning Publications Inc.

Silberstein-Storfer, M. and M. Jones. (1982). *Doing Art Together. The Remarkable Parent-Child Workshop of the Metropolitan Museum of Art.* New York: Simon and Schuster.

Smith, R. (1986). *Excellence in Art Education, Ideas and Initiatives.* Reston, VA: National Art Education Association.

Steward, J. and C. Kent. (1992). *Learning by Heart.* New York: Bantam Books.

Szekely, G. (1988). *Encouraging Creativity in Art Lessons.* New York: Teachers College Press, Columbia University.

Valencia, S. (1990). A portfolio approach to classroom reading assessment: The why, whats, and hows. *The Reading Teacher,* January, pp. 338–340.

Vavrus, L. (1990). Put portfolios to the test. *Instructor,* August, pp. 48–53.

Wachowiak, F. (1985). *Emphasis Art, A Qualitative Art Program for Elementary and Middle Schools.* Fourth Edition. New York: Harper and Row.

Whitmore, J. (1980). *Giftedness, Conflict and Underachievement.* Boston: Allyn and Bacon.

Wolf, K. (1991). The schoolteacher's portfolio: Issues in design, implementation, and evaluation. *Phi Delta Kappan,* October, pp. 129–36.

CHAPTER 5

Fundamentals of Design and Art Appreciation

• • • • • • Introduction

When you look at a painting, your eyes can focus on only a very small part of the picture at one time; you then scan the surface to bring all the parts of the images into some kind of order. Whether or not you see the painting as making visual sense, or whether it has a coherent pattern, depends partly on the design, and partly on your experience and understanding of art.

In this chapter, we explore design and the vocabulary commonly used to talk about it. The purpose of an art vocabulary is to be able to communicate about art. Becoming familiar with art as a language builds students' ability to appreciate all the different forms and media that make up the visual arts.

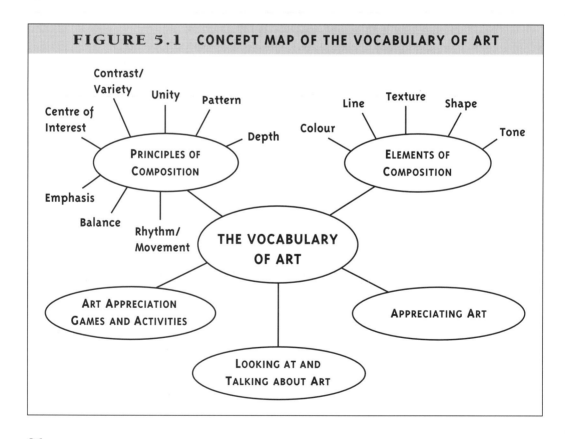

FIGURE 5.1 CONCEPT MAP OF THE VOCABULARY OF ART

The elements of design, colour theory, and the illusion of depth are discussed in this chapter, as well as activities for looking at art and talking about it, processes that develop appreciation of art. We also consider ways design problems and activities can be integrated with other subject investigations.

> The arts fuel the academic and the academic fuels the arts. There are different intelligences that might not be covered in one area in one classroom; but if the children have the experience with different types of learning, those differences in intelligence will be dealt with and broaden the child's learning base. — Director of St. Aygystubem School, The South Bronx. (The Boston Public Schools, 1993, p. 2).

• • • • • •
Elements of Composition

All works of art are composed of forms, whether they are songs, instrumental pieces, dances or movement sequences, plays, or visual compositions. Composition is simply the organization of forms and their qualities to create visual statements. In the visual arts, composition refers to the way art elements and principles work together. These elements and principles can be learned and put to use in any art mode whether it is two-dimensional, three-dimensional, or a relief.

A two-dimensional image has only the dimensions of width and height, as, for example, a piece of paper does. A three-dimensional image has width, height and depth, and is free-standing; for example, a lamp post or a building, which you can walk around and see from all sides. Relief works are not free-standing. They usually have one side not created for viewing — like a painting — but they have areas that are raised above the surface.

All three of these modes of expression include the elements of composition: colour and intensity, line, texture, shape and form, and value or tone.

COLOUR

A professor once painted his office walls black, and when he left the institution and another teacher wanted to use the same office, it had to be repainted. In a redecorating frenzy, a woman wanted to paint a room burgundy, but the colour in the paint can was more like a hot pink and after a few brush strokes she put away the paint and used beige instead. These examples show that people have a strong reaction to colour.

Artists who understand colour theory use colour in the visual arts to express and evoke emotion. Colour theory is integral to any art program, and can be taught effectively, even to young children. In fact, when children are given guidance and allowed to experiment with colour, they often experience intense excitement from their discoveries.

The Colour Wheel

The colour wheel is the most common method used for organizing the basic colours. It uses twelve colours, which are divided into three categories. These categories are not arbitrary, but are based on the perceptions of the human eye. Red, blue, and yellow are called primary colours because they appear dominant to the human eye, and because from these you can obtain all the

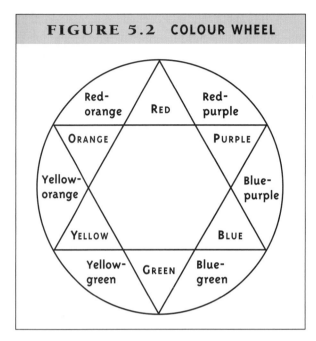

FIGURE 5.2 COLOUR WHEEL

other colours. There are three secondary colours, hues that have a direct relationship to the primary colours: orange, made by mixing red and yellow; purple or violet, made by mixing blue and red; and green made by mixing blue and yellow. Tertiary colours are made by mixing a primary and a secondary colour together.

Colour Intensity

Intensity refers to the brightness of a colour. Colour is at full intensity only when it is pure and unmixed. You can lower the intensity of colour in two ways: by mixing it with grey, or mixing it with its complement (a colour on the opposite side of the colour wheel). When complements are mixed in equal amounts, they cancel each other out, and a neutral tone of brown or grey is the result.

Tone or Value

Value, or tone, means the lightness and darkness of the colour. Adding black darkens a colour and produces a shade or low-value colour. Adding white lightens it and produces a tint or high-value colour. Some examples of words to describe tone are dull, gloomy, strong, weak.

Colour Harmonies, or Schemes

There are four basic colour harmonies, or schemes, that create various effects when specific colours are placed together in a composition. These harmonies can be helpful to designers when they plan the visual effects they wish a finished pattern to have.

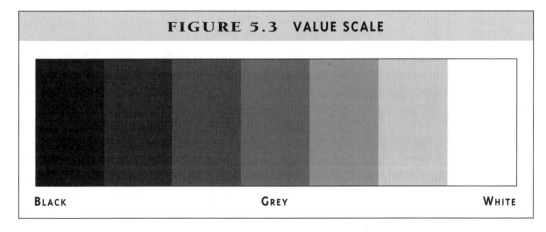

FIGURE 5.3 VALUE SCALE

BLACK GREY WHITE

- **Monochromatic colour schemes** contain only one colour. The colour is mixed with different amounts of black and/or white to create a variety of tones. The visual effect is harmonious, and generally quiet, restful and (depending on the range of values) subtle.
- **Analogous colour schemes** combine several colours that sit next to each other on the colour wheel, for example, red, orange, and light orange.
- **Triadic colour schemes** involve three colours equally spaced on the colour wheel, such as red, yellow, and blue. Since the hues come from different parts of the wheel, the result is contrasting and lively.
- **Complementary colour schemes** join colours opposite each other on the colour wheel. The colours to combine would be yellow and purple, red and green, and blue and orange. Double-complementary colour schemes means two complementary colour combinations. These combinations produce lively, exciting patterns, especially with colours at a full intensity.

After-Image

A visual phenomenon having to do with complementary colours is called after-image. Stare at an area of intense colour, such as a large piece of red paper, for a minute or two and then glance away at a white piece of paper. An area of a complementary colour will seem to appear — in this case, green.

When complementary colours are placed next to each other, they intensify the brightness of each other. This is called simultaneous contrast, meaning that each complement simultaneously intensifies the visual brilliance of the other.

Line

The mathematical definition of line as a point moving through space can be applied in the arts. Lines suggest movement, and they are found in both natural and constructed objects. In the visual arts, lines are used to define space — lines as edges — or create decoration, pattern, or texture. Shading and texture can be created by drawing the lines (or dots, which are just short lines) close together, called hatching; or crossing them, called cross-hatching (see pages 114–115 in Chapter 6).

Like colour, lines can evoke emotion, depending on how they are drawn. A picture with lines of equal length, distance, and weight can seem monotonous; but it can be made more interesting by varying the length and width, distance between, weight and thickness, and direction or angle of lines.

With practice you can discover the limitless variety of use of line. You can describe space with thick and thin lines moving in flowing rhythms;

EXHIBIT 5.1 Lines

BOX 5.1 USE OF LINE

- **Size:** Short, long, points/dots, broken, continuous.
- **Width:** Thick, thin, fat, skinny.
- **Shape:** Curved and straight lines, circles and other geometric, biomorphic, or organic shapes can be created with a line or lines. Straight lines are rigid; diagonal, exciting; vertical, dignified; horizontal, quiet and restful; curved, soft; and straight are precise.
- **Direction:** Straight, curved, concave, contour, convex, crooked, circular, horizontal, diagonal, vertical, bent, curly; lines can create the sensation of movement — exploding, undulating, drooping, vibrating, spiralling, pooling — through line direction.
- **Distance:** Converging lines and overlapping lines.

- **Value/tone:** Light, heavy, fuzzy; density, closeness or distance between lines creates tone; heavy lines are bold and thin are exacting.
- **Colour:** The tone and colour of lines can cause a line to advance or recede, or create the effect of movement.
- **Pattern:** Patterns are created by repeating the lines to create spirals, webs, chains, netting, lattice, arabesque, regular and irregular patterns.
- **Texture:** Choppy, bumpy, broken; lines can create textured surfaces, real or simulated.
- **Movement:** Explosive, choppy.
- **Calligraphy:** Eastern artists, especially in China, used lines in a form of writing called calligraphy.

with thick and thin lines moving in angular and jagged rhythms; with textured lines or with broken lines; and with a combination of straight and curving lines.

Through two-dimensional compositions, students can explore line in a variety of art forms: collage, stitchery, weaving, printmaking, calligraphy, lettering, textile decoration, ceramic decoration, and drawing and painting with various media. Students can experience drawing in space by working in such three-dimensional forms as mobiles, stabiles, wire sculptures, and assemblages.

TEXTURE

Of the elements that make up a composition, texture relates most directly with the sense of touch. Texture is the surface quality of material that produces a sensation when touched. Tactile texture describes an actual change in the surface or plane, while visual texture is an illusion created by artists who use variations in light and dark to create the appearance of texture. Various words can be used to describe surface quality: smooth, rough, sandy, grainy, perforated, silky, coarse, gritty, granular, shiny, furry, feathery, cracked, bumpy, jagged, hairy, pointed, sharp, dull, spotted, stippled, leathery, soft, hard, lacy, frilly, corded, twisted, rocky, pebbled. See if you can add to this list of surface qualities. Identify objects in the natural and constructed environment that have these textures.

Materials that suggest texture include wood, glass, cotton, satin, fur, velvet, wool, sandpaper, sand, leather, leaves, salt, flour, and sugar.

As a way of stretching the imagination, think of a familiar object and cover it with a texture it does not usually have. For example, in an exhibition in New York in 1936, the American artist, Meret Oppenheim, showed a cup, saucer, and spoon covered in rabbit fur. Children, offered the opportunity and materials, enjoy playing with textures and familiar objects to invent new experiences with ordinary things.

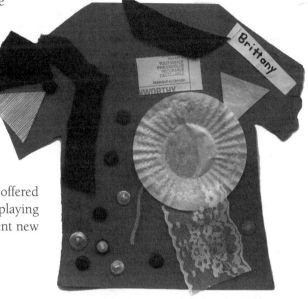

EXHIBIT 5.2 Texture

SHAPE AND FORM

Shapes are generally classified as either geometric or organic. Geometric shapes, such as triangles, circles, and squares, are generally constructed, or mathematically designed. Organic, biomorphic, free-form, or irregular shapes are usually composed of the curving outside edges found in nature.

Shapes can be round, square, triangular, rectangular, oval, curved, straight, zig-zag, squiggly, or biomorphic. They can be drawn, painted, cut from paper or other material, or printed in regular and irregular patterns.

EXHIBIT 5.3 Shape and form

Shapes can define positive shapes, the shape that appears to be the object, and negative spaces, the empty area around the positive shape. In composing an image, positives and negatives should be considered with regard to their visual weight. These can also be used to confuse the viewer as to what are the actual positive shapes and negative spaces.

Form is a term often used for three-dimensional shapes, but it is often implied on a two-dimensional surface with the use of tone or shadow. We use the terms mass and volume to describe the way three-dimensional forms take up or define space. But artists can create even the illusion of mass on a two-dimensional surface by skilful use of light and shadow. Mass can be reduced to the basic forms of cube, cylinder, cone, and sphere; as well as boxes, tunnels, tubes, domes, caverns, columns, and vessels.

TABLE 5.1 VISUAL COMMUNICATIONS CHART

WORD	LINE	SHAPE	TEXTURE	COLOUR	PATTERN
Happy					
Sad					
Hard					
Soft					
Sharp					
Rough					
Strong					
Weak					
Loud					
Quiet					
Light					
Heavy					
Fast					
Slow					
Hot					
Cold					

Have students create lines, shapes, textures, colours, and patterns that they feel relate to the words on the list.

EXHIBIT 5.4 Mass

●●●●●●
Principles of Composition

Artists use the elements of composition in a certain way, based on the principles of composition, which are simply organizational devices. These principles need to be understood separately, although they are rarely used independently of each other. The principles of composition include: balance, unity or harmony, contrast, emphasis, movement and rhythm, and pattern. Gatto, Porter, and Selleck (1987) understood that:

One important aspect of experiencing and understanding these principles is that you can gain the benefit of more sensitive vision. The designer sees the world a great deal differently than does the untrained individual. . . . As these principles become a part of your own design knowledge, you will gain new fluency and expressiveness (p. 134).

• *Balance*

Every element of a composition has weight. When the weight of one element is offset by the weight of another, you have elements in balance. Balance can be formal, symmetrical, informal, or asymmetrical. Formal balance means that all areas of the composition are the same or of similar weight. It creates a feeling of stability and strength. With informal balance, the composition appears busier, more active, and of unequal weight throughout the design.

The relation of one part of a work to another is called proportion. To create mood and balance, the artist must evaluate how to relate light areas to dark, warm colour to cool, intense colour to grey, and textured areas to non-textured.

Some artists feel that a balanced composition requires the same colours or shapes in at least three areas of the picture or sculpture. The amount of colour in a composition should be balanced so that no one part seems heavier than the other. A smaller area of pure colour can be balanced by a larger area of darker colour tone. An artist may choose to make one area of a composition heavier than another.

• *Repetition*

The repetition of shape, colour, value, line, or texture produces unity in a composition.

• *Rhythm and Movement*

The placement of the elements of art creates visual movement, which leads the viewers' eyes across the picture plane, or surface of a sculptural form. Direction is given by repeating a certain shape, colour, or other element of composition. Rhythm is the flow or feeling of movement created by regular repetition of these elements.

• *Contrast and Variety*

Contrast is an effective way of adding interest to a composition. It places emphasis on an area, and keeps the image

EXHIBIT 5.5 Formal balance

EXHIBIT 5.6 Informal balance

EXHIBIT 5.7 Rhythm and movement

from having too much unity and harmony. Vary the shapes, sizes, and colour to avoid monotony and too much repetition.

• *Emphasis*

Emphasis is the principle of composition that gives significance to certain areas, relieves monotony, and provides variety within a work of art. It creates a centre of interest, a focal point to catch the viewer's attention; it emphasizes a certain part of the total composition. Emphasis is achieved through the use of colour, size differences, and other aspects of composition. Emphasize areas that are considered most important.

• *Unity and Harmony*

Unity is the total effect of a work of art that results from the combination of all of the work's component parts (Ocvirk, et al., 1981). Harmony is achieved by making sure that the areas in the composition work together so that the viewers' eye follows a path through the picture or around the form. It is achieved by repetition of characteristics that are the same or similar (Ocvirk, et al., 1985).

• *Patterns*

Patterns are made by repeating elements such as lines, colours, shapes, or textures, and they can be found in constructed and natural objects. These elements can be repeated in a regular or irregular fashion.

BOX 5.2 DESIGN PROBLEMS

- Define the shallow space on a picture plane by drawing flat shapes and eliminate perspective. Balance positive and negative shapes and spaces within the same composition.
- Create a design based on recurring images in the environment — pebbles on a beach, trees on the horizon.
- Design a functional object inspired by natural forms, for example, a bowl based on the shape of a sea shell.
- Create a design or pattern with symmetrical or asymmetrical balance.
- Create a mobile or kite stressing one or more elements of composition.
- Create a non-objective composition — no object is used as a source.
- Create a composition using only geometric shapes of circles, squares, rectangles, and triangles.
- Photograph objects with the intent to

(continued)

(continued)

illustrate one or more art elements and principles, for example, shape or texture.

- Bring utilitarian objects to class; draw or paint them and place them in an environment where they do not normally belong.
- Create a composition in which you use the human figure to suggest the scale of an object in space.
- Create a colour wheel. How many different colours can you make from the three primary colours? How many different tones and tints can you mix? Can you make colours look transparent?
- Create a cool painting and a warm painting using the same theme or image.
- Create a vibrating composition using complementary colours repeatedly.
- Create a composition by using only three shapes of various sizes or one shape of various sizes; overlap the shapes to create unity. These shapes can be cut from coloured construction paper or from stencils to be traced onto paper to be painted or coloured.
- Create areas that appear to be smooth, rough, or patterned, or make surfaces look real, such as the texture of a tree trunk.

Creating the Illusion of Depth

For centuries, artists have created paintings that give the illusion of depth. As early as 1 A.D. artists used architectural elements in their paintings in a way that was visually convincing, though they were not geometrically correct. Artists who are able to use techniques to create an appearance of depth, or conversely, to avoid the illusion of depth when they want a flat surface, open up a range of fascinating visual experiences.

Artists achieve an illusion of depth on a two-dimensional surface through use of foreground, middle ground, and background. Other techniques include overlapping images; changing their size, detail, and position on the page; colour; and using a horizon line and lines of perspective.

- **Overlap**

This is a basic technique used to create the illusion of depth. One shape is partly hidden from view by another shape; for instance, a tree placed behind another appears further away.

- **Size**

Varying the size of images changes one's perception of where they are on a flat surface. Smaller objects appear farther away.

- **Detail**

Greater detail can be seen on objects that are closer. You can see facial detail more clearly on people who are close to you, but when they are farther away, you cannot see their nose or eyes clearly.

• *Position on Page*

Images higher on the page appear farther away because they are positioned closer to the horizon line. In a landscape painting, if houses are painted closer to the horizon line they appear to be more distant. Farther down on the painting the houses seem closer.

• *Colour*

The colour of objects that are close by are more vivid than those that are farther away.

EXHIBIT 5.8 Illusion of depth

• *Lines of Perspective*

Lines of perspective are used by artists to create the illusion of depth by creating lines that converge to one or more vanishing points. This technique is not taught to young children because their sense of space is not developed, but by the time they are ten or twelve the idea of perspective becomes intriguing. Perspective should be taught only if children are interested, and then step by step and with great patience.

••••••
Learning to Appreciate Art

One's appreciation of art develops through observation, experience, and exposure to a variety of types of art. Not only do students need to create art, but they also need opportunities to discuss, question, and respond to the works of others — their classmates, local and national artists, and renowned artists of the past. Provide opportunity for students to talk about their own work when they feel comfortable doing so. Talking about art, appreciating and making critical judgements about art, should become a natural part of the art program; not an exercise tacked on superficially. Further, students need a common understanding of the vocabulary of art so that discussions become learning experiences. Students should know the elements and principles of a composition and have some understanding of various media that artists use.

VIEWING AND TALKING ABOUT ART

Looking at art and talking about it should be an integral part of your art program. As observed by Thompson, "Information drawn from art history, art criticism techniques and aesthetic issues should be incorporated into interdisciplinary teaching units" (1995, p. 39). Broudy's (1972) model of aesthetic perception and Mittler's (1980) model of art criticism divide aesthetics and art criticism into four domains of experience and knowledge. These domains include physical properties (colour and texture), formal properties (structure and balance), technical properties (media and process), and expressive properties that take into account the purpose and meaning of the art work (Marschalek, 1991).

Edmund Feldman (1967) developed a method of helping students discuss a work of art, and this approach has been widely adapted and used. Feldman described a four-step procedure:

description, analysis, interpretation, and judgement. Inexperienced viewers often tend to make quick judgements from brief observations. Going through the steps delays the judgement stage until the viewer has processed as much of the visual information as possible and encourages further looking and understanding. However, there is another valuable part of the process — collecting biographical information — and this should be the first step. Understanding who the artist is and when she or he lived provides a historical perspective and enriches students' understanding of a particular work of art.

Biographical Information

Encourage your students to discover the following information about the artists and art images they study.

- The name of the artist.
- Life, source of inspiration, experience, and training of the artist.
- The presentation of the ideas: realistic, abstract, nonobjective, impressionistic.
- Title of the work.
- Year produced and period in history.
- Location or country.
- Medium used.
- Size of the work.

Through gathering information about artists and their work, students can develop confidence in talking about their understanding of the purpose and meaning of a work of art. When they feel comfortable discussing art, they are able to learn much more readily from what they see and experience.

Description

Describing a painting or sculpture in detail helps students sharpen their ability to observe and take in what they see. This step helps students slow down their viewing pace to identify and describe what they see objectively and as accurately as possible. All the detail should be observed — students can learn to describe a work so well that another person can imagine what it looks like without seeing it.

You can teach students to examine works of art from a number of points of view.

- Describe the subject matter. What objects are in the image: people, animals, plants, buildings? What kind of scene is it: a portrait, a still-life, a landscape?
- Identify the medium and technique. What kind of work of art is it? What materials and tools did the artist use? What is the surface quality: smooth, thick, watery, created with a brush or a pallet knife?
- Identify the design elements: colours, textures, shapes, lines, tone. What kind of lines, shapes, colours, textures, tones? What do you see when you squint your eyes to look at the painting? Where do you see dark and light areas?
- Describe the work using qualitative words or adjectives. How does the image make you feel? Does the work appear gentle, jerky, fluid, massive, graceful, jerky, jarring, or relaxed? Describe the state of the objects or people: run-down, decayed, observant, tired, jolly.

Analysis

Analysis is a continuation of description but it describes the relationship, effect, or influence of the elements in the description stage. Again, using a number of different approaches can help students go further in their discussion of a work of art.

- Describe the ways the artist has used design principles: repetition, rhythm, harmony, balance, overlapping, and variety and directional movement of colour, line, shape, tone, and texture.

 How does the artist achieve unity? What colours, lines, and shapes are repeated most? What about colour relationship — do certain colours dominate?

 Do certain shapes seem to dominate? What has the artist emphasized? What is the first thing that you see? Where is the centre of interest? Why is it the centre of interest? How does your eye move around the composition?

 What kind of balance (symmetrical, asymmetrical) has the artist used?

- Describe the overall feeling of the work. What is the mood? How did the artist create these feelings?

- Did the artist attempt to create the illusion of depth? Does the work have a foreground, middle ground, and background? Can you see more detail or brilliant colour on objects that appear to be closer? Does the work attempt to depict depth, like a prairie landscape where you can see long distances? Does the work depict flat space like a coloured paper collage?

Interpretation

Interpretation follows analysis, and should not be a single, one-line explanation of the image, but a personal response to its meaning. This stage is a combination of fact and opinion. Each viewer comes to the work with unique expectations, experiences, associations, and observations. These will affect the way in which each student interprets the work.

Think of this step as understanding what the artist has created. Some artists work with the intent of communicating an idea or feeling, but others create a work of art to satisfy themselves, assuming it will also offer something to viewers. Is it possible to find out what the artist's purpose was? Of course, through the first steps, students can find clues.

Is the artist attempting to imitate nature? Is the artist mainly expressing an emotion or feeling? Is the artist making a nonobjective formal design? What does the work mean? Do you think the artist is trying to communicate something specific? If so, what do you think it is? What idea does the work communicate to you? Does the title of the work tell you anything about the meaning or purpose? How does the work make you feel? What kind of atmosphere is created? What does it remind you of?

These are the kinds of questions that can help students think about their responses to a work of art. Although art has objective, formal properties, it is also a subjective expression that evokes a variety of responses in different people. In the interpretation, conclusions should never be rigid, and students need to feel that there is room for each person's understanding of a work of art, even though it is different from everyone else's.

Judgement

At this stage, students can talk about how they value a work of art and decide on its significance, based on what they have discovered. Encourage your students to debate diverse opinions. Do not try for total agreement or consensus, but ask them to give reasons for their decision.

ART APPRECIATION PROJECTS AND EVENTS

Looking at art can be exciting, and there are things you can do that will help students enter into the experience wholeheartedly. A few methods are described here for use in the classroom, or in a gallery or museum, depending on the activity and space.

EXHIBIT 5.9 A child's re-creation of *Afternoon, Saint-Simeon,* undated, by Albert Robinson.

Field Trips and Gallery Tours

Field trips and gallery tours take a great deal of time and energy, not only because of the planning but because of the paper work necessary when children leave the school grounds. However, real-life experiences give meaning to the study of art.

Many galleries and museums have staff who will help you plan your lessons, or give you ideas on how to incorporate into your classroom program what the students will be seeing and doing while at the galleries.

What Happens Next?

Have your students study a work of art. Ask them to create a drawing or painting of the work, using the style of the artist. Then ask them to draw or paint what they think would happen next, as though the work were a photograph and the subjects could move onto something else in the next few minutes or days, or seasons, or later in the day, or even years later.

Comparing Artists

When a number of artists paint the same scene, or perhaps the same kind of objects or people, the results can be very different. Choose several artists' impressions of specific subjects and compare how they treated the subject matter. For example:

- Female, male, child, or specific animal portraits.

- Landscapes from the same area or different areas.
- Cityscapes, streets, buildings.
- Dreams and nightmares.
- Trees, flowers, insects, birds.

Written Correspondence

Ask students to write a letter to an artist, or to a person depicted in a work of art. What questions would they want answered? Are the students' lives different from the situations depicted in the works? Are there things that are similar? Do they have anything in common?

The Critic or Curator

An art critic writes or talks about a work of art, and its success and merit. A curator collects works of art for an art show in a gallery or museum. Ask your students to place themselves in the role of a critic or curator. The curator can choose student works or art images for a school or community show. The critic can write for the class newsletter or newscast.

Art Catalogue

Art exhibitions often have a catalogue about the art and artists in the show to display and sell. Ask students to research an artist and develop an art catalogue on this artist. The artist may even be themselves or a fellow student. The catalogue should provide information on the artist's life and works. Illustrations of the works of art should be included. Students can include articles that compare or contrast two or more artists' styles.

Art Videos

Students can work in small groups to develop art videos on an artist from a particular art movement, or on a fellow classmate. Each group must first decide which artists they are going to include, and do their research.

The group can allocate production jobs and responsibilities, such as director, writer, camera-person, technical advisor, costume and make-up artists, and, possibly, actors. A student can dress up and act the part of the artist. If artists are chosen from the same era, who actually knew each other (for example, Impressionists Berthe Morisot, Mary Cassatt, Edgar Degas, and Edouard Manet, or Canadian artists Mary Pratt and Molly Lamb Bobak), several students can play the parts of the artists. Students can videotape the art images from books or reproductions to take the viewer on a tour through an imaginary art gallery show or to the artist's studio to meet the artist.

Inside the Landscape

Choose several paintings and ask students to imagine themselves in the landscape or composition, exploring the terrain, touching the textures, smelling, and tasting. They can create a dance, poem, story, or play about the painting.

Guest Artist

Invite local artists to come into the classroom to talk about their work, show their work, and possibly work with the students.

Artist in Residence

An artist in residence is different from a guest artist in that she or he is at the school and works with the students for a period of time on individual and group projects such as mural paintings or relief murals. The artists may volunteer their time or they may be paid an honorarium by the school or district, or from money raised by the parents or students.

Mystery Search

One way to think about art criticism is that it is like solving a mystery. The mystery is the artwork. What does it mean? What is it about? What is it worth? Your students can imagine themselves in the position of one of the following professionals:

- A detective in search of a lost or stolen piece of artwork; the description, security systems and value of the work are a few of the problems.
- A curator from the National Gallery of Canada looking for artworks that can be exhibited on a specific theme or style, or work by a particular group.
- An art critic for a local newspaper or an art journal. The journalist must not only describe the work but interview the artist.
- A private collector who wishes to purchase some pieces for home or office.
- An insurance agent or appraiser who needs to determine the value of art.
- A commercial artist or writer whose job it is to design a catalogue for an artist, which may include pictures of the artist and his or her work and some information both about the person and the work.

After students have chosen a profession, they should look at works of art according to the dictates of that profession to identify the artists, their nationality, year of the works, title, media, and size. Students should review the steps in looking at art (pages 96–98) and use the questions given to guide them in writing about the work in the manner they feel would best suit their profession.

After going through the steps of observation, the professional evaluates the work to decide whether it is suitable for an exhibition, whether it is appropriate for an office or hospital, or whether an art buyer would want it for a living room. A part of the process for, say, an insurance agent is to determine whether the price is appropriate for the work.

Classroom Gallery

Convert the classroom, hallway, or gym into a gallery of student works. Invite parents, siblings, administrators, and teachers. Serve cookies and punch and ask a local dignitary to give an opening address. Have students play music during the opening.

• • • • • •
Summary

To understand art and the creative process of making art, students need to learn the elements of design — colour, line, texture, and shape or form — and the principles of composition — balance, repetition, rhythm, contrast, emphasis, unity, and pattern.

Appreciating art requires a vocabulary that helps one articulate the impact of art. Visual literacy and the understanding of art and art making must be developed with continued looking,

discussing, critiquing, analyzing, and working with art materials. There are many ways that teachers can introduce the history of art and art appreciation through projects, games, and other activities, along with viewing and creating art.

REFLECTION

❶ Visual communication chart problem: Given a series of words in the left-hand column, the object is to fill the relevant squares with the shape, line, texture, colour, or pattern that corresponds to and communicates the idea of the word. Materials: Two sheets of white cartridge paper (30 cm x 46 cm) taped together, with five-centimetre squares marked off. Use pen, pencil, crayons, and any found material that you believe best illustrates or communicates the word. Different groups of students can be given different lists of words, and lists can be developed that use the principles of composition or various types of patterns.

❷ Look at a work of art and describe the piece.

❸ Research local artists; document their life and their work. Invite them into the classroom to discuss why they create art.

❹ Search out painters who are not considered professional, full-time artists — who make art for their own pleasure, and not for exhibition. Why do they create art? Is their work different from that of people who pursue art more "seriously"?

❺ Search out art, painting, sketching, pottery, and printmaking clubs in your community. What is their mandate? Why do they have this organization? What does the club do for the individual in the group? Do they sponsor art shows, lectures, or workshops? Would members like to come and talk to the class or give a workshop on their special media or technique? Add your name to their mailing list for art openings and shows.

❻ Search out the cultural community organizations from the Chinese, Japanese, East Indian, Canadian aboriginal, African, or South American communities. Discover if they have volunteers who would be willing to come to the school and share the art of their mother country. Do they have a cultural centre open to the public where you could take your class for a tour?

❼ Contact your local (or nearest) museum or art gallery to find out what they can offer you and your students — visits, field trips, guest speakers.

CLASSROOM PROJECTS

❶ Dot: Have your students find pictures of drawings created using dots in newspapers or magazines. Look for dots in nature, markings on stones and insects. Create a design or image using dots in a pointillist manner, placing dots closer together to create areas of shading.

❷ Line: Have your students find pictures or compositions or designs using line. Look for lines in nature and constructed objects. Look for different types of lines — straight, curved, thin, thick, wavy.

❸ Shape: Students can look for shapes in natural and constructed objects. They can collect objects of various shapes, discuss the shapes, and classify them. Create a design with geometric or organic shapes by varying the size and shape or colour.

❹ Colour and value: Have your students look for colours in nature. Collect coloured objects, natural and constructed, and classify, organize, or label the colours. Create a colour wheel or value scale with these colours. Collect and classify coloured fabric, or coloured pictures from a magazine, and create a collage, colour wheel, or value scale.

❺ Texture: Have your students look for tactile surfaces in nature and in constructed objects. Collect and classify textured fabric, or pictures that depict texture. Collect rubbings from textured surfaces.

BIBLIOGRAPHY

Ames, L. (1982). *The Dot, Line and Shape Connection, or How to Be Driven to Abstraction.* New York: Doubleday and Company.

Boston Public Schools, Boston Symphony Orchestra, New England Conservatory and WGBH Educational Foundation. (1993). *Proposal: A Partnership Program.* Unpublished document, April 15.

Brigadier, A. (1970). *Collage: A Complete Guide for Artists.* New York: Watson-Guptill Publishing.

Brommer, G. (1978). *The Art of Collage.* Worcester, MA: Davis Publications, Inc.

Broudy, H. (1972). *Enlightened Cherishing: An Essay on Aesthetic Education.* Urbana, IL: University of Illinois Press.

Capon, R. (1975). *Paper Collage.* London: BT Batsford Limited.

Caucutt, A. (1990). Grading elementary art. *NAEA Advisory.* Reston, VA: The National Art Education Association, Winter, p. 16.

Cheatham, F., J. Cheatham, and S. Owens. (1987). *Design Concepts and Applications.* Second Edition. Englewood Cliffs, NJ: Prentice-Hall.

Clarke, J., R. Wideman, and S. Eadie. (1990). *Together We Learn.* Scarborough, ON: Prentice-Hall Canada.

Educational Quality Indicators CBE/CCSB Project. (1989). Calgary, AB.

Feldman, E. (1982). *The Artist.* Englewood Cliffs, NJ: Prentice-Hall.

Feldman, E. (1970). *Becoming Human through Art.* Englewood Cliffs, NJ: Prentice-Hall.

Feldman, E. (1967). *Art as Image and Idea.* Englewood Cliffs, NJ: Prentice-Hall.

Gatto, J., A. Porter, and J. Selleck. (1987). *Exploring Visual Design.* Second Edition. Worcester, MA: Davis Publications, Inc.

Goldstein, E. (1987). *Creating and Understanding Art.* Champaign, IL: Gerrard Publishing Company.

Greenberg, J. and S. Jordan. (1991). *The Painter's Eye. Learning to Look at Contemporary American Art.* New York: Delacorte Press.

Hollingsworth, P. (1987). Apples and onions. *School Arts,* April, pp. 28–31.

Hubbard, G. (1986). *Art in Action.* San Diego: Coronado Publishers.

Hurwitz, A. and S. Madeja. (1977). *The Joyous Vision: A Source Book for Elementary Art Appreciation.* Englewood Cliffs, NJ: Prentice Hall.

Laing, J. (1984). *Do-it-Yourself Graphic Design.* New York: Collier Books, MacMillan Publishing Company.

Lauer, D. (1985). *Design Basics.* Second Edition. Fort Worth: Holt, Rinehart and Winston, Inc.

Lowenfeld, V. and W. Brittain. (1964). *Creative and Mental Growth.* Fourth Edition. New York: The Macmillan Company.

MacGregor, R. (1977). *Art Plus.* Toronto: McGraw-Hill Ryerson.

Marschalek, D. (1991). The National Gallery of Art laserdisk and accompanying database: A means to enhance art instruction. *Art Education,* May, pp. 48–53.

Mittler, G. (1989). *Art in Focus.* Second Edition. Mission Hills, CA: Glencoe Publishing Company.

Mittler, G. (1980). Learning to look/looking to learn: A proposed approach to art appreciation at the secondary school level. *Art Education.* 33 (3) pp. 17–23.

Myers, J. (1989). *The Language of Visual Art. Perception as a Basis for Design.* Fort Worth: Holt, Rinehart and Winston.

Ocvirk, O., R. Bone, R. Stinson, and P. Wigg. (1985). *Art Fundamentals, Theory and Practice.* Fifth Edition. Dubuque, IA: Wm. C. Brown Publishers.

Parramon, J. (1973). *How to Compose a Picture.* Hertfordshire, England: Fountain Press.

Preble, D. and S. Preble. (1989). *Artforms: An Introduction to the Visual Arts.* Fourth Edition. New York: Harper & Row, Publishers.

Ragans, R. (1970). *Art Talk.* Mission Hills, CA: Glencoe Publishing Company.

Richardson, J., F. Coleman, and M. Smith. (1984). *Basic Design, Systems, Elements, Applications.* Englewood Cliffs, N.J.: Prentice-Hall, Inc.

Roukes, N. (1988). *Design Synectics, Stimulating Creativity in Design.* Worcester, MA: Davis Publications, Inc.

Roukes, N. (1982). *Art Synectics. Stimulating Creativity in Art — A Teachers' Guide.* Calgary: Juniro Arts Publications.

Smeets, R. (1982). *Signs, Symbols & Ornaments.* New York: Van Nostrand Reinhold Company.

Stoops, J. and J. Samuelson. (1983). *Design Dialogue.* Worcester, MA: Davis Publications, Inc.

Thompson, K. (1995). Maintaining artistic integrity in an interdisciplinary setting. *Art Education,* November, pp. 38–45.

Tollifson, J. (1990). Tips on teaching art criticism. *NAEA Advisory.* Reston, VA: The National Art Education Association, Summer, pp. 14–15.

Woodford, S. (1991). *Looking at Pictures.* Cambridge: Cambridge University Press.

Zelanski, P. and M. Fisher. (1984). *Design Principles and Problems.* New York: Holt, Rinehart and Winston.

P A R T • T W O

Media and Methods

...........

Drawing

•••••• Introduction

Jamalie began drawing as soon as she could hold a pencil, and she drew constantly until she went to elementary school. The summer between grades one and two, her mother noticed that Jamalie drew very little, and was puzzled by this change, for which she could find no cause. Jamalie's experience is very common.

Children begin drawing spontaneously at a very young age, but frequently after they begin elementary school, at about age eight or nine, they stop because they think they don't know how or they become bored with repeating the same symbols (Brookes, 1991, p. xix). It is not surprising, then, that most adults feel they can't draw, and often say, "I can't draw a straight line." What does drawing ability have to do with straight lines? What is drawing? What does drawing demand that makes most people think they can't do it?

Drawing is about seeing and requires practice.

"Drawing is a discipline by which I constantly rediscover the world. I have learned that what I have not drawn, I have never really seen, and that when I start drawing an ordinary thing, I realize how extra-ordinary it is" (Franck, 1973, p. 3).

If drawing is about seeing, and most of us say we can't draw, are we also not able to see? What happens to young children's ability to see when they start elementary school? If your

BOX 6.1 ACTIVITIES AND GAMES TO SHARPEN STUDENTS' ABILITY TO SEE

- Collect leaves, stones, potatoes, marbles, or other small objects and categorize them according to their size, shape, and colour. Organize the objects in increasing or decreasing size, and by shape — oval to rectangular.
- Categorize crayons, pencils, brushes, tools (pliers, hammer, tape measure), or kitchen tools (wooden spoons, whisks, strainers) and draw their positive and negative shapes.
- Cut frames of different sizes from heavy cardboard and look through these to focus on a specific area and draw what you see. Look at an area through a toilet paper roll and draw what you see.
- Look at objects by using a flashlight, or create shadows with an overhead projector. Observe the shadows on the walls, and draw them.
- Design jigsaw puzzles based on textures, colours, shapes. Consider the elements and principles of composition when designing the jigsaw or game.

students feel they can't draw, how can you as a teacher help them retrieve their ability to see and draw? Can you feel confident about teaching drawing if you feel you cannot draw? How is teaching drawing different from the process of drawing? Nicolaides (1969), who developed a well-known way of teaching drawing, said it is a teacher's job not to teach students how to draw, but how to learn to draw. This might appear to be a small distinction, but the concept is worth considering as you read this chapter that offers suggestions on teaching drawing and drawing techniques.

• • • • • •
Teaching Drawing

If you were asked to define drawing in the simplest terms, you might suggest something like this: dragging a tool across a surface to make a mark. Other answers would be: making an outline, or creating images by shading. Making marks is what each of these definitions has in common.

MAKING MARKS — TOOLS AND SURFACES

To draw, you need a tool and a surface to draw on, and the end result depends a lot on what you use. Children need to have available a wide variety of conventional and unconventional drawing tools and materials. These can include fingers and toes, sticks, rocks, leaves, feathers, string, yarn, cloth, cotton balls, cotton tips, toothpicks, straws, forks, and pencils.

Pencils of different hardness are available to produce a variety of surface marks. The HB pencils are the most common for ordinary classroom use. The hardest, the H pencils, produce fine, silvery lines — the higher the number the harder the pencil. Many draftspeople use a 6H pencil. Soft Bs are most useful for shading — the higher the number the softer the pencil. Other drawing tools that should be available for students include: coloured pencils, crayons, pastels, chalk, conte, charcoal, pens, felt pens, ink pens, brushes (hard, soft, square, round, pointed, flat), paints (watery, thick, dry, water, poster, tempera, acrylic), inks (black and coloured), food colouring, berries, plants, leaves, flowers, soil, and fabric dyes.

Paper is the most common surface used for drawing and it comes in a variety of textures and colours. If possible, stock a wide range of papers for students: rough, coloured, smooth, lightweight and heavy cardboard, newsprint, newspaper, tissue, wax paper, tin foil, and handmade paper. Paper in large rolls

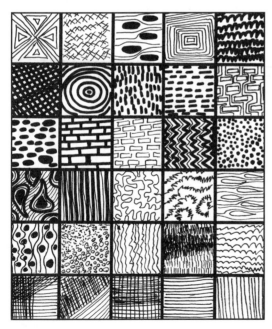

EXHIBIT 6.1 Encourage students to explore making marks with all kinds of materials.

is economical and works well for large drawings and murals. Children also enjoy experimenting with drawing on other surfaces if they are available, smooth stones and wood, for example.

Encourage students to explore making marks with all kinds of materials. Before drawing or painting sessions, set aside times for students to experiment with mark making, and have them save the results for their portfolios. They can label the samples so they can refer back to them and use what they learned about, for example, the difference between using ink and pastels.

MOTIVATION

Students who initially might feel drawing to be foreign to them can discover they enjoy it, and eventually become good at it, particularly if you can find ways to help them become motivated. Arousing their curiosity about how things work is effective — students are more likely to respond and follow their curiosity in an environment that is conducive to visual and tactile research, as well as observation.

If children have not had opportunities for visual expression, and were perhaps even discouraged by adults from trying to draw, they are inclined to work quickly and draw stereotypical images — lollipop trees, for example — unless they feel motivated to use a different approach to drawing. For this reason teachers need to give a great deal of thought to the beginning of drawing sessions, particularly the very first one.

OBSERVATION

Students need to discover from experience that drawing depends on learning to see. They have to be able to see detail, so the earlier you help them become alert and observe carefully, the more pleased they will be with what they create (McFee and Degge, 1977). Developing their ability to see, practising observation, is just as essential as spending time drawing, although students might be sceptical of this idea in the beginning.

Suggest to your students that they can work on their observation skills even when they are not in drawing class. While they wait in line in transitions during the day, or when they ride in the car or bus, or as they walk down the street they can look at the shapes and textures of images along the way.

In the first drawing sessions, you might emphasize drawing projects based on what students observed, explored, and studied. Direct your students to examine design and structure, linear qualities, variety of colour, patterns, textures, unique shapes, and spaces in their environment.

In addition to teaching your students to sharpen their powers of observation individually, you can plan class experiences that will develop their observation and enrich drawing experiences.

- Plan field trips or sketching trips to interesting places — a farm, the zoo, fire or police or automobile service station, grocery store, greenhouse. Students can also sketch what they see around the school — office buildings, old houses, fences, cars, and trees. Develop a checklist for things you wish the students to observe, draw, or photograph. Incorporate your field trip into a larger unit of study; for example, display, packaging, and advertising could be the focus of a grocery store visit.
- Resource materials such as slides, filmstrips, films, videos, art reproductions from established artists, music, and artifacts can offer stimulation for students. Be sure to preview

EXHIBIT 6.2 In early drawing sessions, encourage students to draw what they have observed.

the resource material before class so that you know the material is relevant to the theme you have chosen.

- Create displays and still-life arrangements of fruit, vegetables, shells, driftwood, gourds, dried plants, mounted birds, bottles, gear wheels, small engines, and musical instruments. You can store and display interesting objects on shelves and create a variety of arrangements. Suggest a drawing picnic on a sunny day — students can draw vegetables, fruits and nuts, before eating them, and perhaps even draw apples and sandwiches at the various stages of being eaten.

- Use poems, stories, songs, myths, guided discussions, memory, and imagination to bring visual images to the surface.

- Arrange for guest visits by local visual artists, dancers, clowns, musicians, athletes, and people from different cultures in native dress, not only to discuss their work and costume but also to pose as models for a drawing session.

- Demonstrations of techniques using various media can arouse interest in students, especially when you want to provide incentive to try new materials and tools and their combinations.

MAKING EXPRESSIVE LINES

Drawing lines is one of the oldest techniques used to create images on a two-dimensional surface. Lines record movement of the hand, and the characteristics of a particular line tell you something about the tool used to make it. You can make different kinds of lines that vary in size, length, thickness, direction, density, tone, and colour.

Lines can be used to express human emotions and feelings, and to create an impression of movement and energy. Many artists use lines — from delicate curves to bold angles — to create expressive images. Some of Picasso's deft line drawings offer good examples.

The last chapter introduced the idea that dots and lines can be used as part of creating the illusion of depth and volume in a two-dimensional surface by placing the dots closer together, or by drawing lines closer together (called hatching), or by crossing lines (called cross-hatching). Also, texture can be created by using dots and lines.

After children have explored making a range of different kinds of lines, you can bring into the classroom a variety of sources of inspiration. You can play different types of music while the students experiment with making lines in response to the music. Music and art, together, can also be used as stimulation for the imagination: for example, Igor Stravinsky's "The Fire Bird" and Marc Chagall's painting of the fire bird; Paul Klee's painting of the "Twittering Machine"; Petrusska's music "Circus Polka" and Picasso's and Seurat's paintings of the circus.

Line exercises can be initiated through the use of expressive words, words that stand alone or move from one idea or expression to another. These words can be changed or added to, depending on the ages of the students and the words you wish them to experience and use in the language arts.

EXHIBIT 6.3 Expressive lines

- Straight lines that move into curved lines. Graceful lines that move into crude or awkward lines.
- Nervous lines changing into relaxed lines. Bold into delicate lines. Tired lines becoming active.
- Angry into calm. Tortured into free. Noisy into quiet. Vibrating into smooth. Rough to gentle. Smooth to jagged. Cruel to kind.
- Prickly into gentle. Hard versus soft.

Images and feelings can be developed through the use of line. What images come to mind with words such as hunger, idea, faith, fear, love, anger, stability, growth, falter, busy, calm? Some images may be stereotyped, such as the light bulb image for "idea." Students could investigate other images that could be used.

Lines can be used to create nonobjective compositions. You can suggest themes for this exercise, but be sure that the students understand the terms you are using. You may wish to choose one or several at the beginning of a long art session to stimulate ideas.

- Straight and curved lines with straight lines dominant.
- Long, short, thick, and thin lines with one type dominant.
- Various line directions with vertical movement dominating.
- A composition suggesting rigidity, flexibility, staccato, rhythm. Selected pieces of music may assist the development of the composition.
- A harmonious composition using straight or curved lines.
- A painting with the element of line as dominant.
- A line sculpture, created with wire.
- A line drawing created with yarn, string, and glue.

COLLABORATIVE DRAWINGS

The surrealists made a game of collaborative drawings, which are also called spontaneous or cooperative drawings. This kind of drawing has many variations and children usually enjoy the playful spirit of cooperative drawings. These are some of the variations.

- **Complete the picture.** One student draws some lines on a piece of paper; the paper is then given to another student to complete.
- **Picture in the round.** Each student draws lines on a piece of paper, then rotates the paper to the student to the right, who draws again, and moves the paper to the next until all students have made their mark on the picture.
- **Hidden picture.** The idea is the same as picture in the round, but each student folds the paper over the drawing so the next person cannot seen what has been previously drawn.
- **String in ink.** Dip a string in ink; pull the string across the paper. When the ink is dry, pass the paper on to the next person, who must develop an image with pastels, crayons, or ink.
- **Rubbings.** Each student chooses a surface for a rubbing. After taking rubbings, again the paper is passed on to the next student who must develop an image.

EXHIBIT 6.4 Gesture drawing

DRAWING TECHNIQUES
Gesture

Gesture drawings are quick drawings done by artists for possibly two reasons. One reason is to loosen up before a longer session in drawing. The idea is to observe the proportions of the object or figure to be drawn and to capture the essence, to suggest the structure of the body in action or at rest. Basically, in gesture drawings you draw not what the thing looks like, but what it is doing.

The second purpose for gesture drawing is to capture the movement and proportions of the object or figure before it moves on or changes shape; later the drawing can be used as a reference or can be refined into a more finished drawing. Often gesture drawings are created in a very loose circular drawing form, just to get the essence of the shape and proportion, and not the detail.

Mass

Drawings emphasizing mass, or **mass drawings**, depict the light and shade of a figure or object without the use of line, but using the medium to create shading. Shading means using light and shadow to create the sense of depth and volume on a two-dimensional surface. Tonal (dark and light) areas define the form and create the illusion of depth and shadowing.

Studying light, looking at how light strikes a surface and creates shadows, for example, is an essential part of learning to make mass drawings. Start mass drawings without the use of line, by beginning to shade with gradual applications of darker tones. Charcoal, conte, chalk, or soft pencils are good tools to use to express the concept of mass.

EXHIBIT 6.5 Mass drawing

EXHIBIT 6.6 Cross-hatch drawing

Contour

Contour drawing means drawing the edge of an object as a way of co-ordinating one's sense of touch and sight. Contour drawings are line drawings that are developed form by form, or detail by detail, to arrive at the completed form. As the eye follows the contours of the object, the hand draws the line, trying to feel the edge of the object visually. Suggest that your students look at one point of the object, then place their pencil on the paper, which will be the same place their eyes are resting on the object, and as they move their eye slowly along the contour of the object they should move their pencil on the paper at the same time.

Drawing hands is a good exercise — they are always available. Students can draw their own hand, or their hand holding something. Drawing objects is also a good exercise; for example, draw a paper bag, a hammer, an egg beater, a shoe, a bottle, a flower, or a plant. Choose a variety of objects that have different forms.

Blind-contour drawing means keeping the eye on the form while the pencil delineates the form on paper. This is practice in looking more at the form or object drawn than at the paper. The artist draws without looking at the paper, returning to look at the paper only to find the place where the pencil line was left off and continuing the drawing.

Cross-contour drawings take contour drawing further to give roundness to objects. When drawing a tin can or barrel, the students should draw the outside contours first, then the rounded shapes, trying to feel they are following the contour of the object. When drawing cross contours on a human figure, draw them as though they were bandages around the limbs, pressing lightly on the high spots and heavily on the low spots.

Cross-Hatching

The hatched technique of drawing, also called vertical drawing, shapes the object by building up the

EXHIBIT 6.7 Combination of drawing techniques

form and shading with a series of vertical lines. Darker areas or shading are created by placing the vertical lines closer together.

The **cross-hatch drawing** technique determines the shape of an object or figure by a series of lines crossed with other lines.

Combining Techniques

Combining a variety of drawing techniques is a way of giving a composition a great deal of interest, and creating texture. In the same picture, students can use, for example, gestural lines along with contour drawing and cross-hatching. A variety of tools can also be employed — pen, pencil, brush, and washes using inks and paints.

Employing a number of techniques and media in a drawing can become a complex process. Students need time to develop understanding of the characteristics of each before they try complicated drawings.

LINEAR PERSPECTIVE

Artists have developed ways to suggest three-dimensional depth on a two-dimensional surface. Creating **linear perspective** is a familiar technique; for example, the one-point perspective of a narrowing road meeting at a point on the horizon line, where the sky meets the earth.

There are five other ways to suggest space or depth on a flat surface; they include overlapping shapes, relative size, position of the object, detail, and tone contrast. These are discussed in Chapter 5. Encourage students to draw or paint pictures incorporating many of these elements to create the illusion of depth on a two-dimensional surface. Provide reproductions of paintings and drawings in which artists have used these techniques when you discuss these ways of developing pictures. Ask students to observe landscapes and other two-dimensional art to find out how the artists used these techniques.

Children are usually not ready to work with linear perspective until they are in the upper elementary grades. If you feel your students would be able to understand the methods for creating linear perspective, this is the vocabulary they will need to learn.

- *Horizon Line*

Where the sky meets the land. This line is always at your eye level. If you are lying down on the grass looking up, you see a greater amount of sky; if you are flying in a hot air balloon looking down, you will see more land.

- *Converging Lines*

Lines that meet at a vanishing point.

- *Vanishing Point*

A point on the horizon line.

- *One-Point Perspective*

Lines converging to one point.

FIGURE 6.1 LINEAR PERSPECTIVE

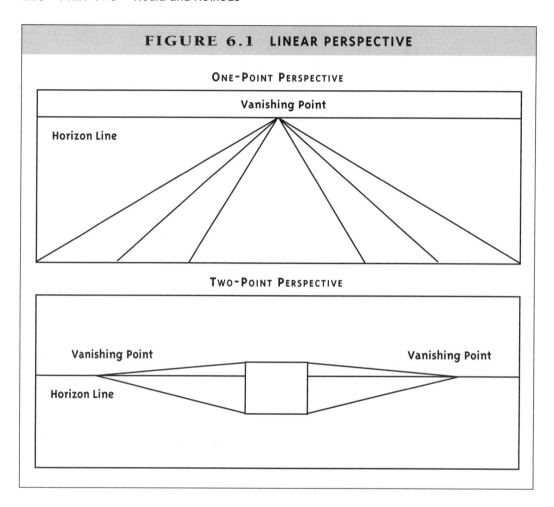

• Two-Point Perspective

Lines converging to two points on the two-dimensional or flat surface.

After discussing these concepts, have students do an experiment. They can write out their names with all edges converging to one vanishing point, colouring or painting their names in an invented environment.

"Boxes in Space" is another assignment that helps students to understand perspective. Collect a number of boxes of different shapes, at least one for each student, and use the boxes when discussing the process of drawing perspective. Illustrate one-point perspective on the horizon line toward the left and

EXHIBIT 6.8 A name converging to one vanishing point

right (at eye level), and above and below the horizon line. Discuss each idea one step at a time, having the students draw along after you have illustrated.

When you are demonstrating the use of two-point perspective, start by looking at the corner of the box, placed perpendicular across the horizon line. After placing two vanishing points on the horizon line, one at each end of the paper, draw the converging lines from the perpendicular line to the vanishing point, then decide on the length and width of the box. On boxes above the hori-

EXHIBIT 6.9 Boxes in space

zon line, the underside of the boxes will be seen; on boxes below the horizon line, the top side of the boxes will be seen and therefore should be drawn. You can have students develop these boxes in space, emphasizing various lesson objectives such as invented environments, the use of pen and ink, decorative lines and shapes, use of colour, and colour schemes.

• • • • • •
Variations on Drawing

Students and artists alike benefit from studying, drawing, and redrawing an object or idea several times. Through drawing, they can make connections with what they already know about their world, using their observations and ideas. Check the bibliography for readings and books on the subject of drawing; for example, Roukes (1982 and 1988) and Robertson (1988). The bibliography in Chapter 5 also lists a number of books. Many of the suggestions here can be used for painting assignments, and the painting assignments in Chapter 7 can also be used for drawing.

Our schools and our society are made up of people from all over the world. For further lesson ideas, study artists from a number of countries and cultures, and their styles of drawing and subject matter. Of course, you can also use topics or themes from other subject areas.

NONREALISTIC RENDERING

There are many variations other than realistic rendering that can help your students to create exciting visual statements.

• *Points of View*

Looking at an object from many points of view and all sides: ant's-eye view, bird's-eye view, front, back, top, sides, and angles.

- **Simplification**

Simplifying into geometric shapes, drawing the object with just straight lines or curved lines, or dividing the shapes and spaces into black, white, and grey areas.

- **Transformation**

Drawing an object and changing the form or appearance, character, or function; taking ordinary images and making them uncommon or extraordinary.

- **Surrealism**

Drawing a common object and placing it in an uncommon environment.

- **Abstraction**

Taking the basic elements of an object or selecting part of the object and abstracting the basic shapes.

EXHIBIT 6.10 Simplification of geometric shapes

- **Magnification**

Using a microscope, or the idea of a microscope, zoom in on the details of the object, and enlarge them.

- **Minification**

Making the subject on a much smaller scale than it would be in reality.

- **Metamorphosis**

Drawing the image in a progressive state of change, one frame at a time; for example a tree becomes a ballerina, the letter H becomes a house.

- **Exaggeration**

Drawing part of the object in detail and enlarging it, changing and exaggerating proportions, shapes, colours, sizes.

- **Distortion**

Changing the object by deforming it, possibly to fit a shape like Mondrian's trees filling an oval or a circle.

- **Elaboration**

Drawing an object and decorating it with dots, circles, or paisley, as characterized by Art Nouveau.

- **Variation**

Drawing an object with a variety of lines and/or materials, hatched, cross-hatched, stippled, textured, patterned, curved, jagged, angular, thick, and thin lines.

- **Fragmentation**

Splitting or cutting up the images and putting them together again in a different arrangement.

- **Multiplication**

Repeating the object or image in a composition, varying the size and overlapping, using a grid pattern to repeat the image.

- **Mirrored Image**

Creating a drawing and then its mirrored image, or drawing an object by looking at its image in a mirror.

- **Substitution**

Changing the qualities of an object, or surface of the object, creating an oxymoron, such as a brick (patterned) pillow.

EXHIBIT 6.11 Elaboration

- **Characterization and Cartooning**

Drawing animate and inanimate objects, people and animals, and exaggerating their features or giving them human qualities.

- **Animation**

Giving an inanimate object human qualities, such as a telephone with a face, legs, and arms.

- **Automotion**

Drawing an object or person in motion in a series, in separate drawings (studies) or in one picture — another form of animation. The futurist artists often depicted motion of trains and people moving, for example, Marcel Duchamp's "Nude Descending A Staircase."

- **Visual Pun**

Drawing an object in combination with another to create a visual pun, such as seahorse, hammerhead shark, cowboy.

- **Cross-Links**

Drawing two objects as if they were one — a skunk and an elephant becomes an ele-skunk.

- **Preposterous Images**

Developing an image into something almost surreal, highly impossible — what if? drawings. What if the fish had legs, or apples grew as big as a room the way René Magritte depicted an apple in his painting, *La Chambre d'Ecoute* (1952) (*The Listening Room.* Oil on canvas, 45 x 55 cm, Menil Collection, Houston, Texas).

- **Synectics**

Choosing several irrelevant and nonrelated objects, such as fingers and airplanes, and creating fingers that fly.

- **Encoded Image**

Creating a visual equivalent of music, sound, noise or smell; for example, listening to a sound and depicting it visually with paint on paper.

- **Spaces and Shapes**

Drawing the negative spaces around the positive shape of objects, or simplifying the objects into a black and white composition.

- **Signs and Symbols**

Developing an image or object into a sign or symbol to become a logo or symbol for an idea, organization, person, or area.

- **Calligraphy**

Elegant handwriting using the techniques developed by the Chinese centuries ago through simplification of images.

- **Silhouettes and Paper-cuts**

Cutting shapes and objects out of coloured paper. As an assignment, students can arrange the shapes to create a composition. Limits can be placed on the number of subjects to be drawn, the category of objects (for example, art tools or fruit), the number of sizes, and the colours.

- **Architecture**

Reproducing buildings and other constructions in the neighbourhood, from around the world, or from different eras in history. Students can study, reproduce, recreate, or design and construct their own structures.

EXHIBIT 6.12 Negative and positive shapes

FIGURE 6.2 GRID DRAWING

When drawing using a grid, images can be enlarged or reduced, stretched or distorted, by changing the grid lines. One trick for helping students use a grid is to create a transparency of a grid and place this over the picture to be drawn.

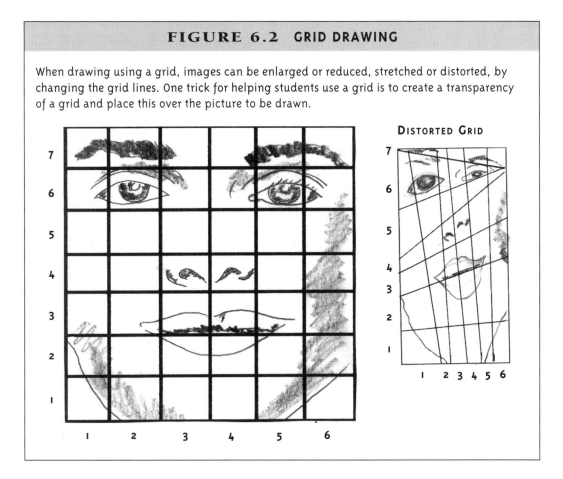

DISTORTED GRID

• *The Grid*

Using a grid to develop a composition. This old way of drawing is credited to Albrecht Durer (1471–1528) who used an upright stationary wire grid to look through and a paper with identical grids marked off. Perhaps you have been told that copying is almost equivalent to cheating, but long ago artists learned the value of studying and copying the techniques of great masters, and your students can also discover the benefit of copying other artists. When asking your students to copy from a picture, photograph, or artist reproduction of drawings or paintings, suggest specific objectives: learning drawing and shading techniques; understanding the mathematical idea of using the grid (proportion, enlargement, magnification, distortion). Using distortion grids can be fun and produces interesting, inventive results.

ILLUSTRATION

Children begin drawing pictures to illustrate a story when they are very young. To initiate this type of drawing, read or tell stories to the class — or have students read them to the class — fables, myths, and fantasies from different cultures. Stories and images of mythical creatures can

be found in most cultures: dragons, monsters, elves, and dwarfs. You can also use fairy tales and their heroes.

For other illustration ideas, have students look at visual images and discuss such events as sports, royal visits, construction projects, and musical groups. Play an instrumental or vocal CD, tape or record which tells a story. Discuss parts of the song or story that could be illustrated, and encourage your students to research how the objects or animals look. Discuss details of the story or song; where did it take place and what might the environment look like? Was it long ago, real, or a dream world? What did the characters, buildings, and landscape look like? Encourage the children to use the whole page and include detail. Talk to your students about centre of interest, foreground, background, and colour.

FIGURE DRAWING AND PORTRAITURE

For centuries, artists have used the process of creating visual interpretations as a means of understanding themselves, depicting their family and friends, and capturing moments of social interaction.

Just as students observe objects closely when they are drawing, they should also look closely at the proportions and details of people and faces. A good method for calculating proportions and measurements is the following: hold a pencil between your thumb and forefinger, and reach upward with your arm to position the tip of the pencil at the top edge of what you are measuring, and the tip of the thumb at the base. For example, measure a person's head from its top to the bottom of the chin. How many head measurements make up the height of the figure?

How many head lengths make up the length of the arms and legs?

Many methods can be used to start students drawing portraits and people. Drawing from live models is best, but photos and other pictures can also be used.

The face or portrait can be drawn one part at a time through measurement. Measure the length of the eye, draw the eye; measure one eye length, and draw the other eye. Measure the nose, approximately one eye length down, and the lips another eye length down. The corners of the mouth end at the mid-point of the iris. All these measurements are average — to create a likeness, the artist must observe and exaggerate irregularities, for example a longer nose.

EXHIBIT 6.13 Portraiture

NATURE STUDY

Field trips are great starting strategies to direct children's awareness so that they become more aware and observant of colours, textures, and

shapes found in the outdoor environment, through the senses of sight, sound, and touch.

These activities, each with a different focus, can be used to direct students' attention to the outdoor environment (Naested, 1982), and can be adapted to the age, vocabulary, and grade levels of the students, as well as to the location and time for the field trip. Before you go, discuss with the students the importance of not damaging the environment by trampling down natural growth outdoors and by taking away too many materials.

Colour

The materials you will need are: plastic bags, a large sheet of paper, and transparent tape. Ask the students what colours one might see on the field trip — a walk through the woods or along a river bank. Have them collect as many colours as possible in a given time limit, for example fifteen minutes. This can be done in groups. Upon returning, have the students arrange the colour samples from light to dark on a sheet of white paper. View the arrangements of all the students and make note of their comments and observations. Some may arrange their colours in a colour wheel, others in rows or other shapes.

Texture

Activity #1

The materials you will need are: a list of characteristics, a large sheet of paper, plastic bags, transparent tape, and pencils. Give the students a list of characteristics and ask them to collect objects that have one of the named characteristics. You might want to have students work in groups of two or three. Have them return at a given time and arrange their objects on a sheet of white paper. The list of characteristics might include: hairy, thin, flat, rough, sharp, specked, velvety, rectangular, rubbery, perforated, square, painted, prickly, jagged, orange, shiny, soft, fuzzy, round, smooth, fluffy, oval, yellow, dull, and spongy.

Activity #2

The materials you will need are: paper, crayons, clay, and tape. Have the students collect texture by taking rubbings from tree trunks and leaves. Have them also take samples of leaves from the same trees and attach the leaf beside the rubbings. Students should collect at least four different types. Try to identify or name the trees. Ask students to collect at least four rubbings from rocks and discuss what created the texture on the rocks. With a piece of clay, have the students transfer an interesting texture onto the clay slab. Wrap the clay in a piece of plastic, being careful not to damage the textured surface, and bring it back to the classroom. The slab pieces, or tiles, can be added to, trimmed, and dried to become parts of a class mural.

Colour and Value

The materials you will need are: plastic bags, large sheets of paper, names of colours to be pulled from a hat, and tape. Explain to the students that tone in colour is the lightness and darkness of the colour, or hue. Have each student or member from the group pull from the hat a colour written on a piece of paper and have each collect from the environment at least four tones of that colour. In a given time limit — ten minutes — have the students arrange the coloured objects in order from lightest to darkest. Observe and discuss the arrangements.

Shape and Colour

The materials you will need are: sketchbooks or paper attached to heavy cardboard, crayons, pastels, and pencils. Ask your students to take time to look at the clouds, their shapes and colour. Encourage fantasies, speculations, analogies, imaginings such as animals, people, and monsters. Students can try to capture these images on paper.

Shape and Texture

The materials you will need are: interesting found objects, a strip of cloth to be used as a blind-fold, paper, pencils, crayons and/or pastels. Ask the students to bring to class a found object (for example, bone, shell, or rock) concealed in a paper bag. Ask them not to show others what is in the bag. You might wish to collect objects for the bags ahead of time, in addition to, or instead of, having the students bring them to class. Group the students into pairs and blindfold one person in each pair. Give the blindfolded person the concealed object to touch in order to discover its shape and texture. After the blindfolded student is familiar with the object's shape and texture, hide it and remove the blindfold. This student should then try to reproduce the object in a drawing.

After the drawing is completed, the student can look at the object and modify or supplement the drawing with shapes and textures overlooked during tactile exploration. The next student can be blindfolded while the first student is drawing or after completion. As a conclusion, the students can discuss what they each missed, overlooked, or found to be surprising.

General Observation I

The materials you will need are: sketchbooks, pastels or crayons, pencils, wire coat hanger made into a hoop, and tape. Choose an area on the field trip and ask the students to throw the wire hoop into the air and watch where it lands. Ask the students to focus on the area inside the hoop to observe any insects, the colours, textures, and component parts. Catalogue these observations and record them visually and by writing.

General Observation II

The materials you will need are: sketchbooks and pencils. Choose a site and ask your students how the land, city, animals, and people affect this site. What might be the history of this site? What is the future of this site? What effect does this site have on their emotions, words, images? What could this site be (fantasy)? What could this site once have been used for (Native burial ground, buffalo grazing area, mining town)? Collect objects, twigs, leaves, or rubbings from this site to create a collage, drawing, or painting of their impressions when they return to the classroom.

• • • • • •

Summary

Drawing is a discipline through which we constantly rediscover the world by learning to see. A variety of tools and surfaces are available for drawing.

If students are reluctant to draw, you can use a number of interesting enjoyable activities to motivate them. Teaching children to learn to see detail is a basic part of teaching drawing. You

can also teach the techniques of drawing, which include gesture, mass, contour drawing, hatching, and cross-hatching.

Most students in the lower elementary grades have not developed the ability to create perspective on two-dimensional surfaces. However, many older students might be able to create the illusion of depth through the use of overlapping, relative size, detail, and tone contrast.

Students of all ages in elementary school can learn the many different ways to create nonrepresentational drawings, as well as developing representational pictures through figure drawing and portraiture.

REFLECTION

❶ In your journal or sketchbook, draw a figure from memory (a person from head to toe), a portrait of a person, and an animal. Date these drawings and redraw the same ones several times over the course of several months. Draw while looking at the subjects. Compare your drawings throughout the year with your first efforts.

❷ Collect examples for your own personal resource file of drawings and paintings illustrating various styles and periods.

❸ Create nonobjective drawings using expressive lines that communicate states of being such as stable/unstable, heavy/light, static/motion, or feelings such as peaceful/violent, happy/sad, energetic/exhausted.

❹ View a dance or listen to music and create nonobjective drawings based on what you see and hear.

❺ Explore the expressive potential of lines. Do a drawing that communicates a light airy feeling. What subjects will work best? What types of lines will you use?

❻ Create a series of small drawings using a variety of expressive lines. Beside each drawing indicate in writing the expressive qualities you captured.

❼ Combine in one drawing all the methods artists use to create the illusion of depth. Be as obvious as possible.

CLASSROOM PROJECTS

❶ Have your students draw a still life as realistically as possible. Then ask them to draw the same picture several times using a series of different kinds of marks to model the shape and shadow values.

❷ Suggest that your students create a series of drawings of the same subject using a variety of expressive lines that communicate a variety of characteristics: delicate, heavy, static, active, moving.

❸ Students can create a wire sculpture of the same subject as one of their drawings. They can also create a gesture study using wire.

BIBLIOGRAPHY

Albert, C. (1986). *Figure Drawing Comes to Life.* New York: Prentice-Hall.

Betti, C. and T. Sale. (1986). *Drawing, A Contemporary Approach.* Second Edition. New York: Holt, Rinehart and Winston.

Brookes, M. (1991). *Drawing for Older Children and Teens. A Creative Method that Works for Adults and Beginners, Too.* New York: Jeremy P. Tarcher.

Brookes, M. (1986). *Drawing with Children. A Creative Teaching and Learning Method That Works for Adults, Too.* Los Angeles: Jeremy P. Tarcher, Inc.

Ching, F. (1990). *Drawing, A Creative Process.* New York: Van Nostrand Reinhold.

Douglas, D. and D. van Wyk. (1993). *The Drawing Process, Rendering.* Englewood Cliffs, NJ: Prentice-Hall.

Edwards, B. (1986). *Drawing on the Artist Within.* New York: Simon and Schuster.

Edwards, B. (1979). *Drawing on the Right Side of the Brain. A Course in Enhancing Creativity and Artistic Confidence.* Los Angeles: J. P. Tarcher, Inc.

Franck, F. (1993). *Zen Seeing, Zen Drawing: Meditation in Action.* New York: Bantam Books.

Franck, F. (1973). *The Zen of Seeing: Seeing Drawing as Meditation.* New York: Vintage.

Goldstein, N. (1984). *The Art of Responsive Drawing.* Third Edition. Englewood Cliffs, NJ: Prentice-Hall.

Hanks, K. and L. Belliston. (1977). *Draw! A Visual Approach to Thinking, Learning and Communicating.* Los Altos, CA: William Kaufmann, Inc.

Jonson, M. (1990). *Teach Your Child to Draw, Bringing Out Your Child's Talents and Appreciation for Art.* Los Angeles, CA: Lowell House.

Kaupelis, R. (1983). *Learning to Draw, A Creative Approach to Expressive Drawing.* New York: Watson-Guptill Publications.

McFee, J. and R. Degge. (1977). *Art, Culture and Environment: A Catalyst for Teaching.* Belmont, CA: Wadsworth.

Naested, I. (1982). *Effects of Directed Observation on Undergraduate Students' Paintings.* Master's thesis. University of Calgary.

Nicolaides, K. (1969). *The Natural Way to Draw. A Working Plan for Art Study.* Boston: Houghton Mifflin Company.

Purser, S. (1976). *The Drawing Handbook.* Gainesville, FL: Purser Publications.

Rawson, P. (1984). *The Art of Drawing. An Instructional Guide.* Englewood Cliffs, NJ: Prentice-Hall.

Robertson, B. (1988). *Fantasy Art.* Cincinnati, OH: North Light Books.

Roukes, N. (1988). *Design Synectics, Stimulating Creativity in Design.* Worcester, MA: Davis Publications, Inc.

Roukes, N. (1982). *Art Synectics. Stimulating Creativity in Art — A Teachers' Guide.* Calgary: Juniro Arts Publications.

Simmons, S. and M. Winer. (1986). *Drawing, the Creative Process.* New York: Prentice-Hall Press.

Taylor, B. (1974). *Design Lessons from Nature.* New York: Watson-Guptill Publications.

Wilson, B., A. Hurwitz, and M. Wilson. (1987). *Teaching Drawing from Art.* Worcester, MA: Davis Publications, Inc.

Wilson, M. and B. Wilson. (1982). *Teaching Children to Draw. A Guide for Teachers and Parents.* Englewood Cliffs, NJ: Prentice-Hall.

Painting

•••••• Introduction

Have you ever watched young children using several different pots of paint? They play around with the colours, mixing them and reacting to what happens with brushing them on paper — brushing enthusiastically if they like the results and frowning if the colours turn muddy. Often they are pleased with their accomplishment, and tell you something about their picture if they think you are interested.

The kind of discovery that children experience with colour and a paintbrush is at the heart of painting. As adults, artists paint to express what they see, feel, think, visualize, imagine, understand, and remember, or they might paint to explore the properties of colour. Your students likely paint for the same reasons.

When you teach painting, you can build on students' desire to express themselves with paint, and to learn more about it. Well-designed painting projects give students a broad understanding of the elements and principles of design, and of colour theory. This chapter discusses motivations for painting and the variety of techniques you can use with your students.

•••••• Approaches to Painting

PAINTING TO ILLUSTRATE

To initiate painting projects based on the idea of illustration you may wish to try some of the following suggestions.

Read or tell stories from different cultures to the class — folk tales, fables, myths, and fantasies from around the world offer rich images. Introduce such mythical creatures as unicorns, dragons, monsters, elves, sprites, mermaids, minotaurs, unicorns, and so on.

Bring into the classroom visual images to stimulate the students' imaginations. Discuss a wide range of topics that students can illustrate in their paintings, depending on their interests; for example, sporting events, royal visits, current news stories in your area, local construction projects, and musical groups. Play expressive music, both

EXHIBIT 7.1 When you teach painting, you can build on students' desires to express themselves with paint.

EXHIBIT 7.2 A painting of an event

instrumental and vocal. Discuss parts of the song or story that could be illustrated and encourage your students to do the necessary research to discover the details of objects, animals, or buildings they might be painting. Discuss the details of a song or story. Where did it take place and what might the environment look like? Was it long ago, real, or from a dream world? What did the characters, buildings, and landscape look like? Encourage the children to use the whole sheet of paper and include detail. Talk to your students about centre of interest, foreground and background, and colour.

Drawing and painting a still life, or from real life, provides an excellent opportunity to observe closely the details of subjects for the purpose of recording them for use in other visual statements, possibly for sculptures or prints.

UNDERSTANDING SELF AND THE EMOTIONS

Artists have used the process of creating visual interpretations as a means to understanding themselves. Some artists have used free association, just drawing and painting without previous thought about what images they would make. This technique, called Automatism, was a favourite of the Surrealists, and it was also used by a group of Quebec artists (*Les Automatistes*), beginning in the mid- to late-1940s, who wanted to break free of the constraints of objective painting. Around the same time and later American Abstract Expressionists also painted in a similar fashion. For some of the New York artists, their gestures became an integral part of their visual expression because the paint on the canvas showed the artists' movements.

Many artists have attempted to paint pure emotion, and you can encourage your students to do the same. Their feelings can be visualized with the help of words, music, and movement. Talk about how music makes them feel. Select music ranging from happy, light, and gay to heavy, sad music and encourage your students to paint rhythmically while the music is playing.

EXHIBIT 7.3 A painting that shows emotion

Physically attempting to feel can give students more concrete experiences to depict. Have them use their body, perhaps through dance movements, and then they can express with paint the emotions they experienced in their movements. Imitation of movements can also elicit students' emotions; for example, the movements of an elephant's swaying trunk or the bending and swaying of a tree as the wind blows through its branches and leaves. Words, stories, and poems can also be used to generate feelings.

PAINTING MEMORIES

Drawing and painting from memory is not easy because we often filter out details. However, often our senses evoke memories. For example, when a student opened a bag of clay, the musty smell of the clay reminded her of the smell when she played in a ditch with her friend. She remembered that her friend's mother was upset because the girls had become so muddy. This is the kind of scene students could re-create in a painting.

Ask your students to close their eyes and think about the smell of popcorn, chocolate brownies, or burned toast. What other smells of food bring back memories? What scenes can be re-created by remembering the smell of foods?

Use the same approach for sounds. Have your students close their eyes and try to remember particular sounds. If possible, tape a variety of sounds — footsteps, breaking glass, running water, a food grinder, any household sounds — and play them in the class. Have students talk about memories related to sounds and then paint the scenes.

FIGURES AND PORTRAITS

For painting figures and portraits, students would benefit by looking at reproductions of artists' painting techniques. If possible, assemble a collection of slides of self-portraits, portraits, and figure paintings and view and discuss the techniques artists have used.

Alternatively, with some direction, students can research portraits in the library. Canadian artists Paraskeva Clark (1898–1986), Joyce Wieland (1930–), and Paterson Ewen (1925–) each created expressive self-portraits, and Barker Fairley (1887–1983) painted a series of portraits of other people — all these would offer students ideas for approaching this method of painting.

Painting self-portraits with the use of a mirror is a useful exercise, an experience in self-expression that can help students learn proportions as well.

Techniques for drawing figures and portraits are discussed in Chapter 6.

EXHIBIT 7.4 A self-portrait

ART HISTORY

Artists throughout history looked at the work of other artists to learn how they created their visual images. Studying the work of both male and female artists who have created great paintings throughout the history of art should coincide with the students' own painting. Chapter 15 offers suggestions for studying art history.

Copying paintings of artists whose work students admire is a useful approach, along with looking at artists' work from other countries and cultures.

If possible, provide resources for students to look at how artists in different cultures have treated the same subject matter. Students can also paint the same objects with several different approaches, according to the artist reproductions they are studying. The techniques students learn in drawing (see Chapter 6) can also be integrated into their painting.

Painting projects can be based on styles artists used throughout the history of art. For example, as a way of learning about colour theory, students can study the work of French artist Georges Seurat (1859–1891), who through experimentation developed a technique later called pointillism. Seurat studied the work of the Impressionists, but wanted to develop a more scientific approach. After many experiments, he painted by placing dots of pure colour next to each other to create variations of hue without losing the brilliance of the colours. Students can be assigned a project to create a painting using this technique.

LEARNING THROUGH PAINTING

Tools and Materials

Brushes and other tools come in a variety of shapes and sizes. A supply of brushes for students should include ones with firm bristles as well as soft, flat, and round. It is good to have a wide variety available. Teach your students how to clean the brushes after using them, with soap if necessary, pressing the wet bristles back in shape with the fingers and storing them with "the hair side up, just like your head." Children should be discouraged from leaving the brushes standing in water; and when they are painting with a brush, gently discourage scrubbing because this action is hard on the brushes. Instead, encourage dabbing, sweeping, rolling, twisting, and drawing, and for scrubbing, provide old toothbrushes.

There are many other tools and materials that can be used for painting. These include sticks, twigs, feathers, rags tied to sticks, cotton balls and cotton tips, cardboard cut in various sizes and shapes, dish scrapers, sponges, plastic squeeze bottles, string, yarn, drinking straws, toothpicks, popsicle sticks, pipe cleaners, toothbrushes, window screen, and crumpled paper, as well as fingers, hands, and feet.

SURFACES

Surfaces commonly used for painting include a variety of types of paper: newsprint, cartridge paper, cream manilla paper, coloured construction paper, newspaper, telephone-book pages, paper grocery bags, wallpaper samples, magazines, paper doilies, paper plates, tissue paper, finger-painting paper or glossy paper, computer paper, craft paper, and freezer-wrap paper. Printing and watercolour paper can be used with watercolour paints for older students.

Fabrics — including burlap, canvas, and both linen and cotton — can also be used, but these can be prohibitively expensive. If you have access to a source for interesting pieces of wood, these can offer students exciting alternatives, along with rocks, glass, and sheets of tin.

COLOUR MEDIA

There is a wide range of paint and colour media to choose from. Tempera comes in block, liquid (ready-mixed), or powdered form (to be mixed with water and/or laundry starch). Water colours and acrylic are also excellent, but they are more expensive.

Acrylic paint is a synthetic, quick-dry-

EXHIBIT 7.5 A painting on an unusual surface — fabric, mesh, and wallpaper glued onto craft paper.

ing, water-soluble paint that comes in tubes or jars. You can make your own acrylic paint by mixing powdered tempera with polymer medium. Other painting media include: India ink, coloured inks, coloured felt tip pens, oil pastels, chalk, crayons, and finger paint (commercially made or homemade). Finger paints can be made by mixing wallpaper paste and water, laundry starch, or detergent with tempera paint. In addition to using paints, students can experiment with liquid wax, food dyes, liquid shoe polish, tea, coffee, berry juices, earth mixed with water, and plants.

BOX 7.1 HOME-MADE PAINTS

- **Flour and salt finger paint**
 Mix 2 cups of flour and 2 tea-spoons of salt. Add 2½ cups of cold water; beat until smooth and gradually add 2 cups of hot water. Boil until clear. Beat mixture until smooth. Add food colouring to colour.

- **Soap-finger paint**
 Mix enough soap flakes and water to form a thick consistency. Beat until creamy, adding food colouring or powdered tempera paint to colour.

- **Extra thick paint**
 Mix 1 cup of powdered tempera, 2 tablespoons of wallpaper paste, and ¼ to ½ cup of liquid starch. Mix until thick enough to spread like frosting. Popsicle sticks and fingers can be used to spread paint on card-board.

- **Starch paint**
 Mix liquid starch, powdered tempera paint, and water until a creamy con-sistency and the desired colour is achieved.

- **Acrylic-like paint**
 Mix equal parts of white glue and liquid tempera paint.

• • • • • •
Painting Techniques

All children need time for experimenting with paints and tools, to mix and arrange colours and shapes. You can introduce your students to many manipulation activities, problems, and projects to help them better understand working with colour and other design elements. The following are some beginning exercises you may wish to incorporate into your lesson plans.

- ## Wet on Wet
Dampen a sheet of paper with a large sponge, brush, or cloth. Brush colour on the wet surface; it will spread and bleed into the wet areas. Drip or dab colour on the wet paper and tip and move the paper around so that the colours combine. Try loading one colour onto half the brush, another colour on the other half, and then painting on the wet paper.

- ## Dry-Brush Painting
Wipe off any excess water from the brush and then heavily load the brush with paint. Now wipe off any excess paint and apply the paint to the paper. This should produce a rough texture. Paint can also be dabbed on with a sponge, crumpled paper, or wadded cloth, and details can be added later.

- ## Washes
Load your brush with water and paint. Draw the brush across the paper from one edge to the next. Repeat this paint application, letting the stroke touch the wet edge of the previous stroke. Graduated washes are achieved by applying a streak of paint across the paper and then loading the brush with water instead of paint. Touch the edge as in the first step so the water and paint will blend to create lighter tones.

- ## Wax Resists
Draw with water-resistant materials such as crayons, candles, candle drips, rubber cement, or white glue (let the glue dry before adding paint). Brush paint over the covered areas and the design will come through like secret writing.

- ## Wax Rubbings
Use the side of a crayon or candle to rub on paper that has been placed over different textured surfaces such as wood, cloth, lace, burlap, sandpaper, bricks, sidewalks, leaves, twigs, and screening. Rub heavily. Brush over with paint, allow to dry, and take another rubbing; paint over, allow to dry, and repeat. After completing the rubbings, students can allow the paper to dry and develop images suggested in the rubbings. Some of the work of Max Ernst would be useful for students to study when they do this kind of painting.

- ## Paint and String Drip
Drip paint onto a sheet of paper, or load string with tempera paint, and drip or pull the string along the surface of the paper. Repeat the process by overlapping a new colour. Let the paint dry and then draw or paint over these, elaborating on the shapes, images, and details. Invent titles for these imaginative designs.

EXHIBIT 7.6 Paint and string drip

• Take a Line for a Walk

Paint curved lines from one edge of the paper to another edge. Repeat seven to eight times, then cross over your lines so that you have a number of large spaces. Paint each space using just three colours in the entire painting or use specific colour schemes.

• Splatter Painting

Collect leaves, flowers, or shapes cut from paper and place them on the painting surface. Dip a toothbrush into paint and rub it over a window screen to splatter the paper. The shapes of the objects will remain, with the colour surrounding them. Move objects around on the paper and, using a different colour, splatter again by rubbing the paint-filled toothbrush over the window screen, or flicking the brush with fingers.

• Straw, or Blow Painting

With a finger over the top of a straw, pick up paint and drop it on paper. Then blow gently through the straw to spread the paint. Use a separate straw for each colour. Develop the image by adding paint or other materials to add detail.

• Finger Painting

Finger painting should be an optional activity. Some children might think this way of painting is too childish, but others will really enjoy it. Mix powdered tempera with liquid starch and a pinch of soap flakes. Dampen glossy surface paper and encourage students to get different effects by using the entire hand or the fingers, nails, palms, fists, and sides of hands. Other tools can be used to draw through the wet paint; for example, notched cardboard, combs, corrugated paper, scraps of wood, crumpled paper, or sponges. Finger painting can result in visual effects that are not possible with other techniques.

EXHIBIT 7.7 Splatter painting

EXHIBIT 7.8 Finger painting

• *Brayer Painting*

Apply thick paint to a brayer or cardboard tube (such as a mailing tube) with either a stir-stick or brush. Roll the paint onto the paper. This coloured surface can be used as a background for a painting or collage, or the areas can be developed into imaginative images.

• *Crushed-Paper Batik*

When creating a composition for paper batik, apply light-coloured crayon thickly onto cream manilla drawing paper, leaving some empty spaces. Place the paper in water and crackle. Smooth the paper out and paint a thin wash of dark paint or ink over it, and let it dry, flat. The picture will have a traditional crackled batik effect.

• *Etching*

Cover heavy drawing paper completely with crayons or pastels using a variety of bright colours. Paint on a layer of thick, dark paint that has been mixed with liquid soap, or use India ink. When the paint or ink is dry, use a sharp tool such as a nail or other pointed object to scratch lines and textures to develop a nonobjective composition or one on a specific theme, such as "fantastic flying fish in my floral garden."

• *Tissue Painting*

Coloured tissue gives a lovely, transparent watercolour effect. The paper can be cut into specific shapes or ripped and applied to areas of the painting surface after liquid starch has been applied. Because of the transparency of the tissue, overlapping sheets will produce colour blending and varying colour intensities. After brushing liquid starch onto the background paper, place the tissue paper on the wet surface and pull it off. This leaves a transparent watercolour effect. Students can work directly with tissue without any sketch or they can develop the paintings according to a theme, using ink, pencils, crayons, pastels, or paint to bring out details.

• *Chalk Painting*

Wet chalk can be used on dry paper or dry chalk on wet paper to make vivid paintings. When chalk becomes wet, it dissolves and fixes to the paper surface.

• *Arranging Shapes*

Cut out three shapes of various sizes from heavy paper. The shapes can be different objects or the same object in different sizes; for example, the first letter of the student's name. These shapes can be used as tracing stencils. Trace the stencils onto paper, overlapping the shapes. The students can then paint the positive shapes and negative spaces as a monochromatic painting or other colour scheme.

Collage

Collage is a technique of picture making. The term "collage" comes from the French verb *coller,* "to paste, stick, glue." Collage is not difficult and is an excellent medium for learning principles of composition.

Collage has been used for hundreds of years around the world, but was generally not considered a fine art until Pablo Picasso and Georges Braque made compositions of glued materials. Other artists continued and expanded the collage technique — Juan Gris, Max Ernst, Jean Arp, Marcel Duchamp, Man Ray, and Jean Dubuffet.

EXHIBIT 7.9 Arranged shapes

Collages can be produced with virtually any material, and the tactile nature of the activity makes it fascinating for all ages. Collage draws on the intuitive response to the qualities of shape, colour, and texture of materials. Few stereotypes exist to show how collages should look; therefore students are free to be inventive. The arrangement and patterns that may be produced are infinite. Since this art-making medium does not depend on sophisticated drawing skills, it is useful for discussing design elements and principles.

EXHIBIT 7.10 Collage

Pointers for Successful Collages

Successful collages incorporate the elements of art — line, shape, form, colour, texture — as well as the principles of design — balance, unity, variety, contrast, emphasis, movement, rhythm, pattern, and proportion. Planning a collage composition before gluing is helpful: playing with placement, shapes, colour, centre of interest, movement or path of vision, figure and ground, or positive and negative shapes and spaces, and overlapping of shapes.

Shape is a basic element of collage and, to avoid monotony, students can use pieces of different sizes in the work. There are some questions that you can ask yourself or your students when composing a collage image. Is one shape too large in proportion to the rest of the composition? Would it help to use the ground colour as a shape by allowing it to show through? Is the space between your shapes too regular?

Balance creates harmony in a collage. Elements that can be balanced are such things as colours, values, and shapes; and each of these has visual weight. Dark values and intense colours have heavier visual weight than light tones or values. Therefore, a small shape of intense colour may balance a large shape of lighter tone or colour.

Unity in art is a sense of oneness, a feeling that everything that is in a collage belongs there and works together. Elements that help to establish a sense of unity include: related colours, similar shapes, rectangles, free form, similarly-sized pieces of paper, pieces of paper that are either all cut or all torn, all photographic material, and pieces of similar smoothness and roughness. Similarity is the key characteristic. Pattern, line, and subject matter can also aid in unifying a collage.

Contrast and emphasis are important elements that are often forgotten, yet they are essential in developing a visual focus in the composition. The eye needs a place to start the looking process. Visual movement leads the eye through the work and can be developed by grouping shapes, arranging tones, placing contrasting elements, and using lines. Visual rhythms are developed by the repetition of certain aspects of the work — colours, shapes, or lines.

Collage Projects

Collage projects, problems, and assignments are limitless, but here are some suggestions: a collage on the theme of some human activity; social issues such as caring for the environment, or a frightening experience; a collage about the natural environment, the city, and its people; an expression of mood or feeling, such as fear, loneliness, war, poverty, pollution, love, or hate. Take common ordinary pictures and combine them with other ordinary pictures to produce an entirely new and uncommon image.

If letters or words are used, include colours and shapes or pictures that emphasize the meaning of the word. When planning to create a colour collage, students can choose a colour and design a collage of many different tones or textures of the one colour.

Create compositions using other colour schemes or warm and cool colours; or design texture collages composed of hard versus soft, smooth versus rough, shiny versus dull. Create pattern collages using one basic geometric shape — a circle, square, triangle, or linear pattern that may be used as a textile decoration. Use two or more shapes, colours, or textures. Create a landscape, cityscape, or portrait from textured paper, tissue papers, cardboard, grasses, sand, stones, seeds, or rubbings.

MONTAGE AND DECOUPAGE

A montage is a form of collage, a composition made by combining various ready-made elements such as photographs, pictures from magazines, photocopies, drawings, and paintings either whole or cut out. A photo-montage is a collage using only photographs or pictures.

A decoupage is made by pasting cutouts over the surface of an object to decorate it.

Traditionally, mosaics were made by inlaying small pieces of coloured glass, small clay tiles, or stone to form compositions. If it is not possible for students to work with these materials, they can use bits of coloured paper and cardboard.

Murals are large, two-dimensional compositions that can be created using collage or paint, or a combination of the two. Creating murals offers excellent opportunities for groups of students to develop visual concepts and carry them out.

EXHIBIT 7.11 Mosaic

MANDALA AND KALEIDOSCOPES

The mandala is a graphic mystic symbol of the universe that is typically in the form of a circle, enclosing a square and often bearing symmetrically arranged representations of deities. The mandala is found in many religions and cultures, among them, Hinduism and Buddhism.

The earth is a living mandala, as are the sun and moon. Other natural objects that contain a radial design are the cross section of a tree trunk, dandelion, daisy, sea shells, cones from trees, and snowflakes.

Kaleidoscopes and spokes in a wheel are two constructed mandala forms. Mandalas can be created to represent the seasons, significant animals, or the self.

The kaleidoscope is a popular toy patented by Sir David Brewster in 1817. It is a cylinder containing two mirrors that meet at an angle and run the length of the tube. When viewing through the eyehole at one end and against a light source at the other, one can see constantly changing series of designs composed of four, six, eight, or more wedge-shaped sections.

Students can create their own kaleidoscope by designing a picture wedge. The theme or images of the kaleidoscope should be researched in advance. The drawing or pattern for the wedge shape should fill the space and touch the edges. For a six-wedge circular design, mark points at 60 degrees; for a four-wedge design, mark points at 90 degrees. The wedge is traced on the circle and the mirrored image is traced (using carbon paper) next to it and repeated.

• • • • • •
Summary

Children and artists paint to express their thoughts and feelings and experiences. You can teach painting using a number of different approaches: illustration, painting as understanding the self, using memory to stimulate expression, painting portraits and figures, and painting as a way of understanding art history.

There are many tools and materials available for students, and these can be used in teaching a variety of painting techniques: wet brush on damp paper, dry brush, washes, wax resists, wax rubbings, and splatter painting, among others.

The techniques of collage, montage, and decoupage are also appropriate for the classroom. Collage is particularly suitable for students because it allows them to explore composition without having first mastered other more difficult art-making techniques.

REFLECTION

❶ For your own personal resource file, collect examples of drawings and paintings that illustrate a variety of styles and periods in art history.

❷ View a dance or listen to music and create nonobjective drawings and paintings based on what you see and hear.

❸ Paint a still-life composition as realistically as possible. Then paint it several times using a series of different brushes and brush strokes to model the shape and values.

❹ Create a series of small paintings using a variety of colours, tools, and brushes. Beside each painting indicate in writing the expressive qualities you captured. Indicate how this is evident to the viewer.

CLASSROOM PROJECTS

❶ Show your students reproductions of paintings by contemporary Canadian artists and then let them choose a painting by one artist to look at closely and copy. They should use the same colours and techniques of the painting they have chosen as a way of learning how that artist works.

❷ Have your students paint the same theme or topic several times using different colour schemes, media, and techniques.

❸ Ask your students to create a collage of an object using textured materials that resemble its texture.

❹ Play a piece of music, for example, Vivaldi's *The Four Seasons,* and have the students make a painting while they listen to the music. The paintings should be an interpretation of their response to the music.

BIBLIOGRAPHY

Ames, L. (1982). *The Dot, Line and Shape Connection, or How to Be Driven to Abstraction.* New York: Doubleday and Company.

Ashurst, E. (1976). *Collage.* London: Marshall Cavendish.

Brommer, G. (1978). *The Art of Collage.* Worcester, MA: Davis Publications, Inc.

Gatto, J., A. Porter, J. Selleck. (1987). *Exploring Visual Design.* Second Edition. Worcester, MA: Davis Publications, Inc.

Herberholz, D. and B. Herberholz. (1994). *Artworks for Elementary Teachers: Developing Artistic and Perceptual Awareness.* Madison, WI: WCB Brown & Benchmark.

Hubbard, G. (1986). *Art in Action.* San Diego: Coronado Publishers.

Hutton, H. (1968). *The Technique of Collage.* London: B. T. Batsford Ltd.

Naested, I. (1984). *Developing a Children's Painting Program.* Paper. Edmonton: Alberta Culture.

Ocvirk, O., R. Bone, R. Stinson, and P. Wigg. (1985). *Art Fundamentals, Theory and Practice.* Fifth Edition. Dubuque, IA: Wm. C. Brown Publishers.

Preble, D. and S. Preble. (1989). *Artforms: An Introduction to the Visual Arts.* Fourth Edition. New York: Harper & Row.

Richardson, J. (1986). *Art: The Way It Is.* Third Edition. Englewood Cliffs, NJ: Prentice-Hall.

Robertson, B. (1988). *Fantasy Art.* Cincinnati, OH: North Light Books.

Roukes, N. (1988). *Design Synectics, Stimulating Creativity in Design.* Worcester, MA: Davis Publications, Inc.

Roukes, N. (1982). *Art Synectics. Stimulating Creativity in Art — A Teachers' Guide.* Calgary: Juniro Arts Publications.

Stoops, J. and J. Samuelson. (1983). *Design Dialogue.* Worcester, MA: Davis Publications, Inc.

Taylor, B. (1974). *Design Lessons from Nature.* New York: Watson-Guptill Publications.

Wachowiak, F. (1985). *Emphasis Art: A Qualitative Art Program for Elementary and Middle Schools.* New York: Harper & Row.

Woodford, S. (1991). *Looking at Pictures.* Cambridge: Cambridge University Press.

Zelanski, P. and M. Fisher. (1984). *Design Principles and Problems.* New York: Holt, Rinehart and Winston.

CHAPTER 8

Printmaking, Fabric Arts, and Jewellery

•••••
Introduction

Printmaking, working in the fabric arts, and making jewellery offer tactile experiences for students. These media are sure to capture the interest and imagination of children, no matter what their particular inclination might be.

In this chapter, we explore how to incorporate each of these three media into your classroom. We also introduce the appropriate vocabulary that children can learn to use in talking about printmaking, jewellery, and the fabric arts.

BOX 8.1 PRINTMAKING VOCABULARY

These are terms that your students can learn to use if you explain their meaning when you begin printmaking projects.

- **Block** or **plate.** The material on which the image is cut.
- **Brayer.** A tool used for applying ink to the block.
- **Inking tray.** A palette or slab with a smooth nonporous surface used for rolling out ink.
- **Gouging tool.** A tool used for cutting away nonimage areas from a block.
- **Rolling-up.** To ink the image on the block to be printed.
- **Pulling a print.** Printing the image from the block and pulling it off the block.
- **Mirror** or **reverse image.** The image on the print that will be reversed from the image on the block.
- **Edition.** The set of identical prints, numbered and signed by the artist.

The first number is the print in the series and the second number is the total number of prints (for example, 3/20 means the third print in an edition of 20).

- **Trial proof.** A trial print pulled to test the progress of the image.
- **Artist proof.** A print the artist keeps that might have slight deviations (good or bad) from the edition.
- **Bench hook.** A wooden or metal plate with a downward-bent lip on one end, and an upward-bent lip on the other. It is used to secure the block of lino or wood when gouging to prevent slippage.
- **Overprinting.** Printing the same image on paper; the second impression is slightly off register.
- **Registration.** The process for obtaining exact correspondence of blocks or screens to assure alignment for multicolour printing.

140

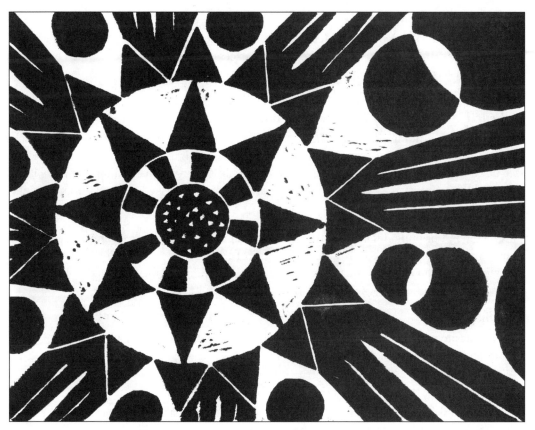

EXHIBIT 8.1 Printmaking

• • • • • •
Printmaking

Printmaking is a mechanical process of transferring images from one surface to another, to enable artists to make multiple copies of an original. A print is an impression made on one surface, such as paper, by another surface, which is generally referred to as the plate. Several prints are often produced by the same image, and this is referred to as a series, set, or edition.

METHODS OF PRINTMAKING

There are four different types of printmaking, and their differences have to do with how the ink is applied to the paper or other surface. Printing ink is not a thin liquid like the ink used in fountain pens, but it has a paste-like consistency.

- *Relief Printing*

Prints created in this process have an image that is raised from a background; the raised areas are inked and applied to paper or another surface.

- ***Intaglio or Etching***

In this process, a corrosive material (called a mordant) is used on a metal printing plate to bite into the surface. Ink is forced into grooves and the excess ink on the surface is wiped away. The image is transferred to the paper (which is generally made wet) by applying pressure to the plate so that the ink is drawn from the grooves.

- ***Stencil, Serigraphy, or Silk-screen Printing***

In each of these printing processes, the image is cut into a protective material used as a block-out (to block out the ink). In stencilling, ink is applied through these cut-out shapes to the surface underneath. In silk-screen printing, areas of the silk-screen are masked out; then the ink is squeezed through the areas that are to form the image and the masked-out areas do not print.

- ***Planographic or Lithographic Printing***

This method of printing differs from the others in that the printing surface is not etched or cut. In lithography, the process is based on the inability of oil and water to mix. The image is created in a greasy medium and then the stone is made wet. The drawing then attracts oil-based inks, but the wet part of the surface repels the ink, so the drawn image remains.

- ***Monoprints***

Monoprints are made by drawing with inks and paints on a flat surface. Paper is applied to the surface and one print is taken off the surface.

PRINTMAKING IN THE ELEMENTARY CLASSROOM

Water-based inks are the kind most commonly used in the classroom because they are easy to clean up. A wide variety of paints — such as liquid tempera, tempera block paints, watercolour, and finger paint — can be used for various printing processes.

Relief Printmaking

Cardboard, fabric, string, or other two-dimensional materials can be layered and glued to build up a surface; but make sure to let the glue dry. If several prints are going to be produced, it is best to apply a coat of thin white glue or acrylic medium to the surface first and set it aside to dry before printing. Ink the surface using a roller or paintbrush; try to make the ink smooth on the raised surface. Place paper over the plate (relief surface) and rub or use a printing press.

Many other materials can be used for relief printing, such as lace, burlap, leaves, and grasses. Clay or Plasticine can be rolled flat, the surface marked, rolled up with ink, and prints pulled. Tin foil-on-cardboard print is cardboard or newspaper covered with tin foil, with the surface marked by pen or pencil. Styrofoam can also be used, with or without the tin foil covering.

Relief prints can be made from wood and linoleum or lino prints, but these require carving tools, which are sharp and therefore not appropriate for younger students. Older students should be taught how to handle carving tools with care.

Cardboard rolls, wooden rollers, or brayers can be used to create patterns and backgrounds by merely inking the roll and rolling the ink over the paper. The rolls can be given texture by wrapping string, yarn, lace, or other material onto the roll for a continuous design.

EXHIBIT 8.2 Rubbing

Rubbings or Frottages

Rubbings or frottages are simple forms of printing that offer exciting ways of recording texture and pattern. Begin by placing paper over textured areas and rubbing crayon, chalk, pencil, pencil crayon, or pastels over the paper. To build the texture, more than one rubbing can be taken on a single piece of paper. Take a rubbing, and if you are using paint, brush lightly over the wax rubbing with watery paint; let it dry and take another rubbing, and repeat.

Stamp Printing

Almost anything can be a tool to make a print or part of a print. Collect gadgets, tools, objects, forks, toothbrushes, sponges, erasers, Plasticine, clay, and wood. Hands and feet are also good stamp printing gadgets! Carve potatoes (or other solid firm vegetables), Plasticine, clay, and erasers into shapes, to be inked and printed. Styrofoam meat trays can be marked with a pen or pencil or cut with scissors, and then inked and printed.

Block Printing

Materials commonly used for block prints are wood and lino. Lino is a flexible mixture of cork applied to a burlap backing. Linoleum, a type of floor covering, can also be used. Gouging tools are used to remove surface areas, and the remaining raised areas are inked over and printed.

Monoprinting

In monoprinting, only one print can be made from the printing surface. Sometimes professionals produce more than one, called ghost images. Monoprinting is an incredibly versatile printing technique that is free of constraints and is closely related to drawing and painting. Many well-known artists created

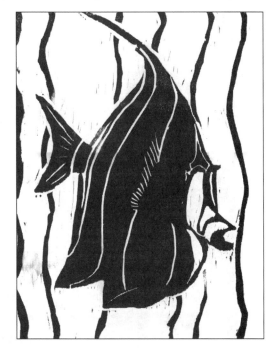

EXHIBIT 8.3 Block printing

monoprints, among them Rembrandt, Degas, Chagall, and Matisse. It is a simple process, and a wide variety of materials, tools, inks, and paints can be used.

• *Drawing*

Monoprints can be created through the drawing process. Spread a layer of ink onto the printing plate or surface and draw into the ink with a tool or finger. Place paper lightly over the inked area and lightly smooth the paper down, and then pull it off. Another approach is to place paper lightly over the inked surface and draw gently with a tool or object on the paper. This produces yet a different effect. Students can experiment with this kind of monoprint to find out what the different results are.

• *Paper-Stop-Out*

Most types of paper or other flat material are suitable for blocking out part of the inked surface. Place the stencil on the inked surface, lay a sheet of paper on it, and rub it carefully all over. A variety of materials can be used: paper cutouts, leaves, gauze, netting, and lace. The positive shapes or the negative shapes remaining from cutouts can also be used as stencils to create images.

Stencil and Screen Printing

Silk-screen printing is based on the process of screening ink through a silk-screen or similar mesh material to make a number of multicolour prints from a single design. The fine meshed silk or nylon screen is stretched onto a frame of wood, or other stiff material such as heavy cardboard, mat board, embroidery hoops, lids, or old picture frames. The area that is not part of the design colour to be printed is blocked out on the screen either by the application of paper stencil or other block-out material.

The printing is done by pouring ink on the screen and then, with a tool called a squeegee (a

flat rubber edge with a handle), pulling the ink across the screen. Other materials such as heavy cardboard or plastic can also be used as a squeegee. With part of the silk covered, the ink will be squeezed through the screen in only the open areas. When the ink has dried, another colour can be printed, and continuing in this way a multicoloured print can be created.

Embossing, Collograph, and Etching

A collograph is a relief print made from a surface that has been built up by gluing or attaching cut cardboard shapes or other low-relief found objects — string, yarn, burlap or other fabric, lace, plastic, styrofoam, toothpicks, and leaves. The collograph can be printed using either the relief-printing method or an incised method. This relief collage can be used as a printing block for a collograph, using ink.

EXHIBIT 8.4 Silk-screen

Embossing or embossed printing can be done with or without ink. However, ink is generally not used. The paper is embossed by making it wet and placing it over the relief printing block; then you press the paper down gently, taking care not to tear it. Pressing the wet paper gently stretches it into the shape of the relief areas. A printing press is most useful for this purpose.

Etchings are prints made from plates on which the image is scratched to form grooves. Artists might use copper plates covered with wax or varnish into which they draw images with a pointed tool. The plate is immersed into an acid bath that etches the drawn lines, which are exposed.

Obviously, this process is not appropriate for most school children, but they can make etchings by scratching into a plastic or styrofoam plate. The ink is rubbed onto the plate and into the grooves, and then the excess ink is removed. The paper should then be slightly wet and pressed onto the plate.

• • • • • •
Fabric Arts and Jewellery

The human body was the first surface to be decorated. Body paints are part of the traditions of many aboriginal peoples. Depending on the climate, throughout human history, clothing was used not only for protection from the environmental elements of wind, rain, snow, sun, cold, and heat but also for adornment. Clothing was decorated to declare a person's accomplishments, status, stories and myths, family ties and origin, and even to express respect for the natural environment made up of animals and plants, planets and stars, sun and moon.

Even in our own time, clothing reveals something about a person's status and culture. For example, what does a business suit tell you about the person wearing it? At the opposite end of the spectrum, if you see an African chief in traditional costume, you know he probably does not work on Bay Street in Toronto.

Clothing and fabrics are used for functional purposes, but many artists create what is often called "wearable art." Often these are special, handwoven or painted one-of-a-kind pieces shown in gallery exhibitions.

Jewellery, which is also generally intended to be worn, has no practical uses, but is simply for adornment. As happens in the textile arts, some artists make one-of-a-kind jewellery pieces that also are shown in gallery exhibitions. These pieces are sometimes elaborate and expensive if they are made of precious metals and stones.

FABRIC MAKING
Weaving

Weaving, which is one of the oldest arts, is the process of making cloth by crossing sets of threads over and under each other. Throughout history the art of weaving was used for numerous purposes, many of them practical — baskets for carrying things, and garments and blankets for protection against the elements. Such natural materials as grass and reeds were used for baskets; and fibres from animals were used for clothing: wool from sheep and other animals, such as alpacas, camels, cashmere goats, angora goats (mohair), and vicunas; silk from the silkworm; and cotton and flax from plants.

Synthetic fibres used in weaving cloth are made through polymerization, a process in which substances are created artificially by combining two or more elements to make a new compound. After the chemical process has been completed, the synthetic may be formed into fibres, film, or liquid. Nylon and polyester are examples of synthetic fibres (World Book, 1992, V. 21).

You can help students begin to develop an awareness of fabrics by suggesting they look at the labels on their clothing to find out what fibres they contain. They can also learn whether a shirt, for example, is made of synthetic fibres or natural fibres.

Wool is the easiest fibre to acquire for exploring the stages of producing yardage. After the wool has been sheared from sheep, it is washed and carded or combed; then it is spun into yarn. The yarn can be dyed and woven into yardage for blankets and clothing. If possible, arrange a field trip to a sheep farm for demonstrations of the stages of processing wool and weaving. Some heritage museums also have this type of demonstration to explain the process to school groups.

Weaving in the Classroom

There are many materials and ways to introduce your students to the art of weaving. Simple paper weaving is a start in developing the understanding of plain weaving. Simply cut slits to make strips within a piece of paper (making sure not to cut to the end) and weave strips of coloured paper over and under the strips in the sheet. These weavings can be used as placemats for special occasions, or they can be made into book covers. The small paper weavings are good for book marks.

To make weavings in fabrics, choose a coarse cloth such as burlap or scrim. Students can pull threads at regular intervals from the fabric and replace these with colourful yarn. Large, blunt darning needles work well for weaving the yarn in and out of existing cross threads.

God's Eyes are yarn symbols used by Indians of Mexico in religious festivals. Students can make similar objects by gluing or tying two sticks — popsicle sticks work well — or dowels together at the centre to form a cross. The next step is to attach one end of a piece of yarn to the centre of the cross, then wind the yarn forward and completely around one dowel. Bring the yarn back over the top of the dowel and move on to the next dowel making a circle of yarn around it. Students can choose several different colours of yarn for each God's Eye. These objects can be used to decorate the class-room, or even to decorate a Christmas tree.

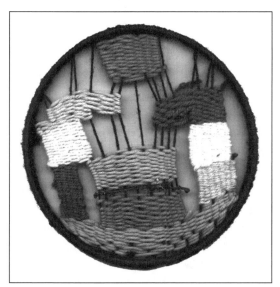

EXHIBIT 8.5 Weaving

Working on looms is the most common method of weaving fabrics. Looms are the frames on which the warp threads are strung, through which the weft threads are woven. Looms for use in a classroom can be

FIGURE 8.1 GOD'S EYE WEAVING

The God's Eye is a craft that comes from Mexico. God's Eyes can be made with yarn or string wrapped around wood dowels or sticks. Hold the two sticks together in one hand. Put some glue at the centre where the sticks cross. Place the end of the yarn on the glue, and let set. Start a crisscross pattern with the yarn by looping the yarn around the end of each stick. If you use several colours, the hanging will look like an eye.

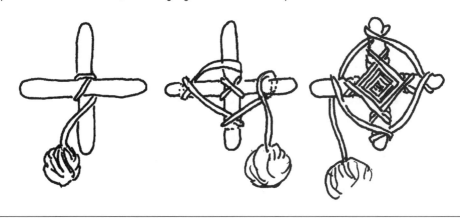

made from a wide variety of materials. Cardboard cut in various shapes with notches at regular intervals can be used as looms on which to tie the warp. Wooden and cardboard boxes and lids can also be used as looms. Cardboard or wooden fruit shipping boxes also work well. Just hammer nails into the two ends at regular intervals and wrap your warp around them.

Embroidery hoops or twigs tied in a circle create circular weaving. Board or cardboard looms can be simple or complicated, depending on the size and construction. There are other materials that can be used as a warp if you want to eliminate that step; for example, wire mesh, onion sacks, plastic mesh cartons, and burlap with threads removed.

FABRIC DECORATION

Experimenting with natural substances to create dyes can be easily integrated into your art program. Many of the materials are readily available and inexpensive. In fact, perhaps the students would enjoy collecting materials for making dyes: berries, bark, lichens, moss, leaves and grasses, earth, onion skins, tea leaves and coffee grounds, roots such as carrots and beets; flowers such as marigold blossoms, dyers camomile (also called golden marguerites), and lily of the valley leaves. Commercial synthetic or chemical dyes provide an almost limitless range of colours.

Batik and Tie-Dye

Batik is an ancient handicraft, likely about two thousand years old. It originated in ancient Egypt and spread to India by way of Persia. Noblewomen in Indonesia did batiking before the thirteenth century.

BOX 8.2 WEAVING TERMS

- **Warp.** Vertical threads making the structural "skeleton" for weaving stretched across a frame or loom.
- **Weft.** Horizontal fibres woven through the warp.
- **Beater.** Device used to push the weft down; forks, combs, or a block with nails can also be used as beaters.
- **Row.** One line of weft across the warp.
- **Plain weave** or **tabby.** Weaving over and under, one row under and over the next row.
- **Waisting.** When weft thread is pulled too tightly it creates a pulled-in effect on the weaving.

BOX 8.3 MAKING DYES FROM ORDINARY MATERIALS

For making dyes from any of the cloth materials, boil them in water for about thirty minutes. Sieve off the material with a screen and boil the cloth, wool, or yarn for a few minutes, or just soak it in the natural dye pot for several minutes. The more water used in the dye, the less intense the colour. To be certain the dyes are permanent, use a mordant. Mordants are chemical salts that affect colour fastness and permanence of dyes. Mordants have a certain amount of colour in themselves, and therefore will affect the colour of the dye.

Even though we usually think of batik as an Eastern and Middle-Eastern technique, batiks are found around the world. They are used in many ways as yardage for curtains, drapes, room dividers, blouses, shirts, scarves, wall hangings, window screens, tablecloths, napkins, placemats, stuffed pillows, toys and dolls, and as greeting cards. When batik is used as a window screen, drape, or lampshade, the light that shines through it has a luminous quality.

Traditional batik patterns and designs are often based on birds, flowers, fruits, foliage, butterflies, and fish. In Javanese, batik means "wax writing." Basically, batik is a wax-resist process — the areas of fabric that are waxed will not be permeated by the dyes, which are water based. If you begin with a white fabric, you wax all the areas of the cloth you want to remain white. Dye the cloth in the next darkest colour, (yellow), let it dry, and wax and dye the next colour (red, which will give you an orange colour); let it dry, wax and dye again. Using this procedure, batiking becomes a good exercise in colour theory.

The wax in the batik process can be pure paraffin from the grocery store or a mixture of paraffin and beeswax. Always take great care when using hot wax with children. Keep in mind, too, that wax is highly flammable, and for that reason it is not a good idea to work with wax over direct heat. The wax can be heated in a electric frying pan, double boiler, or tin can in a pot of water.

You will need brushes for applying the wax, and a tool called a Tjanting, which is a handle to which a small metal cup is attached. The cup has a tiny tube or spout from which hot wax is dripped or poured.

A tjap or stamping tool can be made with nails, cookie cutters, toothpicks, dental instruments, and most metal objects.

A hot iron is used to melt the wax from the fabric. Place the fabric between layers of newspapers so that they absorb the wax as it melts.

Tie-dyeing, which is a different kind of resist technique, began at least a thousand years ago in India and Japan. Incas in Peru and North American aboriginals created tie-dyes, and it is still a favourite way of decorating fabrics in many nations of West Africa.

Tie-dyeing does not require wax. Fabric sections are either tied off, folded, or clamped with blocks. The tied-off, protected sections do not absorb the dye, and an undyed pattern against a dyed background is the result. Most students enjoy the fast, dynamic process of tie-dyeing, and sometimes enjoy tie-dyeing their T-shirts or pants.

Here is a list of materials and tools you will need for tie-dyeing projects in the classroom.

- All-cotton fabric, old cotton sheeting, T-shirts or other cotton cloth; polyesters and other synthetic fabrics do not absorb the dyes very well.
- Cold water dyes.
 There are various brands on the market. You might also like to investigate natural dyes. It is easy to just boil up beets, or onion skins, tea leaves, grasses or berries to extract the colour (see Box 8.3).
- Plastic buckets for mixing dyes and for dipping the cloth.

FIGURE 8.2 TIE-DYE KNOTS

Each of the following tying methods give very different results.

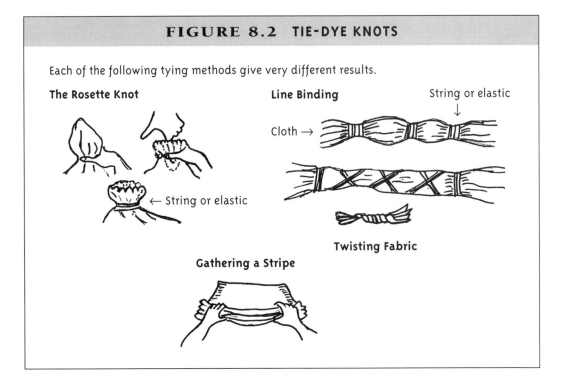

The Rosette Knot

← String or elastic

Line Binding

Cloth →

String or elastic
↓

Twisting Fabric

Gathering a Stripe

- Stir sticks and brushes to apply the wax or the dye.
- Plastic squeeze bottles or eye droppers are convenient for squirting the dyes on the fabrics.
- Drop cloths, newspaper, rags, or sponges for clean-up and rubber gloves to avoid dyeing the hands.
- String, rubber bands, or strong thread for tying the cloth before dipping it into the dye.

Exploring Other Fabric Arts

• *Stamping Fabrics*

Stamps can be created from many materials or found objects and spread with textile ink or paint and stamped onto fabric to create simple or intricate patterns.

• *Stencil and Screen Printing*

Stencils can be cut from heavy cardboard and used to decorate fabric. Textile inks can be purchased or acrylic paint can be used. Silk-screen printing can also be done on cloth with fabric inks.

• *Fabric Paint and Crayons*

Fabric paints and crayons can be purchased from craft and fabric shops. Acrylic paint also works as a fabric paint. Wax crayons melted into fabric also can be used as dye. Pieces of wax crayon can be spread onto the fabric, covered with newsprint, and ironed.

• *Stitchery*

Needlework and embroidery is the addition of thread onto fabric or fabric-like material or the decorating of fabric by using needle and thread. Tapestry needles with blunt ends and large eyes are excellent tools for use with various yarns or string. Loosely woven materials such as burlap, net, onion sacks, cotton, or linen make good backgrounds for stitching images, lines, and coloured yarn. Students can experiment with various stitches such as the running stitch, back stitch, and cross stitch.

• *Appliqué*

The technique of appliqué is simply cutting fabric shapes and arranging them on a background. The shapes can be attached to the background either by gluing or stitching them on.

• *Quilting and Stuffing*

The quilting traditions are a rich part of Canadian heritage, and though quilts were originally created for practical purposes, they are also an art form. Toronto artist Joyce Wieland used quiltmaking as one of her most expressive media, and deliberately chose it because it is traditionally considered women's work. In fact, she made some of her strongest political statements in her quilts.

Quilting is simply running stitches through layers of fabric and filler. Stuffing follows less rigid definitions and is the process of applying areas of cloth through sewing, stitching, or gluing and stuffing with cotton or other material to create raised areas or sculptural objects.

FIGURE 8.3 STITCHERY

Stitchery is a term for needlework — the combining of thread with fabric, usually in a decorative manner. There are traditional stitchery techniques and others developed more recently. Here are some common techniques, but there are many, many more.

Running Stitch

Whipped and Threaded

Chain Stitch

Herringbone Stitch

Satin Stitch

- ### Pulling Strings

Fabric such as burlap or other loosely woven material, in which students can see the warp and the weft, can be a good introduction to the weaving process. As we already mentioned, threads can be pulled from the material to allow for weaving in other colours of yarn. This is a good introductory experience for weaving. Threads can be tied in clusters with coloured yarn or other materials such as pebbles, moss, beads, grasses, twigs, or driftwood.

- ### Macramé

Macramé, an art form with a long history, is thought to have originated with sailors who used decorative knot tying. For a simple beginning project, mount cords onto a wooden stick or pencil using the larkshead knot. Position the stick firmly in place, either on a table or chair, so it cannot move when the cord is pulled. Holding the cords in your hands, you simply make a series of knots. The square knot is the basic one used in macramé.

JEWELLERY

The first jewellery in human history was made of materials that were the most familiar — teeth, shells, claws, bones of animals, pierced tusks — and were arranged and strung on long cords, or put into the hair. Later the materials for jewellery varied from culture to culture — gold, copper, bronze, iron, silver, platinum, enamels, pearls, and gems. Various patterns and designs also included the scalloped collar style of ancient Egypt, stylized animal forms of some tribal cultures, and colourful beads from India.

FIGURE 8.4 SIMPLE WEAVING TECHNIQUES

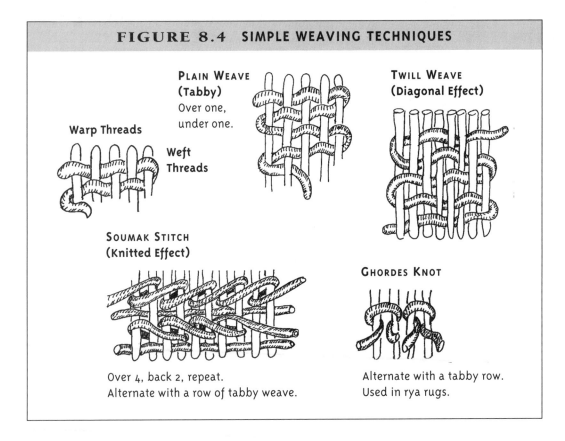

PLAIN WEAVE (Tabby)
Over one, under one.

Warp Threads

Weft Threads

TWILL WEAVE (Diagonal Effect)

SOUMAK STITCH (Knitted Effect)

Over 4, back 2, repeat.
Alternate with a row of tabby weave.

GHORDES KNOT

Alternate with a tabby row.
Used in rya rugs.

Today, jewellery designs from almost any country, and made from a variety of materials, are available all over the world. In every country, besides simply decorating the body, jewellery often is a mark of wealth, a badge of office, and sometimes a medium of exchange. For some people, such forms as the cross, birthstones, and a variety of good-luck rings and other symbolic shapes carry supernatural or mystical meaning.

In the classroom, when students are studying a particular country or culture, you can introduce jewellery and other body adornment characteristic of that part of the world. Students can research the designs and images used in the culture and create their own jewellery based on these patterns.

A wide variety of media are available for children to use in making jewellery. These include: paper in various forms, for example, strips of paper rolled and glued, papier mâché, laminated paper, cardboard, and tin foil; clay beads and medallions; wire, shells, stones, and found objects. (Naested, et al., 1987).

TROPHIES, MEDALS, AND MEDALLIONS

A medallist can be either a recipient of a medal as an award or the designer, engraver, or maker of medals. A medal is a piece of metal (like a coin) issued to commemorate a person or event or awarded for excellence or achievement. A medallion resembles a large medal. It can be a tablet

or panel in a wall or window in relief, and is generally a figure or portrait. In ancient Greece or Rome, a trophy was a memorial of a victory on the field of battle, or other accomplishment (Naested, et al., 1987).

The study of trophies, medals, or medallions can be incorporated into other school events or units of study — sports events, performances, awards for literary or artistic accomplishments, or personal accomplishments and achievements. Children can create their own personal trophy, medal, or medallion based on something they like or that they consider to be their best attribute, favourite sport, pastime, or aspiration. The students can create a trophy for their best friend, parent, teacher, coach, favourite author, poet, artist, or

EXHIBIT 8.6 Clay medallion

athlete. The idea of awards can be integrated with language arts, social studies, physical education, and the fine arts courses of drama, dance, music, and art.

Medals and trophies can be constructed from clay, self-hardening clay, play-dough, Plasticine, soft-sculpture, cardboard construction, coloured paper, plaster, wood, or a combination of media.

HATS AND HEADDRESSES

Like jewellery, hats and headdresses are worn for body adornment or as an expression of self-image and prestige. Of course, hats are also worn for protection from the natural elements; but nevertheless, the type of hat does make a personal statement about the person. Research into hats and headdresses can lead to fascinating discoveries. According to Dreher (1981),

> A hat is an extremely powerful image-maker. Whenever someone chooses to wear a hat, a personal statement is being made about the way the person feels or would like to feel, or would like others to think they feel. Simply by donning a hat a person can seem to become sophisticated, playful, solemn, authoritative, daring, glamorous, or virtually anything. Hats and head-dresses, the style, material and when and how they are worn are often culturally and religiously regulated — the role the individual plays in society whether it be a queen, king, medicine man, pauper, prince, or priest.

Students can investigate the use and construction of hats and headdresses in a variety of cultures, including their own. They can then construct hats based on their investigation from any available materials that are suitable, including paper, cloth, papier mâché, chicken wire, and combinations of materials. You might consider having an exhibition of the hats students make in connection with a parents' night. Or, you might suggest to students that when you have a school celebration they each design and create special hats to wear for the occasion.

•••••

Summary

In this chapter, we discussed several different art forms that teachers can introduce to their students: printmaking, fabric making and decoration, as well as jewellery, hats, and headdresses.

The four main printmaking processes are relief; intaglio or etching; stencil, serigraphy or silk-screen; and planographic or lithographic. There are a number of approaches to these printmaking techniques that are especially suitable for the elementary classroom.

A variety of forms of weaving are also suitable for elementary classrooms, either on loom or off loom. Other methods of working with fabrics were also discussed: stitchery, appliqué, quilting and stuffing, and pulling strings. Fabrics can be dyed using batiking, tie-dyeing, or stamps and stencils.

Jewellery, medals, medallions, and trophies, as well as hats and headdresses were discussed in this chapter as art forms elementary school students can explore, particularly in the context of studies of cultures around the world.

REFLECTION

❶ Research the work of Canadian artists who have done printmaking. For example, Christopher Pratt, David Blackwood, Betty Goodwin, Joyce Wieland, and Kenojuak. Record the results of your research in your notebook of resources.

❷ Visit your local gallery to look at the work of printmakers on exhibit. Also, visit a local printmaker's studio.

❸ Batik or tie-dye a piece of cotton cloth to create your own kimono or nightshirt.

❹ Design a hat for yourself for a special occasion or celebration.

❺ Collect small samples of fabrics, colours, and textures (both natural and synthetic) and keep them for reference in your sketchbook or notebook.

CLASSROOM PROJECTS

❶ Collect samples of fabrics, colours, and textures (both natural and synthetic) and make a display for the classroom. Set up the display in a way that invites students to touch and feel the samples.

❷ Batik or tie-dye materials for banners, kites, and wind socks to hang in the classroom or school.

❸ Get hold of a spinning wheel or spindle and encourage your students to practise making yarn.

❹ After introducing students to weaving and fabric decoration, encourage them to create their own pencil cases, eyeglasses cases, or wallets. Weave armbands or headbands, hair-bands or waistbands.

❺ Organize a T-shirt tie-dying or silk-screen session during lunch hour or after school for your students. Designs could be personal or symbolize the special group or class.

BIBLIOGRAPHY

Beshore, G. (1988). *Science in Ancient China*. New York: F. Watts.

Dreher, D. (1981). *From the Neck Up: An Illustrated Guide to Hatmaking*. Minneapolis, MN: Madhatter Press.

Hower, V. (1976). *Weaving, Spinning and Dyeing. A Beginner's Manual*. Englewood Cliffs, NJ: Prentice-Hall.

Meilach, D. (1973). *Contemporary Batik and Tie-Dye*. New York: Crown Publishers, Inc.

Meilach, D. and L. Snow. (1978). *Weaving Off-Loom*. Chicago: Contemporary Books, Inc.

Mosesson, G. and V. Elbert. (1975). *Jewelry Craft for Beginners*. Indianapolis: Bobbs-Merrill.

Naested, I. (1985). From tattoos to t-shirts. *School Arts*, pp. 25–26.

Naested, I., C. Marshall, L. Bolton, and G. Johnston. (1987). *The Olympics and the Fine Arts: Integrating the Fine Arts Through an Olympic Theme*. Fine Arts Council, The Alberta Teachers' Association, Edmonton.

Parker, R. (1989). *The Subversive Stitch — Embroidery and the Making of the Feminine*. New York: Routledge.

Svinicki, E. (1974). *Step by Step Spinning and Dyeing*. New York: Golden Press.

Wieland, J. (1987). *Joyce Wieland*. Toronto: Key Porter Books.

World Book. (1992). *The World Book Encyclopedia*. Volume 21. Chicago: World Book Inc.

Sculpture and Ceramics

•••••
Introduction

When Saskatchewan sculptor Joe Fafard was a young boy riding in the family sledge on the way to school in the winter, he imagined a set of identical horses and sledge, but miniatures, travelling alongside him by the edge of the road. He used his imagination to create another world, and as an adult he drew on his childhood on the farm to make sculptures. Among other things, he sculpted cows. In fact, seven of his oversized bronze cows, called *The Pasture* (1985) lie in downtown Toronto by the Toronto Dominion Centre on a patch of green grass.

For many years Fafard worked mainly in clay, making and firing small portraits of people in his home town, as well as historical figures, politicians, and writers and artists. In the 1980s he began working in bronze, for one reason because he likes to explore new media (Teitelbaum and White, 1987, p. 51).

Fafard has never lost his childhood curiosity, and for him sculpture offers endless possibilities for exploration. When you introduce sculpture to children, you might also discover that exploring form and materials provides many exciting experiences.

Given the opportunity, children enter wholeheartedly into manipulating sculpting materials. This chapter introduces the wide variety of methods and media for creating sculptures with children. Clay is an excellent medium for sculpting and is also used, of course, for functional pottery. We discuss both of these ways of working with clay in the classroom.

•••••
Sculpture

> The world contains no people so crude in culture that they lack a decorative art . . . Whatever it may be, to whatever biological or psychological need of the organism art is the response, it must be recognized as one of the most constant forms of human behaviour (Bunzel, 1972, p. 1).

Creating three-dimensional art or sculpture is as much a part of cultural development as drawing and painting. Early humans collected and assembled objects they found appealing, carved images in rocks along river banks and cave walls, manipulated clay and carved wood to create symbolic figures, and decorated functional vessels, tools, and weapons.

Sculpture is categorized according to whether it is relief or a freestanding structure, and by the method of construction, such as modelling or rearranging material through manipulation, subtracting or cutting away, or a building process. Other forms of sculpture include mobiles, stabiles, kinetic sculptures, assemblages, environments, and installations. Masks,

puppets, and dioramas are also discussed in this chapter. Various materials can and have been used to create sculptures that range from the more traditional to more contemporary — rock, clay, wood, leather, fur, feathers, hair, grasses, glass, plaster, cement, wire, fabric, Plasticine, rubber, yarn, plastic, acrylic, fiberglass, as well as collections of discarded objects sometimes referred to as junk.

When you first introduce sculpture into your classroom, bring in posters and other resources that can help the students gain an understanding that making three-dimensional objects is a part of human history. This sense of history enriches the experience.

SCULPTURE IN THE ELEMENTARY CLASSROOM

In addition to providing a perspective on human history, explore ways of also providing a context of art history. How did individual artists and groups of artists in various cultures create sculptures? What materials did they use? What images did they create for functional and non-functional use? Students can absorb the elements and principles of sculpture through learning about the work of other artists as they themselves also manipulate materials to investigate form and structure.

Keep in mind that developmental stages in modelling parallel the stages in drawing. However, the more the students have access to the art materials the more adept they will become. Developmental stages only serve as a guide to developing programs and not a standard by which to evaluate the students. The most simple, basic sculpture experiences are best for the elementary art program, so the sculpting projects you introduce would fit into one of these four types: modelling, sculpting, constructing, and relief.

- **Modelling** means rearranging material through manipulation — sometimes adding or carving away. Materials to model include Plasticine, clay, salt and flour mixtures, play dough, wire, papier-mâché and papier-mâché pulp, and plaster in sand or Plasticine.
- **Sculpting** or **carving** means altering the appearance of the mass, subtracting, or cutting away. Materials include paper, Plasticine, cardboard, plaster of Paris (with sawdust filler), styrofoam, bar of soap, paraffin wax, wood, ice, firebrick, stone, and clay.
- **Constructing** is the assembling of materials in a building process. Materials include wood, cardboard, stone, fabric, metal, containers, boxes, bottles, cans, plastics, toothpicks, straws, popsicle sticks, multimedia, and found objects.
- **Relief sculpture** is technically a two-dimensional picture with raised areas on its surface and is generally viewed from only one side. Relief sculpture can be constructed with any material.

MATERIALS
Paper

Paper is versatile, inexpensive, and accessible. It comes in different shapes and weights from cardboard to tissue paper. In preparation for teaching, collect paper in every form possible, from scraps to large rolls available from billboard companies. Encourage students to bring boxes and paper rolls to school.

Students can explore the properties of paper through cutting, folding, rolling, ripping, and attaching pieces together with paste, staples, and glue. Heavy corrugated cardboard can be used for large paper sculptures. Forms can be connected together to create fascinating figures, faces or heads of animals, birds, or fish.

BOX 9.1 RECIPES FOR MODELLING MATERIALS

There are many commercial and home-made clay-type materials that are good alternatives to working with clay. Experiment with the recipes to be sure they result in the kind of material you want. Some people might object to the cost and preparation time of cookie dough, but a recipe is included for those who like the idea.

- Play dough (cooked) — 1 cup white flour, 1 tbsp. oil, 1/2 cup salt, 1 cup coloured water, 1 tbsp. cream of tarter. Mix over medium heat for about 5 minutes. Knead and store in plastic in the refrigerator.

- Salt and flour dough — Mix equal parts, salt and flour and water with added food colouring. Air-dry the dough. You can also use equal parts cornstarch, salt, and water.

- Sawdust — Mix two parts sawdust to one part wallpaper paste, or equal parts, sawdust, wallpaper paste, and water. This molding material air dries.

- Dough clay — Mix 3 cups flour, 1 cup salt, 2 cups water, OR 4 cups flour, 1 cup salt, and 1 1/2 cups of water (for colour, mix in tempera paint). Knead for 10 minutes, sculpt, and bake at 250° to 300°F overnight.

- Gingerbread cookies — 10 cups all-purpose flour, 1 pound butter or margarine softened, 3 cups sugar, 2 tbsp. each of ground cloves, ginger and cinnamon, 2 tbsp. dark corn syrup. Mix the butter and sugar in large mixing bowl. Set aside. In a small saucepan, mix 1 1/2 cups water and the remaining ingredients, except the flour. Bring to a boil and pour the liquid mixture over the butter and sugar. Stir until the sugar is dissolved. Add the flour, one cup at a time and blend well. Store the dough covered overnight in the refrigerator. The dough will keep up to two weeks. Shapes can be cut out or placed in aluminum foil that has been shaped. Bake on ungreased cookie sheets in a moderate oven at 375°F for six minutes. Let the cookies cool and decorate them. This recipe should make about 35 cookies.

- Donna Russell's Gingerbread Cookies — 2 1/2 cups flour, 2 1/2 tsp. of soda, 3/4 tsp. of cloves, 1 1/2 tsp. of cinnamon, 1 1/2 tsp. of ginger, 1/3 cup molasses, 1 1/4 cup brown sugar, 1 cup shortening, 1 egg, 1/4 tsp. salt. Mix eggs, molasses, and brown sugar in a mixer and add shortening and mix, then add dry ingredients, mix well. Chill for 1–2 hours, then roll out, cup into shapes and cook in oven at 375°F for 10–12 minutes. Makes 7–8.

One lesson can be limited to just paper strips, bending and folding to create a variety of shapes. Strips can be added to create flower or fish shapes. Papers of various weights, textures, and colours can be used. The strips can be stapled together or held in place with paper clips until the glue has dried, and the shapes can then be suspended as a mobile or joined together to form free-standing sculptures.

Papier-Mâché

Papier-mâché is a French term meaning "paper pulp." It is light and resilient and can be moulded into shapes. Papier-mâché can be made into a pulp to create small sculptures or to add to larger sculptures.

Paper torn in strips and soaked in a mixture of wallpaper paste, glue, or flour and water can be moulded over an armature made of wire, aluminum foil, containers, clay, paper towel rolls, boxes, bal-

EXHIBIT 9.1 Papier-mâché

loons, cardboard, or shaped paper. The last layer of a construction should be white paper or paper towels. When a papier-mâché piece has been formed, smooth all cracks and loose edges. Let the work dry thoroughly, and sand any rough edges that remain. Then the sculpture can be painted, decorated, or embellished with objects — cloth, yarn, buttons, whatever can be found to enhance the visual expression.

Papier-Mâché Pulp

Papier-mâché pulp is made by tearing paper or newspaper into small pieces. The paper is placed in a container and covered with water. A teaspoon of salt is added to each quart of pulp to prevent it from spoiling. The mixture should stand overnight, or longer. The excess water is squeezed out and wallpaper paste or another glue is added. This pulp can be used for modelling.

Many artworks can be made from papier-mâché or paper pulp; for example, masks, puppet heads, and piñatas. Masks and puppets made with papier-mâché pulp are sturdy and light-weight.

Traditionally, a Mexican piñata was made from clay, usually for Christmas, often in the shape of a donkey, star or chicken. Brightly decorated with tissue and paint and filled with small toys and candy, it was suspended from the ceiling on a hook or rope and pulley. As a game, a blind-folded player used a stick to reach up to break the piñata.

Building a piñata of papier-mâché is a good group project, especially on a cold, stormy winter day when children need active indoor activities. Perhaps the children's families can provide treats to put inside the piñata as a surprise, and breaking the piñata can be part of a winter festival or celebration.

Plaster

Plaster or plaster of Paris is made from the mineral, gypsum, which is calcium sulphate. It is a dry white powder that is mixed with water, poured over forms or into containers, and can be used for carving. Setting time is about fifteen to twenty minutes. Cloth can be soaked in plaster and placed over an armature (skeletal structure). When the plaster has lost its fluidity and begins to thicken, you can carve it and move it around with your hands for about five to ten minutes. After this time the plaster sets and crumbles if handled longer.

There are two methods to use in measuring the amount of plaster in proportion to water. One is mixing three parts plaster to two parts water; the other is the less exact "mountain" method. Here you simply sift your plaster into a container less than one-third full of water until a mountain rises slightly out of the water. Once you begin to mix, the plaster begins to set.

- Marble can be simulated by mixing equal parts of vermiculite with the plaster and water. Pour the mixture into a container and allow it to dry. It can be carved with a knife and sanded with sandpaper or a rasp.
- Stone can be simulated by mixing one part sand, one part cement, four parts zonalite, and one part plaster. Mix the ingredients dry, add water to form a thick paste, and pour into a container to harden and dry.
- Casting with plaster in sand is an exciting process because it is so immediate in creating a relief plaque. Designs can be drawn or pressed into a tray of wet sand and plaster poured over it. When the plaster is beginning to set, place hooks or paper clips in the back and let it harden. Remove the plaster relief from the sand, and paint or finish it another way and hang it up.
- Plaster slabs or forms can be prepared ahead of class time to be etched or carved by the students.

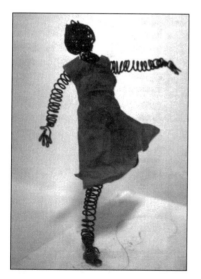

EXHIBIT 9.2

Wire sculpture

Wire

A flexible, thin wire can be used to make drawings in space. As in drawing on paper, each line, or wire, is related to the other. Projects in wire can include figures in motion, animals, and still-life objects. Students can draw an object on paper first and then create it with wire, or work directly with the wire while observing a form. A wire sculpture can be left as is, or can be added to with papier-mâché or tin foil covering, and details added later. String, twine, and wire mesh can also be incorporated into the work.

Many artists have worked with wire, including Picasso and Alexander Calder.

Fabric — Soft Sculpture

Pieces of fabric and cloth can be stitched together to create exciting figures, animals, and other forms. Just cut, stitch, stuff, and finish with paint or decorate with other materials.

Sculptures made of fabric are called soft sculptures. The most common soft sculptures are dolls made from nylon stockings, filled with fibrefill, and stitched with thread; details can be added with beads for eyes, felt and cloth fabrics for clothes, and wool for hair.

MOBILES, STABILES, AND KINETIC SCULPTURES

A mobile is a three-dimensional sculpture suspended in the air. Its parts move — are mobile — and should not touch each other. Balance is the essential element. A mobile is usually made of a series of shapes connected with wire or rods. The fascination with a mobile is the changing sequence of lines, planes, and colours — three-dimensional movement.

A stabile is similar to a mobile, but is static and does not move. These

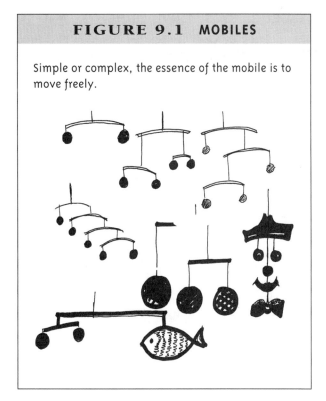

FIGURE 9.1 MOBILES

Simple or complex, the essence of the mobile is to move freely.

two forms of sculpture were invented by American artist, Alexander Calder (1898–1976). However, the term, "mobile" was coined by Marcel Duchamp (1887–1968) and "stabile" by surrealist artist Jean Arp (1887–1966).

Calder was born in Philadelphia, Pennsylvania to a painter mother and a sculptor father; he was trained as an engineer but had his first mobile exhibition in Paris in 1932. He experimented with shapes and colour to create beautiful compositions of forms in space. His work can be seen in galleries and museums around the world.

You can introduce the idea of mobiles and stabiles through pictures of Calder's work. You might consider suggesting a theme students can use to develop ideas for mobiles. They can make shapes — geometric forms, flowers, birds, insects, figures, circus animals, or anything else your imagination devises — to string together with fishing line, string, thread, or wire on a single string, on a bar, ring or other shape or on shapes made from coat hangers, cardboard, branches, wood, or plastic. Students can be encouraged to work out plans for mobiles so that they create lyrical, balanced movement.

The idea behind kinetic art is that movement and light can become works of art. Although Calder's mobiles can be considered a simple form of kinetic art, that art is usually made of objects that incorporate electric motors and gyrate and revolve to combine colour and light in interesting patterns. True kinetic art is likely too complicated to produce in an elementary school classroom, but if you have students interested in the art form, you can certainly encourage them to pursue it on their own.

Assemblages, Environments, and Installations

Assemblages are works of art that are assembled instead of being modelled, carved, drawn, or painted. Many assemblages are created from objects or parts of objects originally intended for other purposes. The term was coined by William C. Seitz when he organized a show in 1961 at the Museum of Modern Art in New York, called "The Art of Assemblage."

"Environments combine the qualities of painting, sculpture, collage, and stagecraft," (Janson, p. 773, 1991) and being constructed mostly as a three-dimensional art work, they can be considered sculptures. According to Janson installations "are expansions of environments into room-size settings" (p. 773). George Segal (b. 1934) and Duane Hanson (b. 1925) created works depicting people in everyday situations. Judy Pfaff's (b. 1946) installations "can be likened to exotic indoor landscapes" (p. 775).

During the 1950s and 1960s in New York, a number of artists — Robert Rauschenberg, Richard Stankiewicz, and Jean Follett, for example — constructed sculptures from junk materials. During that period the term "junk art" came into use — New York City produces plenty of junk. Many of the artists worked in cast-off metal pieces and welded them together. However, these New York artists were not the first to create assemblages. The Dadaists (including Max Ernst, Francis Picabia, and Marcel Duchamp) around the time of World War I, put bits of machinery into their work.

Any city produces an endless amount of junk that can be recycled into assemblages. Even rural areas can yield resources for assemblages and sculpture. For example, Andreas Drenters, who lives near Guelph, Ontario, has successfully created his own trademark assemblages from parts of old farm machinery and tools. Some of his sculptures have parts that move and are perfectly balanced.

Assemblages, environments, and installations lend themselves to classroom construction. A part of the classroom, an empty storage room (if they can ever be found), or the end of a hall can be transformed into a unique, inventive, and exotic environment. It's a good idea to provide visual examples of these to give your students an idea of how artists work with these techniques. Your students can build sculptures based on themes; for example, social comment (industrial waste), humour (the ordinary placed in incongruous contexts), and the purely aesthetic arrangement of forms in space.

Masks and Puppets

Throughout the ages masks have played an important social, historical, artistic, and theatrical role in society. With masks the human face can be disguised or transformed into other identities such as animals, spirits, and gods. A wide range of human emotions can be expressed by the use of masks. They can be made to be worn or to be used simply for decorative purposes. In some aboriginal cultures, masks are used in dance rituals; for example, if a person's identity is connected to a wolf, he or she might wear a wolf mask and do a wolf dance.

Making masks in the classroom should have a purpose. You might include masks as part of lessons on the design principles of colour, shape, line, and texture. When you are teaching a unit on a particular culture, making masks can be incorporated into the unit as a way of creating visual images related to students' research of that culture. For example, masks are an integral part

EXHIBIT 9.3 Mask

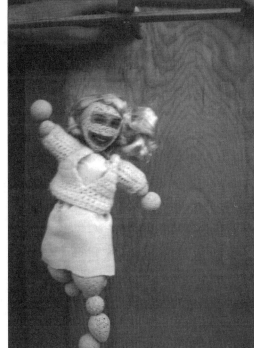

EXHIBIT 9.4 Puppet

of the life and rituals of West Coast native culture, and research into these masks offers students a rich resource for exploring design and symbols in mask making.

You can pair or group your students to create masks depicting characters in a story and create a play based on the story; or the students can develop their own story and make masks of the characters to be used in dramatizing the story, both animals and humans or other imaginary creatures.

Masks can be made from a variety of inexpensive materials: paper bags and plates; cardboard boxes and shaped cardboard; papier-mâché formed over blown-up balloons, plaster molds, bowls or crumpled newspaper as temporary armatures (skeletal support). Nonfunctional masks can be made from clay or plaster formed over newspaper or other molds. Though plaster and clay are too heavy to be worn, they work well for making decorative masks.

After the masks have been formed, they can be finished with paint of various types, cloth, yarn, wool, feathers, fur, straw, wire, coloured paper, pebbles, buttons, and other found objects.

Making puppets in the classroom can also be incorporated into other units of study, and students can dramatize their stories or scenes from plays. As with masks, puppets can be created from a wide variety of materials depending on the age of your children and the cost involved. Paper bag, stick, and sock puppets are the simplest to construct. Puppet heads and hands can be built from clay or clay substitutes, papier-mâché or pulp; and these materials can be used over styrofoam balls to make the heads of puppets lighter.

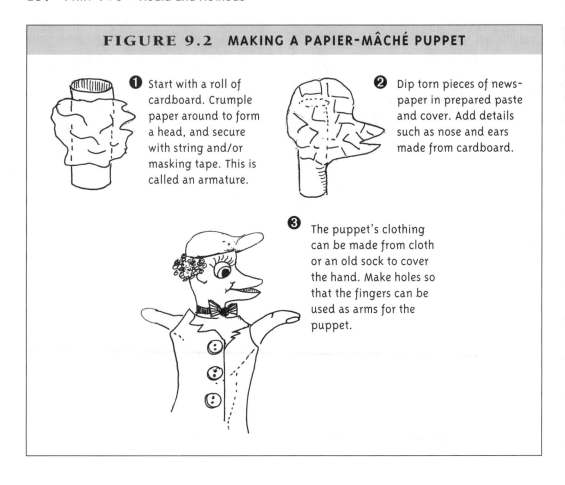

FIGURE 9.2 MAKING A PAPIER-MÂCHÉ PUPPET

① Start with a roll of cardboard. Crumple paper around to form a head, and secure with string and/or masking tape. This is called an armature.

② Dip torn pieces of newspaper in prepared paste and cover. Add details such as nose and ears made from cardboard.

③ The puppet's clothing can be made from cloth or an old sock to cover the hand. Make holes so that the fingers can be used as arms for the puppet.

Dioramas

A diorama is a constructed or designed environment for an object or sculptural piece such as an animal or invented creature. A diorama is generally made with three sides, or four sides with a hole at the end to look through. Boxes work best for making dioramas, but a curved piece of cardboard or paper can also be used, depending on the idea being developed. A variety of materials can be used, including fabric, yarn, and other found objects. Details such as trees and rocks can be made from Plasticine or other materials and included in the diorama.

••••••
Ceramics

The qualities which make plastic clay immediately attractive to children are probably qualities which attracted early people who as far as we can tell, shaped simple pots and modelled small figures. What could seem to be more natural than to pick up a lump of clay from a river bed or by the side of a lake and press it into shapes with the fingers (Cooper, 1981, p. 12).

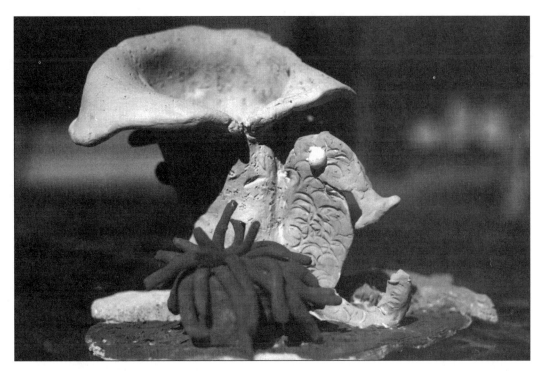

EXHIBIT 9.5 Diorama

Ceramics is the art and technology of forming, firing, and glazing clay objects. The technique originated during the Neolithic Age, but the term came later from the Greek *Keramos*, meaning "earthenware." Throughout history clay has been used for making such utensils as plates, cups, bowls, and vases; building materials and furnaces; and articles and sculptures for social, religious, and cultural purposes. Clay is perhaps more useful than any other single substance, and the ease with which it can be shaped makes it suitable for an astonishing variety of purposes.

THE ORIGINS OF FUNCTIONAL POTTERY

From very early times myth and magic have played an important part in the life of different communities and societies. It is more than probable that symbolic figures were modelled in clay at this stage as part of fertility rituals and ceremonies. Only later, as societies became more settled, were pots made as containers for food or seeds or religious purposes (Cooper, 1981, p. 12).

For gathering, storing, and cooking food, our early ancestors required vessels. They made containers from wood, bark, leaves, animal skins, gourds, and other vegetation. Clay pots were developed when the properties of clay were discovered — its plastic quality, its ability to hold the shape when dried, and its almost waterproof properties when fired.

The first pottery had the characteristics of the original vessels. Most early pottery had round bottoms to allow for uneven surfaces on the ground or in a fire, and to make it more comfortable to carry on the head or shoulders. For carrying water, the neck of some containers was usually closed; and to allow for more volume, the body was made rounder.

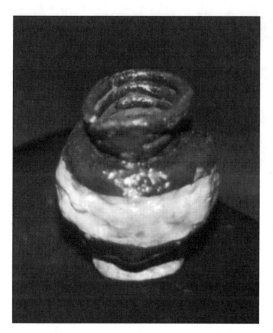

EXHIBIT 9.6 Functional pottery

Early potters often used simple molds such as shells, gourds, or old pots as a base for the pot. Ropes, coils, or rings of clay were built up on this base and then smoothed over to form an even wall (Cooper, 1981, p. 12).

WHAT IS CLAY?

Clay is decomposed feldspar rock, a compound of alumina and silica. Millions of years of weathering have gradually broken up granite rocks into particles of microscopic size, and during this natural process, water has combined chemically with each particle to form clay crystals. Clay crystals are essentially flat and allow water to go between them, causing them to slide on one another. The water provides suction and lubrication and accounts for the plastic characteristic of clay.

Clay can be found over most of the earth's surface, but its plasticity and colour vary. It is not known how humans discovered that dried clay, when subjected to red heat (about 600° C, 1112° F), would become hard and not disintegrate in water. However, Cooper (1981) presented two theories, the hearth and the basket theories. Fires were valued by the early societies and therefore were carefully tended and maintained. Holes were made in the ground and could have been lined with clay. Fire in this hearth would have turned the clay into a crude, hardened vessel. The second theory is that baskets could have been lined with wet clay to render them waterproof. These clay-lined baskets could have fallen into the fire, which left a simple basket-textured pot behind.

CLAY IN THE ELEMENTARY CLASSROOM

Clay is inviting to manipulate and almost all children enjoy the medium. Some children might not like it at first because they do not like to get their hands dirty; but when they see the pleasure other children gain from working with clay, they might gradually come to enjoy it. There is the possibility that occasionally a child might be allergic to clay. Keep the work area free of dust by thoroughly cleaning with water. Clay does dry out the skin, so having skin cream available for children who want it is a good idea.

Before you begin working with clay have the children put on art shirts to keep their clothes clean. The clay should be kept soft and workable to avoid frustration. Do not give the children water to use with the clay. A wet sponge and slip are adequate for joining pieces together. Not having a kiln should not hold you back from working with clay. The children's work does not need to be fired. It can be dried and painted, but the students should realize these pieces are fragile. Dried pieces can be glued together with vinegar or white glue.

Introducing Clay

When children first encounter clay, they should be given time to touch, grasp, knead, push, pull, punch, rub, and caress it. By simply responding to the tactile nature of clay, children discover what it is like and what can be done with it. Children with special needs generally respond well to the plastic quality of clay, and working with this material provides sensory and motor experiences for them.

Give your students a handful of moist workable clay, and help them get to know its qualities by using the following questions and suggestions. How does the clay make you feel? Does it make you angry? What do you feel like doing with it? Does the clay make you feel loving? What would you do with it if you love the clay?

How long a roll can you make from your clay? What happens if you roll it too thin? How tall can you build with it? What happens if you build really high?

Pick up your clay lump. It has form, shape, weight. It has mass. Let it fall. What happens at the point of contact? How does your mass of clay look now? Pinch, punch, pull, push, and try every way you can think of to change the shape, form, and mass of the clay lump.

Have the children pat out the clay and press textured, found objects into it. Then have them use objects to scrape the clay and make a variety of textures. To explore textures, the children can use natural objects, such as leaves and shells, or other kinds of material such as burlap, onion bags, and lace.

Clay Tools

Clay can be worked without the use of tools other than fingers and fingernails. Younger children do not need a great variety of tools and often a few from the kitchen or gadget/junk drawer will suffice. Following are some other tools that are useful.

• *Canvas-Covered Boards*

Cover pieces of plywood with canvas or heavy cotton such as a tea towel, tightly stretched, for students to work on. These are needed because clay sticks to smooth, finished table tops. If you do not have a covered board for every student have them share, especially when they are trying to roll out the clay. The students can do some of their work on newspaper, but make sure their clay is not too wet.

• *Wooden Rolling Pins*

You can buy rolling pins at kitchen-supply stores, or a more economical approach is to buy thick wooden dowels and cut them into twenty- to thirty-centimetre lengths.

• *Garlic Press or Sieve*

Pushing clay through a sieve or garlic press makes wonderful hair and fur, and depending on what the children are doing, these tools can also be used for grass, bushes, moss, and other imaginary creations.

• *Table Knives, Forks, and Old Toothbrushes*

A table knife is useful for cutting the clay — knives do not need to be sharp, particularly for younger children. Forks are good for scoring or scratching the clay in preparation for joining

one piece of clay to another, or for texture. Old toothbrushes can be used for texture, to apply slip, to join clay, or to paint the finished pieces.

• *Pin or Needle Tool*

You can make another tool for cutting and joining clay by inserting a darning needle dipped in glue into a dense cork.

• *Toggle Cutting Wire*

Make a cutting wire by using five-kilogram-test fishing line or heavy wire about forty to fifty centimetres long. Attach the ends to large metal washers, wooden clothes pegs, or short pieces of dowel.

• *Paper and Cloth Towels and Plastic Bags*

You need paper towels or old cloth towels and plastic for covering clay work so it does not dry out when students must leave it to be finished later. Wet the towels (they should not be dripping,

BOX 9.2 PRACTICAL TIPS FOR WORKING WITH CLAY

- Wedging is a process of working and squeezing clay by hand to remove air bubbles and distribute moisture evenly.
- Clay should be thoroughly dry before firing. If the piece is cold to the touch (especially when held to the cheek) then it is probably too wet.
- Small air holes should be made in hollow pieces and large solid structures should be hollowed out to ensure complete drying.
- Dry clay (greenware) can be reclaimed by dissolving in water, but fired clay (bisqueware) cannot.
- Clay dries quickly in the air; therefore unused clay should be wrapped in damp rags or paper towels and plastic. It is a good idea to sprinkle water in the clay bag after it has been opened to replenish the water content in the clay.
- Soft, wet clay cannot be added to harder, drier clay because the moist

clay shrinks more than the dry clay and breaks off.
- Dry clay pieces that have cracked or have broken can sometimes be mended with vinegar, or vinegar and dry clay mixture. However, the mended area cracks during firing. The other alternative is to fire the pieces and glue them with contact cement afterwards.
- When clay has dried out too much to be used, or if it cracks from drying out, you can put it in a plastic bag with water for a day or so and then work or wedge it. However, if you have a large amount of clay that is dry, put it in a bucket and cover it with water. Allow it to soak until it is thoroughly wet; then when the water has mostly evaporated, put the wet clay on a slab of plaster or canvas board. Work the clay and wedge it until it is the right consistency to be used again.

but well moistened) and cover tightly with a plastic bag. To allow the piece to dry slowly, loosely cover with a dry cloth and plastic bag.

Forming Clay

Before the invention of the wheel, pottery was made entirely by hand by one of several methods or by a combination of methods. These hand-building methods include: pinch, coil, slab, and molds. Many artists still use these methods.

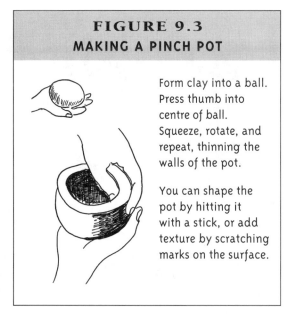

FIGURE 9.3
MAKING A PINCH POT

Form clay into a ball. Press thumb into centre of ball. Squeeze, rotate, and repeat, thinning the walls of the pot.

You can shape the pot by hitting it with a stick, or add texture by scratching marks on the surface.

- **Pinch pots** are made in the hand by squeezing and manipulating clay between the fingers and thumb.
- **Coil pots** are made by joining rolled pieces of clay together. Pieces are joined by scratching the surface of one piece of clay and adding slip before joining together. Slip, often called "Potter's Glue," is wet clay with the texture of yogurt and is used as a glue.
- **Slab pots** are made with flattened, rolled-out pieces of clay. Sometimes the slabs are placed over a convex mold to dry.
- **Molds** are forms that help shape the pot. Clay pieces can be built on the ground, which acts as a support while building. Early potters used a "puki," a previously made and fired clay saucer on which they built their pots, or they used two pukis, on top of each other, spinning the form with one hand while throwing with the other. This became the first potter's wheel.

To be sure the clay retains its moisture, store it in airtight plastic bags. When unused scraps of dried-out clay accumulate, put them into a plastic bag and sprinkle with water and close up the bag tightly. The clay can be reused.

As we mentioned, the clay must be moist and plastic for students to work with it. Once the clay becomes drier it feels like leather, and it is called leather-hard. This is the best stage for carving clay. Greenware is clay that is dry enough to fire in a kiln. Once the clay has been fired and becomes vitrified, but still porous, it is called bisqueware. Glaze can be applied to the surface of bisqueware, inside and out, and then it is fired for a second time, which makes the work waterproof. The fired, glazed pieces are called glazeware.

FUNCTIONAL POTTERY

The study of pottery, its function, shape, finish, texture, pattern, and decoration can be fascinating. Have the students research pottery of a culture they are studying in Social Studies, or of the nearest aboriginal reserve, cultural centre, or countries where their parents or grandparents

EXHIBIT 9.7 Fired clay

may have originated. How were the pieces created and finished, and what is the significance of the decoration and patterns? You may have your students duplicate the work or create their own pieces based on previously decided designs.

The pinching method of shaping clay is a very direct experience. You could work alongside the students forming your piece and explaining the procedure in the process.

A pinch pot is started by patting a piece of clay into a round shape that fits in a hand. When the ball is round, a hole is made partway down by pushing the thumb in the centre. Have the students keep their hands damp with a wet sponge or cloth. Keeping the thumb in the centre squeeze the ball, rotate slightly and squeeze again. The hole is enlarged by this rhythmic squeezing and pinching, thinning the walls and forming a bowl. The bowl can be enlarged with the addition of coils on the top, but remind students to use slip (wet clay used as glue) when joining clay pieces. The outside of the piece may then be smoothed for decoration, or incised, or carved.

CLAY RELIEF AND SCULPTURE

Clay can be used to create relief tiles. Students can create tiles with texture much the way they took rubbings. Clay will pick up the texture of leaves and other objects and fabrics.

Here are additional suggestions for student projects.

- Create a lesson with objectives based on the development and understanding of texture, line, pattern, and shape. Clay pieces can be added to the surface or it can be carved away to create realistic or nonobjective images.

- Students, who love creating imaginary or fantasy animals or creatures, can be encouraged to tell stories about their creatures. Create dioramas, settings, and environments for the creatures made from various materials using a shoe box or other cardboard.
- Students can use pinch-pot techniques to form sculptures, including abstracted or simplified animals or people. Pinch-pot people can be made, with small pinched pots for the head and body parts. Keep in mind that any closed, hollow forms that will be fired must have a small hole through which air can escape. The needle tool is ideal for making the holes. You can explain to the children that the air expands as it heats, and the clay shrinks in the firing (about 10 percent), and the result is a small explosion if there is no hole.
- Newspaper can be crushed and taped to form a support core for human and animal forms. When the slab core has been covered, the head and other details can be modelled separately. Clay slabs should not be more than a centimetre thick.
- Nonfunctional masks can be created over a wad of crumpled newspaper. Place a slab of clay over the newspaper and add features. After the piece has been dried and/or fired, paint and add yarn, fabric, feathers, corn husk hair, and other found material.

Finishing Clay Work

There are several different ways of finishing and decorating bisque-fired pottery and clay sculptures. The surface can be treated to make the ware more waterproof, or for aesthetic reasons.

- ### *Burnishing*

Smoothing leather-hard clay surfaces with a smooth stone or other tool is called burnishing. A spoon can be used to create this effect as well.

- ### *Slipping (Slipping and Burnishing)*

Creating a liquid from plants, minerals, oxides, and coloured clays and brushing it on the greenware or bisqueware is known as slipping. The piece can then be burnished if it is leather hard.

- ### *Sgraffito*

This is a term meaning carving or scratching designs on slip-covered pots to reveal the colour of the clay underneath.

- ### *Shoe Polish*

Shoe polish can be used to give a wood-grain effect on fired clay. Brush on the polish with a toothbrush, getting into the cracks and textures of the piece, and then polish with a cloth.

- ### *Glazing*

Simply defined, a glaze is a thin coating of silica and other components applied wet to the surface of the clay body, which is then fired in a kiln. During the firing the substance turns to glass. Glazes may be commercially purchased or developed from recipes. Labels on glazes provide information on toxicity, firing temperature, and colour.

- ### *Painting*

Various types and qualities of paint can be used on fired clay. Poster paint or water-based paint can be used, in order to give the work a shine. To prevent the paint from brushing off,

apply a coat of acrylic medium. Acrylic paint works well because it does not rub off, but it is more expensive.

Firing Clay

Three main types of kilns are available: electric, gas, and wood burning. You can find many low-firing kilns on the market, some of them small and inexpensive. If your school has a kiln and you do not know how to operate it, consult a ceramic merchant or professional potter. If your school does not have a kiln you may be able to rent firing time at a local ceramic studio. If your students' work does not have to be permanent or durable, merely allow the clay to dry and finish with paint and/or mat medium. There are interesting alternative ways of firing, such as pit firing, using bonfires, sawdust or even a fireplace.

Another firing technique, which is more difficult and requires a particular type of clay, is raku firing. It has its origins in early sixteenth-century Japan, and contemporary potters and sculptors use the technique with beautiful results. If you know a potter who would be willing to do a raku firing demonstration for your students, you could arrange a field trip in connection with clay work on a sunny day.

Firing the students' clay pieces in a bonfire is a good alternative, providing you have enough help to take proper safety precautions in an appropriate area. The clay pieces are placed on a bed of twigs and surrounded with fuel material such as charcoal and wood. More fuel is added until the pots are covered by hot embers and become red hot. The pots should be held at high temperatures for at least three to five hours to harden the clay. A barbecue or fireplace may also be used for firing. Remember, the fuel used may affect the piece by adding textured particles and changing the colour of the clay. Wrapping the pottery in paper towels, dried grass or newspaper, then wrapping it with heavy aluminum foil will produce a carbonized finish characteristic of traditional blackware. If the pottery was burnished during the leather-hard stage, it will have a glossy surface after firing.

Digging Clay

As was mentioned earlier, clay can be found in many areas of the country. Clay that is already prepared for studio use can be purchased from suppliers, but if you live in an area that has clay soil, students might enjoy the experience of digging clay. Discovering clay deposits can become part of a science unit on soil and land. You will need to research the area so that you know where the best area is to find clay, and also you must get permission from the owner of the land. Clay is most commonly found along river banks, on construction sites where the top soil has been removed, or where the surface of the ground appears cracked.

When you're looking for clay, pick up a lump of earth and if it feels sticky or soapy it is probably clay. Work the lump in your hands until it is smooth. Is it workable? Roll out clay into a coil, wrap it around your finger. If it cracks too much, little can be made with it; but if it holds its shape without cracking, you might be able to use it.

Dig some clay and add water to it. When clay is in a slip state (like yogurt), it is ready to be screened to eliminate foreign matter, such as pebbles and grass. Let it stand and when the clay has settled, siphon off excess water. You can eliminate more excess moisture by putting the clay

on a plaster bat or canvas-covered board. You can also put wet clay on scrap pieces of carpeting to get rid of water in clay.

If the clay is too plastic, it can be made workable by the addition of some fillers (nonplastic minerals) such as sand, volcanic ash, or grog (ground, fired clay available from pottery suppliers). Fillers reduce stickiness and decrease cracking tendencies. If the clay lacks sufficient plasticity, it can be made more plastic by the addition of 1 to 5 percent Kaolin or bentonite.

BOX 9.3 CLAY AND SCULPTURE PROJECTS

Many objects can be formed from clay and other sculptural materials. The themes for the creation of three-dimensional works can be integrated with themes or units of study from other subjects.

- Hand puppet heads and hands, marionettes, dolls, piñatas, dioramas.
- Masks, functional and nonfunctional.
- Clay sketches of a model or natural object, vegetable study, favourite food, nature study, texture study.
- Animal study, realistic or stylized.
- Character from a story or myth.
- Beads, brooches, earrings, worry beads, jewellery boxes.
- Containers, vases, flower pots, mugs, cups, plates, candleholders, dried flower holders, lamp bases, hot-plate holders.
- Musical instruments, trumpets, flutes, drums, marimbas, maracas, bells, wind chimes, string instruments.
- Buildings, cars, invented vehicles, spaceships.
- Personal trophies, awards, medallions, brooches; literary, medical, dramatic, musical, Olympic or sports cup, tribute to a bazaar event.
- Tiles, social comment plaque, group mural.
- Chess pieces and board games.
- Portraits, hero tributes, cartoon characters, mythological beasts, preposterous hybrids.
- Famous figure dinner plate, social comment place setting. (Look at the works of Judy Chicago.)
- Visual puns (swordfish), estranged objects (not normally made of clay, like shoes and paper bags), collage of diverse images, enlarged simple form. What do you get when you cross a _____ with a _____ ? (elephant and fly, alligator and car)
- Imaginary or realistic environments.
- Oversized objects such as a giant-sized toothbrush or coke can.
- Inflatables.
- Soft sculpture people and animals.
- Environmental, playground, architectural, totemic sculptures.
- Bowls, trays, decorative plaques, bottles.
- Hats, headdresses.
- Origami.
- Vehicles, trains, hot-air balloons, aircraft, spaceships.
- Figures, portraits, human or animal forms — a song or story that has numerous characters, science fiction

(continued)

(continued)

story, movie or T.V. program, Star Wars, Star Trek, robots, either real or imaginary characters and animals, heroes. Discuss the shapes of people and animals. Discuss certain animals or birds, shapes, body covering, details such as ears, beak, nose.

- Organic or nonobjective free-forms including motifs based on fruit, vegetables, rocks, shells, nuts, and other natural or biomorphic inspiration.
- Sculpture for the blind, or a feeling sculpture, a work of art most appreciated by the sense of touch.
- A "pocket-pal" — something created that fits into the pocket.

These ideas for sculpture projects can be incorporated into units of study on a variety of topics. Connect the assignment with pre-investigation, which may include drawing from real life, collecting pictures of the theme, discussion, and visuals of other artists' works.

Encourage students to plan what they want to do, after they have had previous experience in working with sculptural materials. Discuss the art elements and principles with the students individually and in the larger group before, during, and after their work has been completed.

A Teacher's Story

I decided to offer my Grade 6 students a "total clay experience" in conjunction with a North American aboriginal social studies unit. Fortunately the school was near a river and park. One sunny afternoon, after getting the appropriate off-campus forms signed by the school administration and my students' parents, we trundled off to the river bank with buckets and shovels to look for and collect clay. (I had previously tested the clay and knew it would be useable.)

I divided the students into groups and described what they should be looking for (ideally cracked surfaces or sticky earth) and that they may have to dig down into the ground below the top layer of earth to find the clay. The group was to locate clay deposits, dig a sample to take back to school, map out the area in order to relocate the deposit, and create several detailed drawings of the area in pencil and pastel.

Back at the school the next day we added just a little water to the clay, wedged it and picked out the bigger particles of stones and grass. We then formed clay pinch pots and decorated them using rope-like textures found on the local Cluny, Alberta, Blackfoot Indian pottery. We also looked at the burnished pottery of the Navajo, so some of the children polished the pieces with a spoon when the clay was leather hard.

After the pieces were dry, I fired them in the kiln just to make sure they would survive an outdoor firing. The following week, with parent assistance, we built a fire in a fire pit in the park, placed the pieces around the fire to get warm, and then pushed the clay pieces into the fire with a shovel.

After the fire burned down the pieces were pushed to the edge to cool. The students were excited about seeing the results; some pots were shiny, black, partially black, brown and black. The pots were taken back to the school, washed and some were polished with shoe or floor wax, and then placed on display in the school library.

• • • • • •
Summary

This chapter describes how three-dimensional materials can be used in the classroom to make sculptures and functional clay objects. The two basic ways of creating sculpture are through adding or cutting away the material; and these two methods are used in modelling, carving, constructing, and creating reliefs. A number of different kinds of sculptures can be introduced in the elementary classroom, including mobiles, stabiles, kinetic sculptures, and assemblages. Students can use paper, papier-mâché, papier-mâché pulp, plaster, wire, fabric, clay, wood, and found objects for making sculptures.

Ceramics is the art and technology of forming, firing, and glazing clay objects. The four simple techniques for hand-building with clay are discussed: pinching, coiling, slabbing, and using molds. These methods can be combined to create both functional and nonfunctional pieces. After clay has been formed, it is allowed to dry to a leather-hard stage, and then it is further dried before it is bisque fired. Bisqueware can be glazed and refired.

Instead of buying commercially prepared clay, some clays found in certain areas can be dug and used for making pots or sculptures.

REFLECTION

❶ Research Canadian sculptors to get ideas for different approaches you can use with students in the classroom. Look for films on artists that you could show to your students.

❷ Brainstorm for ideas on how the study of sculpture can be integrated with physical education, social studies, language arts, science, music, drama, and movement. Create a mind-map. Develop your ideas into a unit of study.

❸ Design a unit of study that incorporates the use of clay and the study of at least one aspect of a culture.

CLASSROOM PROJECTS

❶ Study the raku method of creating, glazing, and firing a tea bowl. Invite a knowledgeable member of the Japanese community to discuss and share the tea ceremony with you and your students.

❷ Create a graduating class mural, giving each member of the class a piece of clay made into a slab to create and decorate.

❸ Research art films or videos that would be informative and inspiring, and show them to your students.

❹ Choose an animal that you would like to personalize and create a mask or puppet to use with your class while discussing various topics.

❺ Investigate local potters and tour their studios or ask them to visit your class.

❻ Have your students investigate kites, balloons, windsocks and other "fliers" — their construction and their place in history or the culture. Design and construct kites individually or in groups.

BIBLIOGRAPHY

Alberta Potters Association (1988). *Alberta Clay Comes of Age. Studio Ceramics in Alberta III, 1964–1984.* Alberta Art Foundation, Edmonton.

Ball, C. and J. Lovoos. (1965). *Making Pottery without a Wheel.* New York: Van Nostrand Reinhold Company.

Beecroft, G. (1979). *Casting Techniques for Sculpture.* New York: Charles Scribner's Sons.

Berensohn, P. (1972). *Finding One's Way with Clay. Pinched Pottery and the Colour of Clay.* New York: Simon and Schuster.

Blackman, A. (1978). *Rolled Pottery Figures.* New York: Pitman, Watson-Guptill.

Block, J. and J. Leisure. (1987) *Understanding Three Dimensions.* Englewood Cliffs, NJ: Prentice-Hall.

Bunzel, R. (1972). *The Pueblo Potter. A Study of Creative Imagination in Primitive Art.* New York: Dover Publications, Inc.

Charleston, R. (ed.) (1975). *World Ceramics.* London: Hamlyn.

Chroman, E. (1974). *The Potter's Primer.* New York: Hawthorn Books, Inc.

Clark, G. and M. Hughto. (1979). *A Century of Ceramics in the United States, 1878–1978.* New York: E.P. Dutton.

Cohen, E.P. and R.S. Gainer. (1976). *Art: Another Language for Learning.* New York: Schocken Books.

Cooper, E. (1981). *A History of World Pottery.* Second Edition. New York: Larousse & Co. Inc.

Forbis, R. (1977). *Cluny: An Ancient Fortified Village in Alberta.* Occasional Papers, No. 4. Calgary: Department of Archaeology, University of Calgary.

Hill, B. (1975). *Guide to Indian Rock Carvings of the Pacific Northwest Coast.* Saanichton, BC: Hancock House Publishers.

Janson, H. (1991). *History of Art.* Fourth Edition. New York: Harry N. Abrams Inc.

Kenny, J. (1974). *The Complete Book of Pottery Making.* First Edition. Pennsylvania: Chilton Book Company.

Linderman, E. and M. Linderman. (1977). *Crafts for the Classroom.* New York: Macmillan Publishing Co.

Meilach, D. (1974). *Soft Sculpture and Other Soft Art Forms, with Stuffed Fabrics, Fibers, and Plastics.* New York: Crown Publishers, Inc.

Molesworth, H. (1965). *European Sculpture from Romanesque to Neoclassic.* New York: Frederick A. Praeger.

Newcomb, Jr., W. (1974). *North American Indians: An Anthropological Perspective.* Santa Monica, CA: Goodyear Publishing Company, Inc.

Nigrosh, L. (1975). *Claywork, Form and Idea in Ceramic Design.* Worcester, MA: Davis Publications, Inc.

Piepenburg, R. (1972). *Raku Pottery.* New York: Collier Books.

Primmer, L. (1974). *Making Pottery, With and Without the Wheel.* Toronto: Coles Publishing
 Company Limited.
Richards, M. (1962). *Centering, In Pottery, Poetry, and the Person.* Connecticut: Wesleyan
 University Press.
Rhodes, D. (1976). *Pottery Form.* Pennsylvania: Chilton Book Company.
Rhodes, D. (1974). *Clay and Glazes for the Potter.* Pennsylvania: Chilton Book Company.
Storr-Britz, H. (1977). *Ornaments and Surfaces on Ceramics.* Germany: Kunst & Handwerk.
Teitelbaum, M. and P. White. (1987). *Joe Fafard — Cows and Other Luminaries 1977–1987.* Regina:
 Mendel Art Gallery, Saskatoon and Dunlop Art Gallery.
Torbrugge, W. (1968). *Prehistoric European Art.* New York: Harry N. Abrams, Inc.
Wirt, S. (1984). *American Indian Pottery.* Surrey, BC: Hancock House Publishers Ltd.
Zelanski, P. and M. Fisher. (1987). *Shaping Space. The Dynamics of Three-Dimensional Design.*
 New York: Holt, Rinehart and Winston.

FILMS

National Film Board of Canada. *Crafts of My Province* (1964), about New Brunswick artisans; *I Don't
 Have to Work that Big* (1973), about Joe Fafard; and *Earthware* (1975), about craftspeople from
 around the world who work with clay.

CHAPTER 10

Illustration, Photography, Video, and Computers

● ● ● ● ● ●
Introduction

Children who have had access to computers from the time they were a few years old are completely at home with the technology. In fact, many parents have learned from their children how to run the home computer. The uses of technology have also been integrated into the arts at many levels. For example, video is an accepted art form, as is photography; some artists also use colour copying in making art.

This chapter offers a brief survey of some of the technology used in making art. There are many resources available that can give you more information on the various media introduced here. The range of methods and approaches discussed — applied design, commercial art, illustration, and the media of video, computers, and other technologies — are all components in an art program. These applied art forms have an influence on your teaching as you integrate art into the school curricula, and they will have an impact on the way students view, create, and appreciate visual art.

● ● ● ● ● ●
Illustration

Illustration in all its forms — advertising, poster making, bookmaking, photography, slide making and overheads, video, and computer — are communication media that can be integrated with all subjects.

ADVERTISING

You can often hear adults and children singing or humming radio and TV commercials, and just as frequently, images from advertising haunt us. It's not news that North Americans are constantly bombarded by advertising, in billboards, bus stops, newspapers, magazines, television, company logos, food packaging, shopping bags and clothing. T-shirts and bluejeans also advertise company brand names and announce the wearer's status, wealth, and interests.

Frequently the natural beauty of the landscape has been destroyed by hotel and food-services billboards, and gasoline station and car repair signs — especially along roads leading to urban centres. Like it or not, ours is a consumer society, and the advertising that goes with it has become so integrated into our lives that we often cannot see it for what it is. As a teacher, you have a responsibility to your students to help them understand how advertising works so that they do not become "slaves" to consumer products. As part of understanding advertising, they

178

can learn to see the aesthetic components of design so that they can recognize good design and gain a sense of responsibility of the designer.

Poster Making

Posters are designed to catch the attention of people in an instant. The objective is immediate visual impact through the use of colour, line, and shape. Any writing must be simple, brief, and direct and the typeface should be large and clear, especially for the main statement.

Students need to learn the elements and principles of design to

EXHIBIT 10.1 Poster

create effective visual statements. With an understanding of design, students can design not only effective posters but also displays, cards, portfolios, music covers, book covers or research paper covers, and a variety of types of packaging. The following elements are part of making successful advertising images.

- **Theme**

To begin with, the students should consider the subject, theme, message, and emotion they wish to express. They should then create rough sketches or ideas, images, and colours.

- **Lettering**

The lettering should be consistent; no more than three sizes and types of lettering should be used. The type and style of the lettering should help convey the message.

- **Colour**

Consult the colour wheel and colour schemes to decide on the colours to be used and their visual impact. Students may choose cool or warm colours or complementary colours for high contrast. The number of colours should be limited to three or four.

- **Repetition**

Repeat colours and shapes throughout the poster design to create harmony and rhythm and movement.

- **Centre of Interest**

A poster needs a centre of interest in which the eye is initially captured through elements of design. Placing the centre of interest in the centre of the poster is often effective, but other areas can also be considered.

FIGURE 10.1 CALLIGRAPHY

Calligraphy is the art of writing. The 45° angle of the edge of the pen nib is important to good lettering techniques.

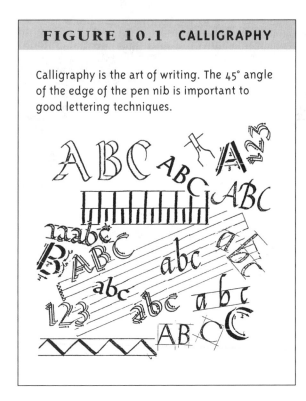

- *Overlapping*

Overlapping shapes helps to create unity as does the repetition of shapes and colours.

- *Movement*

Line and line direction and shape are also integral for movement and emotion.

- *Presentation*

A poster must be neat, clean, and well-presented.

Lettering

Many styles and types of lettering are available in a variety of media. A ruler is an essential tool, and commercial stencils are widely available. Letters can also be cut from paper. With practice and care, students can learn to do hand lettering, which is appropriate for certain types of posters.

Calligraphy

Calligraphy, or the art of beautiful writing, can be done with a flat felt-tip pen or a flat C-style speed-ball nib with India ink. Many books are available that illustrate a variety of styles of calligraphy. A good rule to follow in calligraphy is to hold the pen nib at a forty-five degree angle. As a way of practising, create zigzag lines that are thick and then thin.

BOOKMAKING

Bookmaking is a wonderful individual or group project for compiling and illustrating student work, or the work of other writers and poets. The books can be written and illustrated for specific purposes and audiences. They can become part of the school or classroom permanent collection for others to enjoy, or students can take them home. A bookmaking project can simply be a picture book, containing two-dimensional artworks of a student or group. Many different types of books can be written and illustrated, depending on the age group — narrations, folklore, myths, epics, poetry, and prose.

Narrations recount an event or series of events and have a strong plot, with problem situations or conflict. A realistic narration is about real-life experiences, biographical accounts, or stories about people in different lands and backgrounds; it can also include decision making and emotional experiences.

The term folklore encompasses a vast and largely anonymous heritage of myth, legend, ballad, folk and fairy tale, epic and fable. These types of folklore have

been preserved throughout the ages by word of mouth (Gillespie and Conner, 1975, p. 11).

According to Gillespie and Conner (1975), myth evolved from attempts to explain natural phenomena, such as the movement of the sun and stars, thunder and lightning. An epic is a heroic narrative and fables are brief narratives designed to teach a lesson or a moral (p. 12).

Poetry is an aesthetic verbal expression about life, and often includes particular rhythms and patterning of language in rhymed verse, ballads, ritualistic chants, and lyric (poetry that sings). Unrhymed verse is often called free verse.

Be it prose, poetry, or drama, the words should appeal to the senses and should arouse images that are seen, heard, felt, tasted, and smelled. Students can write and illustrate their

FIGURE 10.2 SIMPLE BOOKBINDING

THE "STITCHED-DOWN FOLD"

Materials needed are two sheets of heavy cardboard 1.5 cm larger than the folded paper (which will become the pages), and one sheet as wide as the book is thick. Also needed is fabric, tie-dyed cloth, or other material for the cover, cloth strips (or gauze), rubber cement, needle and thread, and two sheets of coloured construction paper as large as the book cover.

Procedure:

1. Mark the inside edge of the folded paper with six points. Puncture these points with a fine needle, making sure the pages of the booklet are lined up perfectly.
2. Sew pages together using thread and needle (double thickness).
3. Lay cloth for the cover down onto the three pieces of heavy cardboard (front, side, and back of the book), and glue it down with rubber cement. Fold cloth inwards, glue again, and use weight to hold in place until dry.
4. Weave four strips of 2.5 cm wide cloth or gauze through the binding of the booklet, glue the booklet into the cover (that is, glue gauze/cloth onto cover).
5. Glue a clean sheet of coloured construction paper (or heavier paper) on the inside of the front and back of the cover. This will cover the strips of gauze and edges of the folded pieces of cloth and give the book cover a more finished appearance.

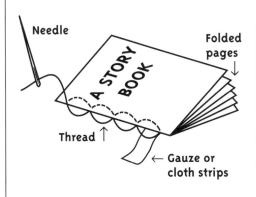

stories through visual images using various art materials — paint, collage, pen and ink, and printmaking. It is up to you to assist in stimulating their ideas and imagination, not only to write but also to produce the visual images that enhance the words.

Constructing Books

The shape of the book can take many formats, from the regular square or rectangular shapes to less frequently used shapes — such as circles and diamonds, or fruit shapes like apples, or people and animal shapes that reflect the content of the book.

For binding, books can be glued, stitched, or stapled together.

PHOTOGRAPHY

"Photography is both an art and a science. As an art, it expresses a personal vision. As a science, it relies on technology" (O'Brien and Sibley, 1988, p. 7). The camera aids the artist in capturing visual statements. The camera and other photographic image-making tools require experience and understanding of their potential. In every photograph or photographic image, the elements and principles of design should be reinforced. Photography involves the personal interpretation of the world, a singling out of subject; the medium is the film and the tool is the camera.

Aristotle recorded the optical principles of the camera obscura and Leonardo da Vinci described the camera in his notebooks in the early fourteenth century. However, before the advent of computers, photography as a technological tool, made one of the greatest impacts on art making.

> Photography opens up all sorts of communication about ways of seeing and about things of importance to children at home, at school and in the community. The preserved image gives concrete reality to a child's perceptions; it is something he can hold in his hand and show others, and as such is a great motivator for discussion, writing and other creative activities (Taylor, 1977, p. 14).

Taylor suggests teachers let their students go out and take pictures instead of beginning with technical do's and don'ts. After the pictures have been developed, you can discuss point of view, focus, cropping and framing, light source, subject matter, centre of interest, and other compositional factors. Later on, give the students a framework or guidelines within which to take pictures.

MAKING SLIDES AND OVERHEADS

Slides

Slides and overheads can be developed on transparent material to create images; patterns; the design elements of colour, line, and texture; and the principles of composition.

Slide making requires slide holders, or mounts, purchased or constructed; old slides also can be used as slide mounts. Old slides can be used to create images by scraping onto the surface and adding ink or acrylic paint. Clear or coloured acetate can be cut to fit the slide mounts. Colour can be painted on or glued on using coloured tissue paper or acetate. Food colouring or wax crayon, pastels, or other coloured objects can be sandwiched between two pieces of acetate.

EXHIBIT 10.2 Photography

Shapes and textures from cut or found objects such as paper, leaves, lace, feathers, insects, seeds, and moss can also be sandwiched between the pieces of acetate.

Overheads

Sheets of acetate can be used to create impressive overheads using the same methods as described for slides.

When viewing the slides and overheads with your students, encourage discussion about the principles and elements of design.

THE PINHOLE CAMERA

On April 15, 1839 the *Quebec Gazette* published a report on "The New Art of Sun Painting." Sun painting was new, but the camera that led to its discovery was not. The camera obscura was originally a dark room with a tiny hole in one wall through which the view outside was projected onto the opposite wall. This type of camera obscura, improved by the use of a lens and mirror so that the view was projected onto a table, was a successful attraction at Niagara Falls in the nineteenth century. At the time of Daguerre's and Fox Talbot's discoveries, the camera obscura in the form of a portable box was a popular aid to drawing. The box had a lens at one end and a mirror at the other that reflected the image onto a ground glass on top, where a tracing could be made on thin paper (Greenhill, 1965, p. 17).

EXHIBIT 10.3 Images from a pinhole camera

The first daguerreotypes of photographic-type images were still lifes or street scenes. Since it required between eighteen and thirty minutes for exposure, people often appeared only as a blur unless they remained still for the duration. You and your students can easily construct the contemporary type of daguerreotype camera, commonly called a pinhole camera.

Pinhole Camera Construction

Some cameras are very complicated. However, a pinhole camera can be made from a tin can or light-tight box with a lid, and film or light-sensitive photo paper. The camera box needs a small hole or aperture to let in light to strike the film or photo paper, and a shutter over the hole to control the amount of light entering the box.

Here is how you can construct a pinhole camera. Cover the inside of a box with flat, black paint to eliminate reflection of incoming light. Seal all joints with black tape. You must make a tiny, round hole to admit light by slowly drilling with a small needle into a piece of heavy-duty aluminum foil. Tape this foil with the pinhole to the opposite end of the box from where the film or paper will be placed. The box should have a lid so you can insert and remove the photo-sensitive paper or film.

A strip of black light-proof tape can be used as the shutter to open and close the pinhole or aperture. In a dark area or room, attach the photo paper with the shiny side facing the aperture. Place the box in position, open the aperture and expose for approximately one minute. If the negative print is too dark, shorten the time or make a smaller aperture.

Light-sensitive photo paper can be purchased at a photo-supply store, along with the chemicals to develop the pictures. If film cartridges are used instead of photo paper, a photo shop can develop the film. Mount the film cartridge to the back of the box and tape the cartridge to the box. Use a stick to wind the film forward, open the aperture, close, and wind the film forward again.

Photograms

A photogram is made by placing opaque or semi-opaque objects on light-sensitive paper and exposing it to bright light — in a darkroom with an enlarger for several seconds or in sunlight for several minutes. Photograms are also called "cameraless photography." Those parts of the paper

that have been covered remain un-changed, and the result is a light silhouette of white or grey on a dark or black exposed background.

Making photograms is a good way to introduce children to the photographic process and offers an exciting method of experimenting with shapes, tones, and textures. Students can experiment with arrangements of objects that produce opaque, transparent, or translucent shapes; they can puncture holes in card or foil, or use netting, plastic bags, or natural objects. Another technique is to expose hand-made images drawn

EXHIBIT 10.4 Photogram

on transparent film with india ink, or scratch into old X-ray film or slides and expose them. As you can see, students can experiment with all kinds of ideas and try a variety of materials to make photograms.

Developing

Developing is required for each of these photographic methods. The process of developing the photo paper varies, depending on the photo chemicals used. Mixing instructions are available from suppliers. In a darkroom with only a safelight to work from, four baths are generally used: a developer, a stop bath, a fixer, and a water wash.

A mini-darkroom can be made with a large cardboard box lined with dark green garbage bags. Cut two holes into the side of the box large enough to allow hands to go through. Insert into the holes two heavy-duty, light-proof garbage bags rolled into a tube shape. Rubber bands can be used to tighten the bags around the arms.

SUN IMAGES

Other forms of photograms or sun images can be made using materials other than photographic light-sensitive papers.

• *Coloured Construction Paper*

Simple but less expensive than using photo paper for photograms are sun images created with art-room coloured construction paper. Place objects or shapes onto the paper and expose it to sunlight for an extended period of time.

• *Photocopier*

Shapes, lines, textures, and a variety of images can be explored using a photocopier. Guidelines and expectations should be established before students play with the copier. Black, white, and grey paper shapes can be cut and manipulated to create various patterns. Found objects, such as leaves and flowers, fabrics and laces, can be collected and arranged.

• *Blueprint Paper*

Blueprint, or diazo, paper can also be used to produce photograms. Four steps make up this process.

1. Arrange objects and shapes onto the blueprint paper and expose it to light. The longer the exposure the darker the image will be.
2. Place the exposed paper into a large jar with a J-cloth soaked in ammonia. The fumes will develop the image.
3. Take the paper out and put it into an empty jar for two to five minutes.
4. Rinse the paper in a solution made of one-fourth cup of hydrogen peroxide mixed with one litre of water. Take the paper out and let it dry on newsprint or paper towels.

• • • • • •
Animation and Video

ANIMATION

Animation is any film that is shot frame by frame. In other words, it is filming static images, not live action. This technique is sometimes called art in moment. Three animation techniques are: drawing, cutouts, and models (and combinations). Drawing animation means that a new image is created for every movement. Cutouts can be any flat piece of material that may be moved around. Model animation is the term for photographing a three-dimensional object, moving it, and photographing it again, and continuing until the resulting image moves as desired. Almost any material can be used, including drawings, clay or Plasticine, wire figures, or puppets (Hayward, 1977). In fact, any object can also be used, and given personal or animated human features or qualities.

Norman McLaren was a pioneer in film animation in Canada. He began making films when he washed off old film and painted on it when he was a student at the Glasgow School of Art. In 1941, he joined the National Film Board of Canada. He has been described as "an artist, animator film-maker, scientist, inventor and technical genius — a man who is obsessed with the idea of manipulating motion" and credited as "the one who rediscovered the lost animation techniques which had been introduced by early film pioneers" (Valliere, 1990, p. 13). His films have won top honours in virtually every film festival in the world. In 1972, McLaren became a member of the Order of Canada. Many of his animated films are available through the National Film Board of Canada. His films include: *Blinkety Blank* (1954), *Chairy Tales* (1957), *Lines Vertical* (1960), *Lines Horizontal* (1962), and *Ballet Adagio* (1972). Looking at McLaren's work can provide inspiration for students to create their own animated films.

Whether it is a drawing or a lump of clay or a puppet or a collage, the animator places life and meaning into the material by making it move (Laybourne, 1979, p. 7).

FLIP BOOKS

Flip books are a simple form of cell animation. Each page of the book repeats the same image that has been slightly altered from the one on the previous page. The flip book can be filmed or

can simply be used as a flip book by fanning the pages quickly so that the image appears to move as you flip the pages.

THAUMATROPE

A thaumatrope is a construction that is twirled causing the images on the opposite sides to appear to blend together. A thaumatrope can be made from cardboard discs and string. "The image drawn on the two sides of the disc are different but complementary, and when the disc is spun, the eye perceives both sides as one image" (Taylor, 1977, p. 91). For example, if you draw a bird on one side of a disc and a cage on the other, when you spin the disc the visual effect is of a bird in a cage.

COMPUTER ANIMATION

Computer animation is the art of producing drawings to be made into films by using computer technology — integrating artwork and scanned photographs, or actually drawing the image using a plotter or mouse. Computer programs continue to be developed to make creating animation in the classroom easier.

STORYBOARDS

The storyboard is helpful for animators and live-action filmmakers to plan and organize a story. Usually storyboards consist of a series of frames, similar to a comic book, with descriptions of actions and sounds.

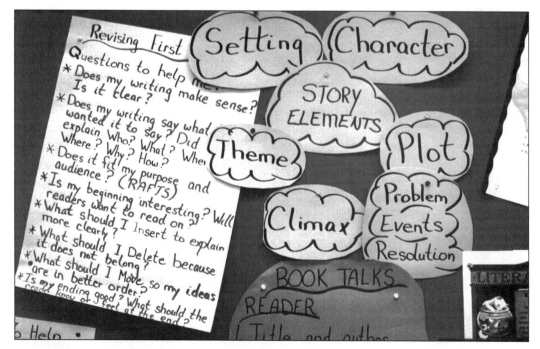

EXHIBIT 10.5 Storyboard

VIDEO CAMERAS

There are many types of video cameras on the market with varying prices and a range of complexity. Take care not to purchase a camera with too many special features that may be difficult to operate and may break down with inexperienced video camera users. A camera stand and good lighting are essential for quality video, especially when you are doing animation.

••••••
Making Films

Producing films in the classroom — animation or live action — is an exciting, cooperative group project. Students can take on various roles and responsibilities, depending on their individual strengths and interests. They can take on more than one job, or several students can work together at one task or responsibility.

The scriptwriter is responsible for creating the script for a film, and the ideas and the approach the filming will take. Writing a script can form the basis of a lesson.

The film producer assigns people to the various jobs, sets deadlines and budgets, and works with the scriptwriter. However, the final film product is the responsibility of the director — the consistency of the story, design, soundtrack, and style of animation or live action.

Designers and animators work with the writer to get the correct feeling of the character and environment. Background artists create the environment with visual effects, details, and textures. A typographer creates the lettering for film credits, titles, logos in advertising, and other abstract designs.

Depending on the type of film, a cartoonist might draw storyboards and characters. Draughtspeople often work out complex animation movements and perspective viewpoints when three-dimensional animation is involved (Hayward, 1977).

The cameraperson, who is the one most skilled in operating the camera, understands how to position the camera and achieve correct lighting for the various scenes.

In some films, an interviewer is needed. This person should be familiar with the topic and the individual being interviewed.

Actors are required for live-action films. However, in animation films, sometimes only voice actors are needed.

The sound-person develops the soundtrack and usually works with musicians and actors. Soundtracks are based on several sources: sound effects, either real or simulated, associated with visuals; and music, synthesized, instrumental, or recorded, to create mood or rhythm consistent with action and voice.

An editor is responsible for cuts and for shifting the filmed images and soundtrack. Two VCRs can be used for crude editing; however, a well-planned script that has been carefully filmed should need very little editing. Sound, voice, and titles can sometimes be added to the video with some cameras.

If you work with students in the classroom to produce films, the different roles and functions can be adapted to suit your circumstances and the skills and interests of your students.

••••• Technology and Art

Artists have always been closely allied with technological development (Hubbard, 1989), beginning with the discovery of fire and its use with clay, metallurgy, and jewellery. In our century, plastics for painting were developed, photography and videotape were expanded, and now we have the technology of the computer, laserdisc, and satellites. There are many great

EXHIBIT 10.6 Computer art

possibilities with the new technologies; you may wish to consider some of these in the study of art and art making, and in the integration with other subjects.

COMPUTERS AND ART

The computer can be used to assist the artist in creating images. "Artists absorb and assimilate the unique character of computer systems and the capabilities, intuitively using them as a vehicle for visual expression, and for visual communication of information" (Truckenbrod, 1988, p. 1).

The computer is merely a new tool compelled to obey the will of artists, with tremendous flexibility for producing form and colour. Some people claim that art made with a machine cannot be true art. But a computer cannot create without input from the artist — it cannot work by itself (Prueitt, 1984, p. 2).

The artist may have access to various input devices to create the initial image, but the most common method is drawing by hand or with a controlled device such as the mouse. Other hand-controlled devices include a tablet and stylus, light, pen, pressure-sensitive tablets, touch-sensitive devices, and 3-D digitizer. The most common visual imagery can be created from other sources including the video digitizer, video camera, videotape, television, laserdisc, camcorder, optical scanner, and digitizing plotter (Truckenbrod, 1988).

> Computers can store, retrieve, accept, and automatically capture images; and because an image stored in computer memory is not a static record but an integral part of an active, ongoing image-processing system, computers represent a combination of artistic tool and visual medium that is completely unprecedented (Spencer and Spencer, 1989, p. 16).

The typical computer image is not smooth and continuous but contains small individual picture elements, called pixels, arranged in rows and columns like tiles of a mosaic, giving the images a rough and granular appearance.

BOX 10.1 ON-LINE EMOTIONS

"Techies" have developed ways to express emotion on the Internet through the use of symbols. These were taken from the *Calgary Herald* (January 21, 1996, p. B1). Can you develop others?

:-)	Your basic happy face.
:-(Your basic sad face.
:-o	You are amazed or surprised.
:-{	You have a moustache.
:-p	You are sticking your tongue out.
:-#	You wear braces.
:-X	Your lips are sealed.
C=:-)	You are a chef.
{(:-)	You wear a toupee.
+":-)	This might be a pope!
*":-)#	Would you believe Santa Claus?
*:)o)	You are a clown.

THE COMPUTER AND SYMBOLIC SPACE

Computer graphics can produce a visual interpretation of three dimensions, computer sculpture, and sculpture simulation. Programs that incorporate Computer Assisted Design enable architects and draftspersons to create symbolic space.

Computer-generated images display qualities of colour and texture that are uniquely different from print. (Hubbard and Greh, 1991). Drawing and painting programs are available for nearly every microcomputer on the market and the names indicate their functions of drawing, painting or illustrating. All combine some form of on-screen drawing area with an input device that is used to do the actual drawing (Spencer and Spencer, 1989, p. 18).

Images can be altered, coloured, copied, undulated, overlapped, moved, stretched, mirrored, multiplied, compressed, distorted, decorated, shaded, separated, contoured, contrasted, and transformed. However, Hubbard and Boling (1983) believed that students should be prepared with ideas about what they want to draw before using the computer. After students have learned the fundamentals of operating the computer, manipulating and creating graphics, they need to be given clear directions and guidance.

ART LASERDISCS

Electronic technology in the form of the laserdisc or videodisc has resolved some of the problems associated with the storage and use of slides, prints, motion pictures, and reproductions in books (Hubbard, 1989). The laser videodisc represents the state of the art in visual and audio storage and retrieval. The thin metallic disc, which contains millions of tiny pits encoded digitally with information, is protected with a plastic coating (Schwartz, 1991). Laserdiscs are reasonably priced and are durable.

Laserdisc technology offers the visual arts a wealth of images that can impact upon art learning in studio experiences, art history, aesthetics, and art criticism.

Numerous museums have reproduced, or are in the process of reproducing, their art collections on laserdiscs (Marschalek, 1991).

One disc can hold around 110 000 individual images. With the use of small database programs, art teachers can develop collections of art and prepare art lessons that can be used with large groups of students or individual students, and can be easily accessed. Students themselves can access the programmed lesson (Hubbard, 1989).

THE COMPUTER AS A TEACHING TOOL

You can use a computer to create learning packages. Students can view the visual images and solve problems you have prepared as part of their computer-assisted learning.

A computer can be used to research and retrieve information on artists, artworks and historical events through access to CD ROMs, video- and laserdiscs.

> The computer can be used to generate images. The computer will be of humanitarian value only insofar as their use is informed and guided by the discipline or art — that is, by the will to transformation. Art is a process of exploration and inquiry. It asks: How can we be different? (Loveless, 1989, p. 8).

• • • • • •
Summary

This chapter presented a brief introduction to illustration, photography, video, and computers and how they might be used in your art education program, or integrated with other subjects. We also discussed illustration and design in advertising — students can learn to understand the impact of advertising, and also learn to differentiate between good and bad design in ads.

This chapter also discussed designing posters. Students can produce better quality posters if they understand the elements in poster design: lettering, colour, repetition, centre of interest, overlap, movement, presentation.

The other applied arts included in this chapter are bookmaking, photography, animation, and making films, slides, and overheads.

The impact of technology affects nearly every area of the arts. Computers, particularly, have had an impact. Software packages, as well as laserdiscs, are available to be used in various ways for drawing and painting and for viewing artworks. Teachers can create learning packages that integrate art with other subject areas for students' computer-assisted learning.

REFLECTION

❶ If you live in a city, go for a walk with the purpose of looking at outdoor advertising, or look at a lot of ads on television. In a notebook jot down why each ad does or does not make an impact. Try to understand the thought behind the ad; analyze the design, and decide whether or not the design is integrated with the message.

❷ Explore what might be some of the advantages of, or drawbacks to, the use of computers in the art room.

❸ Investigate various computer software packages that you might use in the art room, or to integrate with a unit of study, as a tool for creating art or for researching artists.

❹ Research or search out computer or graphic artists near you. Are there galleries that exhibit computer-generated images?

❺ Discover how you can access laser videodisc technology that you can use to enhance the study of art and artists.

❻ Develop a lesson or unit of study based on a laserdisc program with specific artists or cultures.

❼ "Virtual reality" has become a "techno-buzz-word." What impact does this have on art education? How can teachers use the idea of virtual reality?

❽ Investigate the use of the Internet and art research with your students.

CLASSROOM PROJECTS

❶ Have your students take pictures of each other and develop them. They can use these pictures to produce a grid drawing or painting of themselves.

❷ Let the students make pinhole cameras and experiment with the images they can create.

❸ Have your students look at ten ads and analyze the assumptions behind the ads. For example, do the ads assume that certain things appeal to women and don't appeal to men, and vice versa. Students should write up their findings and give an oral report to the class.

❹ After the students have completed their project on ten ads, have them choose a product and design an ad and make a poster.

BIBLIOGRAPHY

ACM *Siggraph*, (1989). *Computer Art in Context, Siggraph '89 Art Show Catalog*, Leonardo, Supplemental Issue, Journal of the International Society for the Arts, Sciences and Technology. Headington Hill Hall, Oxford: Pergamon Press.

Andersen, Y. (1991). *Make Your Own Animated Movies and Videotapes*. Boston: Little, Brown and Company.

Berger, R. and L. Eby. (1986). *Art and Technology*. An Icus Book. New York: Paragon House Publishers.

Clements, R. (1985). Adolescents' computer art. *Art Education*. March, pp. 6–9.

Davis, P. (1975). *Photography*. Second Edition. Dubuque, IA: Wm. C. Brown Company.

Dowswell, P. (1988). *Design, An Introduction to Graphic Design*. Calgary: The Calgary Board of Education, Media Services.

Fellows, M. (1977). *The Amateur Film Maker*. Toronto: Coles Publishing Company Limited.

Freedman, K. (1991). Possibilities of interactive computer graphics for art instruction: A summary of research. *Art Education*, May, pp. 40–47.

Gillespie, M. and J. Conner. (1975). *Creative Growth Through Literature for Children and Adolescents.* Columbus, OH: Charles E. Merrill Publishing Co.

Goodman, C. (1987). *Digital Visions, Computers and Art.* New York: Harry N. Abrams, Inc., Publishers.

Greenhill, R. (1965). *Early Photography in Canada.* Toronto: Oxford University Press.

Hayward, S. (1977). *Scriptwriting for Animation.* London: Focal Press.

Holter, P. (1980). *Photography Without a Camera.* New York: Van Nostrand Reinhold Company.

Howell-Koehler, N. (1980). *Photo Art Processes.* Worcester, MA: Davis Publications, Inc.

Hubbard, G. (1989). Art and technology: potential for the future. *NASSP Bulletin,* October, pp. 30–34.

Hubbard, G. and E. Boling. (1983). Computer graphics and art education. *School Arts,* November, pp. 18–21.

Hubbard, G. and D. Greh. (1991). Integrating computing into art education: A progress report. *Art Education,* May, pp. 18–24.

Kennedy, K. (1972). *Film in Teaching.* London: B. T. Batsford Limited.

Laybourne, K. (1979). *The Animation Book. A Complete Guide to Animated Filmmaking — From Flip Books to Sound Cartoons.* New York: Crown Publishers, Inc.

Loveless, R. (1989). *The Computer Revolution and the Arts.* Tampa: University of South Florida Press.

Marmoy, P. (1976). *Simple Photography, With and Without a Camera.* London: Studio Vista.

Marschalek, D. (1991). The national gallery of art laserdisk and accompanying database: A means to enhance art instruction. *Art Education,* May, pp. 48–53.

McLaren, Norman. (1975). *The Drawings of Norman McLaren.* Montreal: Tundra Books.

National Film Board of Canada. (1993). *Art of the Animator, Part I and Part II.* (Film, 24 min.) Canada.

O'Brien, M. and N. Sibley. (1988). *The Photographic Eye, Learning to See with a Camera.* Worcester, MA: Davis Publications, Inc.

Patterson, F. (1979). *Photography and the Art of Seeing.* Toronto: Van Nostrand Reinhold Ltd.

Prueitt, M. (1984). *Art and the Computer.* New York: McGraw-Hill.

Valliere, T. Richard. (1990). *Norman McLaren, Manipulator of Movement: The National Film Board Years, 1947–1967.* Newark: University of Delaware Press; London and Toronto: Associated University Press.

Sarnoff, B. (1988). *Cartoons and Comics, Ideas and Techniques.* Worcester, MA: Davis Publications, Inc.

Schwartz, B. (1991). The power and potential of laser videodisc technology for art education in the 90's. *Art Education,* May, pp. 8–17.

Spencer, D. and S. Spencer. (1989). *Drawing with a Microcomputer.* Ormond Beach, FL: Camelot Publishing Company.

Taylor, A. (1977). *Hands On. A Media Resource Book for Teachers.* An Education Support Project, Media/Research Division. Montreal: National Film Board of Canada.

Truckenbrod, J. (1988). *Creative Computer Imaging.* Englewood Cliffs, NJ: Prentice-Hall.

PART • THREE

Integrating Art into the School Curricula

• • • • • • • • • • • •

Integrating Art with Language Arts and Social Studies

•••••• Introduction

Imagine a scene in a traditional classroom where students sat in rows at their desks reciting facts from stories and memorizing what crops were grown in which country, and how people dressed there. Contrast this schoolroom with students developing and writing stories based on their research into another culture, and then painting a mural to illustrate what they learned. Which way of learning engages students more fully?

In this chapter we explore the integration of art with language arts and social studies for the purpose of developing a learning environment for these subject areas. We introduce curriculum themes and topics that can be used in investigation, research, problem solving, and articulating discoveries visually and through language.

You will find many ideas that you can use in your teaching as you plan lessons that integrate art with language and social studies.

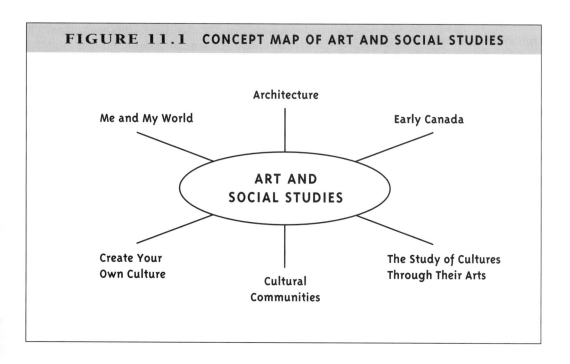

FIGURE 11.1 CONCEPT MAP OF ART AND SOCIAL STUDIES

Architecture

Me and My World

Early Canada

ART AND SOCIAL STUDIES

Create Your Own Culture

Cultural Communities

The Study of Cultures Through Their Arts

BOX 11.1

Writing is an effective tool for learning in all subjects including the study of visual arts, to check learning, to answer questions and to prepare for discussion (Lewis and Lindaman, 1989, p. 70).

BOX 11.2

Art is an ideal discipline for interdisciplinary instruction for several reasons. It seems to me that art can connect to almost every topic or subject. The hands-on aspect of art complements the more theoretical instruction in academic classes and produces a product that can be displayed for parents and community. Slide presentations and discussions in art add the dimension of effective higher order thinking to an academic unit . . . Gains to be achieved from an interdisciplinary approach are numerous (Thompson, 1995, p. 45).

••••••
Art and the Language Arts Curriculum

Learning includes a number of processes: recalling, describing, interpreting, and communicating ideas and experiences. These learning processes require some kind of language. Verbal, written, and visual arts languages are methods of communication. Children learn these methods of communication through imitating others and by trying different forms of communication themselves.

Students' learning experiences must offer opportunities to build on what they already know, so that they can increase their ability and confidence to use language to explore, construct, and communicate meaning. Talking, reading, writing, and interpreting their understanding through the use of art, drama, dance, and music are some of the ways students explore communication.

There are many advantages to combining children's visual and verbal experiences. However, according to Grauer (1984), "Art does not always illustrate language any more than language can always explain art. They are two different modes of communication that can, however, be used to complement and expand understanding" (p. 32).

In the language arts program, students learn to read, listen, and write about characters, times, settings, and events. These experiences often result in an emotional response — an identification with the characters or incidents. You can use these experiences to stimulate your students' imagination, calling upon their senses of seeing, smelling, feeling, hearing, and tasting to provide motivation to create, invent, illustrate, express, restate, and demonstrate through words, written and spoken, and through visual arts, drama, dance, or music.

Through the arts, students can illustrate various parts of a story's plot: the beginning of the story, which sets the mood or the initial event; the setting, or conflict; the middle of the story as the situation develops and becomes more complicated; the climax or turning point when the reader can predict the outcome; and the end of the story, or the final outcome. The illustration can be one image or a series of images as in a cartoon strip, storyboard, animation, or video.

FIGURE 11.2 INTEGRATING ART INTO THE SCHOOL CURRICULUM

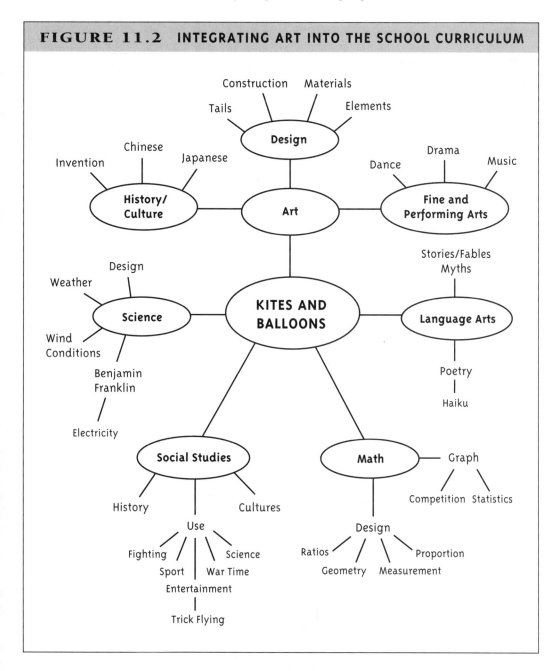

You can plan your lessons around stories, poems, myths, legends, ballads, and fairy tales, or use other writings from real or imagined experiences.

The visual arts can be incorporated into the language program because they can give expression to the stories through drawing, painting, collage, posters, greeting cards, postcards, symbols, printmaking, cartoon creation, calligraphy, storyboards, flip books, bookmaking,

puppetry, masks, slide making, photography, filmmaking, computer graphics, and animation — all the media explored in Chapter 10.

Words can create images that may become a source of inspiration, impression, visual recollection, and mental picturing for visual arts expression and communication. Conversely, visual arts images can be used as starters for the process of writing, revising, and editing.

THEMES AND IDEAS FOR ART AND LANGUAGE ARTS INTEGRATION

A theme is a term for any title, topic, concept, issue, or problem that is used as a unifying focus in curriculum design. "In fact, any discipline can be represented in terms of the core ideas that bring purpose to information" (Clarke and Agne, 1997, p. 85).

You can use the ideas and themes that follow as starting points for your students to create visual images, which can provide motivation for writing and talking, or starters for reading, writing, and talking.

Who Am I?

- *Who am I?*

Trace your students' profiles or body shapes on paper by using an overhead projector or having them lie down on paper and tracing the outline. The students' body images can be completed using art elements of line, colour, shape, and texture. The shapes can be filled with images and words signifying the things the students find most important in their lives — what they like or dislike. This project can also be connected to studies of the student's heritage or ancestry.

- *Me Trophies and Posters*

Students can create two-dimensional or relief posters or three-dimensional or relief trophies of what they like, their accomplishments, and some aspects of who they are.

EXHIBIT 11.1 Outline

Poetry

Poetry grows out of a relationship between body and language, perception and experience (Swede, 1990). According to Powell (1973), three concepts are important when incorporating poetry into the study of language arts: involvement, relevance, and discovery. Involvement means that the students are actively engaged through motivational methods such as role playing, group discussion, or the use of images. Relevance starts with what the students know and what they

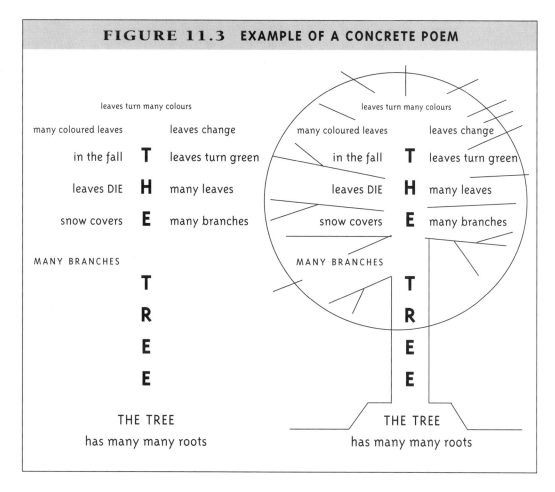

FIGURE 11.3 EXAMPLE OF A CONCRETE POEM

want to know. When students want to find out something new, they will make discoveries.

You can introduce several different forms of poetry that will elicit visual responses.

• *Concrete Poems*

This form of poetry can be a word or words written in a visual form to represent the subject of the poem. The words can expand to include statements and thoughts, but they retain a form that reflects the meaning. For example, the words of a poem might fit into the shape of a tree (Marshall, 1983).

• *Formula Poetry*

This form of poetry uses a set of instructions for each line and can include specific instructions for choosing a title; for example, pick a colour, emotion, feeling, or memory. The first line describes something associated with it — a noun, a sound. The second line uses a simile, metaphor or verb, plus the colour, or verb phrase. The third line describes where — the mood, what it feels like (Hess, 1989, pp. 6–7).

Blue
warm
sky, blue, warm
Friendly day

- ## *Haiku*

Haiku is a form of Japanese poetry that focuses on nature. Inspiration for haiku can also originate in pictures or artworks, and they can be illustrated with watercolour and written with a paint-brush on large paper. The writing begins with a phrase describing the object observed — adjectives, alliteration. Then comes a phrase or series of words describing the action of the object. The third line is something significant about the object (Hess, 1989).

- ## *Contrast Poetry*

This kind of poetry depicts the same object, person, or idea in two different ways, beginning with the most obvious, and moving to the unusual (Hess, 1989, p. 27).

- ## *Colour Poems*

Colour poems focus on the colour of an object, and describe the colour. The third line describes the feeling, and the fourth line is a noun related to the colour (p. 37).

- ## *Poetry Comics and Cartoons*

These can be produced using comic strip balloons or panels. "Poetry comics and cartoons integrate cartoon characters, comic strip format and the words of poems for the characters' dialogue" (Hess, 1989, p. 44).

Cartoon Strips

A cartoon strip is a series of pictures in which something happens, and each picture in the series contains a part of the story. Cartoon images, people, or animals are developed by observing features and exaggerating them. You can plan a lesson around cartoon images of characters in a story. Encourage your students to develop these images into a cartoon strip, flip-book, story-book, picture book, storyboard, or animation.

Emphasize that the success of the characters depends to a large extent on their facial expressions throughout the story as they carry on their activities. These characters can be developed from a story that has been read or written by the students.

BOX 11.3 HAIKU

Apple
Green apple
The green apples turns red
The apple is delicious

Problem Solving

Edward De Bono (1971, 1993) developed ideas for "lateral thinking, creativity step-by-step," to create new ideas and redesign problems. De Bono's redesigning problems were meant to stimulate students to solve problems in nontraditional ways so that they become creative, nonlinear thinkers. For example, why is a shoe designed the

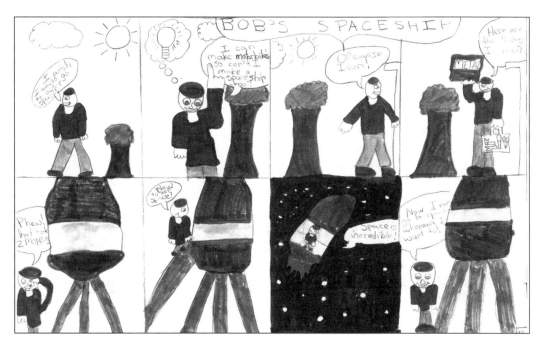

EXHIBIT 11.2 Cartoon strip

way it is? Could it be made differently? Could a shoe be designed with built-in socks? Or, could TV sets be clipped onto glasses?

Have your students look at ordinary objects and redesign them — for example, cars, toothbrushes, T.V. sets, chairs, tents, bicycles, beds, shoes, pencils, computers. Other design problems could include: designing an automatically controlled vacuum cleaner, dishwasher, bed maker, dog walker, animal exerciser, snow shoveller, chocolate maker. This project should include a specific activity and a problem being solved; this should not simply be seen as a picture-making task.

Your students could also brainstorm to create a list of objects that are or could be used as containers, both natural and constructed. They should describe what the containers hold. Another container assignment might be to ask your students to choose a specific object and design a container for it, and then write about this experience.

Animals

Animals are a source of ideas for writing prose and poetry, as well as a source of visual-arts experiences. If it seems appropriate, you might arrange to have students bring a few pets to the classroom, or plan a field trip to the zoo or farm, circus or forest. Find out in advance which students are allergic to animals. Cats, dogs, rabbits, snakes, fish, lizards, frogs, and butterflies in various stages of development can be brought into your classroom to be used as sources for different types of writing and visual art experiences.

Animal study can be integrated into science and social studies as well as art. After students have studied real animals, suggest that they combine details of various animals and create new creatures, or hybrids. They can also develop stories around these combined creatures.

Stories and Myths

Read to your students myths about monsters or dragons that fly, swim, or walk. What do they eat and what do they look like? Develop the image from the stories in various art media, in a sculpture, painting, or print. Have your students create their own myths based on these creatures.

Read and create fables about special "little people" from various countries such as the leprechauns, dwarfs, fairies, and other invented creatures. Suggest to your students familiar storybook characters such as Peter Pan and the Hobbits in *The Lord of the Rings* by Tolkien. Plan a unit of study around a fable or story such as the Hobbits. Ask your students to create Hobbits and Hobbit houses, or other beings and their habitat, with clay, Plasticine, or papier-mâché, in sculptural form. Students can then create a diorama or environment for these forms.

Develop a story into a play. Design costumes and hats. Construct and paint the backdrop and props. Create a dance based on a story or poem.

• • • • • •
Art and the Social Studies Curriculum

> The academic disciplines began as means, and they became ends . . . Despite
> their nearly universal use as organizers of education, the traditional disciplines
> are not the best available tools for teaching about reality (Brady, 1993, p. 439).

Topics included in traditional disciplines can be used as themes in a program that integrates art with social studies. Thematic unit development should be based on students' interests so that they learn about the world as it really is. This approach honours learning styles, and fosters the development of important concepts and skills (Clarke and Agne, 1997). Boyer (1983) recommended eight themes to tie together subject areas based on "human commonalities" that cross all ages and cultural lines. They include:

1. The life cycle — reflections on birth, growth, death, body.
2. Language — symbols and communication.
3. The arts — universal language of self-expression.
4. Time and space — past, present, future.
5. Groups, institutions — the social web that shapes our lives.
6. Work — producing and consuming.
7. The natural world — survival.
8. Search for meaning — commitment to ourselves and each other.

Noddings (1995) wrote that studies of early childhood, adulthood, and old age seem central to education for real life. Such themes as love and friendship are of special interest to young students and, aside from their intellectual value, these themes are relevant to self-understanding and growth. Gender differences in friendship patterns can also be studied. Noddings also felt that teachers should encourage a way of caring for animals, plants, and the environment that is consistent with caring for humans, and encourage a caring approach for the human-made world as well.

According to Beane (1991), themes can be organized around rich and provocative topics rather than abstract and artificial subject areas. These themes include human relationships, cultural formation, global interdependence, environmental problems, school recycling, aspects of pollution, environmental regulations, and business. Life in the future is another big topic: personal and social futures, biotechnological developments, work trends, community improvement, moral issues, and advancing technology.

Studying the concept of independence might include conflicts with authority figures, historical causes of revolutions, media and conformity, and movements for human and civil rights (Beane, 1990).

> . . . a unit on identities in which students examine how self-perceptions are formed, how culture influences their self-concepts, how various cultures express their identities, and how increasing cultural diversity promises to reshape politics and the economy. Imagine a unit on Living in the Future, in which students construct models of desirable communities, analyze extrapolations of current trends, investigate personal aspirations, and imagine new inventions for bettering the quality of life. Imagine a unit on health in which students investigate their personal lives and the larger world as they study environmental issues, nutrition, disease, stress, and health regulations (Beane, 1991, p. 11).

ME AND MY WORLD

In social studies in the elementary grades, the students themselves are often the starting point. All the things that are personal and immediate to students help to celebrate personal identity. What they look like, their physical features, what they enjoy doing and eating, where they are in their family, and finding out about their family tree can be interesting topics of investigation and expression. Be sensitive to the fact that some students do not have access to their family tree and many are from single parent families.

The units of study can begin with the students listing questions about themselves and their world. They can identify a number of themes, personally choose a specific one, and suggest activities and questions that form the basis of their study.

Beyond the personal elements, "Me and My World" includes my family and neighbourhood, community, city or town, province, and country. Countries and cultures are also introduced in some social studies curricula. The development of space, such as houses and other buildings or architecture, streets, parks, and playgrounds may be incorporated into the curriculum as themes for investigation. The exploration of Canada, the explorers, missionaries, fur traders, settlers, and Canadian aboriginal people are also topics found in elementary curricula; others include natural resources and vegetation, land formation, and levels of government.

ARCHITECTURE

Architecture is the art and science of planning and building structures; an architect is a person who plans for both functional use and aesthetics, and oversees the construction. Architecture evolved to meet humans' need for shelter, while attention to design meets the human need for

an aesthetically pleasing environment. The purpose of buildings and how well they meet the functional and aesthetic needs affects everyone's life.

> Building our environment is an inevitable element in the process of making ourselves at home in the world. Learning about environmental aesthetics is of the essence in harmonizing the human habitat with nature and in creating beautiful, healthy environments. Environmental aesthetic concerns the natural environment and the built environment (Kauppinen, 1990, p. 12).

You can start the unit of studies on architecture by drawing on what the students already know about architecture. Encourage them to really observe by focusing their attention on details in the architecture in your area. Why were the buildings designed the way they are? For example, why would buildings have steep roofs? Why are balconies part of some buildings? Are most buildings angular or round? Why? What is the main purpose or use of the buildings? How are designs of old buildings different from new buildings? Can you tell the age of a building by its architecture?

After scrutinizing the architecture in your area, introduce students to buildings and architectural features found in other parts of the world.

When students are ready to design buildings, they can begin on graph paper and work to scale and proportion. Later they can develop their ideas in three-dimensional models using such materials as cardboard, clay, wood, Plasticine, styrofoam, tubes, shoe boxes and furniture packing boxes, dowels, sticks, ice and stone, or other found material and combinations of materials.

Box 11.4 provides many suggestions for architecture projects that lend themselves to integrating with language arts, science, or mathematics.

HISTORY AND CULTURE

One approach for teaching history is to require students to memorize names and dates. This method does not give students a deep understanding, excitement, and enjoyment of the period they are studying. Ron Berger (undated) said, "It gives a false and lifeless impression that history is something we know, rather than something we are forever deciphering, theorizing and arguing about, and rewriting from different perspectives" (p. 1). Rote learning contradicts the way we actually learn history because the details of history, especially ancient history, are often constructed from careful analysis of ancient art.

EXHIBIT 11.3 Architecture project

BOX 11.4 ARCHITECTURE PROJECTS

NEIGHBOURHOOD

- **A walk around the neighbourhood**

Take a walk around the school neighbourhood with your students and observe the buildings, their shapes, function, and decorative elements. Students can create a three-dimensional model or map of the neighbourhood. This can be done in groups with each student creating part of the model.

- **Streets, playgrounds, sidewalks, green areas**

Students can draw a plan of these areas.

- **Mapping**

Students can draw a map of where they live in relation to the school, and where other students in the class live.

TYPES OF BUILDINGS

- **Residential**

Identify the houses in the area as one-family or duplexes, townhouses or apartment blocks, single storey or two. Take note of the windows, the roof, and where the doors are. What is the centre of interest for the building? What are the decorative features?

- **Commercial**

Are some buildings in the area used for commerce? What is their function — for example, are they grocery or clothing stores, or are they medical buildings? Which buildings lack aesthetic appeal? What design features are aesthetically pleasing? How could the buildings be improved?

- **Public buildings**

What public buildings besides the school are in the area — government buildings or churches?

PLANNING

- **City planning**

Investigate city planning by-laws, and zoning (industrial, commercial, residential, multi-family, high-rise).

- **The perfect playground**

Divide students into groups to brainstorm ideas to design a playground. What features make a good playground? What qualities would make a playground most interesting? What materials could be used? Have your students make rough sketches and then plan the design in detail. Create a model of this playground with Plasticine, clay, or other modelling material, and popsicle sticks and dowels.

- **A model village**

What do the citizens of a village, or a group of families, need to have in the way of housing, leisure (sports area or green belts), government buildings, schools and libraries, roadways and walkways? Have the class brainstorm for ideas beyond the traditional, and work in groups to plan a model village.

(continued)

(continued)

DESIGNING

- **A dream home**

 Ask your students to first draw their own house or apartment, including the front of the building and the floor plan. Obtain an architect's drawings for a house, or a drawing made by a designer, for students to use, and then have them design a floor plan for their own family, based on the way architects illustrate hallways, doors, kitchen and bathroom fixtures. Students can also design the exterior, and then create a model with cardboard, clay, and other available materials. You may wish to invite architects, landscape artists, contractors, and builders to your classroom to discuss their profession.

- **Classroom environments**

 Collect large packing boxes from furniture stores or moving companies and create a full-sized architectural fantasy in an area of the school, hall, or classroom. You may wish to rearrange and subdivide the classroom, creating areas for private study and other classroom activities.

- **Structures in nature**

 The out-of-doors is a wonderful source of inspiration and ideas for architecture. Study bird, ant, and other insect's nests and homes, as well as sea and turtle shells. Investigate the structural form of the habitat. Ask your students to design a building based on a natural form, such as a pine-cone shaped concert hall.

- **Ecological structures**

 Function and purpose can set limits on designed structures. Ecology, air and water pollution, and food production can become architectural design problems. Interested students could design a structure for a floating city, a city under water, an orbiting satellite city, a sports-plex, a hobbit's house, an envirosphere, a biosphere, or a technosphere.

- **A school**

 What do your students like about their school's design and layout? What features would make the school a more pleasant place? Which changes are realistic? Interested students could draw up a design for a school building.

- **Animal habitat**

 Family pets or zoo animals have special needs for their shelter. Some students might want to study an animal and design a habitat to meet its specific needs.

PUBLIC AND HISTORIC BUILDINGS

- **Buildings in history**

 There are many historical buildings found throughout the world that are studied and sometimes copied, at least in part. Have your students look at some of the government buildings in their area, especially the design features. Where do these design features originate? Remember you do not need to know all the answers. Encourage your students to conduct the research.

(continued)

(continued)

- **Religious buildings**

 Study buildings designed for religious purposes — churches, mosques, cathedrals, monasteries, and temples. How have the religious beliefs influenced design?

- **Government buildings**

 Study buildings constructed for the purpose of government, for royalty, and other heads of state. Study the construction and design features of the castles in Europe, the provincial legislature, and national parliament buildings. The Canadian Pacific Railway designed many impressive hotels from coast to coast. Investigate the reasons they were built and some of their similar design features.

- **Greek Temples**

 The Greeks built temples in honour of their gods, and many cities in the world have been built with features that resemble the architecture of the classic Greek temples. The Parthenon was built in Athens around 440 B.C. It was made completely of marble with a slanted stone roof resting on flat stone beams. This immense weight was held up by columns of marble. A frieze, a line of carved figures, decorates the space under the roof and goes all around the building and the pediment, and the triangle space at each end is filled with carved figures.

 After studying Greek architecture, students can plan a building, a library, a home, an arena, a temple for the Greek gods, or an Olympic stadium.

- **Ancient Egypt**

 Ancient Egypt is renowned for its large pyramids, elaborate burial chambers, temples, sphinx statues (lion's body and head of a man), and obelisks (tapering four-sided shaft of stone with a pyramid on top). The age of the pyramids (2686 to 2181 B.C.), known as the Old Kingdom, was a time of peace and security in Egypt. Burial chambers and tombs, with treasures, paintings, murals, and reliefs, were important parts of the temples. (College of Education, 1986). The study of ancient Egypt's architecture, religion, culture, jewellery, and other art forms can be fascinating. After research, students can develop three-dimensional models, reliefs, murals, drawings, or paintings as replicas. Students can adapt the ideas and images into personal statements.

RESEARCH AND INTERVIEWING

Some students might want to research well-known architects — American Frank Lloyd Wright, or Raymond Moriyama who designed such public buildings as the Ontario Science Centre and the Metropolitan Toronto Library. Other suggestions: Alberta's Douglas Cardinal who designed the Canadian Museum of Civilization in Hull, Quebec; Patricia and John Patkau from Vancouver who designed the Canadian Clay and Glass Gallery in Waterloo, Ontario, as well as libraries, schools, and houses. If you can contact architects in your area, have students interview them and write up a report of the interview.

EXHIBIT 11.4 Project on culture

Early Canadian History

The history of Canada's aboriginal people and European explorers, missionaries, fur traders, and settlers is usually included in elementary curricula. European and British artists documented how they viewed the country and its people when they first saw it. A few of these artists are mentioned in Chapter 15.

The art and culture of the Canadian aboriginal is rich in visual imagery. Their stories, legends, myths, dances, and visual images all told their history, values, attitudes, and religious beliefs. The images depicted the natural environment, the animals they cherished, their relationship to the land, the water, the sky, the sun, and the seasons. Their whole culture and their art were one.

The Indian nations developed ways of living suitable to the regions in which they lived — suitable homes, clothing, hunting tools, and other means of catching or gathering food, depending on the resources available. The regions are described in Chapter 15, along with a map on page 289.

Students should study a particular nation or tribe in a region and investigate the characteristics of the area and then explore the paintings, drawings, totem poles, and other images symbolizing their family or clan, as well as tent and house decoration, masks, clothing design, headdresses, and jewellery. Reading aboriginal creation myths and legends is also a way of learning about the history of native groups.

Understanding "Culture"

> Culture is a term that refers to the way in which a particular group of people live. It includes many things. It is how people think and behave. It is how they make their homes and their clothes. It is their language and their stories, their songs and their dances. It is their religion and their laws (MacLean, 1982, p. 5).

Studying the images and artifacts and the materials used in daily life in other cultures can lead to greater cross-cultural understanding. Our country is home to people from all over the world, and children in your classroom can benefit from learning about cultures in the countries of origin of their classmates.

For example, learning about clothing, headdresses, and jewellery tells you something about the aesthetic sense and resources of a culture. What materials were used and why? What was the reason for the adornment (rank, position, status)? Art objects are often designed for recognition

BOX 11.5 FLAGS AND BANNERS

Since the dawn of history groups of people have represented themselves by images of animals or other designs. Although the origin of flags is unknown, they are used to symbolize communities and their leaders. Words are seldom used on flags because they would be difficult to read. Small details in design are equally hard to distinguish; therefore, bold patterns of contrasting colour are used. The shape of flags has become generally standardized in a basic rectangle, but the patterns and colours used in designs show a remarkable variety. Colours are selected for his-torical, political, or symbolic reasons. Animals and plant forms from the areas are often used, or heraldic beasts such as the lion or eagle. Such images as a cross are also used, as are buildings, heavenly bodies, and significant utensils.

Studying flags and banners can be a fascinating project, and students can design a flag for their country or group, incorporating the principles of composition. Materials can include fabric — appliqued, stitched or glued, hand-woven, silkscreened, batiked — coloured paper, and glue or paint on paper.

of achievement, and awards are created in the form of medals, medallions, and trophies. The images chosen for these honours also tell you something about the culture.

Students can study cultural, seasonal, national, and religious celebrations and holidays, along with the symbols and sculptures, monuments and masks that might be part of celebratory rituals. Remember that you do not need to know all about a culture that your students want to explore — you can help them to learn how to get the information they need, and you can learn along with them as they research the topics of their choice.

Cultural Communities

Canada is a multicultural country largely populated through immigration. These cultural communities that have their own languages teach their children in the language of their country of origin and have traditional songs, dances, and other art forms. Many restaurants and food stores cater to culturally distinctive foods. Cultural and religious artworks can be purchased in specialty stores. Musical, dramatic, and dance groups keep the traditions alive. Your students can research the communities in your area: Hutterite colonies, Mennonite groups, Chinese, Italian, Vietnamese, Polish, Greek, English, French, German, El Salvadorian, Cuban, and so on. Encourage your students to share their family or ancestors' artifacts and celebrations.

GEOGRAPHY

The study of climate, vegetation, and landform is a wonderful opportunity to observe, investigate, and create. Students can create reliefs or dioramas, landforms with mountains or hills,

rivers and vegetation. Clay, Plasticine, papier-mâché, cardboard, and other found media can be used.

The country or region students explore can be that of the cultural group they are studying to maintain a cohesive whole to the projects.

NEWSPAPERS

Nearly all towns and cities, as well as many organizations, produce their own newspaper. The topic of newspapers has great potential for an integrated unit of study. Take the class on a field trip to a local newspaper, or ask newspaper reporters or editors to speak to your class. Students can study the contents, layout, and illustrations in newspapers. Box 11.6 provides some ideas for starting a unit of study.

BOX 11.6 NEWSPAPER

LANGUAGE ARTS:
- Reading to identify the stories as to the source of information and as fact or opinion.
- Source of Information: Discuss ways news reaches the newspaper.
- Bring in a guest speaker from a newspaper.
- Select a news story and list facts in the order in which they were reported.
- Compare an editorial to a letter to an editor.
- Interview community members.

MATH:
- Count and write down the number of theatres that are showing films rated R, PG, and G. Graph your results.
- Conduct a survey to find out how people feel about film ratings that limit attendance on the basis of age.
- Estimate sales figures for the cost of cars.

- Graph the stock market.
- Buy and trade commodities.
- Tabulate the currency.
- Travel, what are the best prices: Km = price.

SCIENCE:
- Locate the weather map in a paper and study the weather symbols and their meaning.
- Predict what the weather will be one week.
- Discover how paper is made and make your own recycled paper.
- Collect and discuss current scientific issues: medicine, environment, wildlife, water-pollution, air-pollution.

DRAMA:
- Take a field trip to a newspaper.
- Create a newspaper room setting.
- Write a script detailing aspects of those involved with the newspaper.

(continued)

(continued)

- Role-play an on-the-job scene.
- Discuss the characters involved.
- Create costume and dress for the characters.
- Write and dramatize an epitaph/obituary to recognize someone's accomplishments.
- Write a critique of a drama.

HEALTH AND PHYS.ED.:

- Look for related careers in the employment section of the newspaper.
- Plan a menu and compare prices of various items within a budget.
- Plan a menu using the four food groups.
- Review a restaurant.
- Review sports.
- Develop/analyze receipts and diets.
- Discuss various health hazards (e.g., tobacco, alcohol, steroids, car fumes).
- Investigate the benefits and hazards of various types of exercises.
- Create an advice or homework helper column.

SOCIAL STUDIES:

- Discover the history of the printing press.
- Discuss the economics of publishing the paper and why advertising is vital to the financial production of the newspaper.
- Find an opinion poll — record the subject of the poll.
- Develop an opinion poll on issues of interest.

- Read and write about world news, trouble spots, wars, and natural disasters.

ART:

- Create computer graphics for specific sections of the newspaper.
- Develop satirical cartoons of specific characters.
- Photograph specific events.
- Design advertising and company logo.
- Create a three-box comic strip using new characters.
- Critique an art show.
- Create a record design of a local band or musical group.
- Design clothing/fashions for a special occasion.

INTEGRATED STUDY — NEWSPAPER:

- Create a Newspaper for the Future.

FRENCH/FOREIGN LANGUAGE:

- Translate various sections of the newspaper.
- Discuss the various issues that affect the offering of language courses (e.g., Quebec separation, trade with Japan).

DANCE/MUSIC:

- Critique a dance or music concert.
- Create a musical score based on newspaper room sounds.
- Create a dance/movement piece based on the music room.

CREATE YOUR OWN CULTURE

After your students have explored the many different aspects that make up a culture, they can develop imaginary cultures. Divide the class into groups and have each group create their own culture. Assign each group a particular climate, as suggested below.

Climate, vegetation, agricultural production, and animals have a great deal of influence on the development of a culture. Here are suggestions students could use.

- Continental climate. Cold with snow in winter.
- Humid equatorial climate. High temperatures and heavy rainfall.
- Mediterranean climate. Mild winters, hot summers, humid at times with a rainy season.
- Desert climate. Dry and hot with a wide range of temperature changes between day and night.

The students can brainstorm in their groups about the elements that make up a culture or country. Have them create a mind-map of culture, including government, education, money, transportation, commerce, and, of course, the arts. They can design flags and banners, coins and other money; traditional costume, jewellery, head-gear, or hats and masks for special occasions; a diorama or relief of the country or island; trophies and other awards; native animals and vegetation. Encourage the students to be inventive.

• • • • • •
Summary

This chapter discussed ways of integrating art in the social studies and language arts curricula. Language and the visual arts are two modes of communication that are interrelated and each can help expand understanding of the other. Stories, poems, myths, and other writings can be understood and interpreted through visual-arts projects.

Social studies in the elementary curriculum focuses on students as individuals and as members of larger communities. The field of architecture offers a rich resource for study in the arts and social studies. History and culture — for example, Canadian aboriginal people and early European expansion into Canada — along with other cultures and countries, can also be understood through studying the arts. In each of these areas of study students gain an understanding of their world and have opportunities for expression in their own visual-arts statements.

REFLECTION

❶ What areas or themes, which were not mentioned in this chapter, could be integrated with art and social studies or language arts?

❷ Comment on effective ways to achieve integration of art into the social studies and language arts curricula.

❸ Examine the social studies curriculum guides for your school district for the grade level you are teaching. What are the main themes and topics? List specific cultures or countries suggested for study?

❹ Choose a country or culture and brainstorm topics for research. Make a mind-map of themes and develop a unit of study incorporating art appreciation and production.

❺ Investigate various types of poetry and develop a unit of study on a specific theme in art history and an art medium for visual expression.

❻ Begin creating a resource file of visuals, poetry, and stories based on specific themes such as animals, birds, trees, plants. These can be used as generative ideas and reference for lessons on these themes.

❼ Develop art lessons on a theme. Brainstorm language arts and social studies themes. Develop a mind-map with possible lessons that can be integrated.

CLASSROOM PROJECTS

❶ Assign your students to draw a map of Canada and show the six regions of aboriginal nations. Have the students develop drawings based on the art forms of these nations.

❷ Students can write stories based on their research into a specific culture, or write a story based on an incident in their community. Have them draw illustrations for the stories.

❸ As a class project, have the students make a large mural to illustrate an event in the community; for example, a park clean-up or tree planting, or a special school event such as a track and field day, or a mural as a culmination of a field trip to a home for the aged.

BIBLIOGRAPHY

Alberta Education (1991). *Program of Studies: Elementary Schools, Language Learning.* Edmonton: Alberta Education.

Beane, J. (1991). The middle school: The natural home of integrated curriculum. *Educational Leadership,* October, pp. 9–13.

Beane, J. (1990). Rethinking the middle school curriculum. *Middle School Journal,* May, pp. 1–5.

Beers, B. (1989). *World History, Patterns of Civilization.* Scarborough, ON: Prentice-Hall Canada.

Berger, Ron. (n.d.). *Integrated Units of Study.* Unpublished document.

Boyer, E. (1993). Making connections. *Carnegie Foundation for the Advancement of Teaching.* Presentation at the ASCD Annual Convention, Washington, DC.

Boyer, E. (1983). *High School: A Report on Secondary Education in America.* New York: Harper & Row.

Brady, M. (1993). Single-discipline schooling. *Phi Delta Kappan,* February, pp. 438–43.

Clarke, J. and R. Agne. (1997). *Interdisciplinary High School Teaching.* Boston: Allyn and Bacon.

College of Education, Brigham Young University. (1985–86). *Rameses II: The Pharaoh and His Time. Teacher Resource Packet.* Provo, UT: Brigham Young University.

Cott, Jonathan. (1985). *Pipers at the Gates of Dawn: The Wisdom of Children's Literature.* Toronto: McGraw-Hill.

De Bono, E. (1992). *Serious Creativity: Using the Power of Lateral Thinking to Create New Ideas.* Toronto: Harper Collins.

De Bono, E. (1973). *Lateral Thinking: Creativity Step by Step.* New York: Harper Colophon Books.

Gillespie, M. and J. Conner. (1975). *Creative Growth through Literature for Children and Adolescents.* Columbus, OH: Charles E. Merrill Publishing Co.

Grauer, K. (1984). Art and writing: Enhancing expression in images and words. *Art Education,* September, pp. 32–34.

Hayden, C. (1992). *Venture into Cultures. A Resource Book of Multicultural Materials and Programs.* Chicago: American Library Association.

Hess, K. (1989). *Image and Write . . . Poetry.* Monroe, NY: Trillium Press.

Kauppinen, H. (1990). Environmental aesthetics and art education. *Art Education,* July, pp. 12–21.

Lewis, M. and A. Lindaman. (1989). How do we evaluate student writing? One district's answer. *Educational Leadership,* April, pp. 70–71.

MacLean, H. (1982). *Indians, Inuit, and Metis of Canada.* Toronto: Gage Publishing Limited.

Marshall, S. (1983). *A Falling Leaf and other Poetry Activities.* Holmes Beach, FL: Learning Publications, Inc.

Massey, D. (1986). *Canada, Its Land and People, Teacher's Resource.* Edmonton: Reidmore Pocol Enterprises Ltd.

Massey, D. and B. Connors. (1986). *Canada, Its Land and People.* Edmonton: Reidmore Pocol Enterprises Ltd.

Moore, T. and A. Hampton. (1991). *Book Bridges, Story-Inspired Activities for Children Three through Eight.* Englewood, CO: Teachers Idea Press.

Nielsen, M. (1989). Integrative learning for young children: A thematic approach. *Educational Horizons,* Fall, pp. 18–24.

Noddings, N. (1995). A morally defensible mission for schools in the 21st century. *Phi Delta Kappan,* January, pp. 365–68.

Palmer, L. (1992). *Common Ground. Book-Based Activities for Young Children.* Allen, TX: DLM.

Powell, B. (1973). *Making Poetry.* Don Mills, ON: Collier Macmillan.

Raddan, A. (1985). *Exploring Cultural Diversity. An Annotated Fiction List.* Oxford: School Library Association.

Swede, G. (1990). *The Universe is One Poem, Four Poets Talk Poetry.* Toronto: Simon & Pierre.

Thompson, K. (1995). Maintaining Artistic Integrity in an Interdisciplinary setting. *Art Education,* November, pp. 38–44.

Whitman, R. and H. Feinberg. (1975). *Poem-making, Poets in Classrooms.* Lawrence, MA: Massachusetts Council of Teachers of English.

Zuk, W. and D. Bergland. (1992). *Art, First Nations, Tradition and Innovation.* Intermediate Program, Teacher's Guide. Montreal: Art Images Publications, Inc.

Integrating Art with Science and Math

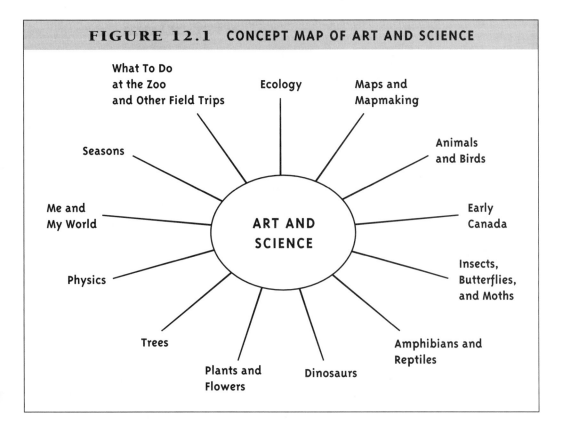

FIGURE 12.1 CONCEPT MAP OF ART AND SCIENCE

What To Do at the Zoo and Other Field Trips

Ecology

Maps and Mapmaking

Seasons

Animals and Birds

Me and My World

ART AND SCIENCE

Early Canada

Physics

Insects, Butterflies, and Moths

Trees

Amphibians and Reptiles

Plants and Flowers

Dinosaurs

• • • • • •
Introduction

One of the great European artists was an inventor, a scientist, and a mathematician. Leonardo da Vinci, who is known for *The Last Supper* and *Mona Lisa*, among other paintings, also left behind many notes and sketches about a variety of mechanical inventions. For example, his "Codex on the Flight of Birds" is about building a flying machine — he was fascinated by the way birds fly.

Obviously, for Leonardo, there was no division between art, science, and mathematics — this is a concept that is often lost in our education system. This chapter can help you explore ideas and approaches in an integrated program. The science themes we discuss include the study of the human body, the seasons, ecology and conservation, maps and map making, animals and birds, sea life, insects, butterflies and moths, amphibians and reptiles, dinosaurs, plants, flowers

BOX 12.1 THE ROLE OF SUBJECT SPECIALISTS

Drake (1991) describes her team's experience developing projects in areas with which team members were unfamiliar.

We found ourselves squeezing in such areas as mathematics that we were not familiar with. When we involved a math teacher in the process, the natural place of math became obvious; we had been limited by our own narrow perspective. We also found, for example, a teacher trained in art could find ample places where specifics about art techniques had a natural place. It was our limitations that put boundaries on possibilities (p. 22).

and trees, physics, and the northern lights. All these themes can be integrated with your art education program.

Art and the Science Curriculum

Science uses images, and experiments with imaginary situations, exactly as art does . . . To believe otherwise is one of the sad fallacies of our laggard education (Bronowski, 1978, p. 20).

The study of science is the study of all things physical. Science is not merely reasoning; it requires using the imagination in a constant experimental process, playing with ideas and materials, and above all, observing, clarifying, classifying, recording, and communicating thoughts, insights, understandings, and ideas.

CONCEPTUAL THEMES

According to Hurd (1991), the concept of developing human resources as a theme for science teaching has implications for curriculum development related to social concerns, personal development, and such human-affairs issues as values, ethics, probability, policy, and preference. Students learn to "distinguish theory from dogma, probability from certainty, fact from fiction, science from myth and folklore, and the limitations of science and technology in personal and social contexts" (p. 34).

The National Center for Improving Science Education (Clarke and Agne, 1997) offers a set of conceptual themes for looking at change in science and related disciplines. They include such change topics as: cause and effect, diversity and variation, evolution and equilibrium, probability and prediction, systems and interaction, change and conservation, energy and matter, models and theories, structures and function, time and scale. "It is not difficult to find similar or supporting themes in most disciplines" (p. 87).

Eliott Eisner (1983), a renowned art-education advocate, wrote in his article "The Kind of Schools We Need" about science and schooling.

We need to develop more amateurs through schooling. An amateur is someone who does something for the love of it. Perhaps Alfred North Whitehead put it best when he said, 'Most people think that scientists inquire in order to know.

Just the opposite is the case. Scientists know in order to inquire.' The journey, rather than the destination, is the driving motive for their work (p. 53).

Children learn by doing and, if they have not been taught otherwise, their activities are for their own sake. They work with intensity as they focus on the journey, as Eisner put it.

FIGURE 12.2 CONCEPT MAP OF ART AND THE HUMAN BODY

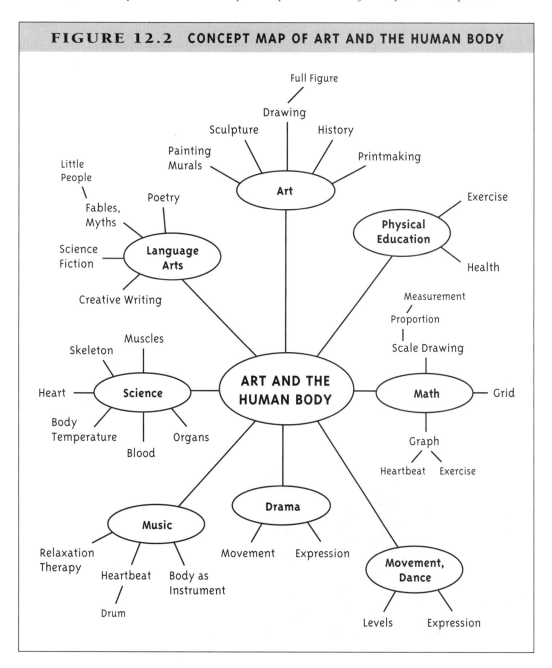

THE HUMAN BODY

Children are curious about the insides of themselves and how their bodies work. Studying the human body — body parts and their functions — provides an excellent approach to the topic on self-identity. Who am I? What do I look like? What is similar and different about me in relation to my family or peers (eye and hair colour, size, gender)?

The study of body parts and what they do together as an organism includes learning about the senses, general health, and nutrition. Students can do research on many aspects of health and the human body, and then develop visual presentations based on their research. Colourful posters are available — ask local doctors to donate them — that show body structure, the nervous system, the circulatory system, and the vital organs. You can hang these posters in the classroom, to be used as a source for drawing, painting, and sculpting projects.

Students can also trace their body, or body parts such as hands and feet, and compare the parts of the body to different basic shapes; then cut the shapes from paper and build a person. These could be posted individually on the wall, or could be blended into a huge wrap-around mural in the classroom. Students can also make self-portraits in clay or Plasticine.

THE SEASONS

The changing of the seasons is a topic that encompasses all subject areas. Each season includes its own holidays and celebrations that can be interpreted through the visual arts, drama, dance, movement, song, writing, and poetry. With each season the weather changes, as do trees and other plants, and the colours on the ground and in the sky. Each season is recognized and celebrated by various cultures and countries; these can become units of study not only for science and art but also language arts and social studies.

Fall

Fall is a season when colours outdoors become more intense. Children enjoy collecting and pressing leaves, and using them to create rubbings or collages. Collages can easily be created using leaves and flowers. Have your students arrange the collection on a piece of wax paper sprinkled with coloured crayon or paraffin wax pieces. Place another sheet of wax paper over the collage, cover it with layers of newspaper, and iron. How you organize this project depends on the age of the students — younger students might need help so they do not burn themselves on the iron. The collage can become a window decoration or part of a larger mural or other construction. Leaves can also be observed for their shapes, the patterns of veins, and their textures; and they can be used as stencils

EXHIBIT 12.1 Fall

for a variety of compositions (see ideas for use of stencils in Chapters 7 and 8).

Winter

In winter, the structure of deciduous trees can be more easily seen. Students can compare the size and texture and colour of different species, both the evergreens and those that have shed their leaves.

Snow and ice become natural media. Children can create ice and snow sculptures and can observe and re-create the shapes of snowflakes. Gates (1989) described a method of preserving

EXHIBIT 12.2 Winter

snowflakes if you want to study their structure. Store a small piece of glass in a freezer; when it snows, take the glass outside quickly. Spray the glass with lacquer, then hold out the glass to collect snowflakes and leave it for about an hour to dry in a protected place, either indoors or outside, where nothing will fall on the snowflakes. When the glass is dry, observe the shape of the flakes with a magnifying glass.

Students can draw what they see by using felt tip pens or folding paper and cutting snowflake shapes. These shapes can be hung from the ceiling as mobiles to celebrate snow, or used as stencils to create patterns, greeting cards, or wrapping paper.

If you live in a cold climate, children can observe frost flowers on the windows. Frost sometimes moves up the windowpane, creating fantastic flowers and simulated landscapes. If you want frost flowers when the weather is not cold, you can make them indoors by boiling some water and allowing the steam to go onto a piece of glass. Place the glass in the freezer immediately; take it out of the freezer and it develops frost flowers. Students can develop their own frost flowers with pen and ink, felt pen, or paint.

Spring and Summer

Spring and summer are the times to take advantage of warm, mild weather and "do stuff" outdoors. Observation activities are suggested in Chapters 6 and 7.

Allard and Howes (1989) developed an integrated unit for their Grade 1 class based on the theme of seasons. As an introductory activity, they read *Chicken Soup with Rice* by Maurice Sendak. Students learned a song based on the seasons, and created a chart of what they already knew about the seasons using pictures. After brainstorming, they developed a word bank to use in talking about the seasons and brought articles of clothing to depict each time of year.

Concepts related to the seasons were introduced through songs, books, and posters about seasons, along with a trip to a conservation centre. The class discussed the calendar — weeks, days, months — and divided it into seasons. They kept weather charts and graphed the weather and seasonal birthdays, and observed and recorded seasonal changes and the adaptation in

EXHIBIT 12.3 Spring

EXHIBIT 12.4 Summer

people and animals. A science centre guest speaker was invited to discuss the seasons and assist in some experiments. The class talked about how families get ready for seasonal changes or celebrate seasonal holidays.

The students added something from their research by creating their own poems, songs, and riddles and took part in movement activities related to animals and people in different seasons. Writing a play about their favourite seasons and acting it out formed another mode of expression, as did creating a wall mural. The theme of seasons culminated with a sharing of the students' work through presentations and performances.

With a unit of study such as seasons, the topic could be ongoing throughout the school year while the students investigate other themes or topics. Art projects can be ongoing in this unit. Students could design seasonal clothing, make seasonal collages, leaf rubbings, texture and colour studies, and works based on camouflage, transformation, and metamorphosis in a variety of media.

Planning Field Trips

Field trips generate excitement, but productive field trips are the result of serious classroom preparation (Galle and Warren, 1989, p. 160). Aside from preparing the students for a field trip, a teacher has a number of advance-planning responsibilities. It's a good idea to visit the site yourself first. You will also need to obtain signed permission from your school administration and/or school board, and from the parents or guardians of your students.

Consideration must be given to the cost of field trips, along with the best method of transportation. Would any parents be available to help out? Would car-pooling be a viable option? Could you use public transportation, or would renting a bus or school bus be the best option? What supplies, equipment or tools, snacks or lunches, and clothing should you and the students bring along? What will be the rules for the day? Generally all school rules apply, but others may be pertinent on the field trip, such as taking extra care of the environment, working

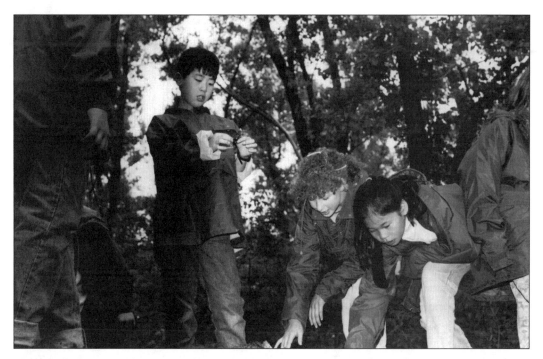

PHOTO 12.1 Planning a field trip is time consuming, but with practice, the process becomes easier.

cooperatively with group members — and no walkmans. Planning a field trip is time-consuming, but with practice, the process becomes easier.

To prepare the students for the field-trip learning experience, introduce the topic for investigation well in advance so they can do some research, and be sure they know what the purpose is for the field trip. For example, if students know what animal and bird they want to learn about before a visit to a zoo, their attention will be more focused. Have students use observation ideas offered in Chapter 6, because drawing assists students' understanding of objects under scientific investigation.

The students also need an overview of the whole process and the end result. Will they be making a visual presentation, a book on an animal, a diorama of an animal in its environment, a collection of two-dimensional and three-dimensional visual studies, or a fantasy-animal sculpture? Using the senses — taste, smell, touch, hearing, and sight — increases the likelihood that the sensory details collected in the field can be transposed into enjoyable writing in the classroom (Galle and Warren, 1989, p. 187), as well as visual statements.

MAPS AND MAP MAKING

Map-making projects can be initiated in connection with field trips — students can map the area they visit — or making maps can be linked to other areas of study. Looking through a good atlas can give students an understanding of the different kinds of maps and their purposes:

topographical, physical, cultural, local, and regional maps. Students can study maps and create their own maps of specific areas, such as the playground or their neighbourhood. Older students can take on more ambitious projects of mapping entire cities or regions, while focusing on one aspect; for example, mapping parks, or rivers, streams, and ravines.

After studying contour maps in an atlas, students can develop contour maps of areas with which they are familiar. The next step would be to construct a contour map in three dimensions on a table top. Clay or Plasticine or other modelling materials are suitable for this type of project. Students can work on maps and land models either individually or in groups.

ECOLOGY AND CONSERVATION

Ecology is a science based on the interactions and relationships between organisms and their living and inanimate environment (Galle and Warren, 1989, p. 7). Working in this area requires skills in observing, describing, generalizing, inferring, drawing conclusions, classifying, measuring, and communicating. These skills can be developed or enhanced through the art process, which draws heavily on the development of observation skills — using the senses to assist in measuring, classifying, describing, and communicating. According to Romey (1980, p. 43), "Careful observation is one of the traditionally important values of science, whether the subject is physics or archaeology." How similar to learning to draw!

The idea of animals becoming extinct or endangered is a theme that covers many areas of study, such as conservation, social responsibility, and advertising and awareness campaigns to protect endangered animals and national forests, parks, and wildlife refuges.

Ecology and conservation of our natural environments are issues in which many children have an interest and want to explore. Students can contribute to awareness on such issues as water pollution, air pollution, waste management, and local conservation in the school and in their community. Encourage your students to take action on environmental issues. They can research local environmental problems and create posters and put together newsletters as a way of sharing their discoveries with the community. This kind of practical approach gives children a broad experience as citizens, along with their learning in topics in the curriculum.

STUDYING SOIL

Soil is formed over time when large rocks are affected by wind, precipitation, and temperature changes. Large pieces of rock break down into small granules and change into soil mixed with vegetable or animal matter, depending on the area. The soil is alive with microorganisms as well as countless insects and worms that contribute to the health of the soil.

Soil types can be described by their texture and identified with the "Snake-Roll Test" when you handle it: gravel is a coarse soil type with many pebbles, which does not roll; sand is coarse with fine grains, which also does not roll; loam is velvety with soft particles, and rolls but breaks; clay is smooth and sticky when wet, and it rolls and keeps its shape well (Galle and Warren, 1989). Experimenting with different types of soil — digging, identifying, and using found clay to create traditional pottery or personal ceramic statements — is an excellent purpose for a field trip. Digging and using native clay is described in Chapter 9 in the sections on Ceramics.

ANIMALS

Children are always interested in animals and their activities: they walk, crawl, run, swim, and fly, and eat all kinds of food. There are wild animals and domesticated animals, land and water animals, warm-blooded and cold-blooded. Scientists and zoologists have classified animals into phylum, then classes, orders, families, genera, and species, depending on their similarities and differences. Throughout history artists have worked closely with scientists, or worked as artist-scientists in documenting the natural world. These artists have visually captured animal structure and skeleton, body covering and colouration, habitat, adaptations, environment, and food sources.

Sketchbook Assignment for a Zoo Field Trip

Your students can become artist-scientists. The following is a sketchbook assignment for a field trip to the zoo. You can change this assignment, add to it, or make it more specific. Students will need: a sketchbook or paper attached to a board or heavy cardboard; drawing materials such as pencils, crayons, pastels, felt pens, paints, or pens; and possibly a camera.

Have your students each choose an animal to study. Before the field trip, they should read and take notes and think of questions they want to answer about this animal. What is its natural habitat? How does it reproduce? What natural enemies does it have? What behaviours are characteristic of the animal?

These are the kinds of suggestions that will help students get the most from a trip to the zoo. Sketch the geometric shapes you see in the animal in its body parts. Look for squares, rectangles, spheres, circles, and cylinders. Make three to four drawings of detailed parts of the animal: head, eyes, feet, and ears. Draw several complete sketches of the animal in characteristic poses. Record the animal's colour using coloured pencils, pastels, crayons, or paint. Do several quick gesture drawings of the animal. Make note of the sounds it produces. Watch the animal for five or ten minutes and make a map of it's travel/movement in its enclosure. Take pictures of this animal in different poses and from different angles. Look for pictures of the animal in magazines, and photocopy articles and pictures. Look for images in magazines or newspapers that remind you of this animal.

Making Footprints

Students can collect footprints of their pets, and cast them in plaster; or even make their own foot- and hand prints in wet sand, with plaster poured into the imprint to create the cast. Prints from imaginary animals can also be made the same way. Information on plaster and other sculptural materials is discussed in Chapter 9.

EXHIBIT 12.5 Animal sketch

Camouflage

Animals use several visual survival strategies: they attempt to hide or camouflage themselves in their environment or they show off with brilliant colours and shapes; or they confuse enemies by their appearance — they appear to be what they are not.

Camouflage involves the pattern in the background. A simple form seen against a richly broken background will stand out very clearly. But when animals are visually camouflaged, their pattern, scale, and colour is similar to the surroundings.

Students can use the concept of camouflage to create an animal or other life form, real or imaginary, and make the animal in two-dimensional or three-dimensional form, and conceal it in an environment. They can also use a variety of objects (such as bottles, balls, stones) and paint them within a background so that they "disappear." In a similar project, students can paint a form so that it stands out in the surroundings, instead of blending in. These projects encourage the students to observe the elements of design: line, colour, texture, tone, and shape.

BIRDS

Our world has more than 8600 kinds of birds, the largest being the ostrich and the smallest the hummingbird. Birds have feathers and wings — the feathers help them stay dry and contribute to their ability to fly, but not all birds can fly. Some wild birds, such as ducks and geese, have been traditionally used for food, but domestic chickens and turkeys are also a source of food.

Many birds live in flocks and migrate south for the winters, but they return north to nest in the spring. Some are known as birds of prey, and others as songbirds. Many areas of the country have bird sanctuaries where birds are protected and often overwinter because they have access to food and open water. Your students can classify birds, draw details of their beaks, feet, feathers, and colouration, as well as their habitat and food. They can investigate which birds are most common locally, and research their history and habits. Their observations and drawings can be used as information to create prints, paintings, murals, and sculptural forms or as a basis for imaginary or hybrid birds.

A focus on birds could also form the beginning of a much broader, related unit. For example, Jacobs (1989) developed an interdisciplinary unit on flight. "Flight" was the centre of the planning web with math, science, social studies, language arts, the arts, and philosophy as connecting threads. The science aspects included investigation into birds' flight patterns, aerodynamics, insects that fly, space flight, and UFOs. The math component included a study of angles for smooth landings, scale models of airports, and the economics of flying and airfares. Language arts were covered through biographies of the Wright brothers, Amelia Earhart and James Audubon as well as flying heroes including Superman, Peter Pan, and Icarus. Da Vinci's designs, Japanese kites, mobiles, and films on flight, such as *Star Wars*, made up the arts. Philosophy investigations included "fight or flight," the ethics of airport noise, and the reasons for flying. Important questions concerning flight can be developed along Bloom's taxonomy of knowledge (identify, list), comprehension (recall, translate), application (chart, illustrate), analysis (compare), synthesis (create, write), and evaluation (appraise). For example, a project on synthesis could be about creating a new flying machine in blueprint or writing a biography of a fictional

EXHIBIT 12.6 Bird

flying hero of the future. Evaluation could include an appraisal of the machine's effectiveness (Jacobs, 1989) or a critique of the biography.

SEA LIFE

Oceans cover more than seven-tenths of the earth's surface, and many cultures and civilizations have been shaped by the seas. Most of us respond to the lure of the sea — the wide expanse of space, water, and sky under varying weather conditions.

The following sketchbook or journal assignment is based on sea life but you can adapt the ideas for almost any nature study.

- Compile a dossier of visual material about sea life. Collect pictures cut from magazines, photocopies, and articles on the topic. Collect shells, fish skeletons, lobster tails, crab legs. Eat at a seafood restaurant and bring the shells to class (after cleaning and boiling them), or ask people who have shells to donate them for class projects. Make texture rubbings of these and draw them using various media.
- Make an enlarged drawing of observed patterns on sea-life shells. A viewfinder is like a window or slide holder, which helps the artist focus on an area to study and draw. Make a viewfinder out of cardboard, hold it out and focus on a detail of an area as you make drawings.
- Find short stories or poems based on sea life or make up your own story or poem.
- Make a collage picture based on the theme of sea life. Be especially concerned about the centre of interests, overlapping of shapes, and the movement of line, colour, and shapes.

- Create a list of sea-life word combinations that could be used as visual puns; for example: sea-horse, hammer-head shark, star-fish, gold-eye, angel-fish, sun-fish, dog-fish, shark-fin soup, crab-legs, crab-net, escargot (s-car-go).

INSECTS, BUTTERFLIES, AND MOTHS

Butterflies and moths make up 140 000 species, called *Lepidoptera,* meaning "scaly-winged" — most adults have tiny, shingle-like scales covering their wings and bodies. The development of butterflies and moths through the various stages of transformation from egg, to caterpillar or larva, to chrysalis or pupae, to adults is fascinating.

Your students can draw the stages of development and can use the patterns and designs as the basis for their painting and drawing. The study of butterfly wing patterns — their symmetry, colour, shape, texture, and line — is also fascinating and can lead into many areas of artistic investigation, such as printmaking, painting, and fabric decoration.

Students might be interested in also researching and drawing other insects — for example, spiders and flies. They can study the patterns and lines in the wings, the detail of the legs, and even the patterns of spider webs. A magnifying glass or a microscope is useful for this kind of study.

There are several approaches students can take in studying and drawing insects. Large paintings of a small area of an insect can be developed, or precise drawings of the entire insect. Either way, students can discover the intricate patterns in these insects.

PHOTO 12.2 Butterfly

AMPHIBIANS AND REPTILES

Amphibians include frogs, toads, and salamanders. How tadpoles grow up to become frogs is an example of transformation. Reptiles — turtles, alligators, crocodiles, snakes, and lizards — have skin covered in scales of many patterns and colours, except, of course, turtles, which have a shell. Art and science lessons could include the observation and drawing of pattern, colour, adaptation, camouflage, and environment.

DINOSAURS

It is believed that dinosaurs roamed North America approximately 65 million years ago and then became extinct. Dinosaur skeletons have been found in many areas, and in studying the bones and assembling them, scientists have been able to learn more about these creatures. Many dinosaur bones have been found in Canada's midwest, and Drumheller, Alberta has a museum dedicated to dinosaurs.

Angie DiNapoli (1989) developed an integrated unit on dinosaurs for her Grade 3 students. She began the unit of studies by arousing students' curiosity with a box of sand. In it she had buried a puzzle, and the students tried to guess what was in the box. Next they dug out a few pieces and speculated what it was by attempting to assemble the excavated pieces.

The students considered a number of questions. What are fossils? How do scientists know about dinosaurs if they are extinct? How are extinction theories validated? On what do scientists base their way of assembling excavated bones? DiNapoli utilized films, videos, books, stories, and poems about dinosaurs and a simulated excavation experience at a science centre. The students researched the characteristics of dinosaurs — size, defenses, eating habits, and habitats — and developed a time line and habitat location map. Researching how scientists named dinosaurs formed another part of the study to discover the significance of prefixes, roots, and suffixes.

As part of the unit on dinosaurs, students designed their own dinosaur and invented names based on what they learned about how scientists name dinosaurs. They wrote poems, stories, and plays; they produced a mask of their dinosaur and presented their research. The unit culminated with student presentations and a party with dinosaur cookies for treats.

When this kind of study is initiated, and students "invent" a dinosaur, their creations should be based on what they have learned. For example, after drawing skeletons of dinosaurs or lizards (or other animals or birds) they have knowledge on which to base the skeletal structure of an invented animal, and they should be able to answer certain questions about the creature. Is this animal a hybrid of two or more animals? Does it fly or swim, walk or crawl? What habitat does it need? What does it eat? They should also draw in detail such features as body covering, feet, face, eyes, and ears.

PLANT LIFE

Plants are a part of our ecosystem without which neither humans nor animals could survive. Plants provide us with food, oxygen, building materials, paper, and a host of other very important and useful things. Plants grow from seeds to produce a plant similar to, yet different from, the one which produced the seeds.

Originally all flowers were wild. Humans domesticated flowers and other plants, and now we value certain flowers for their appearance, shape and colour, and for their use as dyes and fragrance. Flowers and herbs have been used for centuries as medicine and pain suppressants and for their hallucinative qualities. Flowers are used to show feelings of love and sorrow, and to celebrate special events such as weddings and birthdays. Certain flowers have been given symbolic meanings, such as the rose for love (Valentine's Day), the white Easter lily for purity (Christian), and the lotus as sacred (Buddhists and Hindus). Students can investigate the history of certain flowers and their uses in various cultures, as well as their symbolism on flags and banners. Perhaps your class can create a class logo using a flower, or a flag or banner in coloured paper, paint, or in quilted or dyed cloth.

The study of flowers and plants can be developed into many areas of fascinating study: a scientific approach for studying plant species, or taking on the role of an artist in the field of botany. In both of these approaches, students can study plants in detail under a magnifying glass, observing and recording details of line, colour, and shape.

Some students might want to research which plants are useful for dyes and collect those and dye pieces of cloth or yarns. Different mordants or dye fixers, such as alum, chrome, tin, copper, and iron (which are available in craft shops or chemical supply houses) produce different shades or even different colours from the same plant (Gates, 1989). (See Appendix C.)

Another practical approach to learning about plant life is having students make flower pots from clay (the pots must be fired); fill them with soil; plant seeds from flowering plants, herbs, fruits, and trees; water them and observe their growth; and draw, document, and illustrate the stages of development.

EXHIBIT 12.7 Tree

TREES

Like smaller plants, trees also grow from seeds. The network of branches and foliage you see above the ground is equal to the vast network of roots underground. The trunk breaks out into branches and twigs in a general tapering of forms.

To draw trees well, students must know them well. Frederick Frank wrote that drawing is a discipline by which he constantly rediscovers the world. Every drawing teaches the artist something and can provide information or inspiration for expression in other media. The sketchbook or journal

assignments based on the study of trees can also be added to or changed to fit another study of plants or flowers.

Have students choose a tree and ask questions about it, and use those questions for their research. What type of tree is it? Is it deciduous or evergreen? What is its scientific name? Does it bear fruit? What is its life span? What is its natural habitat?

Next, students can draw the tree, using a specific approach. Before attempting to draw a tree in full foliage, draw a single leaf, then a cluster, then a branch, then a close-up of the bottom branches. Feel the texture of a leaf and the trunk of your tree. Take some rubbings of the leaves and trunk. Look at the skeleton of your tree, the trunk and branches. Do the branches grow up or down or fan out? Look at the shape of your tree. Is the shape formed by the way the branches grow? Draw a silhouette of the tree, the basic outline without detail. Draw the tree with just straight lines; simplify the tree by drawing it with only a few simple lines. Draw the tree as realistically as you can, using pencils or ink. Distort the tree as Mondrian did to fit into a circle, rectangle, or oval format.

Create paintings of trees using various colour schemes, warm and cool colours, to create different emotional effects. Draw a tree in all four seasons. Use the idea of trees to create a motif, for a border pattern, or a mosaic. Create a large painting or mural and incorporate trees into the mural.

Read about trees from several authors, such as Joyce Kilmer who wrote — "I think that I shall never see a poem as lovely as a tree."; or Edwin Markham's song to a tree — "Give me the dance of your boughs." Individually or in groups, create a poem, story, myth, or fairy tale about a tree as a writing project. Write and illustrate "Family Tree" in journals. Plant a tree and visually record weekly changes. As a math connection, measure and graph the results of growth.

PAPER MAKING

The art of paper making has a long history, beginning with the Egyptian's papyrus. When layered and pounded, papyrus held together to form paper, on which one could write or draw. Students can research how paper is made commercially, from trees and from recycled products, and they can make paper by recycling used paper or combining it with plant fibres. Elaborate equipment is not necessary, but you will need a few materials that are readily available and a few simple tools.

- Pulp materials: newspaper, computer paper, newsprint
- Natural fibres: flax, corn husks, hemp, moss, bran, grass, leaves, milkweed seeds, cattail heads — almost any plant fibres
- Plastic window screen stretched over a frame (frames can be made from embroidery hoops, old picture frames or tin cans)
- Blender or mixer; rolling pin and/or iron to flatten paper; sponges and paper towels.

To make paper, tear waste paper or newsprint into small pieces and soak them in water for several days. You can use a small amount of household bleach in the water to avoid an unpleasant odour. Blend the paper pulp in an electric blender or use a beater. Pour the pulp over a screen or dip a screen into the water-pulp mixture to scoop it out. Blot with sponges. Tip the screen with the paper pulp onto a table covered with towels, and blot with sponges to compact

the fibres and take out the excess water. Squeeze out the sponges and blot again. You can flatten the pulp with a rolling pin or bottle, but be sure you have a layer of paper towels or cloth between the pulp and the roller, and then let it dry.

You can also manipulate the paper pulp with your hands or other tools to create shaped paper. The damp paper pulp could also be placed over forms or objects to create three-dimensional forms, and then let them dry.

PHYSICS

Physics is a broad science that includes mechanics, heat, optics, electricity, and magnetism. Isaac Newton could be called a physicist. In 1666, he observed that light passing through a glass prism separated into various colours resembling a rainbow, now called a spectrum.

Wood (1990) described how students can make a prism by filling a bowl with about one inch of water and placing it on a table in bright sunlight. Stand a mirror inside the bowl against the side facing the sun and adjust it to about a forty-five degree angle. Hold a piece of white paper so that the sun's rays can be reflected onto it and a rainbow of colours can be seen. Also, a rainbow can be made simply by placing a glass with water in the sunlight and reflecting it on white paper.

Students can observe rainbows, investigate how they are formed, and then incorporate rainbows into a painting of a familiar landscape.

Students can try another physics experiment — optical illusion — with string, cardboard, paint, and scissors. A coloured disk can be made by dividing a circle into six pie-shaped parts and painting the disk, clockwise, with blue, green, yellow, orange, red, and violet. After the paint is dry make two holes in the centre of the disk. Thread string through both holes and tie the ends together to form a loop. Spin rapidly and the colours will appear to blend to produce white (Wood, 1990, pp. 48–51).

NORTHERN LIGHTS

Aurora borealis is another name for the northern lights, flickering white and coloured beams of light that can be seen in the northern sky at night. It is difficult to see them within a city because of the interference of city lights. The farther north you go, the better they can be seen; many people travel great distances just to have a glimpse of this fantastic phenomenon. Students might want to do research to find out the cause of the aurora borealis, and to try to paint similar patterns of colour and light.

• • • • • •
Art and the Math Curriculum

> Schools are typically organized around the linguistic and logical-mathematical intelligences. If a child is strong in these intelligences, success comes easily, but not all children are strong in these areas . . . teachers need to consider all of the intelligences in planning instruction and assessment. Because children learn best when they use their strengths, they need opportunities to use all of the intelligences throughout the day (Hoerr, 1994, p. 30).

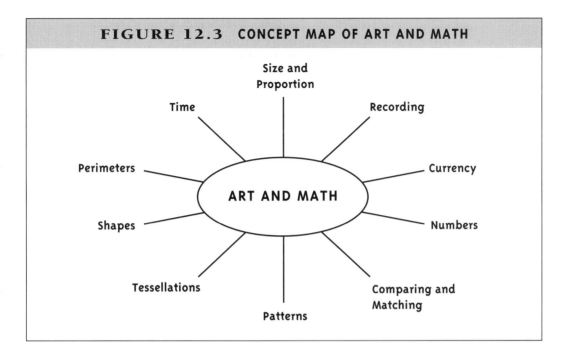

FIGURE 12.3 CONCEPT MAP OF ART AND MATH

Mathematics is intended to help students in organizing and making sense of their world and to provide necessary skills for their future. These are objectives for the art program as well. Both art and mathematics require students to observe, recognize, categorize, and compare, visually and kinesthetically. You and your colleagues can develop connections using a single theme for mathematics and art integration, through brainstorming and using a web or mind-map. According to Kleiman (1991),

> Efforts to integrate mathematics with language arts, social studies, history, art, or music are rare indeed. And as teaching in many subject areas moves toward more process-oriented, holistic, and collaborative approaches, mathematics is often left behind with its traditional workbooks, drills, and texts . . . Many people see mathematics as isolated from other areas of study, irrelevant to everyday life, and devoid of creativity and aesthetics (p. 48).

Some of the themes that appear in elementary mathematics can be successfully integrated with other subjects. In our society, we use mathematics to keep records, allocate resources, make decisions, build, construct, design, play games, and calculate the results of sporting events. "Mathematics has been developed in every culture for the purposes of counting, locating, measuring, designing, playing and explaining" (Kleiman, 1991, p. 48).

The central mathematics themes that follow can all be integrated with art.

- The concept of number, understanding and calculating value (adding, subtracting, multiplying, dividing, fractions, decimals, and ratio), and recording through the use of numerals and symbols.

- Measurement, including length, area, volume, perimeter, capacity, mass, and time.
- Space, including the concept of shape and structure, location, movement, and transformation.
- Classification or recognition of similarities and differences, sorting and comparing.
- Data collection, representation, and analysis of pictorial representations.

The themes in this section can be developed to assist students in gaining a greater understanding, from the concrete or pictorial level to the abstract, using hands-on activities and practical problem situations.

TIME

We use time as a form of measurement and order — the calendar, the seasons, days of the week, holidays. This use of time can be incorporated into art experiences. Students can design cards, clocks, and illustrations for holiday artifacts and celebrations. The theme of time can be further integrated with music, dance, drama, and literature. Students can design their own clock with inventive faces and hands that demonstrate time. They can draw a picture of themselves or others and what they are doing at specific times of the day and indicate the time in the picture.

A study of the history of various cultures can be incorporated into a unit on time — how and when people around the world celebrate various events, and the significance of calendars and the place of holidays. Cultural understanding can be enhanced through songs, poems, dances, and plays related to the passing of time.

SIZE AND PROPORTION

Elementary school children can learn about the concepts of size and proportion by doing body tracings and measuring the results. Students can measure their own height, and measure, for example, shoe size, and then make a class graph of measurements as a way of comparing what they learned. Full-sized student images can be cut out and used in various projects in making discoveries on many topics (see Chapter 11). The body images could be used to create collages, or students could draw or paint their accomplishments and other activities they enjoy onto their image.

As part of an integrated math and science unit, students could plant seeds and draw and measure the plants as they grow. The students could keep a journal of the drawings and measurements and write about their experiences in growing plants.

The concept of proportion can be developed through the use of the grid to enlarge, distort, or reduce (see Chapter 6). Proportion is an interesting topic for integrated studies — body proportions, the size of the head in relation to the length of the whole figure, and portraits with the parts of the head drawn in correct proportion.

RECORDING

Recording information can include drawings, diagrams, graphs, tables, symbols, writings, videos, games, and puzzles. These are forms of communication that provide a way of organizing and recording information in a visual form. Children can produce and interpret graphs or other

forms of recordings on topics such as: the number of children in a family; classmates' birth dates by month; types of housing they live in; favourite sport or subject in school; height of student and family members; or favourite songs, musicians, artists, and television programs.

CURRENCY

Money and understanding currency, especially coins, can become a tactile experience by taking rubbings of the coins. For example, for younger children the question of how many nickels are needed to make change for a quarter could be answered by five rubbings of nickels.

Students can create an extensive project that would give them experience in using money and selling art. A class can be divided into working groups to create toys and art pieces to use as artifacts to set up an art gallery or craft shop. They can price the objects and then either "sell" them in an auction or set up a store. Students could even design and create play money for the project, and the money could be kept in the classroom to be used again for other projects.

If your students' families come from different parts of the world, perhaps they could bring to school currency from other countries. The students can study the shapes and images and create large drawings, paintings, or clay reliefs using the images from the foreign currency.

NUMBERS

Students can use the shapes of numbers in drawings and paintings. They can combine, decorate, elaborate, repeat, and create visual images — stressing colour, positive and negative shapes, and repeated patterns, both regular and irregular. Stamps, stencils, paint, and coloured paper can be used.

CLASSIFICATION

Classification requires recognition of similarities and differences. You can plan art projects based on the concept of classification. For example, have students draw fish in the aquarium — the five yellow ones, the three blue ones, and the one huge grey one. Students can compare the fish, and other objects, for similarities and differences such as their surface texture (smooth/rough), shape (round/square), and their colours (warm/cool). Have your students create mobiles based on one art element such as form or colour, or specific geometric shapes in various sizes and tones of a colour.

COMPARING AND MATCHING

Compare positions of people and objects by looking at paintings or making drawings and paintings that demonstrate beside/between/in front of or over/under/behind. You can provide your students with opportunities to look at and describe objects from different angles by placing still-life objects in the centre of a circle of students. Ask the students to draw and describe what they see, and then move around to a different position and draw and describe the change. Have your students observe the works of others and share what they observed from a different position (Beesey and Davie, 1992).

In large or small groups, discuss pictures, paintings, sculptures, or other art images made by the students or professional artists. Have students sort the artworks by likenesses and

differences; according to theme; according to the use of media and technique, colour, value, line, shape, and texture.

PATTERNS

Students can reproduce, create, repeat, and combine regular, irregular, symmetrical, and asymmetrical patterns and shapes by creating stamp prints or paper cutout coloured patterned designs. Have your students look for patterns in the natural and constructed environment — the pattern of bricks and wood, rings on tree trunks, ripples in the water. Collect pebbles, leaves, or seeds and create patterns from these objects. Find pictures or other objects and images of animals and people parts, or buildings, and classify them as symmetrical or asymmetrical.

Fabric or paper weaving, stitchery, and patchwork quilts illustrate the use of pattern. Collect and sort patterned cloth samples and then students can create their own.

Students can make a mirrored image of their names by printing or writing the name on the upper part of a piece of paper with heavy crayon or thick pastel, then folding the paper and rubbing to get the mirror image of the name. These shapes can be developed into compositions stressing colour, positive and negative shapes, lines, or textures.

Students can use pictures of butterflies, moths, and other insects to study symmetrical patterns. They can draw these or invent their own symmetrical creature-insect. Symmetrical patterns can be made with a sponge, brush, or string, by dabbing or dripping paint or ink onto half of a piece of paper. Fold it in half and rub to produce a symmetrical picture that can be developed into an insect, butterfly, or other invented creature.

Paper can also be folded and cut to create such symmetrical images as hearts, triangles, snowflakes, leaves, and butterflies.

The idea of pattern can be further explored through the use of body movement — hopping, jumping, stepping, and skipping to music with tapping or slapping various body parts (hands, thighs, and feet), or using their voices or musical instruments to create rhythm patterns.

TESSELLATIONS

A tessellation is tiling made up of the repeated use of polygons and other figures to completely fill a plane without gaps or overlapping (Giganti, 1990). The artist M.C. Escher was well known for his use of tessellations. By skilfully altering a basic polygon, such as a triangle or hexagon, he was able to produce intricate tessellations (Maletsky and Hirsch, 1981). Congruent triangles of any shape can be used for a tessellation.

Have students make patterns that tessellate (brick wall, bedspread, patchwork, brick path), using irregular and regular shapes, identifying and creating patterns with shapes. They can select or create different two-dimensional shapes, trace and move the shape to a different position, and trace again.

SHAPES

Geometric shapes such as cylinders, cones, circles, cubes, and rectangles can be drawn and combined to make other forms. Use these forms to produce patterns that are symmetrical or

asymmetrical. Bring geometric shapes into the classroom for students to draw. Ask students to draw objects, animals, and people, simplifying them into geometric shapes in order to understand their basic forms. Relate or identify geometric figures in real-world objects. Construct models from geometric shapes. Reproduce geometric shapes or cubes and use design elements and art media to develop a continuous pattern. Develop a pattern with geometric figures, and create symmetrical compositions with geometric figures.

Creating silhouettes explores the relationship between two- and three-dimensional shapes. With an overhead projector and various shapes, two- and three-dimensional shapes and patterns shown on the screen can be moved, transformed, ordered, and created into various patterns and images (Beesey and Davie, 1992).

FIGURE 12.4 TESSELLATIONS

Tesselations can be made very simple or complex. A plane (flat surface) tessellation is a repeated pattern of one or more shapes that completely covers the plane with no overlapping of the shapes.

Three-dimensional shapes such as boxes, pyramids, and cylinders can be constructed out of paper, cardboard, clay, Plasticine, and plaster. Various sizes and shapes of commercial boxes and other containers can be collected and studied for their shape, function, and decoration.

The three-dimensional form of a box can be pulled apart to investigate it in two-dimensional form. Boxes or other containers can be constructed by the students for specific use, and the surface can be designed to meet specific advertisement and compositional criteria.

PERIMETERS

Measuring the perimeter of shapes — the boundary or edge — encourages students to observe and compare regular and irregular shapes of objects in their environment. Art projects that require the students to measure or observe perimeters can be used to encourage awareness of shapes. Observations can be recorded in a number of ways — drawing and creating models, for example.

You can group students, giving each group a specific area of a mural or large sheet of paper to paint. Also, windows can be measured, divided, and developed into a two-dimensional art piece on a specified theme.

Stained glass windows can be created by painting directly on the classroom window with tempera paint and liquid soap. Cutting shapes out of black construction paper, leaving black lines and taping coloured tissue paper or acetate over the open areas gives a stained-glass-window effect.

Students can develop advertisements for newspapers or flyers on specific merchandise for which the measurements need to be included — such as tablecloths, sheets, picture frames

(Beesey and Davie, 1992). This can become a project more specific to art; for example, producing an art catalogue or article on artists and their work, including the dimensions of their work.

• • • • • •
Summary

This chapter presented themes and units of study for the integration of art with science and mathematics. All three subjects require a great deal of observation. The study of science is the study of all things physical. Science is not merely reasoning; it is using the imagination in a constant experimental process, playing with ideas and materials and, above all, observing, clarifying, classifying, recording, and communicating thoughts, insights, understandings, and ideas.

The science themes discussed in this chapter include the study of the students' world — the seasons, ecology and conservation, maps and map making, animals and birds, sea life, insects, butterflies and moths, amphibians and reptiles, dinosaurs, plants, flowers and trees, physics, and the northern lights.

Themes and units of study were presented for mathematics as it relates to art in elementary school. These ideas included the study of time, size and proportion, recording, currency, numbers, classification, comparing and matching, pattern, tessellations, shapes, and perimeters.

REFLECTION

❶ Make a note of significant questions you wish to discuss or investigate further.

❷ Summarize the insights you gained after reading and discussing the issues presented in this chapter. What new ideas did you discover?

❸ Look at the science and mathematics curriculum guides for your school district, for the grade level you are teaching. What are the main themes and topics? Are there themes and topics not mentioned in this chapter that could be used to integrate with an art study?

❹ Reflect on previous entries in your journal, especially ideas on integrating the study of art with other subjects. Do you feel you have gained greater awareness, new knowledge, or further insight on learning, teaching, and integration? What areas do you want to investigate further?

CLASSROOM PROJECTS

❶ Develop a series of art lessons based on animals, birds, fish, butterflies, or insects. List specific ways you could have students develop art projects on a variety of scientific topics based on this area of the study of animals.

❷ Brainstorm ideas of how you might transform the classroom into a natural environment, such as a jungle, or an invented environment. What do you and the students need to investigate and plan, and what materials will you need?

❸ The regions of Canada have different land forms, animals and birds, and weather patterns. Have your students study these as a class or in groups. What art lessons can you integrate into this unit of study?

..

BIBLIOGRAPHY

Ackerman, D. B. (1989). Intellectual and practical criteria for successful curriculum integration. In H.H. Jacobs, ed., *Interdisciplinary Curriculum: Design and Implementation,* pp. 25–37. Alexandria, VA: Association for Supervision and Curriculum Development.

Allard, M. and P. Howes. (1989). *Integrated Curriculum: Overview and Integrated Units.* Needham, MA: Needham Public Schools.

Beane, J. (1993). Problems and possibilities for an integrative curriculum. *Middle School Journal,* September, pp. 18–23.

Beesey, C. and L. Davie. (1992). *Teacher's Resource Book, Level 2 (3–4).* Toronto: Gage, Educational Publishing Company.

Bronowski, J. (1978). *The Visionary Eye, Essays in the Arts, Literature, and Science.* Cambridge, MA: The MIT Press.

Busch, P. (1975). *The Urban Environment. Grades K-3.* Chicago: J.G. Ferguson Publishing Company.

Clarke, J. and R. Agne. (1997). *Interdisciplinary High School Teaching. Strategies for Integrated Learning.* Boston: Allyn and Bacon.

Devito, A. and G. Krockover. (1976). *Creative Sciencing, Ideas and Activities for Teachers and Children.* Boston: Little, Brown and Company.

DiNapoli, A. (1989). *Integrated Curriculum: Overview and Integrated Units.* Needham, MA: Needham Public Schools.

Drake, S. (1991). Our team dissolved boundaries. *Educational Leadership,* 40 (5), pp. 20–22.

Eisner, E. (1983). The kind of schools we need. *Educational Leadership,* October, pp. 48–55.

Galle, J. and P. Warren. (1989). *Ecology Discovery Activities Kit. A Complete Teaching Unit for Grades 4–8.* West Nyack, NY: The Centre for Applied Research in Education.

Gates, J. (1989). *Consider the Earth. Environmental Activities for Grades 4–8.* Englewood, CO: Teacher Ideas Press.

Giganti, P. (1990). The art of tessellation. *Arithmetic Teacher,* March, pp. 6–16.

Gottlieb, J. (1986). *The Wonders of Science, Land Animals.* Austin, TX: Steck-Vaughn Company.

Hickman, P. (1990). *Bugwise.* Toronto: Kids Can Press.

Hoerr, T. (1994). How the new city school applies the multiple intelligences. *Educational Leadership,* November, pp. 29–34.

Hurd, P. (1991). Why we must transform science education. *Educational Leadership,* October, pp. 33–35.

Jacobs, H. (1989). *Interdisciplinary Curriculum: Design and Implementation.* Alexandria, VA: Association for Supervision and Curriculum Development.

Jennings, T. (1986). *The Young Geographer Investigates, Tropical Forests.* Oxford: Oxford University Press.

Johnson, D. (1957). *Paper Folding for the Mathematics Class.* Washington: National Council of Teachers of Mathematics.

Jurek, D. and S. MacDonald. (1989). *Discovering the World. Biological Science.* Allen, TX: DLM Teaching Resources.

Katz, P. (1990). *Exploring Science Through Art.* New York: Franklin Watts.

Kelly, B., R. Wortzman, J. Cornwall, B. Nimigon, A. Maher, and M. Jagt. (1986). *Math Question Two, Program Manual.* Don Mills, ON: Addison-Wesley.

Kleiman, G. (1991). Mathematics across the curriculum. *Educational Leadership,* October, pp. 48–51.

Klots, A. and E. Klots. (1975). *Living Insects of the World.* Garden City, NY: Doubleday and Company.

Koehler, C. and A. Koehler. (1985). *Answers about Insects.* New York: Wonder Books.

List, L. (1982). *Music, Art, and Drama Experiences for the Elementary Curriculum.* New York: Teachers College, Columbia University.

Maletsky, E. (1981). Designing with Tessellations. In E. Maletsky and C. Hirsch, eds., *Activities from the Mathematics Teacher,* pp. 59–62. Reston, VA: National Council of Teachers of Mathematics.

Nachbar-Hapai, M., and L. Burton. (1990). *Bug Play: Activities with Insects for Young Children.* Menlo Park, CA: Addison-Wesley.

Peck, R. (1973). *Art Lessons that Teach Children about Their Natural Environment.* West Nyack, NY: Parker Pub. Co.

Romey, W. (1980). *Teaching the Gifted and Talented in the Science Classroom.* Washington, DC: National Education Association.

Richards, R. (1990). *An Early Start to Technology.* London: Simon and Shuster.

Sarkissian, J., F. Marsh, R. Connelly, T. Calkins, D. Davis, D. Drost, B. Johnston, R. Johnson, and A. Olsen. (1975). *Mathematics Through Paper Folding.* Reston, VA: National Council of Teachers of Mathematics.

Short, K. and C. Burke. (1996). Examining our beliefs and practices through inquiry. *Language Arts.* Vol. 73, February, pp. 97–104.

Talley, K. (1994). *The Art and Science Connection: Hands-on Activities for Intermediate Students.* Menlo Park, CA: Addison-Wesley.

Thompson, K. (1995). Maintaining artistic integrity in an interdisciplinary setting. *Art Education,* November, pp. 38–45.

Tossell, S. (1987). *Journeys in Math 1. Teacher's Resource Manual.* Scarborough, ON: Ginn and Company, Educational Publishers.

Wood, R. (1990). *Physics for Kids, 49 Easy Experiments with Optics.* Blue Ridge, Summit, PA: TAB Books.

Woodman, A., and E. Albany. (1992). *Mathematics Through Art and Design: 6–13.* London: Collins Educational.

Integrating Visual Art with Music, Drama, Dance, and the Study of Cultures

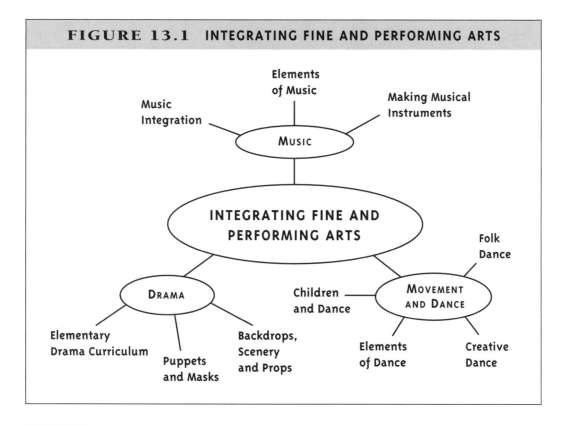

FIGURE 13.1 INTEGRATING FINE AND PERFORMING ARTS

Elements of Music

Music Integration

Making Musical Instruments

MUSIC

INTEGRATING FINE AND PERFORMING ARTS

DRAMA

Children and Dance

MOVEMENT AND DANCE

Folk Dance

Elementary Drama Curriculum

Puppets and Masks

Backdrops, Scenery and Props

Elements of Dance

Creative Dance

• • • • • •
Introduction

If you were to take a trip around the world, you would find diverse forms of music and folk dancing almost everywhere. You would discover that the sounds and movements are distinct in various countries — the music of African countries has a unique sound as does the music of Britain, for example, and their folk dances also differ due to their environmental influences.

It is through the arts that cultures demonstrate their distinction from one another and their similarities, their cultural group's norms, values, and beliefs. In traditional societies the arts,

241

BOX 13.1 ABOUT PLAY

It is in playing and only in playing that the individual child or adult is able to be creative and to use the whole personality, and it is only in being creative that the individual discovers the self" (Nachmanovitch, 1990, p.50).

"The most potent muse of all is our own inner child. The poet, musician, artist continues throughout life to contact this child, the self who still knows how to play" (Nachmanovitch, 1990, p. 47).

rituals, and ceremonies were an integral part of educating and socializing the young. "The arts appeal to a broad range of learners and are seen by many as key to connecting what children learn in one subject with what they discover in another. The arts provide this as no other subject can" (Cortines, 1995, p. 3).

The arts are based on symbolic thought, which combines sensation, feeling, and reason to create objects and performances. The arts are our way of organizing experience in an effort to understand and communicate through words, images, numbers, gestures and sounds. Education in the arts — visual art, drama, movement and dance, choral and instrumental music — helps children become more perceptive and helps them communicate with greater ability and confidence. "The arts, like the sciences, are symbolic systems that convey meaning about the world. The great thinkers of any age do not express themselves solely by the written word" (Fowler, 1989, p. 62).

The visual arts touch all elements and aspects of a culture and the people within the culture. Therefore children need to experience the arts as part of their education.

This chapter discusses curriculum concepts for music, drama, movement, and dance and explores how they can be integrated with visual arts. We also include a section on types of art and how art is used in our society.

••••••
Art and Music

Recent educational research shows very convincingly that there is nothing quite like music to stimulate learning of all kinds and to reach the multiple intelligences of our young. . . . In some schools the introduction of music integrated into the entire curriculum has literally transformed the quality of education and the lives of the children in them (Boston Public Schools, 1993, pp. 1 and 3).

Educators have come to realize the importance of music in the total development of children and that their aesthetic appreciation for music coincides with perceptive understanding of "the inner workings of music" (Beer and Hoffman, 1973, p. 144). Music is a social activity that gives a sense of belonging to a community, a sense of history and cross-cultural understanding.

Many different approaches to music education have been developed, based on Dalcroze Eurhythmics, the Kodaly method, the Orff approach, or various combinations. Dalcroze Eurhythmics involves bodily response to music and requires attentive listening.

FIGURE 13.2 MUSIC EDUCATION CONCEPT MAP

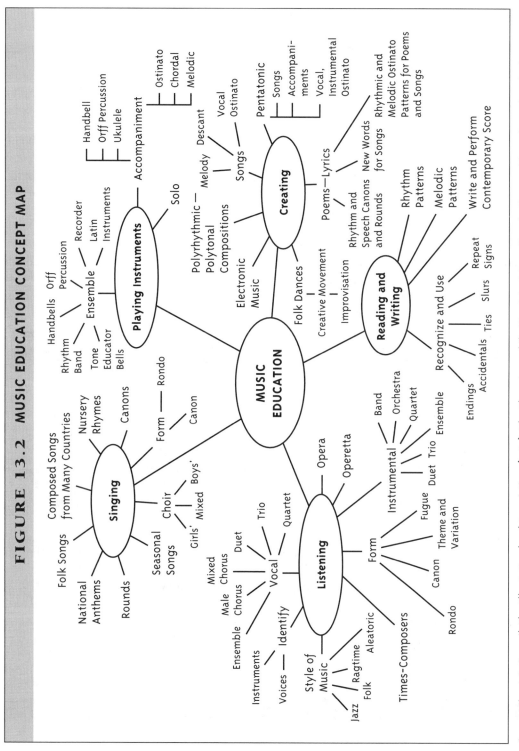

Source: Fine Arts Council, The Alberta Teachers' Association. (1987). *The Olympics and the Fine Arts: Integrating the Fine Arts Through an Olympic Theme.* I. Naested, C. Marshall, L. Bolton, and G. Johnston, contributors. Edmonton: Barnett House. Reproduced with permission.

The child's body is used as a musical instrument to interpret sounds. This procedure is called eurhythmics. Rhythmic sense and voice and body coordination are learned simultaneously through the synchronization of body movement and music (Bayless and Ramsey, 1978, p. 171).

With the Kodaly method, children are first taught singing and rhythmic games; they sing without instrumental accompaniment. A child's voice is the first and most important instrument, and there are hand signals for each tone of the scale as the children sing.

The Orff approach was originally intended for use with adults in gymnastics and movement classes. The method begins with simple rhythms, chanting, and improvised simple sound patterns using four basic body movements: clapping, snapping, slapping the legs, and stamping (Beer and Hoffman, 1973). Students improvise their own accompaniment with special instruments, mainly percussion, for their dances and routines.

Within the study of music, students may take on the role of listener, evaluator, consumer, historian, performer, and composer. Music stimulates development through listening, singing, reading and writing, creating music, and moving. Just as the visual arts have elements of composition, so does music. Composition in music includes dynamics, tone colour, tempo, duration/rhythm, pitch, texture, form, and style (Staton, 1988).

BOX 13.2 DEVELOPMENT OF JAZZ

The development of jazz affected the evolution of music today and gave roots to rock-and-roll and rap. Lori Teneycke, a music and art teacher at University Elementary School, created this integrated unit of study for her students in grades four to six. They discussed the history of jazz and how it influenced the music of today — jazz through time in the United States, from the African American plantation slaves to rock n' roll.

In addition to having specific learning and experiences in music, art, and dance, students could select one of the following topics to research and report back to the class. Their presentation could take many forms: a play, story, poem, talk show, pantomime, puppet show, song, news program, cartoon, invention, news game, T.V. program, book, tape recording, panel discussion, survey, diagram, commercial, report, chart, mobile, sculpture, diary, scrapbook, pictures, court trial, editorial, model, or diorama.

i. Jazz Personalities

Students researched selective personalities, which included: W. C. Hand, Miles Davis, Scott Joplin, Irving Berlin, Jelly Roll Morton, Al Jolson, Louis Armstrong, Glenn Miller, Benny Goodman, Sophie Tucker, King Oliver, Bessie Smith, Ella Fitzgerald, Lionel Hampton, Count Basie,

(continued)

(continued)

Duke Ellington, Tommy Dorsey, Gene Krupa, Bix Beiderbecke, Dizzy Gillespie, Billie Holiday, Woody Herman, Dave Brubeck, Oscar Peterson. They created biographies, described the music of the various composers, explained their contributions to the evolution of jazz, acquired examples of their music, and wrote personal reactions to the music.

2. Era of Jazz — Dances and Instruments of Jazz

Students could choose a specific era of jazz to research, such as ragtime, dixieland, swing, big band, be-bop, cool jazz, modern, latin, blues, funk. Students could create dances of jazz after investigation, research, and viewing such dances as the Lindy Hop, jitter bug, Charleston, tap and swing, or the various instruments of jazz.

3. New Orleans — Birthplace of Jazz

Architecture, cultures, music, food, costumes, Mardi Gras, Bourbon Street, French Quarter — create a travel brochure, a guided tour using pictures. Discuss various points of interest.

4. Music Careers

Research careers; for example, composers, arrangers, or occupations or businesses directly connected with music — artist, manager of music store. Create want ads, applications, promotion.

5. Jazz Collage

Create a jazz collage. Collect and draw pictures of jazz personalities, instruments, and music. Consider elements and principles of design.

6. Short Story

Write a short story or a poem and illustrate it with jazz images.

7. Radio or TV

Write a radio or TV program on a jazz personality. Write and perform a dialogue between a jazz artist and an interviewer, or a jazz artist and a rock performer, each praising his or her own musical style.

8. Time-Line

Create a jazz time-line, of events in history, inventions, dress and hair styles, or communication (radio, record players, etc.) Visually represent this time-line.

9. Jazz Band

Create a jazz band. What kinds of instruments will be needed? Who is the leader or director? What will be the name of the group? Design a record album cover. Create a vocal imitation of instruments playing jazz. List sounds of instruments and then experiment with vocal sounds.

10. Jazz Vocabulary

Create a jazz dictionary or glossary. Develop a crossword puzzle or challenging word search.

11. The Year 2020

Predict how pop music will sound twenty or more years from now. Based on present technology, what kinds of instruments will be popular in the year 2020?

ELEMENTS OF MUSIC

Rhythm

Rhythm is the beat, which moves steadily, evenly, or unevenly, strong and weak, in groupings of long and short sounds and silences to form rhythm patterns. Students may clap and tap to music.

You can help students experience the rhythm by creating a visual graph with line, colour, or shape to represent the musical composition or rhythm patterns. Interpret the beat through movement and then allow students to move into doing a large painting using full arm extensions, like a Jackson Pollock painting.

Texture

Texture is the thickness or thinness of musical sound formed when different pitches are played or sung together, just as lines in art can be drawn or painted thick and thin, or overlapped to create texture. Sound may be sequenced from (pitch) high to low, and from low to high, or stay the same. An interval is the space between two sounds and gives shape or contour to a melody. Harmony occurs with two or more sounds.

Have your students create a visual composition, pattern, or graph representing the contour or shape of the melody.

In another integrated unit, have your students create different melodies by making different sizes of clay pinch pots or cylinders (these pots will need to be fired). Students can experiment with the sizes and shapes of the clay pots, and the sounds that can be created with them.

Form

Music is organized into sections or phrases that are repeated — a verse and chorus — and have a beginning and an ending. Repetition and contrast in music, as in the visual arts, give unity and variety to the form.

Students can develop paintings, collages, relief pictures, and stamp prints depicting specific form, with repetition and contrast. They can identify or collect objects and materials that represent repetition and contrast.

Expression

Expression in music includes tempo (fast and slow, active and tranquil), dynamics (loud and soft), and tone colour (sound that is special to each in speaking, singing, instrumental, and environmental sounds). Contrast in music is expressed through the variety of expression.

Students can illustrate these aspects of music through dance, movement, dramatics, or painting. A good way for students to experience the similar qualities of music and visual art is by listening to music, and then choosing a medium that feels right for interpreting how the music affects them, and working with those materials while they are absorbed by the music.

MUSIC INTEGRATION

Investigate or discuss with your students the similarities and differences of the use of these terms as they relate to the fine and performing arts: colour, shape, space, line, expression, texture, form, and pattern.

Music and the social studies go hand in hand. Special days and holidays are celebrated with music. People and their activities are studied, as is the community . . . Family groups and community groups build meaning into observances and festivals of all kinds (Bayless and Ramsey, 1978, p. 95).

Order, categorization, numbers, and counting coincide with songs that build memory based on sequencing. There are many children's songs and nursery rhymes that include numbers such as "One, two, buckle my shoe" (Bayless and Ramsey, 1978, p. 78).

Making Musical Instruments

Music begins with sound, and children can make music by making air move — in other words, vibration. The methods include strumming stretched rubber bands and blowing through a toothed comb covered with wax paper. To make chimes, the children can tap on water glasses holding varying amounts of water. Wooden dowels or spoons can be used as instruments for tapping.

Maracas were originally made from dried, hard-shelled fruits or gourds (Hayes, 1981). You can teach children to make maracas with papier-mâché moulded over a balloon or light bulb. If you use a light bulb, gently drop the dried papier-mâché bulb on the floor and the broken glass will be the rattle. If you use a balloon mould, put seeds, rice, or beads into the balloon before it is blown up to make the rattle. Shakers can be constructed from two paper plates stitched or glued together with seeds or rice inside.

FIGURE 13.3 MUSICAL INSTRUMENTS

All these instruments can be made from clay.

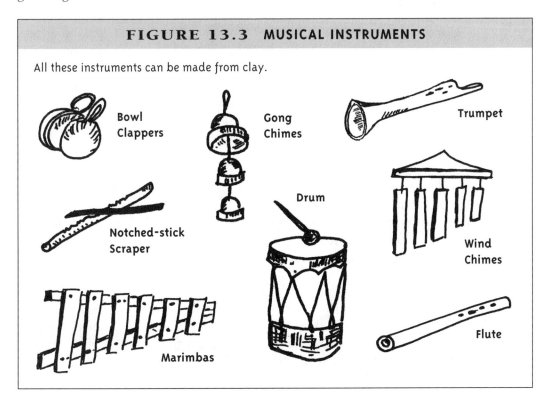

Bowl Clappers

Gong Chimes

Trumpet

Notched-stick Scraper

Drum

Wind Chimes

Marimbas

Flute

BOX 13.3 STIMULI

The mind can be stimulated into action by sound, by light patterns, paintings, and objects. Children can create stimulating artifacts, or these can be brought into the classroom. Patterns and paintings can be made and then interpreted or expressed again in movement. Poetry and prose can be used the same way. With a creative approach, the essence of the materials can be understood and so the experience becomes stimulating (Leese and Packer, 1980, p. 52).

A kazoo can be constructed from a cardboard tube. Cut four finger holes into the tube and tape plastic or wax paper onto the end opposite the blowing end (McLean, 1988). Recorders can be made from simple garden hose or moulded from clay. String instruments can be made from boxes, or other shapes constructed of cardboard, wood, or clay.

Drums were originally made from hollowed out logs that were later covered with animal skins to make the drum head. Drums have been made from other materials such as clay, wood, metal, and turtle shells. Students can construct their own drums from tin cans, wood, or clay, and the head can be made from canvas and decorated with personal symbols and colours.

• • • • • •
Art and Drama

Drama in the elementary classrooms is focused on the development of play, structured dramatic play, and forms of expression, including moving and speaking. These may include mime, storytelling, choral speech, story theatre, and dramatization, with the possibility of using puppets and masks.

Dramatic movement involves the students in physical, intellectual, and emotional activity and provides a basis for physical communication. Movement ranges from simple movement activities stimulated by sound and rhythm to the communication of feelings, ideas, and characters (Alberta Education, 1985). Dramatic movement themes and activities can be used as a motivational springboard to expressions in the visual arts and vice versa.

Skills that are developed through dramatic play include relaxation, cooperation, spontaneity, spatial awareness, imagination, emotional awareness, expression and control, concentration, confidence in self-expression, reflection, and appreciation. All of these skills are of benefit to the students; they cross over and integrate with art and other subjects. Literature and investigations in social studies about cultures and social issues can become the stimuli for creative movement and theatre.

The study of animals introduced as an art or science topic of investigation can be a source for further study and expression through mime. Mime is a silent dramatic art form that uses the body as the method of communication. Mime can be further explored and expressed in the area of human feelings, similarities and differences, and opposite feelings such as love and hate. You can introduce these themes in art, language arts, or social studies.

Storytelling is the dramatic art of giving life to words by employing expression, sound,

pacing, and moments of quiet to stimulate the interest and imagination of the audience about the plot and characters. Storytelling can be a natural form of integration with all curricular investigations; puppets and masks can also be used to tell a story.

Given the opportunity, children can become expert storytellers, especially when they can use puppets to represent the characters. Choosing favourite stories and telling them, with dramatization, is an excellent integrated activity that crosses the usual boundaries of separate disciplines.

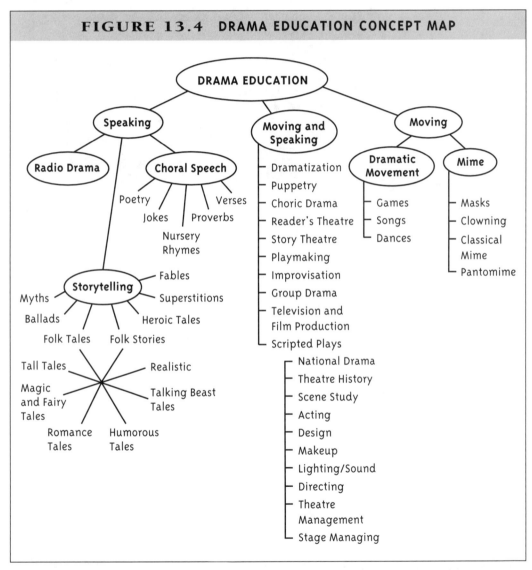

FIGURE 13.4 DRAMA EDUCATION CONCEPT MAP

Source: Fine Arts Council, The Alberta Teachers' Association. 1987. *The Olympics and the Fine Arts: Integrating the Fine Arts Through an Olympic Theme.* I. Naested, C. Marshall, L. Bolton, and G. Johnston, contributors. Edmonton: Barnett House. Reproduced with permission.

PHOTO 13.1 Puppet show

PUPPETS AND MASKS

The use of puppets and masks in the elementary classroom comes with a variety of philosophies and techniques. Consideration of the age level of the students and amount of time you plan to set aside for creating the puppets and masks should determine the type and materials for construction, from simple sock puppets to marionettes, from paper bag masks to papier-mâché, full-body constructions.

Masks and puppets can be created to illustrate a theme such as farm animals, trees, or characters who tell stories about real-life situations, as well as fantasy, myths, and legends, and classic children's stories or stories to illustrate a lesson.

"There is a place for puppets in every child's life. Children are naturally drawn to puppets and never tire of playing with them or watching them perform" (Hunt and Renfro, 1979, p. 20). According to Hunt and Renfro (1979), there are many values attributed to creative puppetry that include enhancement of positive self-concept, encouragement of language development through verbal expression, an acceptable avenue to release emotions, building cooperation and social skills, and enabling children to experience and express life situations. Chapter 9 discusses mask and puppet making.

BACKDROPS, SCENERY, AND PROPS

Backdrops and stages can be made from large cardboard boxes or sheets of cardboard or cloth over a desk. Scenery pieces are objects such as trees, chairs, and tables, which are necessary to

the action of the play or help set the scene. Stage sets include found pieces or those constructed from cardboard and other material.

Props are objects that can be picked up, handled, and used by the student-actors or the puppets to enhance the scene, setting, or story. Objects as simple as a stick can be used. Props can be created using various art materials — paper, papier-mâché, plaster, or clay. These sculptural materials are discussed in Chapter 9.

Art, Dance, and Movement

> Beginning with the first breath and ending with the last, humans move, and from the expressive urges of that movement, dance is born Throughout the span of human existence, dance has been a part of the life of every tribe, society and culture (Fowler, 1977, p. 2).

Before formal education, especially in tribal societies, children learned from their elders the skills necessary for life as adults. Among these skills was dancing, which was an integral part of human life (Exiner and Lloyd, 1974). Dance is a social activity that makes connections by externalizing the internal, a social act engaging the individual in group dynamics (Fowler, 1977).

Dance is cultural. It reinforces lifestyle, and the ethnic fibre of the people is captured in the styles of movement they invent, symbolizing the great ecstasies and tragedies of mankind (Fowler, 1977, p. 8). According to Jensen and Jensen (1973), in the past people usually gathered together for planting or harvesting, house warmings or weddings, and dancing became an integral part of the occasion.

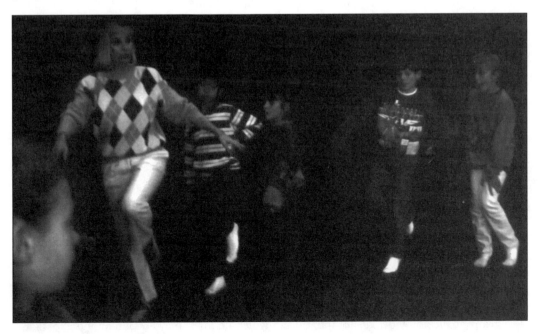

PHOTO 13.2 Dance

CHILDREN AND DANCE

Children do not start learning to dance by first practising a certain step as adults do. According to Joyce (1984), children start by dancing first, and filling in the technical details later as they progress. This is similar to experiencing art media through experimentation and manipulation; elements and principles of composition are taught along the way.

Dance can become a part of many visual arts projects. For example, in your unit on the four seasons, students can develop dances in response as part of a unit on storms, or clouds on a summer day, or the robin's first song in spring. At the same time, these are also appropriate subjects for paintings.

ELEMENTS OF DANCE

The elements of dance — sound, movement, line, pattern, form, space, shape, rhythm, time, energy — are common concepts underlying many subjects, including the visual arts. According to Fowler (1977), "Dance therefore contributes to a better all-around education" (p. 11).

Dance combines the basic movements of the body — extension, contraction, and twisting of the whole body or isolated parts, produced in different relationships — to convey an expression (Leese and Packer, 1980).

The basic concepts related to rhythm study are: pulse — the regular, even, underlying beat; pattern — the combination of longs and shorts, or slows and quicks; accent — placing stress on one beat or movement and phrase, a sentence of sounds (Joyce, 1984).

Locomotor means going from one place to another as opposed to axial or on-the-spot movement. Some basic locomotor steps include walking, stepping, marching, stamping, running, leaping, hopping, jumping, skipping, galloping, and sliding (Joyce, 1984).

Styles of dance include dramatic dance (usually involving a story), lyrical dance (emphasizes spatial aspects and qualities), social (ballroom and disco are two) and jazz dancing, stage and tap dancing, and religious or liturgical (dance as a form of worship or as an expression of religious feelings or beliefs or stories). Folk dancing from many cultures can be taught to children as part of learning about other countries and helping to achieve a class spirit (Leese and Packer, 1980).

CREATIVE DANCE

The body is a sensitive receptor of impressions; however, in our "modern" society few people respect these physical attributes (Exiner and Lloyd, 1974). Experiences with creative dance or movement develop the kinesthetic senses, the senses of movement, perception, and expression. The basic principles governing movement, according to Exiner and Lloyd (1974), are generally force (strength, lightness, weight, balance); space (shapes and pathways); time (rhythm, speed, and duration); dynamics (instantaneous or gradual release of force, swinging, vibrations); and fluency (freedom and restraint). These elements and principles are used in the visual arts and therefore support the planning of integrated themes.

Creative dance provides one of the ways in which children may encounter and experience

BOX 13.4 MOVEMENT STUDY

AUTUMN — TRANSFORMATION OF SHAPE — LEAVES

This lesson, developed by Lowden, is presented here slightly simplified.

Observe an autumn leaf. Draw and describe the shape, exploring words: wilted, twisted, curled, warped, crinkly, wrinkled, holed, sharp, brittle, jagged, rolled. Match the shape with body shape, change the front, point of view, level, and place. Imagine the leaf further decayed and add this shape. Imagine the same leaf in early summer and find words to describe it. Refine the sequence. Create a group study, observe, and refine, and create a sound sequence to accompany the study (1989, p. 100).

language by using two-worded pictures, such as swirling and settling, floating and flying. Words can be grouped to provide a rich source of dance material — strong and light words, sad and happy words, quick and slow words; (run and slither) action words that are used to indicate travel, turning, contracting, rising, vibrating, stopping or freezing, expanding or growing, jumping or leaping; percussive actions such as pounding; and sinking actions and collapsing (Boorman, 1973).

Poetry, especially poems that suggest moving images, can also be integrated into dance. Action words and poems can be used as a stimulus for creative dance; dance can be used as a stimulus for creating in the visual arts. Conversely, painting and sculptures can become motivational devices for dancing.

FOLK DANCING

Folk dance, in its broadest sense, is the form of dance of the ordinary people, not professionals, to meet a variety of personal and social needs. According to Jensen and Jensen (1973), the language of folk dance is common throughout the world and therefore helps people scale international barriers. When you introduce folk dancing, students can investigate costumes worn for dancing as a way of broadening their understanding and appreciation of a country and its history.

Folk dancing is an integral element in the study of culture. Your students can benefit from the multicultural characteristics of our country by learning some of the folk dances of the cultures they investigate, possibly cultures of some of the students in your class.

• • • • • •
Art and the Study of Culture

Social studies curricula at various grade levels include the study of a particular country, and its society and culture. Often societies are studied in isolation without including a study of their art. Because the arts reveal the culture of a people, the study of a society and its culture cannot be undertaken effectively without exploring the fine and performing arts. Studying the different kinds of art and its uses in our society is part of understanding ourselves. You might want to research with your students the different types of art we describe briefly in this section, and also the way we use art in our society.

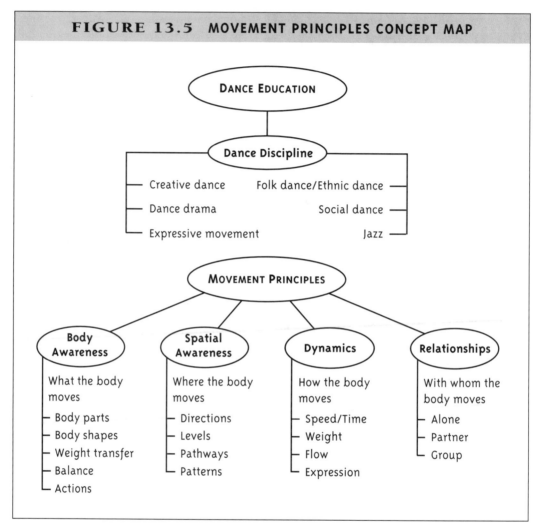

FIGURE 13.5 MOVEMENT PRINCIPLES CONCEPT MAP

Source: Fine Arts Council, The Alberta Teachers' Association. (1987). *The Olympics and the Fine Arts: Integrating the Fine Arts Through an Olympic Theme.* I. Naested, C. Marshall, L. Bolton, and G. Johnston, contributors. Edmonton: Barnett House. Reproduced with permission.

HIGH ART

High art can be classified as classical. In high art, the work involves a division of labour and art is produced by artists for an elite or dominant class. Religious art can be considered high art because many works were commissioned for the Catholic Church; for example, Michelangelo's Sistine Chapel ceiling paintings (1508–12). Since high art is produced for an elite class or institution, institutional patrons influence the artist's work.

The work is classical in the strict sense, in that it shows a standard of excellence, manifested in the periods of highest culture in ancient Greece and Rome. However, the term is also

extended to later works of art regarded as models of excellence. The term is used for art that has lasted the test of time, criticism, political pressure, religious sanctions, and written history.

RELIGIOUS ART

Religious art (religio-art), which includes images or artifacts created for a particular system of faith and worship, is often used as part of worship. Most religions throughout the world use art forms in some manner. Religio-art exhibits the spiritual characteristics of religion: pious, godly, god-fearing, devout, sacred. Religious artifacts are often believed to communicate or enhance communication with the spiritual world.

Artifacts used in rites of passage are often incorporated into religious ceremonies: in situations such as funerals for the dead, the celebrations of birth and marriage, and the transition into adulthood.

Throughout history, art has been used as a powerful and effective teaching tool for the masses. The Christian Catholic and Protestant religions were among the many religions that used the visual arts, but limited artists' creative expression until the early twentieth century. Artists then began taking greater artistic freedom, and this development can be seen in works found in religious settings. These include the works of Georges Rouault, Henri Mattisse, Paul Bercot, and others.

FOLK ART

Folk art is produced in every part of the world. It should not be considered a lower form of sophisticated art because it has its own vibrant traditions. The broad designation for this artistic expression lies within the folk cultures and environments in rural or peasant communities. Expression is not hindered by religious or political dogma, but religious scenes are often presented along with local customs. Communities isolated geographically from large centres of culture develop a continuous artistic tradition outside of trends and fads. Objects and decorations are made in a traditional fashion by artists who do not have formal training.

The skills, methods, techniques, and subject matter of the artifacts produced are often passed on from generation to generation. Patterns and designs persist with little alteration. However, sometimes folk artists improvise and adapt images, themes, and decorative motifs that might have lost their original meaning. Folk art includes a variety of media — wood-carving, clay, embroidery, lace, basketwork, beadwork, and found objects.

ETHNOGRAPHIC OR "PRIMITIVE" ART

Art created by peoples who have no written language and whose social organization is tribal is called ethnographic. For some people, the use of the word "primitive" suggests that the art is aesthetically or technically inferior, although this is not true. Because of the connotation, however, the term "ethnographic" is used instead of "primitive." This term includes art in cultures not dominated or influenced by the centres of Western European and Eastern civilizations; for example, art from the Sahara of Africa and the peoples of the Pacific Islands. The cultures in these vast regions were nonliterate, but they maintained a sophisticated oral history, through storytelling, myths, dance, dramatization, movement, music and sound, and two- and three-dimensional artworks.

The primitive environment is not comparable to the folk environment. Primitive art draws more on the natural environment, as can be seen in the motifs and symbols that depict such elements as the forces of nature, wildlife, or game animals. Primitive artists interpret rather than imitate their subjects, and they create images often believed to contain the spirit of an animal, ancestor, or god. The spiritual link of ethnographic art is very strong. Sculpture (in clay, wood, stone, and bone), weaving, and architecture were significant in the primitive societies and had profound influence on the art of Europe around the turn of the twentieth century.

POPULAR ART

Popular art is appreciated by a large portion of the culture at one point in time, and is often initiated by the youth of the culture; for example, graffiti and other images in public places drawn by artists who might not have formal training. Mass art, art appreciated by a large percentage of people and subject to changing tastes, is often mass-produced. Christmas cards, coronation plates and mugs, and Elvis Presley postage stamps are in this category.

ARCHITECTURE

Architecture includes all environments built and designed by humans for various purposes, such as housing or shelter, as well as government and religious buildings. Generally, societies develop distinct styles and use whatever construction material is available. At times architects borrow styles and ideas and use building materials from other regions. For example, architects of the Parliament buildings and Canadian Pacific hotels borrowed many ideas from the Greeks and Romans.

FUNCTIONAL ART

Functional art includes the practical and utilitarian arts — the furnishings of the buildings, ornaments, tools, and utensils used in everyday life of the culture. To be considered an art form, the work must not only be functional but must also be aesthetically pleasing to look at and to touch or hold.

During the 1930s a school of design called the Bauhaus began using the term "functional" to describe utilitarian design for furniture and other domestic equipment.

BODY ADORNMENT

Body adornment includes designing and making clothing, the function of clothing, clothing decoration, headdresses, jewellery, masks, and body decorations such as tattoos, body piercing, hair colouring, and body painting.

PATRIOTIC ART

Patriotic art forms are used for political purposes and propaganda, and as a part of social issues and environmental concerns. The purpose of propaganda is to further any opinion, creed, or practice; and it is marked by devotion to a cause or the well-being and interests of one's country. Patriotic artists passionately and self-sacrificingly exert their efforts for the freedom and

rights of their country. For instance, patriotic art was used to encourage people in Canada and the United States to enlist in the two World Wars.

ADVERTISING ART

To advertise is to attempt to attract attention to something; usually in our society, it is to influence people to make a purchase or to do a particular thing. An advertisement can be an oral, a written and/or visual statement calling attention to a notice. Advertising art is used for commercial purposes, for packaging and for sales promotion, in posters, billboards, television, business cards, letterheads, and logos. The landscape is filled with commercial artists' images on roadsides, buses, bus stops, and buildings. Some contemporary artists use the methods and techniques of commercial advertising in their art, as a way of calling attention to the power of advertising in our society.

COMMUNICATION ART

Communication art is different from advertising and popular art because it is intended to communicate a specific message. This is a category of art that enhances communication of a culture, sub-culture, or family grouping and can be seen in the form of postcards, stationery, special-event cards, comics, journals, television, and newspaper layout and design.

MILITARY ART

It is unfortunate that human artistic endeavours also include art as part of aggression. Throughout history, humans have decorated their instruments, tools, and weapons for protection, defence, and aggressive acts. The swords, shields, and armour were designed to be not only functional but also fierce. Hunting tools or equipment are not a part of military art.

SPORTS ART

Sports art includes the planning, design, shape, and colour of the team uniforms, masks, head-gear and logo — not the protective elements of the apparel, or the art of the sport, but the pure design elements. Many factors are given attention when designing sports equipment, such as the use of signs, symbols, logos, and images. Emotional and psychological use of images and design elements and principles such as line, shape, and colour are major considerations.

EXHIBIT 13.1 Sports art

• • • • • •
Summary

The fine and performing arts touch all elements and aspects of a society. The arts give a sense of belonging to the community and foster a sense of history and cross-cultural understanding.

Different approaches to music education in the elementary classroom have been developed, largely based on Dalcroze Eurhythmics, the Kodaly method, and the Orff approach. Studying music allows students to experience the elements of rhythm, texture, form, and expression. Music and visual art overlap in their expressions to create interpretations of life experiences. As part of music experiences, students can make instruments using a variety of materials.

Drama in the elementary classroom focuses on the development of play, dramatic play, forms of expression, movement, and speaking. Themes in storytelling, readers' theatre, mime, and the use of puppets and masks, backdrops, scenery, and the stage can be integrated with the visual arts.

Children have a natural inclination for dance, and they learn techniques after they have begun dancing. Similarly, they learn to create by using visual arts media. Through understanding and practice, elements in both dance and the visual arts can be refined.

In our society, the arts not only interpret but also transmit culture in the following forms: high art, religious art, folk art, ethnographic or primitive art, popular art, architecture, functional art, body adornment, patriotic art, advertising, communication art, military, and sports art.

REFLECTION

❶ Record in your journal questions you wish to discuss or investigate further, as well as insights you gained from this chapter.

❷ Look at the drama, dance, and music curriculum guides for your school district for the grade level you are teaching. What are the main themes and topics? Are there themes and topics that could be used to integrate with an art study that were not mentioned in this chapter?

❸ Reflect on previous entries in your journal, especially ideas on integrating the study of art with other subjects. Do you feel you have gained greater awareness, new knowledge, or further insight into learning, teaching, and integration? Do you have further questions?

❹ Form a discussion group and brainstorm possible themes, issues, or concepts that might serve as a focal point for a unit of study. Then choose one of the suggestions and develop a mind-map to visualize how the various subject areas might be integrated.

❺ In a discussion group, share ideas for initiating activities that would motivate or capture students' excitement and interest when starting a unit of study that centres on one of the art themes.

❻ Create a curriculum wall or concept map of art, drama, dance, and music and make connections.

❼ Choose a theme and create an integrated unit of study for art, drama, dance, and music.

❽ Canada is often referred to as a multicultural society, while the United States is a melting pot. What does this mean? Does this affect what Canada does or should do with regard to their immigration policy, education of E.S.L. students, or support for cultural groups? What does this mean for the fine and performing arts in your community? What does this mean to you?

CLASSROOM PROJECTS

❶ Divide your class into groups and ask each group to develop a painting in their creative movement or dramatic movement class.

❷ Have students create artworks based on the theme of machines. They can study the design of machines, create machine sounds, and perform dramatic and creative movement based on machines. They can also do drawings of their ideas for machines, perhaps using as a reference Leonardo da Vinci drawings.

❸ Have students do research on the war artists who worked during World War II to discover the part artists played in recording that part of our history. They could then choose a painting by one of the war artists — Charles Comfort, Alex Colville, Carl Schaefer, and others — and write a story based on the images.

BIBLIOGRAPHY

Alberta Education. (1985). *Elementary Drama Curriculum Guide.* Edmonton, Alberta.

Bayless, K. and M. Ramsey. (1978). *Music, A Way of Life for the Young Child.* Saint Louis: The C. V. Mosby Company.

Beer, A. and M. Hoffman. (1973). *Teaching Music, What, How, and Why.* Morristown, NJ: Silver Burdett Professional Series, General Learning Press.

Benzwie, T. (1987). *A Moving Experience, Dance for Lovers of Children and the Child Within.* Tucson, AZ: Zephyr Press.

Boorman, J. (1973). *Dance and Language Experiences with Children.* Don Mills, ON: Longman Canada.

Boston Public Schools, Boston Symphony Orchestra, New England Conservatory and WGBH Educational Foundation (1993), April. Unpublished proposal.

Brown, L. (ed.). (1993). *A New English Dictionary on Historical Principles.* Oxford: Oxford University Press.

Clarke, J. and R. Agne. (1997). *Interdisciplinary High School Teaching. Strategies for Integrated Learning.* Boston: Allyn and Bacon.

Cortines, R. (1995). Beyond the three R's: Transforming education with the arts. Student achievement through the arts. *Educational Leadership.* Special insert, October, pp. 3–8.

Delighton, L. (1971). *The Encyclopedia of Education.* Volume 1. The Macmillan Company and the Free Press.

Exiner, J. and P. Lloyd. (1974). *Teaching Creative Movement.* Boston: Play, Inc.

Fine Arts Council of the Alberta Teachers' Association. (1987). *The Olympics and the Fine Arts: Integrating the Fine Arts Through an Olympic Theme.* I. Naested, C. Marshall, L. Bolton, G. Johnston, contributors. Edmonton: Barnett House.

Fowler, C. (1989). The arts are essential to education. *Educational Leadership,* November, pp. 60–63.

Fowler, C. (1977). *Dance as Education.* Publication from conference held October 22–25. Washington DC: National Dance Association.

Fraser, D. (1991). *Playdancing. Discovering and Developing Creativity in Young Children.* Pennington, NJ: Princeton Book Company, Publishers.

Gardner, H. (1959). *Art through the Ages.* Fourth edition. New York: Harcourt Brace and Company.

Hanna, J. (1992). Connections: arts, academics, and productive citizens. *Phi Delta Kappan,* April, pp. 601–607.

Hayes, P. (1981). *Musical Instruments You Can Make.* New York: Franklin Watts.

Hennings, G. (1992). "Say 'no' to Madonna and 'yes' to Bach!" *Teaching K–8.* March, pp. 32–35.

Hunt, T. and N. Renfro. (1979). *Puppetry in Early Childhood Education.* Austin, TX: Nancy Renfro Studio.

Janson, H. and A. Janson. (1991). *The History of Art.* Fourth edition. Englewood Cliffs, NJ: Prentice-Hall.

Jensen, M. and C. Jensen. (1973). *Folk Dancing.* Provo, UT: Brigham Young University Press.

Joyce, M. (1984). *Dance Technique for Children.* Palo Alto, California: Mayfield Publishing Company.

Joyce, M. (1980). *First Steps in Teaching Creative Dance to Children.* Palo Alto, CA: Mayfield Publishing Company.

Koehnecke, D. Swenson (1995). Folklore and the multiple intelligences. *Children's Literature in Education.* 26 (4). pp. 241–46.

Lazear, D. (1991). *Seven Ways of Knowing. Teaching for Multiple Intelligences.* Palatine, IL: Skylight Publishing.

Leese, S and M. Packer. (1980). *Creative Dance for Schools.* Boston: Play, Inc.

List, L. (1982). *Music, Art, and Drama Experiences for the Elementary Curriculum.* New York: Teachers College, Columbia University.

Lowden, M. (1989). *Dancing to Learn. Dance as a Strategy in the Primary School Curriculum.* London: The Falmer Press.

McFee, J. and R. Degge. (1977). *Art, culture and environment: A catalyst for teaching.* Belmont, CA: Wadsworth.

McLean, M. (1988). *Make your own musical instruments.* Minneapolis: Lerner Publications Company.

Morton, F. (1992). "Music works for me." *Teaching K-8.* March, pp. 49–51.

Myers, B. (1969). *McGraw-Hill Dictionary of Art.* New York: McGraw-Hill Text.

Nachmanovitch, S. (1990). *Free Play, Improvisation in Life and Art.* Los Angeles: Jeremy P. Tarcher, Inc.

National Film Board of Canada. (1974). *In Praise of Hands/Hommage Aux Mains.* Ottawa.

Osborne, H. (1970). *The Oxford Companion to Art.* Oxford: Clarendon Press.

Schmalholz, Garritson J. (1979). *Child arts: Integrating curriculum through the arts.* Menlo Park, CA: Addison-Wesley.

Sierra, J. (1991). *Fantastic Theatre, Puppets and Plays for Young Performers and Young Audiences.* New York: The H. W. Wilson Company.

Snider, M. (1980). *Folk Dance Handbook.* North Vancouver, British Columbia: Hancock House Publishers.

Staton, B. (1988). *Music and You, Grade 2 kit.* New York: Macmillan.

Stuhr, P., L. Petrovich-Mwaniki, and R. Wasson. (1992). Curriculum guidelines for the multicultural art classroom. *Art Education,* January, pp. 16–24.

Torburgge, W. (1968). *Prehistoric European Art.* New York: Harry N. Abrams, Inc., Publishers.

Werner, P., N. Sins, and L. Debusch. (1989). Creating with Art, Music and Movement. *Runner,* Summer.

Art for Students with Special Needs

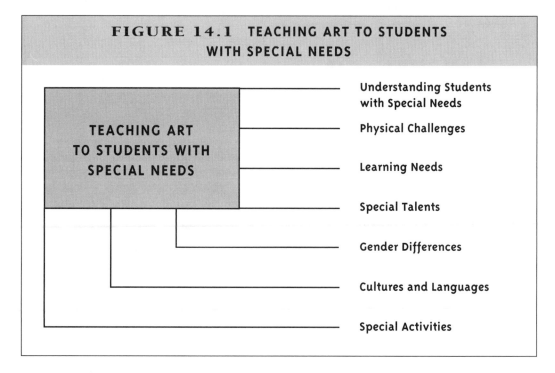

FIGURE 14.1 TEACHING ART TO STUDENTS WITH SPECIAL NEEDS

TEACHING ART TO STUDENTS WITH SPECIAL NEEDS

- Understanding Students with Special Needs
- Physical Challenges
- Learning Needs
- Special Talents
- Gender Differences
- Cultures and Languages
- Special Activities

Introduction

Everyone has likely experienced certain situations in which talking was difficult — we either felt shy or couldn't find the right words. For some children, speaking is a huge struggle most of the time. For others, walking requires great effort or is impossible, or perhaps they cannot control their movements because of a variety of physical disabilities. For children with special needs who do not have the abilities most of us take for granted, the language of art is one of their most effective means of expression.

In many classrooms, art is a common activity in which all children can experience a feeling of being special; in fact, all children are special — no two are exactly alike. They all have special talents and needs and different learning styles, and they all deserve opportunities to discover creative ways of expressing their special qualities.

Because each child develops at a different pace, part of a teacher's task is to get to know each one so that the classroom environment and learning activities can meet individual needs — the

needs of some children are greater, and more obvious. In this chapter we discuss the challenge of teaching children with special needs and offer suggestions that will help you in planning your classroom program for these students.

Understanding Students with Special Needs

Understanding the needs of your students is an integral part of teaching. Students, who in the past have been called "handicapped," often develop strengths and points of view that are unique. In your classroom, you may have children who are hearing-impaired, or deaf, or challenged in other ways, both physically and mentally; and there may also be children who are particularly gifted and talented. Meeting so many different kinds of needs might seem to be difficult, but it is this kind of diversity that can enrich the experiences of all the children in the classroom, and provide challenges and enrichment for teachers as well.

Many children have little sense of control over their own lives and activities. This is especially true of students with special needs, because they are more dependent on those around them and experience acutely the need for some way of creating a sense of order, or gaining a sense of control. Art experiences — sculpting in clay or painting, for example — offer those kind of opportunities. Through tactile media that can be easily manipulated, students can communicate their feelings and experiences.

According to Taylor and Sternberg, approximately 14 to 17 percent of the school-aged population are considered exceptional (including disabled and gifted) (1989, p. 18). In most school systems, students with special needs are integrated or "mainstreamed" into the regular classroom. Categorizing children often blinds us to really seeing them as individual, unique people, so it is wise to be cautious in using labels (Leadbetter and Leadbetter, 1993). The Warnock Report recommended that the categorization of those with disabilities be abolished since it pinned a single label on the student, created unnecessary stigmatization, and perpetuated a sharp distinction between groups of children (Dockrell and McShane, 1993, p. 6).

Multisensory approaches to teaching have been used since at least the 1920s and have been a part of special education programs in varying degrees since that time. "One of the first multisensory programs was the VAKT (visual, auditory, kinesthetic, and tactile) system. It was developed by Grace Fernald (1943) to teach reading to children with a variety of educational problems" (Taylor and Sternberg, 1989, p. 74). Since the arts are by nature made up of multisensory experiences, art education is an integral part of the well-being and successful learning of students with special needs.

Students with Physical Challenges

Throughout history there have been times in our society when the welfare of a group depended upon the ability of each member of the society to work, defend, and fend for themselves. The sick, aged, and handicapped were considered a detriment to the welfare of the group. At other times, society as a whole has accepted responsibility for the handicapped and treated them with

PHOTO 14.1 Teachers must be aware of all students' needs and create lessons that will allow all students to feel successful.

special care. However, those with handicaps were often thought to bring shame to their families and were often kept hidden away at home or in institutions. Today, with proper motivation, special training, and access to the tools and equipment of technology, even individuals with severe physical difficulties can lead productive, fulfilling lives (World Book, Inc. 1996).

Many people have learned how to live with their disability and make contributions to our society. An obvious example is the famous Helen Keller who became blind, deaf, and mute before she was two years old, but who learned to read, write, and speak. Keller devoted her life to helping the deaf and the blind as well as others to see and appreciate the beauty of the world through the senses. (World Book, Inc. 1996).

Equally courageous people, who have not become famous, are part of our society. Some artists, who have no hands, learn to paint by holding a brush in their mouths. A young student, who has three artificial limbs, draws and dances with her classmates.

• • • • • •
Students with Special Learning Needs

"Each of us will, at many times in our lives, experience learning difficulties with particular subjects, skills or novel situations" (Leadbetter and Leadbetter, 1993, p. 23). However, "In all classes there will be children who learn more slowly than their peer group in most subject areas. There will also be children who have problems with particular aspects of the curriculum or specific skills" (Leadbetter and Leadbetter, 1993, p. 27). The term "learning difficulty" is more meaningful if one looks at the context in which the child is being taught and being expected to learn, and examines the teachers' values and expectations (Leadbetter and Leadbetter, 1993).

Like children who are physically challenged, those with special learning needs are also often integrated into the mainstream classroom. The challenge for the mainstream teacher is to produce lessons that are adapted to the needs and strengths of individual children, and that also allow for their particular interests. As a teacher, you should be aware of these special challenges and create lessons that will allow all the students to feel successful. The teaching routines within the classroom should be planned to assist students who require specific help. When possible, seek support and assistance from the parents and others to make success possible.

Ainscow (Ainscow, 1994) studied effective teachers who met the special needs of students in the regular classroom. They found that these teachers set tasks for the students that were realistic yet challenging, had high expectations, and provided a variety of learning experiences in a positive atmosphere. These teachers provided a consistent approach, recognized the students' efforts and achievements, monitored their progress, and provided regular feedback. They also encouraged their pupils to work cooperatively (Ainscow, 1994).

Similarly, Marzola developed guidelines for teachers: such as having the materials that clearly represent the concept being taught, and using a variety of manipulative media to illustrate a concept because students may have trouble generalizing concepts from one form to another. (Taylor and Sternberg, 1989, p. 72).

Students with special learning needs may have difficulty understanding and remembering directions. Demonstrate one step at a time, or one operation at a time. The directions should be brief. For example, if you are teaching how to make a pinch pot, first demonstrate how to make a ball of clay and have the students do it with you. When they have a round ball, push your thumb into your ball of clay and have the students copy you. With your thumb in the centre of the ball, rotate the ball and gently squeeze your thumb toward your fingers. Again have the students follow you. Rotate and squeeze the clay until the walls become thinner and higher; have the students work on their ball of clay at the same time. When the students are satisfied with their bowls, show them how to make texture on the outside surface, and have them scratch their names on the bottom.

Depending on what you are teaching, you can write directions in picture or diagram form on a poster. You might have to simplify and repeat demonstrations and use concrete examples to illustrate an idea. According to Smith (1988), "Learning-disabled children can learn very sophisticated material as long as the teacher thoroughly understands it and breaks it down into simple parts to teach it step by step" (p. 14).

You need to be flexible not only with lesson plans, but also with your expectations of the students. The students may have a limited attention span and may lose interest in an activity fairly quickly. However, avoid busywork and pre-drawn or pre-cut images that are intended for colouring or pasting together. All students deserve the opportunity to create their own images.

Routine in an organized environment provides students with a sense of security. Students with special needs can be situated where eye contact with the teacher and frequent monitoring is possible. Being in close contact with these students also allows for supervision and frequent encouragement and praise, if this is what they need. Above all, use common sense and your own intuition when working with children with special needs, and be genuinely interested in them as individuals.

Children know that art is a language that does not require words. They understand gesture, rhythm, tone, and movement before they use and understand language. They sing and croon before they speak. They draw and paint before they form letters. They dance and leap and act out stories before they can read. We need to use this developmental sequence in our schools and to see the arts as essential to quality education, especially with learning-disabled children (Smith, 1988, p. 11).

Learning to look, learning to listen, remembering what is seen, remembering what is heard — problem areas for the learning disabled — are a part of making art. These skills help

organize experiences. They help make sense of the world, make sense of the messages coming in through the senses. That's what perception is all about: making sense of the environment and organizing it to have meaning. These perceptual skills form the foundations for further learning (Smith, 1988, p. 12).

• • • • • •
Students Who Have Special Talents

Gifted and talented children have their own special needs. Generally they are curious, articulate, and have good memories as well as original ideas and solutions. Academically gifted students are often identified through various methods and tools, including I.Q. Tests. A score of 135 is generally considered high enough for the student to be identified as gifted.

Talent can be defined as an unusually high aptitude, ability, or level of performance in a particular field. The most common types of talents are artistic, musical, physical, mechanical, and social, and having leadership qualities. Talent involves a specific ability, while intellectual giftedness and creativity are more global (D'Zamko and Hedges, 1985).

Renzulli listed characteristics of individuals who are creative as having high nonverbal fluency and originality; adeptness in visual art activities; high creativity in movement, dance, and other physical activities; ability to be highly motivated by games, music, sports, humour, and concrete objects (in Smith, Luckasson and Crealock, 1995, p. 300).

Paul Torrance developed a test called "The Torrance Test of Creative Thinking" with a checklist to identify creative individuals; but he also noted that not all creative people will possess all of the identified traits. Some of these characteristics include the ability to express feelings and emotions, skills in working in groups, enjoyment of group activities, the use of humour, and originality and persistence in problem solving (Taylor and Sternberg, 1989).

There is no reliable measure to identify gifted artists or artistically talented students, although the Torrance Test of Creativity is sometimes used. Artistically talented students often possess a high I.Q. and they have superior manual skills, aesthetic awareness, acute perception, creative imagination, desire to include detail in their work, and inventive problem solving. They are curious and ask a great many questions and have the ability to apply knowledge to unfamiliar situations and problems.

Artistically talented or gifted children exhibit artistic abilities and skills such as drawing, which are more advanced than those of their peers. They generally stay with an artistic problem longer than do other students and are often highly self-motivated, partly because of the pleasure they derive from the work and partly because they see greater possibilities in the problem or assignment (Hurwitz, 1983).

Gifted children possess unusually high standards and goals, are self-critical, and have a dislike for rigid time schedules. They are often bored with repetitious assignments and therefore need to be exposed to a variety of ideas, materials, media, and choices. They learn best if they have time to discover, explore, and experiment, and if they can work on challenging projects and solve problems of an open-ended nature. These students should be given a variety of choices that encourage decision making and be challenged to work with ideas as well as materials. According to Smith, Luckasson, and Crealock (1995), teachers can use various methods to

enrich the gifted students' experiences; these include interdisciplinary instruction, integrated curriculum, independent study, mentorship, and internship.

Gender Differences

> Sex-role stereotypes consist of orientations and values about the typical and appropriate personal characteristics of women and men. As such they are viewed both as public beliefs about the nature of men and women and also as the individual perception of what one is to be — and do. They are viewed as self-fulfilling, providing components of self-concept and identity as well as the role expectations of appropriate sex-typed behaviour. (Lueptow, 1984, p. 51).

The cultural roles and expectations of North American adult men and women have changed over the past several decades. However, studies have found that often teachers' perception of males and females are based on cultural stereotypes and are reflected in teachers' expectations. Girls are still expected to be obedient and dependent and to have difficulty with math and science. Teachers often disapprove of out-of-role behaviour in girls and boys. The expectations for boys are often in conflict: be aggressive, active, and independent but also be a good pupil by being passive, quiet, and conforming.

Chapter 15 discusses women as the subject of art and as practising artists. The dominance of the masculine value system in art and art history has been blinded to female presence and contributions. As a teacher, you have a unique opportunity to help change within the education system the stereotypical attitudes toward women in our society. Include in your teaching curriculum examples of what women have done in history and introduce female artists and other women as role models to your students.

Teaching Students of Diverse Cultures and Languages

Ours is a culturally diverse country, and in its diversity lies its richness — immigrants have landed on the Canadian shore from all parts of the globe. In fact, everyone in this country, except our aboriginal peoples, has come from somewhere else and has contributed to this country many points of view and cultural practices. Many of our immigrants have experienced hardship, war, and political upheaval; and even after they have settled in Canada, the language barrier creates a difficult challenge.

Through the arts and culture, we can find common ground, no matter where we are from. Nicholas Roerich, a painter and philosopher, " . . . dreamt of creating unity of humankind through culture. He said that culture belongs to no one human being, group, nation or era. It is a mutual property of all humankind and the heritage of generations Culture . . . is the common denominator of refined ideas and the wisdom of the ages" (Kalia, 1991, p. 22).

According to Kalia (1991), "We have two official languages, but no official culture and no

culture takes precedence over other cultures." The culturally diverse learners who enter the school system come with a variety of ideas, feelings, artistic expressions, languages, religious beliefs, folklore, and nonverbal communication symbol systems. Teachers have the responsibility of fostering in themselves and among their students an appreciation for the diversity in our society — the attitudes that are fostered in our classrooms have an effect on all of society.

How can you offer a genuine welcome to children and help them feel safe when, perhaps, you do not know their language? As a start, you can find out what language the child speaks, try to find another person in the class or school who speaks the same language, and have that person orient the child in the classroom. Assign a "buddy" and initiate collaborative learning whenever possible (Smith, Luckasson and Crealock, 1995, p. 51). Learn a few key words in the child's language. This will go a long way in helping her or him feel at home.

Discover what the children can and cannot do. Connect lessons with the students' personal experiences. Incorporate greetings and information in the various languages, and display pictures and objects of the cultures represented at the school. Draw on the children's past experiences and the arts of their culture to educate the other students in the class. "Effective multicultural curricula utilize the students' knowledge, experiences, skills, and values in the formation of learning and teaching activities" (Stuhr, Petrovich-Mwaniki, and Wasson, 1992).

Members of children's ethnic communities are often pleased to act as resource people to speak to students in both formal and informal settings (Smith, Luckasson and Crealock, 1995). Use the countries the children represent as a basis for art lessons; include the students' personal experiences as much as possible to encourage cross-cultural understanding.

A number of writers have contributed to our understanding of our culturally diverse population. Ashworth outlined "The Rights of Immigrant Children," which include the right to be accepted with their linguistic, cultural, and racial differences by their teachers and peers and by members of the community. She also includes in her list of rights the recognition within the school of the contribution of ethnic groups, as well as the importance of countering any racist slurs or actions by students and teachers. "The school is probably the first major institution that parents and students encounter after their arrival in Canada. How it receives students will make a lasting impression" (Ashworth, 1988, p. 140).

Ashworth describes the part of our society that we often would prefer to ignore. She says that there are

> . . . many signs of hostility towards immigrants and even towards Canadians of various ethnic origins whose ancestors arrived in Canada two or three generations ago. Yet some Canadians inflict this totally undeserved suffering upon others. It is particularly deplorable when it occurs in schools, not only because the victims are children, but also because of the risk of implanting long-lasting prejudices in other children (1988, p. 206).

According to Kalia (1991) "To create a global citizenry, we need to shift our perception from a narrow focus on differences to a focus on similarities" (p. 28). Furthermore, Anderson (1988) in his article, "Cognitive Styles and Multicultural Populations," gives a helpful insight for teachers regarding similarities.

BOX 14.1 A TEACHER'S STORY

I had a student, Phillip Ng, who had recently arrived from Hong Kong and spoke very little English. He was enrolled in my art class and joined other students from other countries (called E.S.L. students). Success in this class did not depend on the students' ability to speak my mother tongue of English — I incorporated visual demonstrations and many concrete examples in the art lessons. However, I quickly discovered that when I asked the students if they understood, they would always say yes.

Hanging in a high corner of the room were some dusty basket-weaving reeds, which had been there long before I arrived in the classroom. (Good art teachers never throw anything out! They scrounge and save everything from old toothbrushes to styrofoam meat trays). In his limited English, Phillip told me that he knew how to use these materials. Basket weaving was an art media I had not learned, so I was enthusiastic about his interest in weaving a reed basket. I also was very pleased that he told about his interest because he had been generally quiet and had kept to himself.

While Phillip was working on his basket, with a technique he had learned in his homeland, a Canadian aboriginal student observed the procedure and became very interested. This student had also learned a basket-weaving technique when he was taking a summer course for young aboriginal students on a reserve on the Prairies.

Their techniques were different, their language was different; but the students were able to share their artistic experience and skills and learn from each other. The artistic process cut across language and cultural boundaries. The two students delighted in the experience and developed mutual respect.

Many of the other students in the art class became interested in the process. The students became the teachers of the weaving process, and the activity was expanded to dying reeds and working with colour and pattern, as well as shape and skill development in handling the material. This was what educators call a "teachable moment" — a learning and teaching situation that was not planned and could easily have been stifled, but it turned out to benefit the whole class.

All components of a culture are built upon some basic conceptual system or philosophical world view, and the various cultural systems tend to include the same general themes (e.g., life, death, birth, morality, human nature, religion, etc.). Even though these beliefs appear across cultures, they can be viewed differently within each culture (Anderson, 1988, p. 3).

Etta Hollins wrote that "Efficient teaching for culturally diverse learners is a composite of cultural understandings, interrelated behaviours, actions, and reactions that are planned and

intuitive" (1993, p. 95) and that teachers should be able to incorporate important aspects of the learners' local community culture into instruction. The teachers should be able to select materials that are responsive to cultural, group, and individual needs and differences (p. 96); for example, creating units of lessons based on the study of the history of students' countries of origin, including the arts of the culture.

••••••
Special Activities

Many classroom projects are suitable for all children, whatever their ages or needs, and can be simplified for those with special needs or can be made more challenging for students who want to work on more complex projects.

- Have students analyze ads on television, and in newspapers and magazines, as a way of learning about the impact of advertising images that use gender, race, age, and social class to sell products (Stuhr, et al., 1992).
- Consider such issues as graffiti and vandalism in schools and public areas, natural catastrophes, and the environment as a basis for art lessons (Stuhr, et al., 1992).
- Special days such as students' birthdays offer an opportunity to recognize students as individuals. On your class calendar, list the birthdays that will occur each month (Tiedt and Tiedt, 1995). Let the students create something special that day, use their favourite colour on the bulletin board, and bring something to "show and tell" for sharing with the class.
- Have students create a "me" collage that reveals facts about their lives. Have students clip from magazines or bring pictures and objects from home. Words as well as pictures can be included to help tell others in the classroom more about themselves, including words in their first language. Things to include: birthplace, pictures or part of a map, baby pictures, things they like such as food, sports, hobbies, their family, pets, where they have lived or travelled. Let the students brainstorm other ideas and images. This project is especially suitable if your class includes children from different countries.
- Discuss with students some of the ways in which they differ from one another. For example, they are different sizes, they wear different clothing, they live in different places, were born in different places, enjoy different activities, and are good at different things. (Tiedt and Tiedt, 1995). Draw pictures illustrating these differences.
- The colour of me. Ask the students to close their eyes and imagine they are looking at a painting of themselves. If their portrait was only one colour, what colour would it be? (Tiedt and Tiedt, 1995). Have them create some preliminary drawings of themselves (after looking at pictures of themselves or a mirror), and then have them create a self-portrait. For further suggestions, refer to the chapters on drawing and painting.
- My name. Talk to the students about their first names, the origin of their names, and what names mean. Have them make designs based on their first names for display or a cover for their portfolio.
- Family tree. Discuss the idea of family trees and have the students design their personal family tree. Discuss what materials they could use, and whether they want to make it

two- or three-dimensional. Be sensitive to the various family structures that children are brought up in. Trees are different, and so are family structures.

- Working with clay. Clay offers both tactile and kinesthetic experiences. Working with clay will give children with perceptual and motor problems positive experiences, for clay is manageable and undemanding. It is a medium that can be "erased" — clay can be punched, pinched, pounded, torn to bits, and put back together again. Children who need strengthening of self-esteem experience a unique sense of self through working with clay. For more ideas on projects and activities refer to Chapter 9.

• • • • • •
Summary

This chapter focuses on children with special needs and challenges. We also discussed the need for teachers to understand children from a variety of ethnic backgrounds who do not know the main language used in the classroom, and we suggested ways of helping them feel comfortable and at home.

Teachers are responsible for planning a program of studies that provides for all children, regardless of their level of competence. The diversity in the classroom can enrich the program if teachers include images from many different cultures, as well as the history of the children's countries of origin, in planning classroom activities.

REFLECTION

❶ What should a teacher consider when planning art activities for an artistically gifted child?

❷ What visual aids would help a deaf student — or one with limited language understanding — to comprehend an art concept or activity?

❸ Observe a student with special needs or challenges during an art class. What are her or his special needs? What can the teacher do to assist the student in becoming more successful in learning and artistic expression?

❹ Research physical or learning disabilities. Design, or adjust, art activities to meet the needs of the student.

❺ View television advertising, afternoon soaps, sitcoms, children's programs, or children's stories. Describe the main characters and their occupations. How do these programs promote sex-role stereotyping?

❻ List those teaching routines that you think are ethnically conditioned (traditional American style of teaching) and compare them with those of other cultures. (Oliveres and Lopez, 1991, p. 8).

❼ Contact a local library. Many public libraries have a Multilanguage Services Librarian who can supply names and addresses of resource people and groups.

❽ Develop a fact sheet of the major world religions, including Christianity, Islam, Hinduism, Confucianism, Buddhism, Shinto, Taoism, and Judaism. What are their holy days, holy places, symbols, and artifacts?

❾ How would you explain to a child who has a severe learning disability how to make a mobile? Write down the steps in the most simple form to help you discover what directions you would give.

CLASSROOM PROJECTS

❶ Create an illustrated calendar of ethnic and religious celebrations and observances. At the beginning of each month, have your students use a large sheet of paper outlining the days of the month. They can draw pictures to illustrate cultural holidays and celebrations during the month. Post the calendar with the drawings around it.

❷ Bring a stack of magazines and newspapers to class. Have students look through them to find ads that they think include sex-role stereotypes. Have students create different ads for the same products.

BIBLIOGRAPHY

Ainscow, M. (1994). *Special Needs in the Classroom, A Teacher's Education Guide.* Melksham, Wiltshire: Jessica Kingsley Publishers.

Anderson, J. (1988). Theme: minorities, cognitive styles and multicultural populations. *Journal of Teacher Education,* January/February, pp. 2–9.

Ashworth, M. (1988). *Blessed with Bilingual Brains: Education of Immigrant Children with English as a Second Language.* Vancouver: Pacific Educational Press, Faculty of Education, The University of British Columbia.

Atack, S. (1980). *Art Activities for the Handicapped.* London: A Condor Book, Souvenir Press (E & A). Ltd.

Billings, M. (1995). Issues vs. themes: Two approaches to multicultural art curriculum. *Art Education,* January, pp. 21–24 and 53.

Brooks, R. (1978). *The Relationship Between Piagetian Cognitive Development and Cerebral Cognitive Asymmetry.* Educational Research Information Centre (E.R.I.C.) document.

Brown, R. and M. Chazan, eds. (1989). *Learning Difficulties and Emotional Problems.* Calgary: Detselig Enterprises Ltd.

Curriculum Enrichment Advisory Committee. (1981). *Enrichment and gifted education resource book.* Province of British Columbia, Ministry of Education, Curriculum Development Branch.

Dockrell, J. and J. McShane. (1993). *Children's Learning Difficulties: A Cognitive Approach.* Oxford: Blackwell.

D'Zamko, M. and W. Hedges. (1985). *Helping exceptional students succeed in the regular classroom.* New York: Parker Publishing Company, Inc.

Henley, D. (1992). *Exceptional Children, Exceptional Art.* Worchester, MA: Davis Publications, Inc.

Hollins, E. (1993). Assessing teacher competence for diverse populations. *Theory Into Practice: Assessing Tomorrow's Teachers,* Spring, pp. 93–99.

Hurwitz, A. (1983). *The Gifted and Talented in Art: A Guide to Program Planning.* Worcester, MA: Davis Publications, Inc.

Kalia, P. (1991). Toward a global vision: A space-age perspective of earth's many cultures and religions. *Multicultural Education Journal.* 9 (1), May, pp. 21–29.

Law, B. (1990). *More than just surviving: E.S.L. for every classroom teacher.* Winnipeg: Peguis Publishers.

Leadbetter, J. and P. Leadbetter. (1993). *Special Children: Meeting the Challenge in the Primary School.* London: Cassell.

Lueptow, L. (1984). *Adolescent Sex Roles and Social Change.* New York: Columbia University Press.

Madeja, S.(editor) (1983). *Gifted and Talented in Art Education.* Reston, VA: National Art Education Association.

Moody, W. (1990). *Artistic Intelligences: Implications for Education.* New York: Teachers College Press.

Oishi, C. (1991). Multicultural education in the world of art: a teacher's plan of action. *Multicultural Education Journal.* Vol. 9 (1), May, pp. 30–42.

Oliveres, R. and A. Lopez. (1991). Training teachers in multicultural education through cooperative learning activities. *Multicultural Education Journal.* 9 (1), May, pp. 6–20.

Ott, R. and A. Hurwitz. (1984). *Art in Education: An International Perspective.* University Park, PA: The Pennsylvania State University Press.

Shakespeare, R. (1975). *The Psychology of Handicap.* London: Methuen & Co.

Smith, S. (1988). The role of the arts in education of learning-disabled children. *The Pointer.* 32 (3), pp. 11–16.

Smith, D., R. Luckasson, and C. Crealock. (1995). *Introduction to Special Education in Canada. Teaching in an Age of Challenge.* Scarborough, ON: Allyn & Bacon Canada.

Stuhr, P., L. Petrovich-Mwaniki, and R. Wasson. (1992). Curriculum guidelines for the multicultural art classroom. *Art Education,* January, pp. 16–24.

Szirom, R. and S. Dyson. (1987). *Greater Expectations: A Source Book for Working with Girls and Young Women.* New York: Learning Development Aids.

Taylor, R. and L. Sternberg. (1989). *Exceptional Children: Integrating Research and Teaching.* New York: Springer-Verlag.

Tiedt, P. and I. Tiedt. (1995). *Multicultural Teaching: A Handbook of Activities, Information, and Resources.* Boston: Allyn and Bacon.

Triplett-Brady, S. (1992). ADHD (attention-deficit hyperactive disorder). *Teaching Today.* September/October.

The World Book Encyclopedia. (1996). Vol. 5, pp. 219–23. Chicago: World Book Inc.

A Brief Survey of Art History

CHAPTER 15

Introduction

Surveying art history in one chapter is somewhat like trying to cover the whole universe in one volume — it is almost impossible without oversimplifying what happened and why, and in the process there is danger of conveying the wrong meaning. However, the purpose of this final chapter is to introduce names of artists who have influenced how we look at art now, and to present concepts and terms used in the study of art and art history. Perhaps for you it will be a review, or perhaps it will be your first encounter with these names and terms. In either case, this chapter can give you a reference point for your lesson preparation and projects for students.

The chapter begins with a brief look at characteristics of art in Eastern countries and in Europe, and then it discusses major art movements in Europe and North America. A problem with most art-history texts is that women in the arts have largely been ignored, something we discuss in this chapter. Finally, this chapter also offers a survey of the art in our own country, and perhaps through the variety of available resources you can discover with your students the richness and diversity of the work being created in Canada, your province, city, or town.

Art Around the World

We do not presume to cover the many aspects of art in countries around the world in a few paragraphs. Nevertheless, we touch on the art from a number of countries and eras to give you enough information to help you explore those parts of the story of art that interest you most.

THE ART OF EARLY HUMANS

The paintings in the caves of Lascaux, France were made thousands of years ago. These outstanding examples of early artists depicting their lives, and animals in the environment, show that the artists had great skill — bison were painted on bulging rocks in a way that gave the animals mass, and even an illusion of movement in the shoulders.

Many other pieces of art, or artifacts, that have survived from prehistoric times were also skilfully made of clay or rock, and sometimes wood, skins, and other fibres. The study of the arts of aboriginal groups, tribes, and clans in regions and areas of North America, South America, Africa, and Australia have great potential in helping us understand the cultures around the world. The work of archeologist Marija Gimbutas (1989) offers insights into the purpose and meaning of many symbolic objects and figurines that survived over time. Many of the carved objects and figures indicate a symbolism related to the mysteries of life — birth and death and the renewal of the earth (Gimbutas, 1989, p. xix).

FIGURE 15.1 ART HISTORY CONCEPT MAP

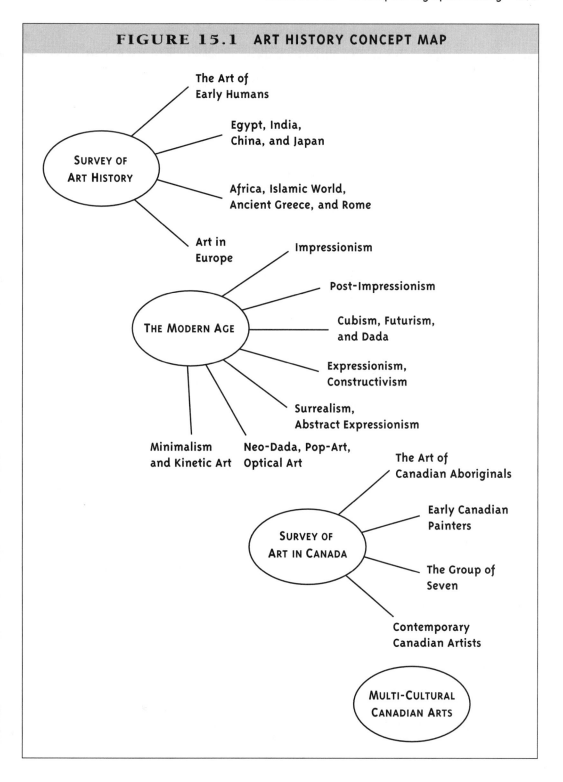

SURVEY OF ART HISTORY

- The Art of Early Humans
- Egypt, India, China, and Japan
- Africa, Islamic World, Ancient Greece, and Rome
- Art in Europe

THE MODERN AGE

- Impressionism
- Post-Impressionism
- Cubism, Futurism, and Dada
- Expressionism, Constructivism
- Surrealism, Abstract Expressionism
- Minimalism and Kinetic Art
- Neo-Dada, Pop-Art, Optical Art

SURVEY OF ART IN CANADA

- The Art of Canadian Aboriginals
- Early Canadian Painters
- The Group of Seven
- Contemporary Canadian Artists

MULTI-CULTURAL CANADIAN ARTS

EGYPT

Egypt, a hot dry country in northeastern Africa, is the land usually associated with pyramids and sphinx. There were thirty-one dynastic periods (a dynasty is a series of kings who are members of the same family) covering more than three thousand years. The dynasties are grouped into the Archaic Period, the Old, Middle, and New Kingdoms, and the Late Period. The Intermediate Periods, which follow each of the kingdoms, were unsettled times (Glubok, 1980).

One Egyptian word for sculptor was "He-who-keeps-alive" (Gombrich, 1968) — art and architecture in Egypt were closely tied to religion, especially to the afterlife.

The ancient Egyptians believed that every person had an invisible twin, a spirit that was born with him or her and stayed throughout life. After death this spirit, or *Ka,* made its home in the tomb in a statue representing the dead person. Little wooden figures of servants were sometimes placed in tombs. It was thought that the servants accompanied their master and could work for him in his afterlife (Glubok, 1980).

The pictures and models were combinations of geometric regularity and keen observation. Egyptian art changed little through three thousand years, even after the Romans made Egypt part of their empire. However, changes did occur when the Islamic conquerors swept across North Africa.

INDIA

The period around the sixth century B.C. was very important in the development of Indian thought and culture, for Gautama, the historical Buddha, and Mahavira, the founder of Jainism, both lived at this time. "Both Buddhism and Jainism were independent investigations of prevailing Hinduism that led to new philosophical and religious practices" (Preble and Preble, 1989, p. 264).

Indian art depicts Hindu divinities in all aspects of human aspirations and experience, and the natural beauty of the human figure is emphasized. Shiva, one of the greatest Hindu gods, encompasses in cyclic time the creation, preservation, dissolution, and recreation of the universe (Preble and Preble, 1989).

CHINA

Chinese historical periods were divided into Dynasties after the Neolithic Period (5th millennium to 18th Century B.C.). They include: the Shang Dynasty (1766–1111 B.C.), Chou Dynasty (1111–221 B.C.), Ch'in Dynasty (221–206 B.C.), Han Dynasty (206 B.C.–A.D. 221). Buddhism, introduced in China during the Han Dynasty, was the greatest influence in Chinese art. The work of the artist was revered and considered an aid to meditation. Art was not used for telling legends of Buddha but for depicting the spirit of reverence for the mountains, rivers, and flowers.

Later dynasties include the Northern and Southern (219–580), Sui (581–618), T'ang (618–906), Five Dynasties (907–960), Liao (907–1125), Sung (960–1279), Yuan (1260–1368). The country had broken apart during the period of the Five Dynasties, but in 1260 the Mongols conquered China and unified the country and built a new capital at Peking.

Perhaps because of the change of status forced upon many writers and painters by the painful situation of foreign domination, the Yuan period is one of individuality and inventiveness. In painting, even given the constraints of the traditions of landscape painting, some Yuan painters have come to be regarded as innovators within the classic school; they opened up the way to further evolution of the style by later painters (Tregear, 1991, p. 136).

The Ming Dynasty (1368–1644) included fifteen reign titles, which began a return to native rule. The presence of foreigners, increased affluence, and heterogeneous tastes supported a wide variety of artists and craftsmen. "Individuality also began to be considered an important quality in a painter; indeed, a small group of artists were even known as the 'Individualists'" (Tregear, 1991, p. 168).

The Ch'ing Dynasty (1644–1911) included ten reign titles. Three of these ten reigns (K'ang Hai, Yung Cheng and Ch'ien Lung) were the most distinguished and provided the major cultural activity of the period. The Republic of China (1912–1949) replaced the Ch'ing Dynasty, which was followed by The People's Republic of China (1949 to the present). Tregear (1991) concluded in her brief history of art in China that "Chinese painting has sought a balance between abstraction and representation for many centuries and therein lies much of its fascination" (p. 200).

JAPAN

According to Stanley-Baker (1991), Japanese art can be divided into six major periods; Prehistoric (11th millenium B.C.–6th century A.D.), Asuka and Nara (552–794), Heian (794–1185), Kamakura and Muromachi (1185–1573), Azuchi-Momoyama and Edo (1576–1868), and Modern Japan.

> From the first moment we look at Japanese art, we are invited to relate in a personal way to the human qualities of imperfection built into the art work . . . like unglazed Bizen pottery, where straw wrappings have been fired to leave uneven markings on the body In each case the artist gives himself wholly to the work, and reveals an unparalleled awareness of his medium (Stanley-Baker, 1991, pp. 11–12).

The sculptural proportions and spatial harmonies expressed the religious and aesthetic values of Shinto. Shinto was a native religion, the major practice of nature worship in ancient Japan. Buddhism came to Japan in the sixth century; and Zen Buddhism, which spread to Japan in the fourteenth century, influenced the aesthetics in poetry, calligraphy, painting, flower arranging, and the tea ceremony, which includes the making and glazing of traditional tea bowls.

By 1867, the Japanese made westernization and modernization their goals. Japanese students studied in the West and foreigners established universities in Japan. A modified traditional Japanese painting style, called Nihonga, maintains the powerful, expressive Japanese line using pure ink landscapes, colour-wash styles, and thick impasto screens with coloured designs on gold.

Japanese children are schooled to distinguish fine art from applied art, but also to appreciate the beauty in all things, natural and constructed. "This quality of beauty which touches them, and its expression in art, is an inseparable part of life itself" (Stanley-Baker, 1991, p. 201).

BOX 15.1 JAPAN THEN AND NOW

JAPAN THEN AND NOW

INTEGRATING ARTS WITHIN THE SCHOOL CURRICULA

Japanese children are schooled in the fine arts and are taught to appreciate the beauty in all things, natural and man-made. "This quality of beauty which touches them, and its expression in art, is an inseparable part of life itself" (Stanley-Baker, 1991, p. 201).

SOCIAL STUDIES
Cultural Determents
Cultural Transmission
Geography
Trade and Commerce
Tourism
History of Japan
History of Samurai
Government and Royalty
1000 Paper Cranes
Kamon–Family Crests
Lineage
Education and Gender
Costume — Kimono
Religion:
 Shinto and Buddhism
Family Structure

MATHEMATICS
Number Systems
Japanese Counting
Geometric Kite Const.
Geometry and Origami
Population Distribution
Population Density
Graphing
Grid Drawing

Currency
Trade and Stock Market
Technology
Trends & Forecasts
Percentages, Proportions, Fractions,
 Ratios, Graphs, Charts

FOOD STUDIES, HEALTH, AND PHYSICAL EDUCATION
Sushi
Food Garnishes
Table Setting
Seasonal Influences
Herbal Medicines
Tea Ceremony
Acupuncture
Kado, Flower Arranging
Keno and Sumo
Karate and Jujitsu
Diet
Leisure

SCIENCE
Miniaturisation
Kites, Fish and Banners
Ecology and Pollution
Acupuncture

(continued)

(continued)

Human Body and Pressure Points	Ikebana
Flora and Fauna	Folding Screen Decor
Fish Prints	Costume/Masks
Technology and Industry	Kirigami, Paper Cut
	Fan Const. and Painting
DRAMA/MOVEMENT/MUSIC	Kite Making and Decor.
Bunraku	Fish Mobiles
Kabuki Music	Banners
No Theatre	Raku Pottery
Dramatic Play	Tea Bowl Making
Protest	Landscape Painting
Masks and Puppets	Nihoga Ink Painting
Tea Ceremony	Block Printing
Musical Instruments	Calligraphy
Traditional Music	Architecture
Modern Japanese Music	
ART	LANGUAGE ARTS
Sumi-e — A Way of the Brush	Haiku Poetry
Paper Making	Tanka
Gyotaku	Japanese Proverbs
Origami	Novel Studies
1000 Paper Cranes	Master Puppeteer
Kimono Design	Sign of Chrysanthemum
Fabric Batik	Of Nightingales that Weep
Paper Batik	Fables and Myths

AFRICA

> Africa is an enormous continent. The Sahara Desert in the north sets apart the countries near the Mediterranean Sea from the vast lands to the south. South of the Sahara the great African continent stretches from seashore to snow-capped mountains, from jungles and forests to vast grasslands, from mighty rivers and waterfalls, to empty deserts and volcanoes (Glubok, 1965, p. 3).

The arts of Africa vary with the areas, kingdoms, and tribal groups of the aboriginals, depending partly on the degree of influences from the West. Most of the tribal images are abstracted, but some are naturalistic. Masks are important in all African tribal ceremonies. Most masks were worn by members of a secret society — ". . . it is believed that a man can stop being himself and become a spirit for a short time when he disguises himself in a mask and costume" (Glubok, 1965, p. 10). Headdresses were also created by many groups.

Music was an important part of African ceremonies, including drums, rattles, horns, and harps. Pottery was often decorated with geometric designs or stylized figures and animals, and clay figures and animals were also produced. Bushmen in southern Africa made rock cave paintings in the style of prehistoric hunters, using black paint made from soot or charcoal, minerals, and coloured stones. They also depicted battles, dances, animals, and scenes of daily life. (Glubok, 1965).

The countries of Africa and the tribal groups should be studied individually to discover stylistic similarities, differences, influences, and materials used.

ISLAMIC ART

Islamic history began in 622 with Mohammed's flight to the Arabian peninsula. The Muslim religion spread quickly and adopted the arts of countries overtaken. Orthodox Islam prohibits the representation of living creatures, therefore an art based on geometric pattern and floral forms developed (Preble and Preble, 1989).

The type of sculpture and painting that developed in Europe was nonexistent in the Far East because of the taboo against reproducing human figures. Islamic designs are extremely elaborate and highly ornamental, particularly in their mosques and temples. Their rich, sumptuous designs are also evident in their metalwork, glass, and textiles.

Photographs of a mosque in Cordoba from the eighth and ninth centuries make obvious the Islamic influence on the work of M.C. Escher. Escher was influenced by the way Islamic artists repeated colourful geometric shapes, using mathematical variations. He produced many drawings and prints based on tessellations using one shape, a regular polygon in patterns (Watson-Newlin, 1995).

ANCIENT GREECE AND ROME

Greece is renowned for the Parthenon in Athens, the perfection of the sculpted human figure, and the discovery of foreshortening, as well as the black and red clay vases that depicted great celebrations and feats.

Rome was a major power in the Western world by the second century B.C. and influenced our systems of government, the calendar, laws, festivals, religion, mathematics, language, science, architecture, art, and drama.

According to Boardman (1985), there is no difficulty in tracing the development of the Classical tradition in Western art from the fifth century B.C. of Greece, through Rome, the Renaissance, to the modern world (p. 19). However, to understand the art and architecture of Greece and Rome, one must also understand the social and political situations and events; for example, the founding of the Roman Empire (27 B.C.), and such influential people as Aristotle, Socrates, and Plato (Boardman, 1985). A sample study of Greece is described in Chapter 1.

EUROPEAN ART BEFORE 1800

By the fourth century, the material grandeur of Rome was rapidly declining. The period from the fall of Rome until the Renaissance, from 476 until about 1450 or 1500, is called the medieval

period, or the Middle Ages. The Middle Ages were so named because they came between ancient Greek and Roman civilizations and the revival, or renaissance, of Greco-Roman interest in humanist ideals.

The Renaissance, which extended from the fourteenth through the sixteenth centuries, was characterized by a renewed interest in literature and the arts, along with a new self-awareness and attention to the individual. The renaissance in art began in Italy, and the painting from this period focused on the human figure. Artists delineated figures clearly by their use of light, and they drew the environment of figures carefully with correct proportions and perspective.

Many Renaissance artists are still admired; among them are Sandro Botticelli (c. 1445–1510), Leonardo da Vinci (1452–1519), Michelangelo Buonarroti (1475–1564), Albrecht Durer (1471–1528), and Jan van Eyck (c. 1385–1441).

By the end of the sixteenth century, artists began experimenting more with light. Caravaggio (1573–1610) painted dramatic figures against a dark background, as did Peter Paul Rubens (1577–1640). Rembrandt (1606–1669) was also a master in the use of light, and many of his masterpieces remain in museums around the world.

Painting portraits, especially of royalty, reached a peak of popularity in Europe during the seventeenth century. Anthony Van Dyck (1599–1641) was a Flemish portrait painter, while Velazquez (1599–1660) painted in Spain. His most famous work is *Las Meninas*.

Several artists stand out in the eighteenth century — Giambattista Tiepolo (1696–1770), whose spectacular ceilings can be found in churches and castles in Europe. He was a master at foreshortening figures and his pinks, greens, and blues dominated his paintings. Francisco Goya's (1746–1828) most dramatic paintings were evoked by the conflict between Spain and France in 1808. *The Third of May, 1808* and *The Second of May, 1808* are two of his most evocative and famous paintings. Goya's work has had a great influence on modern painting — it has been studied by artists in every art movement that came after him.

• • • • • •
Major Western Art Movements from 1800–1980

Three revolutions launched the period of great social and technological change called the Modern Age: the Industrial Revolution in Britain (1760), the American Revolution (1775), and the French Revolution (1786). These disruptions and abrupt changes affected religion and society all over Europe and North America, including, of course, the arts.

During that time, artists began reacting against the classical approach to painting. In 1819, the French painter Theodore Gericault (1791–1824) showed his masterpiece, *The Raft of the Medusa*, about the shipwreck of the Medusa, a French ship enroute to North Africa. The painting had overtones of political criticism — there had been a delay in rescuing the survivors and the public was outraged. Thousands of people flocked to see this painting in London and Dublin. It is a good example of painting from the Romantic period of the 1800s — a work that took a specific situation as its subject matter and was more personal in nature.

Two years after the death of Gericault, the first photographic image was made by Joseph Nicéphore Niepce (1765–1833). Jacques Mande Daguerre (1787–1851) and Niepce worked

together for a while, but after Niepce died Daguerre perfected his "daguerreotypes." According to Preble and Preble (1989), the invention of the camera was motivated by the desire of artists to make accurate depictions of nature. Photography changed the role of artists — they were no longer required to depict life for the aristocrat. By the mid-nineteenth century photographic portraits became common, and painters became somewhat freed from recording people, places, and events and began to experiment with other forms of artistic expression.

The modern movements began around the beginning of the 1880s — a century that yielded the beginning of "isms" that continued into the twentieth century. Pateman (1991) writes about modernism and "post-modernism," which followed.

> The term 'modernism' is far from easy to define for it has been used to refer to a whole variety of movements which would often seem to have little more in common than that they have taken place in the twentieth century. The now highly fashionable word 'post-modernism' in a matter of a few years has come to share a similar fate . . . the shift from modernism around 1980 to post-modernism . . . the latin 'Modo' meaning literally 'just now' (p. 114).

The "isms" of the art world sometimes make people feel intimidated in their efforts to understand artists' work. However, these general classifications help to clarify relationships between artists in different periods. Like historians in general, art historians have, for the most part, ignored the art made by women — the artists cited in the following pages are almost all men. However, in more recent years a few art critics and historians have begun recognizing the work of female artists, a topic we discuss later in the chapter.

IMPRESSIONISM

Impressionism was not an aesthetic movement so much as it was the result of artists experimenting with painting techniques to paint the way the eye sees in putting together light and colour, not in hard outline, but in soft, broken areas of colour. The term was first used by a journalist in 1874 to ridicule Claude Monet's *Impression — Sunrise*. Other examples of Impressionist painters are Mary Cassatt (1844–1926), Edgar Degas (1834–1917), Edouard Manet (1832–83), Claude Monet (1840–1926), Berthe Morisot (1841–95), Camille Pissarro (1831–1903), Pierre Auguste Renoir (1841–1919), and Alfred Sisley (1839–99).

NEO-IMPRESSIONISM

The Impressionists' approach to painting was taken further by the Neo-Impressionists — their paintings were built on the theory of the optical mixture of color, also called Divisionism or Pointillism. Georges Seurat (1859–1891) developed a technique of painting small dots of colour on the canvas without actually mixing the colours. The idea was that colours applied this way were more intense than if they were mixed.

POST-IMPRESSIONISM

Artists respond and react to those who came before. The Post-Impressionist artists reacted against Impressionism and Neo-Impressionism by concentrating on the more formal elements

of painting. British writer Roger Fry's title for an exhibition he arranged in the winter of 1910–11, "*Manet and the Post-Impressionists*," established the use of the term. Examples of Post-Impressionists include Paul Cezanne (1839–1906), Vincent van Gogh (1853–90), and Paul Gauguin (1843–1903).

CUBISM

An art critic who noticed the geometrical forms in a Picasso painting is responsible for the name, "Cubism." Pablo Picasso (1881–1973) and Georges Braque (1882–1963) developed the idea of painting objects from different angles — as though looking at all sides at once. However, before that, Cezanne had made paintings based on the concept of breaking up the pictorial space of a painting into different planes.

At first, cubist paintings were rejected and, in some cases, were considered an affront to people's sense of aesthetics. But eventually people realized that Cubists showed another dimension of seeing — that, in fact, the eye could take apart an object in space and reconstruct it into an exciting composition. Many painters learned from Picasso and Braque and, from time to time, painted in a cubist manner; among them were Robert Delaunay (1885–1941), Sonia Delaunay (1885–1974), Marcel Duchamp (1887–1968), Juan Gris (1887–1927), and Fernand Leger (1881–1995).

FUTURISM

Futurism is different from some of the other art movements in that a group of artists called themselves Futurists, and even wrote a "Manifesto of Futurist Painting." These artists wanted to paint ". . . machines or figures actually in motion" and said "We proclaim . . . that universal dynamism must be rendered as dynamic sensation; that movement and light destroy the substance of objects" (Murray and Murray, 1972, p. 160). The artists who signed the document were Giacomo Balla (1871–1958), Umberto Boccioni (1882–1916), Carlo Carra (1881–1966), Luigi Russolo (1885–1941), and Gino Severini (1883–1966).

DADA

The Dadaist movement arose simultaneously in several different places, partly out of the abhorrence artists felt about World War I. These artists in Zurich, Barcelona, and New York simultaneously made what they called "anti-art" pieces. The name *Dada*, which means "hobbyhorse" in French, was chosen for its childish connotation to express the feeling that European culture had lost its meaning in the face of the destruction of the war. The Dadaists include Hans Arp (1887–1966), Marcel Duchamp (1887–1968), Max Ernst (1891–1976), Francis Picabia (1878–1953), and Man Ray (1890–1976).

EXPRESSIONISM

Expressionism is based on communicating the artist's inner vision, often by distorting physical reality. Rather than imitating nature, as artists did in previous art movements, Expressionists were more interested in transforming nature on the canvas through techniques of exaggeration and distortion. The work of Vincent van Gogh (1853–90) is usually credited as the beginning of

Expressionism. Norwegian painter Edvard Munch (1863–1944) was one of the early Expressionists. Examples of others include Paula Modersohn-Becker (1876–1907), Wassily Kandinsky (1866–1944), Kathe Kollwitz (1867–1945), and Georges Rouault (1870–1958).

CONSTRUCTIVISM

Constructivism was a Russian art movement between 1910–28, partly motivated by the political situation of the time, as was Dadaism. The Constructivist artists were interested in a "constructive" social order during the early years of the Russian Revolution. The techniques of the Constructivists evolved from the use of collage, and they used all kinds of materials from wire to glass. Examples of artists in this movement are Naum Gabo (1890–1977), El Lissitzky (1890–1947), Kasimir Malevich (1878–1935), Antoine Pevsner (1886–1962), and Vladimir Tatlin (1885–1953).

SURREALISM

The Surrealists attempted to express the inner world, or the psyche, which they claimed was more real than the physical world. Deeply influenced by psychoanalysis and the work of Sigmund Freud, they created dream-like juxtapositions in their paintings. Andre Breton (1896–1966), a French poet and writer, wrote his Surrealist Manifesto, which articulated the thinking behind the work of the Surrealists. These artists had a tremendous impact on artists who came after them.

The Surrealists admitted the importance of the role of women in their circle — for some only as muse. But during this time, more than any other, women made art and continued to do so even after they were no longer associated with the male Surrealists. But unfortunately, the contributions of these female artists are often not included in the accounts of the development of Surrealism. The role of "women artists in the Surrealist movement has been . . . difficult to evaluate, for their own histories have often remained buried under those of male Surrealists who have gained wider public recognition" (Chadwick, 1985, p. 7).

Examples of Surrealist artists include Leonora Carrington (b. 1917), Salvador Dali (1904–89), Max Ernst (1891–1976), Rene Magritte (1898–1967), Joan Miro (1893–1983), Merit Oppenhiem (b. 1913), Kay Sage (1898–1963), Dorthea Tanning (b. 1910), and Remedios Varo (1913–63).

ABSTRACT EXPRESSIONISM

Abstract Expressionism could only have followed after Surrealism because it, too, was based on unconscious processes. Beginning in New York in the 1940s, for the first time the materials and the activity of painting took precedence over the subject matter. This new manner of painting ". . . celebrated the gestures and creativity of the maker and what one sees on an Abstract Expressionist canvas are the traces of the artist's activity" (Parker and Pollock, 1989, p. 145).

There was some diversity among the work of Abstract Expressionists — colour field painting and action painting, for example. The movement continued with momentum through the 1950s and into the early sixties, and it had a great deal of influence on the art that followed,

particularly in the types of materials and colours used. Examples of Abstract Expressionists include Helen Frankenthaler (b. 1928), Arshile Gorky (1904–48), Grace Hartigan (b. 1922), Lee Krasner (b. 1908), Hans Hofmann (1880–1966), Franz Kline (1910–62), Willem de Kooning (b. 1904), Robert Motherwell (b. 1915), Barnett Newman (1905–70), Jackson Pollock (1912–56), and Mark Rothko (1903–70).

POP ART

At the end of the 1950s, many artists were tired of the seriousness of Abstract Expressionism and looked for new subject matter. They found it in the everyday images of the media, particularly in television and advertising. Andy Warhol (1930–1987), for example, reproduced soup cans, and Roy Lichtenstein (1923–97) enlarged details of ads in an attempt to erase the lines that divide serious art from popular images.

In fact, most Pop artists used in their work a variety of mechanical processes, including photographs, ads, and enormous blow-ups of cartoons; and they painted in a hard-edge technique with garish colour (Murray and Murray, 1972, p. 336). Examples of Pop artists include Marisol Escobar (b. 1930), Jasper Johns (b. 1930), Robert Rauschenberg (b. 1925), and Claes Oldenburg (b. 1929).

MINIMALISM

In the early sixties, Minimalism evolved also in reaction to Abstract Expressionism. This kind of painting and sculpture is based on the essential elements of structure and form, or the minimal, necessary parts. Minimalist works are impersonal and precise and, in extreme form, simply give a minimal indication of the artist's idea or thought. Minimalist artists include Carl Andre (b. 1935), Eva Hesse (1936–1969), Donald Judd (b. 1928), Ellsworth Kelly (b. 1923), Kenneth Noland (b. 1924), David Rabinowitch (b. 1943), and Royden Rabinowitch (b. 1943).

OP ART

Op art, as its name suggests, is based solely on optical effects. Op artists' intention was to strip away any ideas about meaning or insights. This art from the mid-1960s often contained complex geometric patterns and combinations of colours that were difficult to look at because the patterns appeared to pulsate. Some examples of artists are Bridget Riley (b. 1931), Richard Anuszkiewicz (b. 1930), and Victor Vasarely (b. 1903).

KINETIC ART

"Kinetic art is based on the idea that light and movement can create a work of art" (Murray and Murray, 1972, p. 225). Many kinetic sculptures gyrate to create patterns of light and shadow. Moving pieces of metal, glass, or other material often make up kinetic sculptures that are "combined with changing effects of coloured lights to create the shadows and reflections" (Murray and Murray, 1972, p. 225). Examples of artists who made kinetic art are Julio Le Parc (b. 1928), Naum Gabo (1890–1977), and Alexander Calder (1898–1976).

PERFORMANCE ART

According to Lynton (1989), "Since the mid-fifties a multitude of works and activities have been presented as art that have little in common other than that they are not, in any normal sense, paintings, sculptures or graphics" (p. 318). Performance art grew out of the happenings of the sixties. Many artists began thinking there was no reason why painting and sculpture were the only expression that should be called art. When the idea of performance art had been established many sorts of variations became possible. Historically, performance art, in its resistance to the status quo, can be linked to the Dada movement, as well as to Surrealist exhibitions, which sometimes included performance elements.

In Canada, Gathie Falk, among others, developed a number of performance pieces from the late sixties until 1977. More recently, Shawna Dempsey and Lorri Millan have collaborated on performance art since 1989.

• • • • • •
Recent Trends in Art

NEO-EXPRESSIONISM

Following Abstract Expressionism, artists developed many forms of expression, and some artists, in fact, declared painting was dead. However, in the early 1980s younger artists disproved that theory by returning to painting in an expressionistic fashion, now called Neo-Expressionism. Galleries in Europe and North America launched exhibitions that celebrated "the 'return' to painting," and focused on "a new generation of male Neoexpressionists . . ." (Chadwick, 1985, p. 347).

Neo-Expressionists include: in Canada, Brian Burnett, Nancy Johnson, Rae Johnson, and Oliver Girling; in Germany, George Baselitz, Markus Lupertz, Jorg Immendorff, A. R. Penck, Sigmar Polke, and Anselm Kiefer; in Italy, Francesco Clemente, Enzo Cucchi, Sandro Chia, and Nicola De Maria; in Spain, Ferran Garcia Sevilla and Miguel Barcelo; in Great Britain, Bruce McLean and Christopher LeBrun; in the United States, Julian Schnabel, David Salle, Robert Longo, and Eric Frischl.

MULTIMEDIA ART

Advancements in technology in the 1980s began influencing how artists thought about the media available to them. The possibilities offered by computers particularly excited the imagination of many visual artists. Andy Warhol, in 1986, began using computers, picture-processed photography, and film. Kenneth Knowlton developed computer programs to make use of the black and white combinations that were an inherent part of cathode-ray reproduction (Hoffman, 1991), and Jenny Holzer began using digitalized imagery.

As the fiftieth anniversary of television was celebrated, video artists used the computer increasingly to manipulate and perfect their images. With the use of technology video, artists were able to create works of increasing complexity, "beyond the linear and narrative emphasis of traditional filmmaking" (Hoffman, 1991, p. 368). Multimedia artists include Jill Bellos, Dara Brinbaum, Marien Lewis, John Sanborn, Lisa Steele, Larry Kaufman, Adrian Piper, Teri Yarbrow, Bill Viola, and Rodney Werden.

POSTMODERNISM

The term Postmodernism is used to describe the breakdown of meaning and structure in our society. Pateman (1991) believes we are still too close to Modernism to see clearly the achievements of Postmodernism. However, according to Chadwick (1992):

> Postmodernism has embraced a wide range of practices, from photography, abstract painting, collage, and drawing to constructed sculpture, installations and public art, and more or less traditional methods of art-making. Some artists have been political, others have embraced philosophical or theoretical models (pp. 347–8).

Artists, categorized by critics as Postmodern, use images from popular culture and the media, and their work defies formal analysis. Some artists incorporate other artists' paintings in their own, as well as photographs of themselves and a variety of other materials and texts.

In recent years, the artwork done by women to gain a voice and a place in history within the arts and in other fields has had an impact on artistic practices in our time. This work is part of what characterizes Postmodernism.

• • • • • •
Women and Art

Women have always made art, and they were acknowledged as artists until the nineteenth century when writers began omitting them from art history texts (Parker and Pollock, 1989, pp. 3, 4). At the same time, the female nude has been male artists' favourite subject, and their muse has consistently been female. And yet, the masculine value system dominates art and art history and has been blind to female presence and contributions. Recently, however, art history has expanded its boundaries to include the work of women (Broude and Garrard, 1982, p. 1).

In art as in other areas of society, masculine interests have been taken for granted as universal principles, and this realization has brought about a reexamination of art history. For example, Luomala (1982) reminds her readers that in Egypt the royal family was matrilineal until it was enveloped by the Roman Empire. Yet history textbooks frequently ignore this crucial piece of information when they interpret images and monuments of Egyptian art.

Kampen (1982) pointed out that status in relation to gender is rarely investigated in the history of Roman art. Furthermore, images of medieval woman were depicted as the original cause of all evil (Kraus, 1982). Nochlin (1982) noticed that, in literature and in images, "fallen" in describing men meant they were hurt in war, but the same word in describing women meant they had given themselves over to a particular kind of "vice."

Accepted art history explains German Expressionism by taking into account primarily male artists, even though such artists as Kathe Kollwitz, Paula Modersohn-Becker, and Gabriele Munter (Comini, 1982) contributed to the movement. To examine the history of art requires more than simply accepting the way artists have been presented. "To discover the history of women and art means accounting for the way art history is written" (Robinson, 1987, p. 207), and "Denying women vision and voice deprives them also of power" (Robinson, p. 220). In other words, if we do not know about the women who came before us, we do not know our roots and we lack a sense of who we are and what we can accomplish.

Although women's work is now being shown in galleries across the country, it was as recently as 1971 that the first living woman (Joyce Wieland) had a major exhibition in the National Gallery of Canada; and as late as 1987 that the Art Gallery of Ontario gave the first major retrospective to a living woman artist — again, Joyce Wieland. *Matriart* magazine has a regular feature, "Who Counts and Who's Counting," which reveals that the collections in art galleries still are heavily weighted with the work of male artists. What is needed is not simply a tokenism acceptance of a few women in art shows and galleries, but a change in the structures that determine the way we think about both women and men in making art.

When Maria Tippett began research for her book, *By A Lady*, she was impressed ". . . not simply by the sheer number of women who had consistently produced works of art since the settlement of New France, but the wide range of their work" (1992, p. xii). She cites examples of women who painted in New France and through the succeeding centuries until the 1990s when her book was published.

Fortunately, resources now are available that provide information and documentation on women's art. In preparing to integrate art lessons into your teaching curriculum, you can draw on these resources so that your students do not suffer from a lack of understanding of women's work as students did in previous education programs.

• • • • • •
The Art of the First Nations

The aboriginal people, those who lived in this country for thousands of years before any Europeans arrived, have a unique place in Canadian art history. The figures in rock paintings — the large one of *Mishipeshu* or "great lynx," in Lake Superior Provincial Park in the Sault Ste. Marie area is a good example — are powerful images created by people who had a strong connection to the earth and its creatures. The rock paintings show that their visual expressions rose from this relationship with animals and plants and their concept of the origins of the earth. This characteristic of the First Nations is basic to understanding their images.

The cultural life and the language group of the aboriginal people are part of their art and need to be studied in that context. Historically, the aboriginal people lived in six major regions, and within each region were many tribes — a tribe is defined as a social group of families, clans, or generations. In preparing lesson plans on the arts of aboriginal people, include in the study what materials were available in each region and compare how they used their media and how they depicted animals and other images from the natural environment.

- Northwest Coast includes the coast of British Columbia and a small part of the state of Washington in the United States.
- Northern Plains includes the southern part of the prairie provinces and south into the United States.
- Western Subarctic includes Alaska, Yukon, and most of the Northwest Territories.
- The Arctic includes the most northern part of Quebec.
- Northern Woodlands includes all of Ontario, three-quarters of the southern part of Quebec, and parts south of the Great Lakes.

FIGURE 15.2 MAP OF CANADA

- The Atlantic includes Newfoundland, Prince Edward Island, Nova Scotia, and a small area of the northeastern coast of the United States.

Some contemporary Native artists continue to create traditional artifacts. However, in recent years, other Native artists have chosen not to produce traditional objects, but they bring to their work their personal history and the history of their peoples. The paintings and sculptures created by Native artists often compel viewers to think about how the Native population has been treated in the past — and the prejudices that continue — and to confront issues that are still unresolved.

Many contemporary artists of Native ancestry could be listed, but these are a few you might want to include for study in your art curriculum: Kenojuak Ashevak, Rebecca Gloria-Jean Baird, Carl Beam, Joane Cardinal-Schubert, Faye HeavyShield, George Littlechild, Edward Poitras, and Jane Ash Poitras.

• • • • • •
Early Canadian Artists

The first Europeans in this country recorded events and activities in early Canada in drawings, paintings, and engravings. For example, the explorer, Samuel de Champlain, sketched his battle of 1609 with the Iroquois, which was the basis for an engraving held in the Public Archives of Canada (Lord, 1974, p. 23). Claude Francois (Frère Luc), a friar, and Hugues Pommier were

probably the first real painters to work in Canada between the 1640s and 1670s. Bishop Laval began a school of the arts at St. Joachim in 1668, and the first Canadian canvases were painted to conform to Laval's ideas and those of the Catholic Church, which was in charge of culture in the new colony. Marie Barbier's (1663–1739) rendition of the Christ child is one of the early religious paintings, and likely the first by a Canadian-born woman (Tippett, p. 4).

With the establishment of Halifax in 1749, the British influence became visible. Under the French, almost all painting was for the benefit of the church; but after 1749, artists found a growing market for portraits. Also, the British troops were accompanied by army topographers, who made precise landscape paintings for military purposes. These works would have been in demand in England because of their "exotic" nature (Reid, 1973, p. 26).

Thomas Davies (1737–1812), a British army watercolourist who arrived in Halifax in 1757 as a lieutenant, sketched and painted the Canadian wilderness. His training in rendering the precise detail of the landscape, along with his love of botany, resulted in a unique style that has been compared to the French painter, Henri Rousseau (1844–1910) (Lord, pp. 64, 65).

George Heriot (1759–1839) worked in the British administration of Lower Canada. He made small, wash sketches on his trips and later worked them into watercolours with a sense of light and atmospheric effects.

Louis Dulongpre (1759–1843), who was born in Paris, moved to Montreal in the mid-1780s. He produced three or four thousand portraits in oil or pastel.

Elizabeth Amherst Hale (1774–1826) is remembered for her watercolour, *York, Upper Canada* (1804).

Catherine Margaret Reynolds (c. 1782–1863), the daughter of the builder of Fort Malden, likely had access to art manuals that were available at that time. Her painting, *A View of Amherstburg — 1812*, "demonstrates how familiar she was with the neoclassical tradition of landscape painting" (Tippett, p. 6).

Joseph Legare (1795–1855) painted landscapes that show a direct response to the land, and his urban pictures relate to contemporary events.

Cornelius Krieghoff (1815–72) first arrived in Quebec in 1845 and lived in Longueuil. His paintings of life in the colony, particularly of the Native people, were popular among the British officers and businessmen (Lord, p. 46). His two most well-known paintings are *Merrymaking*, 1860 and *The Toll Gate*, 1861.

• • • • • •
The Era of the Group of Seven

In 1925, A.Y. Jackson said that before World War I, "Art in Canada meant a cow or a windmill" — dull paintings with gold frames, specially lit (Lord, p. 115). This was hardly the kind of painting that could build national pride, the kind for which A.Y. Jackson later became known.

Jackson was among the seven young artists who turned Canadian painting upside down by painting landscapes in a style that startled people, a style different from that used before in Canada. The Group of Seven, the name now recognized everywhere in this country, painted landscapes the way that they thought suited their subject (Harper, 1969, p. 265). The seven original members of the group, founded in 1920, were Frank Carmichael, Lawren Harris, A.Y. Jackson, Franz Johnston, Arthur Lismer, J.E.H. MacDonald, and F.H. Varley.

BOX 15.2 EARLY EUROPEAN-CANADIAN ARTISTS

Robert Field (1769–1819),
Antoine-Sebastien Plamondon
 (1804–95)
 Robert Todd (1809–66)
Robert Whale (1807–87)
Theophile Hamel (1817–70)
William Raphael (1833–1914)
Frederick Verner (1836–1928)
Allan Edson (1846–88)
Lucius R. O'Brien (1832–99)
John A. Fraser (1838–98)
William G. R. Hind (1822–89)

William Brymner (1855–1925)
Paul Peel (1860–92)
Robert Harris (1849–1919)
George A. Reid (1860–1947)
Homer Watson (1855–1936)
Maurice Cullen (1866–1934)
James Wilson Morrice (1865–1924)
Marc-Aurele de Foy Suzor-Coté
 (1869–1937)
Ozias Leduc (1864–1955)
Clarence Gagnon (1881–1942)

J.E.H. MacDonald (1873–1932) created a new expression of the Canadian landscape with brilliant colour and dense surface.

Frank Carmichael's (1890–1945) work shows a more gentle side than do many of the paintings of the Group of Seven. Examples of his paintings include *Jackfish Village* and *Northern Tundra*.

Lawren S. Harris (1885–1970) in 1921 began to create "pictures of formal simplicity and restricted colour, reducing the landscape to the interplay of a few boldly described shapes" (Burnett, 1990, p. 92).

A. Y. Jackson (1882–1974) painted *Terre Sauvage* in 1913, an audacious work that influenced Tom Thomson. His paintings of rocks, trees and sky, expressed the "rhythm of natures' time scale and the passage of the seasons" (Burnett, 1990, p. 97).

Frederick Varley (1881–1969) became a war artist and produced many strong paintings for the Canadian War Records Office. In 1926, he moved to Vancouver and for a time taught at the Vancouver School of Decorative and Applied Arts, but he returned to central Canada in 1936.

Arthur Lismer (1885–1969) developed art education in Canada, encouraging freedom of expression. Lismer created bold, round, interrelated shapes that illustrate nature's forms.

Emily Carr (1871–1945) travelled from the west coast to meet members of the Group in Toronto in 1927. This trip offered Carr new experiences and encouragement — Lawren Harris was particularly encouraging, but she was never really considered a member of the Group.

Tom Thomson (1877–1917) painted the Canadian landscape with directness and freedom. His early death in Algonquin Park kept alive the myth and mystique of his genius.

Franz Johnston (1888–1949) was one of the Group of Seven who was commissioned as a war artist during World War I. His painting, *Beamsville*, 1918–19 is likely the first Canadian painting created from the sky view.

David B. Milne (1882–1953), who lived in the United States in the early 1900s, came back to Canada in 1928. Milne worked independently of art groups and trends in painting with an

BOX 15.3 LIST OF ARTISTS

Edwin Holgate (1892–1977)
Lionel LeMoine FitzGerald
 (1890–1956)
Ernest Lindner (b. 1897)
Carl Schaefer (b. 1903)
John Lyman (1886–1967)
Prudence Heward (1896–1947)

Paraskeva Clark (1898–1986)
Jessie Oonark (1906–85)
Miller Brittain (1912–68)
J. W. G. (Jock) Macdonald (1897–1960)
Jean Paul Lemieux (b. 1904)
Wynona Mulcaster (b. 1915)
William Kurelek (1927–77)

emphasis on texture, tonal values, and pictorial construction. A major book on Milne's work was published in 1996.

Florence Wyle (1881–1968) was a sculptor who came to Canada from the United States. During World War I, she went to munitions plants to find subjects for her sculptures, and she was the only woman on the executive of the Canadian Federation of Artists, the first national artists' organization.

Frances Loring (1887–1968), like Wyle, also created bronzes from figures in a munitions factory. She and Wyle both grounded their work on the tradition that the human figure was the basis of sculpture (Tippett, p. 56).

••••••
Contemporary Canadian Artists

Since the beginning of World War II, when the visual arts in Canada were at a low point, the country has seen an enormous expansion of artists' works. In almost every large and small centre across the country artists are working in a wide variety of styles and media.

The vast expanse of the country has a strong impact on the arts — we live and work in different regions, and the connections between the regions at times seem tenuous. Yet we feel the need to maintain some kind of association with artists in other regions, despite our different points of view. "With Canada's topography and demographic patterns, artistic activity is divided among widely scattered centres, and the essence of that activity is inseparable from regionalist concerns" (Burnett and Schiff, 1983, p. 7).

Researching the life and art of Canadian artists can be a perplexing task for students if they want to study artists outside their own region — gaining access to the work of a Maritime artist if you live in Vancouver might be difficult. For this reason, public institutions — art galleries, museums, colleges, and universities — need to support research on specific artists. With access to art images on laserdiscs, research seems less daunting. Local galleries and museums are the places to begin if you want to find information on artists mentioned in this section. (See Box 15.4 for additional names.)

Bertram Brooker (1888–1955) was a Toronto novelist and painter. In 1927, he was the first Canadian to show abstract works.

Pegi Nicol MacLeod (1904–49), who painted images of our contemporary world with great energy, was one of the first wave of Modernists in Canada. She was one of the founders of the Picture Loan Society.

Hortense Gordon's (1887–1961) abstract paintings were influenced by New York artist Hans Hofmann. She was one of two women in the Painters Eleven.

Alexandra Luke's (1901–67) studio in Oshawa was the place where the organization of Painters Eleven was finalized. She also organized an exhibition of abstract painting in 1952.

Alfred Pellan (1906–88) made paintings that were a synthesis of the Cubist and Surrealist approaches. After spending some time in Paris, in 1940 he returned to Quebec with 400 paintings and taught at the Ecoles Des Beaux-Arts in Montreal.

BOX 15.4 CONTEMPORARY CANADIAN ARTISTS

Jack Bush (1909–77)
Doris McCarthy (b. 1910)
Alex Colville (b. 1920)
Betty Goodwin (b. 1923)
Gathie Falk (b. 1928)
Harold Town (b. 1924)
William Ronald (b.1926)
Jack Shadbolt (b. 1909)
Daphne Odjig (b. 1919)
William Perehudoff (b. 1919)
Alex Colville (b. 1920)
Molly Lamb Bobak (b. 1922)
Bruno Bobak (b. 1923)
Betty Goodwin (b. 1923)
Marcelle Ferron (b. 1924)
Ronald Bloore (b. 1925)
Francoise Sullivan (b. 1925)
Paterson Ewen (b. 1925)
Gershon Iskowitz (1921–88)
Anne Kahane (b. 1924)
Dorothy Knowles (b. 1927)
William Kurelek (1927–77)
Rita Letendre (b. 1929)
Michael Snow (b. 1929)
Jack Chambers (1931–78)

Guido Molinari (b. 1933)
Tony Urquhart (b. 1934)
Charles Gagnon (b. 1934)
Otto Rogers (b. 1935)
Christopher Pratt (b. 1935)
Ivan Eyre (b. 1935)
Mary Pratt (b. 1935)
Christiane Pflug (1936–72)
Greg Curnoe (1936–92)
Sheila Butler (b. 1938)
John Hall (b. 1943)
Joe Fafard (b. 1942)
Irene F. Whittome (b. 1942)
Don Proch (b. 1944)
Colette Whiten (b. 1945)
Jeff Wall (b. 1946)
David Thauberger (b. 1948)
Liz Magor (b. 1948)
Shirley Wiitaslo (b. 1949)
Richard Prince (b. 1941)
Wanda Koop (b. 1951)
Joanne Tod (b. 1953)
Oliver Girling (b. 1953)
Genevieve Cadieux (b. 1955)

Paul-Emile Borduas (1905–60) was a Quebec artist who turned to abstract painting. A leader of the Automatistes, in the 1948 manifesto, *Refus Global*, he advocated the right to total freedom of expression without the restrictions of Quebec society. Borduas had a great deal of influence on the next generation of artists.

Jean-Paul Riopelle (b. 1923) was one of Borduas's students. He, too, left figurative painting for abstract works. In some of his paintings, he experimented with techniques such as squeezing paint from tubes onto the canvas and also working with a palette knife in thick paint to create a mosaic-like effect.

After the abstract painting of the fifties and sixties in Canada, artists' work became diversified; although abstract painting did not end with the 1960s — many painters continue to work in that manner, particularly artists in the Prairies and in Toronto. However, minimalism became a dominant characteristic of the 1970s; for example, the paintings of Ron Martin (b. 1943), Leopold Plotek (b. 1948), Garry Neill Kennedy (b. 1935), and Jaan Poldaas (b. 1948), and the sculptures of David Rabinowitch (b. 1943), Royden Rabinowitch (b. 1943), and Roland Poulin (b. 1940). Throughout the years of "isms" that evolved, landscape painting has always remained strong in this country — the work of Doris McCarthy (b. 1910), Dorothy Knowles (b. 1927), Gordon Smith (b. 1919), David Alexander (b. 1947), Alan Wood (b. 1935), and Barbara Ballachey (b. 1949) are a few examples.

Many younger artists' work is described as neo-expressionistic and post-modern, and it takes the form of painting and sculpture, as well as installation pieces — two- and three-dimensional objects arranged within a specific space to create an environment and make a statement. It is impossible to provide a representative picture here of the work of today's artists, but you will find the names of some of them in Box 15.4 as a starting point for research.

Perhaps the one thing that characterizes all of our art at this point in time is that it has no boundaries. Any material and subject — including the electronic media, video cameras, and photocopy machines — are grist for the artist's mill. A good way to find out about current artists' work is through art magazines. There are more than twenty visual arts magazines in this country, many of them with features on artists and reproductions of their work — the work of artists from every part of the country. (See Appendix C , page 310.)

• • • • • •
An Integrated Unit of Study: Trees in Art

The history of art is a good source for classroom study themes. A variety of subjects can be used as a theme for an integrated unit of study, depending on your curriculum; for example, architecture in art, animals in art, flowers in art, or even topics such as grief or poverty. This section offers some ideas for developing a unit of study on trees in art. This unit would include science and would entail classifying trees, studying their structure and drawing structural diagrams, and learning about the natural habitat of trees — Canada has about 140 native trees.

Students could research the uses of trees, such as building houses and heating them; making paper could be included in this part of the unit (see Chapter 12); and even composting — making leaf mold to enrich the soil — which might lead to a study of ecology and the environment.

As part of a study of ecology, students could research how trees affect the environment, their contribution of oxygen and how they absorb pollution and carbon dioxide, and the effect of cutting down rain forests.

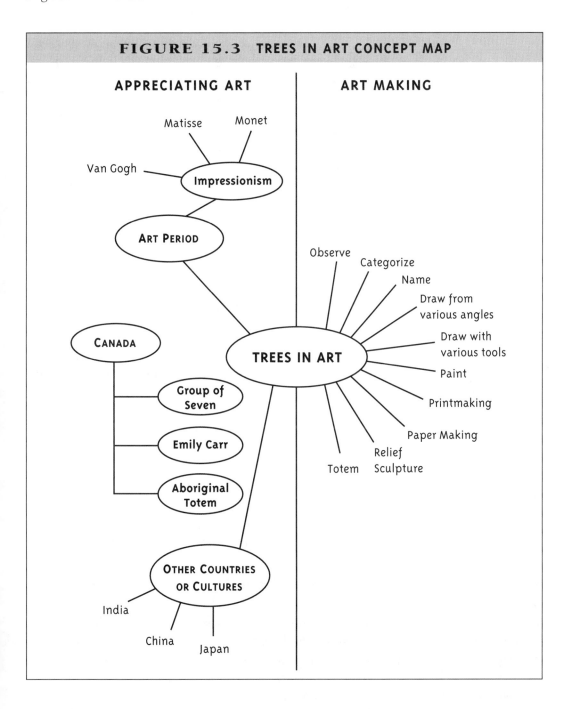

FIGURE 15.3 TREES IN ART CONCEPT MAP

Students can research the place of trees in history, and in myths and other literature. According to Greek legends, spirits lived in trees, and the druids, among others, gave trees religious significance.

Mathematical problems can be based on measuring the height and diameter of trees.

Students can also research trees in paintings and sculptures. The obvious subjects are the paintings of the Group of Seven, the work of Emily Carr, and West Coast native totem poles. But students' research should not stop with these obvious examples. The following artists' works can be explored, among others: George Sawchuck's (b. 1927) use of trees in sculpture (*New New Testament, 1980* is an example); William Kurelek's painting, *The Ukrainian Pioneer #3* (1971); Daniel Fowler's (1810–94) *Fallen Birch*; Homer Watson's (1855–1936) *The Stone Road*; A. Y. Jackson's *Terre Sauvage*; Tom Thomson's *The West Wind*; David Milne's *Painting Place No. 3*. Students can draw and paint trees in the manner of these artists, and from different angles and in a variety of media.

As part of the unit, students can create dance, movement, and musical pieces based on their study of trees. You might consider a special celebration to conclude the unit of study, with performance of the students' works as part of the program. Refer to concept maps in Chapter 2 for other ideas.

• • • • • •
Summary

This chapter, a brief survey of art, is intended to introduce a few artists and some of the movements in art history. We discussed the art of early humans, Egypt, India, China and Japan, Africa, Islamic art, and the art of ancient Greece and Rome, and Europe.

The modern age of art after the three major revolutions produced many art movements including Impressionism, Neo-Impressionism, Post-Impressionism, Cubism, Futurism, Dada, Expressionism, Constructivism, Surrealism, Abstract Expressionism, Neo-Dada, Pop and Op art, Minimalism, kinetic art, and performance art.

A brief survey of Canadian art makes up the last section of the chapter, beginning with aboriginal art, through the Group of Seven, until the present time.

REFLECTION

❶ Choose a topic or theme of study and develop plans for introducing artists and artists' styles into the lesson. For example, develop specific lesson plans based on the ideas given in this chapter on the study of trees.

❷ Study paintings of the Group of Seven, observing and discussing the similarities and differences of the styles.

❸ Choose two artists or two artists from different movements or periods of time, compare and contrast their lives and work.

❹ Why do you think women artists were largely ignored by art historians? Consider doing some research to find out what writers have to say on the subject. Sources are given in the bibliography at the end of the chapter.

❺ Refer to Chapter 4 for lesson approaches to encourage research and investigation of art and artists.

❻ Investigate ways to integrate the learning, knowledge, and understanding of a culture through their arts.

❼ Investigate local artists and artist groups. Choose several for the class to visit to talk about their work.

❽ Take a tour or visit local art galleries and museums. Get your name on their mailing list for invitations to art openings and notification of art shows.

❾ Locate various artists' groups, clubs, and societies, (sketch clubs, watercolourists, monoprinters, paper makers, printmakers, potters) and if possible attend their meetings. Invite members to come and talk to your class. Find out when and where they have their art shows. Put your name on their mailing lists.

❿ Look at some of the ideas for investigating artworks presented in Chapter 5. Can you brainstorm and develop others?

⓫ Locate laserdiscs that contain images and information on artists.

⓬ Subscribe to Canadian art journals: for example *Boarder Crossing*, Y300-393 Portage Avenue, Winnipeg, Manitoba, R3B 9Z9; *Canadian Art*, 70 The Esplanade, 2nd Floor, Toronto, Ontario, M5E 1R2; *Matriart*, 80 Spadina Avenue, Suite 506, Toronto, Ontario, M5V 2J3. (See Appendix C, p. 310 for a more complete list.)

CLASSROOM PROJECTS

❶ After a drawing field trip, have students use their outdoor sketches as reference to paint in the style of an artist they have researched and studied.

❷ Divide the class into groups and have them create a catalogue of an artist or a group of artists after researching the life and work of the person.

❸ Have your students look through art history books to find out the proportion of male and female artists whose work is described.

❹ Have your students each write a review of an artist for the class newspaper.

❺ Give your students an assignment to create a poster advertising an art exhibition highlighting an artist.

❻ Assign a project in which students choose a topic related to social issues — for example, the effects of war or poverty — and have them research artists who used these subjects in their work. Then have your students make paintings on the basis of their research.

BIBLIOGRAPHY

Alberta Education. (1992). *The Artistic Community and Canadian Style.* Art 31, Module 7, Distance Learning. Edmonton: Alberta Education.

Barker, P. (1987). *Short Lessons in Art History: 35 Artists and Their Work.* Portland, ME: J. Weston Walch Publisher.

Berger, R. (n.d.) *Integrated Units of Study.* Unpublished document.

Boardman, J. (1985). *Greek Art.* New revised edition. London: Thames and Hudson.

Bringhurst, Robert, et al. (1983). *Visions: Contemporary Art in Canada.* Vancouver: Douglas & McIntyre.

Broude, N. and M. Garrard. (1992). *The Expanding Discourse. Feminism and Art History.* New York: IconEditions.

Broude, N. and M. Garrard. (1982). *Feminism and Art History. Questioning the Litany.* New York: Harper and Row.

Burnett, D. (1990). *Masterpieces of Canadian Art from the National Gallery of Canada.* Edmonton: Hurtig Publishers.

Burnett, D and M. Schiff. (1983). *Contemporary Canadian Art.* Edmonton: Hurtig Publishers Ltd.

Caine, R. and G. Caine. (1991). *Making Connections: Teaching and the Human Brain.* Alexandria, VA: Association for Supervision and Curriculum.

Chadwick, W. (1992). *Women, Art and Society.* New York: Thames and Hudson.

Chadwick, W. (1985). *Women Artists and the Surrealist Movement.* Hampshire, England: Thames and Hudson.

Collins, J., J. Welchman, D. Chandler, and D. Anfam. (1988). *Techniques of Modern Art.* Secaucus, NJ: Chartwell Books, Inc.

Comini, A. (1982). Gender and genius? The women artists of German expressionism. In N. Broude and M. Garrard, eds. *Feminism and Art History. Questioning the Litany,* pp. 271–92. New York: Harper and Row.

Elsen, A. (1981). *Purposes of Art, An Introduction to the History and Appreciation of Art.* New York: Holt, Rinehart and Winston.

Feest, C. (1992). *Native Arts of North America.* New York: Thames and Hudson.

Gimbutas, Marija. (1989) *The Language of the Goddess — Unearthing the Hidden Symbols of Western Civilization.* San Francisco: Harper and Row.

Glubok, S. (1980). *The Art of Egypt: Under the Pharaohs.* New York: MacMillan Publishing Co. Inc.

Glubok, S. (1965). *The Art of Africa.* New York: Harper & Row.

Gombrich, E. (1968). *The Story of Art.* London: Phaidon.

Harper, J. (1969). *Painting in Canada. A History.* Toronto: University of Toronto Press.

Havelock, C. (1982). Mourners on Greek vases: Remarks on the social history of women. In N. Broude and M. Garrard, eds., *Feminism and Art History. Questioning the Litany,* pp. 45–62. New York: Harper and Row.

Hoffman, K. (1991). *Explorations: The Visual Arts since 1945.* New York: Icon Editions.

Janson, H. (1991). *History of Art.* Fourth Edition. New York: Harry N. Abrams, Inc.

Johnson, C. (1973). *Contemporary Art, Exploring its Roots and Development.* Worcester, MA: Davis Publications, Inc.

Kampen, N. (1982). Social status and gender in Roman art: The case of the saleswoman. In N. Broude and M. Garrard, eds., *Feminism and Art History. Questioning the Litany,* pp. 63–78. New York: Harper and Row.

Kraus, H. (1982). Eve and Mary: Conflicting images of medieval woman. In N. Broude and M. Garrard, eds., *Feminism and Art History. Questioning the Litany,* pp. 79–100. New York: Harper and Row.

Krauss, R. (1985). *The Originality of the Avant-Garde and Other Modernist Myths.* Cambridge: The MIT Press.

Lord, B. (1974). *The History of Painting in Canada, Toward a People's Art.* Toronto: NC Press.

Luomala, N. (1982), Matrilineal reinterpretation of some Egyptian sacred cows. In N. Broude and M. Garrard, eds., *Feminism and Art History. Questioning the Litany,* pp. 19–32. New York: Harper and Row.

Lynes, B. (1992). Georgia O'Keeffe and feminism, a problem of position. In N. Broude and M. Garrard, eds., *The Expanding Discourse. Feminism and Art History.* New York: IconEditions.

Lynton, N. (1989). *The Story of Modern Art.* Oxford: Phaidon.

Mainaradi, P. (1982). Quilts: The great american art. In N. Broude and M. Garrard, eds., *Feminism and Art History. Questioning the Litany,* pp. 331–46. New York: Harper and Row.

Mascheck, J. (1993). *Modernities: Art-Matters in the Present.* University Park, PA: The Pennsylvania State University Press.

Mellen, P. (1978). *Landmarks of Canadian Art.* Toronto: McClelland and Stewart.

Morris, J. (1980). *100 Years of Canadian Drawings.* Toronto: Methuen.

Murray, P. and L. Murray. (1972). *A Dictionary of Art and Artists.* Markham, ON: Penguin Books.

Nochlin, L. (1982). Lost and found: Once more the fallen woman. In N. Broude and M. Garrard, eds., *Feminism and Art History. Questioning the Litany,* pp. 221–46. New York: Harper and Row.

Paoletti, J. (1985). In S. Trachtenberg, ed., *The Postmodern Moment: A Handbook of Contemporary Innovation in the Arts,* pp. 53–79. Westport, CT: Greenwood Press.

Parker, R. and G. Pollock. (1989). *Old Mistresses — Women, Art and Ideology.* London: Pandora.

Pateman, T. (1991). *Key Concepts: A Guide to Aesthetics, Criticism and the Arts in Education.* London: The Falmer Press.

Preble, D. and S. Preble. (1989). *Artforms, An Introduction to the Visual Arts.* Fourth Edition. New York: Harper & Row.

Reid, Dennis. (1973). *A Concise History of Canadian Painting.* Toronto: Oxford University Press.

Robinson, H., ed., (1987). *Visibly Female, Feminism and Art: An Anthology.* London: Camden Press.

Slatkin, W. (1990). *Women Artists in History from Antiquity to the 20th Century.* Englewood Cliffs, NJ: Prentice Hall.

Sporre, D. (1993). *The Creative Impulse, An Introduction to the Arts.* Third Edition. Englewood Cliffs, NJ: Prentice Hall.

Sporre, D. (1991). *Reality through the Arts.* Englewood Cliffs, NJ: Prentice Hall.

Stanley-Baker, J. (1991). *Japanese Art.* London: Thames and Hudson.

Stewart, H. (1979). *Looking at Indian Art of the Northwest Coast.* Vancouver: Douglas & McIntyre.

Tippett, Maria. (1992). *By A Lady Celebrating Three Centuries of Art by Canadian Women.* Toronto: Penguin Books.

Trachtenberg, S. (1985). *The Postmodern Moment: A Handbook of Contemporary Innovation in the Arts.* Westport, CT: Greenwood Press.

Tregear, M. (1991). *Chinese Art.* New York: Thames and Hudson.

Watson-Newlin, K. (1995). Stairways to integrated learning. *School Arts,* October.

Withers, J. (1992). Judy Chicago's Dinner Party: A personal vision of women's history. In N. Broude and M. Garrard, eds., *The Expanding Discourse. Feminism and Art History.* New York: IconEditions.

Zuk, B. and D. Bergland. (1992). *Art First Nations: Tradition and Innovation.* Montreal: Art Image Publication.

Videos

Art Gallery of Ontario. (1990). *The Group of Seven, A Northern Shore.*
Educational Dimensions Group. (1985). *Understanding Surrealism: Painters of the Dream,* Part 1;
 Dada and Surrealist Revolution, Part 1; *Automatism and Dream Painting,* Part 2.
Kinetic Enterprises Ltd. (1988). Art History Series.
Mead Sound Filmstrips. (1980). Contemporary Canadian Paintings, Parts I and II.

Laserdisc Information/ Catalogue Sources

A-J Tech Computers Ltd., R.R. 2 Morinville, Alberta, T0G 1P0, Canada, (403) 939-2141.
Sightlines, A Visual Encyclopedia for the Arts, Sciences and Humanities. Clearing House, Alberta
 Education, 11160 Jasper Avenue, Edmonton, AB, Canada, T5K 0L2. Tel: (403) 427-2984.
Educational Laserdisc Directory, System Impact, Inc., 4400 MacArthur Boulevard N.W., Suite 203,
 Washington, DC, U.S.A. 20007.
Emerging Technology Consultants, Inc., P.O. Box 1244, St. Paul, MN, U.S.A. 55112.
The Instant Replay, 479 Winter Street, Waltham, MA, U.S.A. 02154-1216.
Laser World, 533 Second Street, San Francisco, CA, U.S.A. 94107.
Percpeptix Inc., Suite 1014, 11 Richmond Street West, Toronto, ON, Canada, M5H 2J5,
 Tel: (416) 365-1704.
Pioneer Video Inc., 200 West Grand Avenue, Montvale, NJ, U.S.A. 22066.
Sharship Audio Industries, 605 Utterback Store Road, Great Falls, VA, U.S.A. 22066.
Videodisc for Education: A Director, Minnesota Educational Computing Consortium, 3490 Lexington
 Avenue North, St. Paul, MN, U.S.A. 55126.

APPENDIX A
Materials and Resources

MATERIALS
Papers

Cartridge paper. Smooth white paper, a little heavier than computer paper, good for drawing and printmaking. Computer paper can always be used!

Newsprint. Off-white lightweight paper used for newspapers, and good for rough sketches.

Manilla. Off-yellow medium-weight paper, good for conte, charcoal and pastel work, and printmaking.

Mayfair. More expensive, heavier than cartridge paper and comes in many colours; good for drawing and printmaking.

Construction paper. Cheaper and lighter weight than mayfair paper and comes in many colours. It is the most practical and easily attainable coloured paper. Can be used for a variety of projects.

Stag blank, Bristol board, or Caribou board. Varied in weight but is heavier than mayfair and often has one side smoother than the other. Often comes in several colours. It is good for projects that require a sturdier surface such as acrylic painting, or can be used for a relief print surface or to cut out shapes.

Kraft paper. A brown paper, much like paper bags, sometimes supplied in colours, usually supplied in rolls. Can be used for smaller two-dimensional works, but is especially good for mural painting.

Watercolour paper. Comes in various grades, weights, qualities, and prices. Lighter weight can be purchased as cheaply as mayfair paper or other printmaking papers. Check with your local art store and discuss prices and qualities for your specific purpose.

Other Surfaces

Newspapers, telephone books, paper grocery bags, wallpaper samples, magazines, fabrics (burlap, cotton), wood, paper doilies, paper plates, tissue paper, finger paint paper, computer paper, freezer-wrap paper, cardboard.

Paints

Paint blocks. Convenient opaque tempera paint in patties. Easy to store and distribute. Dip brush in water and rub on the block or patty to bring up the colour.

Liquid tempera or Redi-mix. Comes as a liquid, premixed, and is convenient but more expensive.

Dry tempera powder. Can be mixed with water and/or liquid starch, detergent or buttermilk, which increases gloss and smoothness.

Acrylic tempera. Made by mixing dry tempera powder with polymer mat medium, diluted white glue, or white latex paint if only lighter tones are wanted.

Finger paint. Comes commercially, but can be made with liquid or dry tempera powder, mixed with wallpaper paste, water, laundry starch, detergent, or liquid wax.

Acrylic paint. A synthetic, quick-drying, water-soluble paint, more expensive for painting, but works well on clay figures, fabric, wood.

Watercolour paint. A transparent colour that comes in various qualities and prices.

Other painting materials might include: food colouring, tea, coffee, earth, berry juices, various vegetables, flowers, and leaves. Refer to the section on natural dyes and other books on natural dyes.

Brushes

Brushes come in all sizes, shapes, qualities, and prices. Purchase a variety of sizes and types. Brushes are sold at many locations — paint shops, craft stores, and art supplies stores. Good quality brushes are needed for watercolour.

Other tools that can be used to paint with include: string, brayers, sticks, twigs, feathers, sponges, sponge brushes, rags tied to a stick, cardboard cut into various sizes and shapes, dish scrapers, plastic squeeze bottles (hairdressers have these), drinking straws, cotton balls, toothpicks, popsicle sticks, Q-tips, pipe cleaners, toothbrushes, window screen pieces, fingers, hands and feet, found stamp objects for printing, and crumpled paper.

Glue and Tape

White glue. Works well on wood and cardboard or heavy paper.

Rubber cement. Works well for gluing paper to paper and cardboard and is good for mounting pictures to cardboard. However, it yellows with age. When spilled, it wipes off paper easily but has a toxic odour.

Glue sticks and yellow glue. These work best for gluing paper to paper.

Masking tape and clear tape.

Other Materials

Scissors, rulers, protractors, compasses
Plastic containers with lids, plastic wrap, sponges for clean-up, newspaper to cover tables
Styrofoam meat trays, egg cartons
Butcher's cord, string, yarn
Stapler and staples
Glue gun for special jobs
Mat knife or X-acto for special cutting by, or supervised by, an adult
Iron and blow-dryer

Drawing Materials

Pencils in various grades. HB is normally used in schools. The higher the number with a B (2B, 4B, 6B) the softer the lead. The higher the number with an H (2H, 4H, 6H) the harder the lead and the more silvery, sharp lines can be created.

Charcoal and conte. Conte is pressed charcoal — good for shading.

Other drawing tools include: coloured pencils, felt pens, coloured chalk, paraffin wax, wax crayons, oil pastels, pen and India ink, printing ink.

Sculpture Supplies

Papier-Mâché. Various papers can be used: newspaper, newsprint, paper towels, tissue paper. Gluing mediums include: simple flour and water, watered down white glue, wall-paper paste, and various commercial products such as Pritt and Scolla Cell.

Clay. Low or medium fired stoneware clay — white or buff-coloured is best. Ceramic supply shops, Duncan Ceramic Suppliers (good source for glazes), and local ceramic artists can give you the name of their clay supplier.

Clay tools. Dull knives, forks, sponges, brushes, plastic bags, textured found objects such as twigs, burlap, and onion skin bags for adding textured surfaces to the clay.

Plaster of Paris. Lumber and home improvement stores often carry plaster.

Wood. Ask a local lumber yard or woodworking shop for free ends and lumber scraps.

Chicken wire and various gauges of wire and coat hangers.

Balloons and string.

Tools. Wire cutter, pliers, hammer, nails, saw, mat knife, stapler and staples, glue gun.

Printmaking

Inks should be non-toxic and water-soluble and can be purchased at art stores, teacher-supply stores, and school-supply shops. Tempera paint mixed with liquid starch can also be used for printmaking, but it drys quickly.

Resources

This is a list of resources and ideas where you can get supplies. Be creative in searching out sources and resources — they may be in the most unlikely locations. When you are looking for materials, be as specific as possible so that people can help you or direct you to the right source. You will be amazed at how interested and helpful people can be.

Supplier Information

Phone your local or city school boards.

Contact other schools or art colleges to find suppliers.

Ceramic shops, craft stores, local artists, public libraries, print shops, picture framing stores,

daycare centres, university instructors (especially in areas of art education or early childhood education), art galleries, greenware-ceramic studios, drafting stores, parks and recreation departments and facilities, and department stores.

Stores

Art-supply stores, drafting supply stores, print shops, paint stores, department stores such as K-Mart, Sears, SuperStore (often these have pencils, coloured pencils, and various papers on sale, especially before the school year begins).

Discount stores such as Costco periodically have drawing materials.

Craft stores such as Lewiscraft carry a wide variety of art materials.

School art-supply stores include such places as: Burlington Arts, MacMillan Arts and Crafts, LewisCraft, Craft Canada, Teacher Store, Windsor and Newton, United Stationers, Derivan School Acrylics, Amaco Ceramics.

Get More Canadian Addresses

Check the Internet for other supply companies.

Paint and wallpaper stores with cheap paint, paper and brushes, and maybe even some free samples or end of product supplies.

The Yellow Pages.

Close to Freebies

Don't be afraid to ask, get a parent volunteer or older student to phone around to various outlets.

Wood-product and home-improvement stores my have odds and ends to give away.

Ceramic shops may donate scrap material, old glazes, used clay.

Local newspapers have end-of-roll newsprint, which they often donate.

Printshops and copier stores may have scrap paper.

Picture-framing stores often have pieces of mat-board.

Brainstorm — add to the list.

COLLECTIBLES LIST

Bags — paper, plastic, antique, school bags
Books — pop-up books, illustrations, picture books, comic books, books from other countries
Buttons, beads, pins, jewellery
Magazines, catalogues, newspapers
Clothing for dress-up
Hats for various occasions
Costumes for special occasions
Toys, dolls, stuffed animals

Dishes, pots and pans, vases
Knives, forks, spoons, toothbrushes, garlic press
Potato peeler, vegetable shredder
Electric blender, iron, pan, double boiler
Sponges
Fabric, cloth, lace
Netting, screens
Natural found objects — shells, pebbles, leaves, twigs, bones, skulls, driftwood, tree stumps
Magnifying glasses, binoculars, microscopes, kaleidoscopes, mirrors
Plastics, styrofoam food trays, bottles, buckets, and containers with lids
Make-up, wigs, false noses, ears

APPENDIX B
Dyeing

The first dyes were natural materials — berries, bark, lichens, and roots. The discovery of chemical dyes brought a brilliant range of colours to the process of dyeing.

Synthetic or chemical dyes are produced by mixing certain chemicals of a salt or acid base. Synthetic dyes provide an almost limitless range of colours, and several types are available to consumers (specific directions are given on each package).

Natural dyes, which may be made from various plants and insects, provide a more subtle range of colours. A mordant or chemical salt must be used with most natural dyes to fix the colour. Many beautiful colours can be obtained from dyestuffs found in the kitchen, woods, or garden. The availability of various plants that are sources of natural dyestuffs vary from area to area, depending on soil conditions, rainfall, and length of growing season. Dyestuffs such as berries and blossoms should be picked at the height of their growing season. They may then be used fresh, dried, canned, or frozen. If you are drying dyestuffs, be sure to store them in a cool, dry place; moldy dyestuffs will affect colour adversely. Once a dyestuff has been made into a liquid dye, it can be canned or frozen for future use.

If you are experimenting with various plants in your locality and are uncertain whether or not they can be used for dyeing, crush the substance between your fingers; if it leaves a stain it might be a potential dye. Sometimes, however, the colour of the blossom or berry is not the colour of the resulting dye, so it is a good idea when experimenting to produce a small amount of dye for testing purposes.

The equipment needed for dyeing is quite simple: large enamel pots (with covers), glass (or wood) rods for stirring, rubber gloves, cheesecloth, a scale, and a heating unit.

PREPARING THE DYEBATH

1. Gather one pound of dyestuff for each pound of fibre to be dyed. Pick out all foreign matter and dirt.
2. Place dyestuff in an enamel container and barely cover with soft water (add vinegar).
3. Steep in water overnight.
4. Pulverize dyestuff to bring out the dye pigments. You can use a blender for dyestuffs such as grass, beets, or berries. Harder dyestuffs such as bark and nuts should be broken or pounded into small pieces.
5. Bring the water and dyestuff to a boil in an enamel container. Simmer, covered, for one hour.
6. Strain off the liquid through a cheesecloth.
7. Add four gallons of soft water to the strained dye concentrate.
8. Remember that wet yarn is darker than dry yarn.
9. Colour will vary from bath to bath. Dye all yarn for one project in one bath.

10. Don't expose wool to sudden temperature changes. Rinse it gradually in successively cooler baths.
11. Avoid using metal containers, such as cast iron ones. They can affect the colour of the dye. Enamel pots clean easily with a mild abrasive. Other metals tend to get permanent stains.
12. Keep records for future reference. Remember that natural dyeing is largely a matter of experimentation.

PREPARATION OF FIBRES FOR DYEING

Mordanting

Mordants are chemical salts that affect the colour fastness and permanency of natural dyes. The mordant attaches itself to the fibre and the dye attaches itself to the mordant. Almost all vegetable dyes require a mordant, although some plants contain mordants within their composition and so do not require one. Mordants have a certain amount of colour in themselves, and so they will affect the colour of the resulting dye.

Water, which sometimes contains a small amount of mordant, can also affect the dye. (Many waters contain iron, which is a chemical salt.) Soft water is recommended for dyeing. Hard water may be softened by adding vinegar.

Mordants listed in dye recipes are often termed by common names, but it is wise to learn the chemical names of commonly used mordants. Chemists and chemical suppliers know and sell their products by these names.

Common Names of Mordants	Chemical Names of Mordants
alum	potassium aluminium sulphate
blue vitriol	cupric sulphate
iron or iron sulphate	ferrous sulphate
chrome	potassium dichromate
tin	stannous chloride

Common Household Products Used as Mordants

Alum — ammonium type for pickling
Lye — caustic soda
Salt — sodium chloride
Washing soda — sodium carbonate

Since mordants do affect colour, use a mordant in a colour range that is close to the colour of the dye. Using a mordant in a different colour range may change the colour of the dye completely. For example, dried onion skins with a chrome mordant yield gold, but onion skins with iron sulphate yield olive-green. The colour range of various mordants follows:

Mordant	For Ranges of
alum	yellow, yellow-green
blue vitriol	green

Mordant	For Ranges of
chrome	gold, red
iron sulphate	grey, black, olive-green, purple
tin	gold, orange, red

Adding Mordant to Dyebath

For 0.5 kg of wool, silk, or hair fibres, dissolve the specified amount of mordant in 18.2 L of dyebath before adding the wetter fibre.

Premordanting the Fibre

For 0.5 kg of wool, silk, or hair fibres, dissolve the specified amount of mordant in 18.2 L of soft water. Add wetted fibre and simmer for one hour. Then place the mordanted fibre in the dyebath.

Mordant	Amount to Use
alum	100 g per 0.5 kg of fibre
blue vitriol	100 g per 0.5 kg of fibre
chrome	15 g per 0.5 kg of fibre
iron sulphate	15 g per 0.5 kg of fibre
tin	15 g per 0.5 kg of fibre

COTTON, FLAX, AND SYNTHETIC FIBRES

Cotton dyes fairly well with proper mordanting, but flax and similar vegetable fibres such as hemp do not accept dyeing readily. Synthetic fibres, with the exception of rayon, do not take dyes easily either. Whereas wool, silk, and hair fibres can be mordanted in any of the mordants listed above, the vegetable and synthetic fibres should be mordanted as follows.

Prepare a solution of 30 g of cream of tartar and 100 g of alum to 18.2 L of water. Add the wetter fibre and simmer for one hour.

A Chart of Natural Dyes

Dyestuff	Mordant	Colour
red beets	alum	pink
red beets	none	rose pink
black walnut hulls	iron sulphate	grey
birch bark	alum	tan
white birch leaves	alum	yellow
bracken fern	blue vitriol	green
cochineal	alum	rose-red
cochineal	chrome	red-purple
cochineal	iron sulphate	blue-purple
cochineal (concentrated)	tin	bright red

Dyestuff	*Mordant*	*Colour*
coffee	alum	light brown
cranberries	alum	pink
couch grass	alum	brown
goldenrod blossom	alum	yellow
concord grapes	alum	purple
grass	blue vitriol	green
henna	alum or iron	brown
horse chestnut	alum	brown
indigo	hydrosulfite	blue
lichens	alum	light olive-green
lichens	tin	orange
lily of the valley leaves	alum	green
logwood chips	alum	purple
logwood chips	iron sulphate	navy blue
logwood chips (concentrated)	iron sulphate	black
madder	alum	orange-red
madder	tin	orange
maple bark	alum	tan
maple bark	iron sulphate	grey
marigold blossoms	alum	light gold
marigold blossoms	chrome	deep gold
marigold blossoms	alum	yellow
moss	iron sulphate	olive-green
onion skins	none	orange
dried onion skins	chrome	bright gold
dried onion skins	iron sulphate	olive-green
red sandalwood	alum	brown
sumac berries	alum	tan
sumac berries	iron sulphate	grey
tea	alum	shrimp

APPENDIX C
Visual Art Magazines

Artfocus, P.O. Box 1063, Station F, Toronto, Ontario M4V 2T7.

Artichoke, 901 Jervis Street, #210, Vancouver, British Columbia V6E 2B6.

ArtsAtlantic, ConFed Centre, 145 Richmond St., Charlottetown, Prince Edward Island C1A 1J1.

BorderCrossings, Y300–393 Portage Ave., Winnipeg, Manitoba R3B 3H6.

Canadian Art, 70 The Esplanade, 2nd Floor, Toronto, Ontario M5E 1R2.

C Magazine, Box 5, Station B, Toronto, Ontario M5T 2T2.

Inuit Art Quarterly, 2081 Merivale Rd., Nepean, Ontario K2G 1G9.

Matriart, Women's Art Resource Centre, 80 Spadina Ave., #506, Toronto, Ontario M5V 2J3.

Ontario Craft, Chalmer's Building, 35 McCaul St., Toronto, Ontario M5T lV7.

Parachute, 4060 boulevard SaintLaurent, bureau 501, Montreal, Quebec H2W 1Y9.

Studio Magazine, 124 Galaxy Boulevard, Rexdale, Ontario M9W 4Y6.

Vie des Arts, 200 Saint-Jacques, Suite 600, Montreal, Quebec H2Y 1M1.

APPENDIX D
Children's Books on Art and Artists

The following is a list of books for middle school children. They are divided into books on art and artists, working with art materials, books on the topics of social studies, me and my world, science, animals and insects, math, and fantasy. Many publishers are increasingly addressing the need for books, fiction and non-fiction, historical and cultural, for young readers.

The Arts and Artists

Anholt, L. (1996). *Degas and the Little Dancer.* Georgetown, ON: Barron Educational.

Britten, A. (1996). *The Young Person's Guide to the Orchestra.* Toronto: Harcourt Brace & Co.

Boutan, M. (1996). *Art Kits for Kids: Cezanne; Matisse; Monet; Van Gogh.* Vancouver: Chronicle Books.

Catalanotto, P. (1995). *The Painter.* New York: Orchard Books.

Cummings, Pat, ed. (1992). *Talking with Artists.* Toronto: Maxwell Macmillan Canada.

Doolittle, J. (1991). *Playhouse: Six Fantasy Plays for Children.* Vancouver: Raincoast Books.

Hutchins, H. (1994). *Within a Painted Past.* Willowdale, ON: Annick Press.

Kalman, E. (1997). *Tchaikovsky Discovers America.* North York, ON: Stoddart Publishing Co.

Khol, M. and K. Solga. (1997). *Discovering Great Artists.* Downsview, ON: Monarch Books of Canada.

Krull, K. (1996). *Lives of the Artists: Masterpieces, Messes (and What the Neighbors Thought).* San Diego: Harcourt Brace & Co.

Lind, Jane. (1990). *John McEwen.* Toronto: Douglas & McIntyre.

Lind, Jane. (1989). *Gathie Falk.* Toronto: Douglas & McIntyre.

Lind, Jane. (1989). *Mary and Christopher Pratt.* Toronto: Douglas & McIntyre.

Martin, B. (1996). *The Maestro Plays.* Toronto: Harcourt Brace & Co., Voyager Books.

Newlands, Anne (1988). *Meet Edgar Degas.* Toronto: Kids Can Press.

Sanfield, S. (1996). *The Girl Who Wanted a Song.* Toronto: Harcourt Brace & Co.

Sills, Leslie (1993). *Visions — Stories About Women Artists.* Morton Grove, IL: Albert Whitman & Co.

Spivak, D. (1997). *Grass Sandals.* New York: Simon & Schuster.

Tytla, M. (1994). *See Hear: Playing with Light and Sound.* Willowdale, ON: Annick Press.

Tytla, M. (1993). *Come to your Senses (All Eleven of Them).* Willowdale, ON: Annick Press.

Tytla, M. and Nancy Crystal. (1992). *You Won't Believe Your Eyes.* Willowdale, ON: Annick Press.

Venezia, M. (1997). *Igor Stravinsky.* Danbury, CT: Children's Press Franklin Watts.

Venezia, M. (1997). *Warhol.* Danbury, CT: Children's Press Franklin Watts.

Ventura, Piero. (1984). *Great Painters.* New York: G. P. Putnam's Sons.

Winter, J. (1996). *Josefina.* San Diego: Harcourt Brace & Co.

Working with Art Materials

Araki, C. (1965). *Origami in the Classroom, Book I;* (1968). *Origami in the Classroom, Book II.* Vancouver: Raincoast Books.

Asahi, I. (1992). *Origami Monsters.* Vancouver: Raincoast Books.

Berry, J. (1996). *Rough Sketch Beginning.* San Diego: Harcourt Brace & Co.

Buckingham, S. (1993). *Stencil It! Kid's Projects.* Willowdale, ON: Camden House.

Drake, J. and A. Love. (1994). *The Kid's Campfire Book.* Toronto: Kids Can Press.

Enomoto, N. (1992). *Origami Playtime.* Vancouver: Raincoast Books.

Frank, V. and D. Jaffe. (1996). *Press-Out Masks to Make and Decorate from Around the World.* Toronto: Harcourt Brace & Co.

Lewis, A and E. Melo. (1997). *Lettering: Make Your Own Cards, Signs, Gifts and More.* Toronto: Kids Can Press.

MacGraw, S. (1991). *Papier-Mâché for Kids.* Willowdale, ON: Firefly Books, Camden House.

MacGraw, S. (1990). *Papier-Mâché Today.* Willowdale, ON: Firefly Books, Camden House.

Richmond, M. H. (1997). *Look What You Can Make with Tubes.* Honesdale, PA: Boyds Mills Press.

Sarasas, C. (1984). *ABC's of Origami, Paper Folding for Children.* Vancouver: Raincoast Books.

Thompson, R. (1990). *Frog's Riddle, and other Draw and Tell Stories.* Willowdale, ON: Annick Press.

Thompson, R. (1989). *Draw and Tell, Reading, Writing, Listening, Speaking, Viewing, and Shaping.* Willowdale, ON: Annick Press.

Wallace, M. (1996). *I Can Make Costumes.* Willowdale, ON: Owl Books.

Wallace, M. (1995). *I Can Make Games.* Willowdale, ON: Owl Books.

Social Studies

Adams, E. and D. Choi. (1984). *Korean Cinderella.* Vancouver: Raincoast Books.

Bouchard, D. (1997). *Prairie Born.* Victoria, BC: Orca Book Publishers.

Bruchac, J. (1996). *Between Earth and Sky: Legends of Native American Sacred Places.* San Diego: Harcourt Brace & Co.

Bunting, E. (1996). *SOS Titanic.* San Diego: Harcourt Brace & Co.

Clare, J. (1996). *Classical Rome.* Toronto: Harcourt Brace and Co., Gulliver Books.

Clare, J. (1996). *Fourteenth-Century Towns.* Toronto: Harcourt Brace and Co., Gulliver Books.

Clare, J. (1996). *Knights in Armor.* San Diego: Harcourt Brace & Co.

Clare, J. (1996). *The Vikings.* San Diego: Harcourt Brace & Co.

De Fina, A. (1997). *When A City Leans Against the Sky: A Poetic Glimpse of a City's Diversity.* Honesdale, PA: Boyds Mills Press.

Dunphy, M. (1997). *Here Is the Tropical Rainforest.* New York: Hyperion, Hyperion Books for Children.

Drucker, M. (1992). *A Jewish Holiday ABC.* San Diego: Voyager Books, Harcourt Brace & Co.

Ganeri, A. (1996). *Pharaohs and Mummies.* Toronto: Ladybird Explorers Plus, Penguin Books.

Hirschi, R. and C. Bergum. (1992). *Seya's Song.* Vancouver: Raincoast Books.

Kimmel, E. (1996). *Billy Laroe and the King of the Sea.* Toronto: Harcourt Brace & Co.

Langley, A. and P. De Souza. (1996). *The Roman News*. Toronto: Candlewick Press.

McCaffrey, A. (1996). *Black Horses for the King*. San Diego: Harcourt Brace & Co.

McQuinston, D. (1995). *Dolls and Toys of Native America*. Vancouver: Raincoast Books.

Meeker, C. and C. Lamb. (1994). *Tale of Two Rice Birds: A Folktale from Thailand*. Vancouver: Raincoast Books.

Morpurgo, M. (1996). *Robin of Sherwood*. Toronto: Harcourt Brace Children's Books.

Muramaru, N. (1993). *Japanese Folktales*. Vancouver: Raincoast Books.

Powell A. and P. Steele. *The Greek News*. Toronto: Candlewick Press.

Rinaldi, A. (1996). *Hang a Thousand Trees with Ribbon: The Story of Phillis Wheatley*. Toronto: Harcourt Brace and Co., Gulliver Books.

Rosa-Casanova, S. (1997). *Mama Provi and the Pot of Rice: A Celebration of Good Neighbors and Good Food*. New York: Simon & Schuster.

Russell, Ching Yeung. (1997). *Moon Festival: The Annual Chinese Fall Festival — Seen Through the Eyes of a Child*. Honesdale, PA: Boyds Mills Press.

Sakade, F. and Y. Kurosaki. (1958). *Japanese Children's Favorite Stories*. Vancouver: Raincoast Books.

Me and My World

Bernhard, E. (1996). *A Ride on Mother's Back: A Day of Baby Carrying Around the World*. Toronto: Harcourt Brace & Co., Gulliver Books.

Bouchar, D. and H. Ripplinger. (1995). *If You're Not from the Prairie*. Vancouver: Raincoast Books.

Campbell, L. (1996). *Phoebe's Fabulous Father*. Harcourt Brace & Co.

Clifford, C. (1997). *Our Family Has Cancer, Too!* Downsview, ON: Monarch Books of Canada.

Dalkey, K. (1996). *Little Sister*. Toronto: Harcourt Brace & Co.

Drucker, M. (1992). *A Jewish Holiday ABC*. San Diego: Harcourt Brace & Co., Voyager Books.

Ferguson, A. (1997). *What Makes a Family?* New York: Simon & Schuster, Children's Publishing Division.

Ganeri, A. (1996). *Out of the Ark: Stories from the World's Religions*. San Diego: Harcourt Brace & Co.

Gleitzman, M. (1996). *Puppy Fat*. San Diego: Harcourt Brace & Co.

Gleitzman, M. (1995). *Misery Guts and Worry Warts*. San Diego: Harcourt Brace & Co.

Hallinan, P. K. (1989). *One Day at a Time*. Vancouver: Raincoast Books.

Haseley, D. (1996). *Crosby*. Toronto: Harcourt Brace Children's Books.

Ingold, J. (1996). *The Window*. Toronto: Harcourt Brace Children's Books.

Krull, K. (1996). *Wilma Unlimited: How Wilma Rudolph Became the World's Fastest Woman*. San Diego: Harcourt Brace & Co.

Maple, M. and S. Haight. (1992). *On the Wings of a Butterfly: A Story About Life and Death*. Vancouver: Raincoast Books.

McNicoll, S. (1997). *Walking a Thin Line (How Thin Is Thin Enough?)*. Richmond Hill, ON: Scholastic Canada Inc.

Rand, G. (1996). *Willie Takes a Hike*. San Diego: Harcourt Brace & Co.

Rinaldi, A. (1996). *Keep Smiling Through*. San Diego: Harcourt Brace & Co.

Rosenberg, L. (1996). *Grandmother and the Runaway Shadow*. San Diego: Harcourt Brace & Co.

Rosenberg, L. (1996). *Heart & Soul*. San Diego: Harcourt Brace & Co.

Schnur, S. (1996). *Beyond Providence*. San Diego: Harcourt Brace & Co.

Stearns, M. (1995). *A Starfarer's Dozen: Stories of Things to Come*. San Diego: Harcourt Brace & Co.

Walsh, E. (1996). *Samantha*. San Diego: Harcourt Brace & Co.

Watson, E. (1996). *Talking to Angels*. San Diego: Harcourt Brace & Co.

Wilson, B. (1996). *Mothers and Other Strangers*. San Diego: Harcourt Brace & Co.

Yolen, J. (1996). *Sacred Places*. San Diego: Harcourt Brace & Co.

Zerner, A. (1993). *Zen ABC*. Vancouver: Raincoast Books.

Science

Allison, L. (1975). *The Reasons for Seasons*. Boston: Little, Brown and Co.

Archer, C. *Snow Watch*. Toronto: Kids Can Press.

Asch, F. (1994). *Sawgrass Poems, A View of the Everglades*. Toronto: Harcourt Brace & Co.

Bang, M. (1996). *Chattanooga Sludge*. San Diego: Harcourt Brace & Co.

Biesty, S. and R. Platt. (1992). *Incredible Cross-Sections*. Richmond Hill, ON: Scholastic Canada Ltd.

Bourgeois, P. and B. Slavin. (1997). *Starting with Space: The Moon*. Toronto: Kids Can Press.

Bourgeois, P. and B. Slavin. (1997). *Starting with Space: The Sun*. Toronto: Kids Can Press.

Bunting, E. (1996). *Sunflower House*. San Diego: Harcourt Brace & Co.

Burnie, D. (1997). *Microlife: An Extroaordinary Look from the Inside Out*. Willowdale, ON: Firefly Books.

Burns, M. (1978). *This Book Is About Time*. Covelo, CA: Yolla Bolly Press.

Graham, N. (1995). *Human Body*. Toronto: Penguin Books, Ladybird Explorers Plus.

Grindley, S. (1996). *Peter's Place*. San Diego: Harcourt Brace & Co.

Hickman, P. (1995). *The Kids Canadian Plant Book*. Toronto: Kids Can Press.

Hickman, P. (1994). *Wetlands*. Toronto: Kids Can Press.

Hickman, P. (1993). *Habitats: Making Homes for Animals and Plants*. Toronto: Kids Can Press.

Levy, M. and M. Salvadori. (1992). *Why Buildings Fall Down*. New York: W.W. Norton & Co.

Lewis, A. (1981). *Super Structures*. London: Theorem Publishing Ltd.

Macquitty, M. (1997). *Ocean: An Extroaordinary Look from the Inside Out*. Willowdale, ON: Firefly Books.

Mason, A. (1997). *Oceans: Looking At Beaches and Coral Reefs, Tides and Currents, Sea Mammals and Fish, Seaweeds and Other Ocean Wonders*. Toronto: Kids Can Press.

National Geographic Society (1994). *The Buildings — The Marvels of Engineering*. New York: The Book Division.

Nicolson, C., P. Bourgeois, and B. Slavin. (1997). *The Earth*. Toronto: Kids Can Press.

Oxlade, C. (1996). *Beyond the Night Sky*. Toronto: Penguin Books, Ladybird Explorers Plus.

Platt, S. (1997). *Stephen Biesty's Everything Incredible: How Things Are Made — From Chocolates to False Teeth and Race Cars To Rockets*. Richmond Hill, ON: Scholastic Canada Ltd.

Salvadori, M. (1990). *Why Buildings Stand Up*. New York: W.W. Norton & Co.

Taylor, K. (1992). *Structures*. New York: John Wiley & Sons, Inc.

Animals and Insects

Currie, P. and C. Mastin. (1997). *The World's Newest and Coolest Dinosaurs*. Vancouver: Raincoast Books.

Dudley, K. (1997). *Alligators and Crocodiles*. Vancouver: Raincoast Books.

Emory, J. (1996). *Dirty, Rotten, Dead?* San Diego: Harcourt Brace & Co.

Florian, D. (1996). *On the Wing*. San Diego: Harcourt Brace & Co.

Fox, M. (1996). *Feathers and Fools*. San Diego: Harcourt Brace & Co.

Hickman, P. (1995). *The Kids Canadian Bug Book*. Toronto: Kids Can Press.

Hodge, D. (1997). *Bears: Polar Bears, Black Bears and Grizzly Bears*. Toronto: Kids Can Press.

Hodge, D. (1997). *Wild Cats: Cougars, Bobcats and Lynx*. Toronto: Kids Can Press.

Johnson, J. (1997). *Simon & Schuster's Guide to Insects and Spider's*. New York: Simon & Schuster, Children's Publishing Division.

Love, A. (1993). *Take Action: An Environmental Book for Kids*. Toronto: Kids Can Press.

Moser, M. (1996). *Ever Heard of an Aardwolf? A Miscellany of Uncommon Animals*. San Diego: Harcourt Brace & Co

Paulsen, G. (1996). *Puppies, Dogs, and Blue Northers: Reflections on Being Raised by a Pack of Sled Dogs*. San Diego: Harcourt Brace & Co

Pollock, S. (1996). *Deadly Creatures*. Toronto: Penguin Books, Ladybird Explorers Plus.

Taylor, L. (1997). *Creeps from the Deep*. Vancouver: Raincoast Books.

Math

Grover, M. (1996). *Circles and Squares Everywhere*. San Diego: Harcourt Brace & Co.

Nolan, H. (1997). *How Much, How Many, How Far, How Heavy, How Long, How Tall Is 1000*. Toronto: Kids Can Press.

Pomeroy, D. (1996). *One Potato: A Counting Book of Potato Prints*. San Diego: Harcourt Brace & Co.

Ross, C. (1997). *Circles: Fun Ideas for Getting A-Round Math*. Toronto: Kids Can Press.

Ross, C. (1997). *Squares: Shapes in Math, Science and Nature*. Toronto: Kids Can Press.

Ross, C. (1997). *Triangles: Shapes in Math, Science and Nature*. Toronto: Kids Can Press.

Stories and Fantasy

Alcock, V. (1997). *Time Wreck*. Toronto: McClelland & Stewart.

Bedard, M. (1997). *A Darker Magic*. North York, ON: Stoddart Publishing Co. Ltd., Stoddart Kids.

Bedard, M. (1997). *Painted Devil*. North York, ON: Stoddart Publishing Co. Ltd., Stoddart Kids.

Bedard, M. (1997). *Redwork*. North York, ON: Stoddart Publishing Co. Ltd., Stoddart Kids.

Ben-Ezer, Ehud. (1997). *Hosni the Dreamer: An Arabian Tale*. New York: Farrar Straus Giroux.

Bruchac, J. (1996). *Between Earth and Sky: Legends of Native American Sacred Places*. San Diego: Harcourt Brace & Co.

Brummel Crook, C. (1997). *Maple Moon*. North York, ON: Stoddart Publishing Co. Ltd., Stoddart Kids.

Burke, J. (1997). *Stories from the Stars: Myths of the Zodiac.* Bolton, ON: Fenn Publishing Co.

Cameron A. (1997). *More Stories Huey Tells.* New York: Farrar Straus Giroux.

Demi. (1997). *Buddha Stories.* New York: Henry Holt and Co.

Drawson, B. (1997). *Flying Dimitri.* New York: Orchard Books.

Drummond, A. (1997). *Moby Dick.* New York: Farrar Straus Giroux.

Fan, L. (1997). *The Ch'i–Lin Purse: A Collection of Ancient Chinese Stories.* New York: Farrar Straus Giroux.

Gets, D. (1997). *Life on Mars.* New York: Henry Holt and Co.

Gold, C. (1997). *Dragonfly Secret.* New York: Simon & Schuster, Children's Publishing Division.

Harrison, T. (1997). *Lavender Moon.* Willowdale, ON: Firefly Books.

Hirsch, K. (1997). *Mind Riot: Coming of Age in Comix.* New York: Simon & Schuster, Children's Publishing Division.

Hulpach, V. (1996). *Ahaiyute and Cloud Eater.* San Diego: Harcourt Brace & Co.

MacLachlan, P. (1996). *Tomorrow's Wizard.* San Diego: Harcourt Brace & Co.

McKilip, P. (1996). *The Forgotten Beasts of Eld.* San Diego: Harcourt Brace & Co.

Mellentin, K. and T. Wood. (1997). *Dear Tooth Fairy.* New York: Simon & Schuster, Children's Publishing Division.

Moodie, F. (1997). *Nabulela: An African Folktale.* New York: Farrar Straus Giroux.

Mooser, S. (1997). *Young Marion's Adventure in Sherwood Forest.* New York: Simon & Schuster, Children's Publishing Division.

Nightingale, S. (1992). *A Giraffe on the Moon.* San Diego: Harcourt Brace & Co., Voyager Books.

Pilling, A. (1997). *Creation: Read-Aloud Stories from Many Lands.* Cambridge, MA: Candlewick Press.

Regan, D. (1997). *Monsters in Cyberspace.* New York: Henry Holt & Co.

Taylor, C. (1997). *Little Water and the Gift of the Animals.* Toronto: McClelland & Stewart, Tundra Books.

Taylor, C. (1997). *The Secret of the White Buffalo.* Toronto: McClelland & Stewart, Tundra Books.

Taylor, H. (1997). *When Bear Stole the Chinook.* New York: Farrar Straus Giroux.

Washington, D. (1997). *ANASI.* New York: Simon & Schuster, Children's Publishing Division. (With audiocassette music by UB40, written by Brian Gleeson.)

Westall, R. (1997). *Demons and Shadows: The Ghostly Best Stories.* New York: Farrar Straus Giroux.

Williams, R. (1997). *The Fool and the Flying Ship.* Simon & Schuster, Children's Publishing Division. (With audiocassette music by The Klezmer Conservatory Band, written by Eric Metaxas.)

Whteung, J. (1997). *The Vision Seeker.* North York, ON: Stoddart Publishing Co. Ltd., Stoddart Kids.

Yarbro, C. (1997). *Monet's Ghost.* New York: Simon & Schuster, Children's Publishing Division.

Ye, Ting-Xing. (1997). *Three Monks, No Water.* Willowdale: Firefly Books Ltd.

Zeman, L. (1997). *The First Maple Leaf.* Toronto: McClelland & Stewart, Tundra Books.

CREDITS

Cathie Archbould (photo)	Photo 4.2
Mark Beenham	Cover, Exhibit 3.7
Brittany Ber	Exhibit 5.2
Loutla Bodner	Exhibit 6.9
Jack Boyle	Exhibit 5.1
Christine Cheung	Exhibit 6.6
James Clement	Exhibit 12.7
Scott Cooke	Exhibit 3.5
Becky Cranham	Exhibit 8.3
Neil Davies	Exhibit 3.9
Loan Dang	Exhibit 8.1
George Francis	Exhibit 11.2
Tara Galloway	Exhibit 7.9
Rick Gillespie	Exhibit 10.5
Kristie Golar	Exhibit 5.6
Jacque Gross	Exhibit 9.2
Lisa Gurtler	Exhibit 6.10, Exhibit 6.11, Exhibit 6.12
Jordhynn Guy	Exhibit 3.3
Judith Hart	Exhibit 13.2
Tyler Johnson	Exhibit 3.8, Exhibit 5.4, Exhibit 9.7
Brett Lamb (photos)	Exhibit 11.3, Photo 12.1, Photo 12.2
Megan Lennard	Exhibit 6.2
Desmond Li	Exhibit 12.6
Larissa McLean	Exhibit 6.3
Brook McLeod	Exhibit 9.4
Karen Mok	Exhibit 7.2, Exhibit 7.3, Exhibit 12.5
Irene Naested (photos)	Exhibit 5.3, Exhibit 5.7, Exhibit 6.1, Exhibit 6.4, Exhibit 6.5, Exhibit 6.7, Exhibit 7.5, Exhibit 7.6, Exhibit 7.7, Exhibit 7.8, Exhibit 8.2, Exhibit 8.4, Exhibit 8.5, Exhibit 8.6, Exhibit 9.1, Exhibit 9.5, Exhibit 9.6, Exhibit 10.2, Exhibit 10.3, Exhibit 10.4, Exhibit 10.6, Photo 13.1, Photo 14.1
Thomas Naested	Exhibit 3.4, Exhibit 6.8, Exhibit 7.1, Exhibit 12.1, Exhibit 12.2, Exhibit 12.4
Birgitte Nielsen (photos)	Photo 4.1, Photo 4.3
Kelsi Polland	Exhibit 7.11
Clint Ready	Exhibit 6.13
Katilin Robertson	Exhibit 7.10

Erin Sehn	Exhibit 3.6
Geoffrey Simmering	Exhibit 9.3
Paul Till (photos)	Photo 3.1, Photo 3.2, Exhibit 11.1
D. J. Varga	Exhibit 5.8
Mike Vien	Exhibit 10.1, Exhibit 13.1
Julie Walker	Exhibit 7.4
Christopher White	Exhibit 3.1, Exhibit 3.2
Heather Woods	Exhibit 5.5
Angela Yi	Exhibit 12.3
Blake Young	Exhibit 11.4
Emma Young	Exhibit 5.9

INDEX

Aboriginal people
 art of, 210, 288–89
 culture of, 210
Abstract Expressionism, 128, 284–85
Abstraction, in drawing, 118
Abstract random learners, 49
Abstract sequential learners, 49
Accommodators (learners), 49
Acrylic paints, 131, 150, 302
Action painting, 284
Actors, 188
Adolescents, art development of, 47–48
Advertisements, 178–80, 237–38
 art in, 257
Africa, 279–80
Afterimages, 89
Agne, Russell M., 7, 11, 14, 63, 64, 200, 204, 218
Ainscow, M., 265
Alexander, David, 294
Allard, M., 221
American Revolution, 281
Amphibians, 229
Analytic learners, 52
Anderson, J., 268–69
Andre, Carl, 285
Animals, 203, 208, 224, 225–26
Animation, 119, 186, 187, 188, 202
Anuszkiewicz, Richard, 285
Appliqué, 150
Architecture, 256
 in drawing, 120
 in social studies curricula, 205–206, 207–209
Aristotle, 182
Armstrong, T., 41
 In Their Own Way, 52–54
Arp, Jean, 135, 161, 283
Art
 of aboriginal people, 288–89
 advertising, 257
 of Africa, 279–80
 appreciation of, 96–101
 catalogues, 100

 of China, 276–77
 classical, 254
 communication, 257
 computers and, 189, 286
 criticism, 101
 critics, 100
 in cultures, 20
 curators, 100
 developmental stages in, 42–48
 of Egypt, 276
 ethnographic, 255–56
 folk, 255
 functional, 256
 of Greece, 280
 high, 254–55
 of India, 276
 integration with dance, 251–53
 integration with drama, 248–51
 integration with language arts, 198–204
 integration with music, 242–48
 integration with other disciplines, 32–37
 integration with science, 217 fig., 218–32
 integration with social studies, 204–14
 interdisciplinary instruction and, 198
 interpretation of, 98
 Islamic, 280
 of Japan, 277–79
 as a language, 32, 262, 265
 mass, 256
 of the Middle Ages, 280–81
 military, 257
 newspapers and, 213
 patriotic, 256–57
 popular, 256
 prehistoric, 274
 primitive, 255–56
 religious, 254, 255
 of the Renaissance, 281
 of Rome, 280
 in society, 20, 32, 253–57
 sports, 257
 technology and, 189–91

Art education, 24–27
 classroom management and, 28, 60–61
 gender stereotyping in, 45
 integration with curricula, 417, 28–32
 planning integrated programs, 58–71
 team teaching and, 28
 value of, 34, 21–22
Art galleries
 classrooms as, 101
 field trips to, 67, 99
Art history, 130, 157, 274–94
Artifacts
 cultural aspects of, 210–11
 of First Nations people, 289
 folk, 255
 prehistoric, 274
 religious, 255
Artists, see also Art history
 aboriginal, 288–89
 analysis of work, 98–99
 biographies of, 97
 Canadian, 288–94
 as classroom guests, 100
 comparisons of, 99–100
 correspondence with, 100
 description of work, 97
 interpretation of work, 98
 in residence, 101
 study of, 130
 women, 267, 282, 284, 287–88
Art Nouveau, 118
Arts, the
 academics and, 25–26
 advocacy for, 82
 as communication system, 22–24
 learning through, 54–55
 and social change, 24–25
Arts education, promotion of, 82
Arts integration, culture study and, 14–17
Ashworth, M., 268
Assemblages, 162
Assessment
 checklists, 77
 integrated learning and, 29
 of lessons, 72
 outcome-based, 76
 planning for, 74–80
 of process, 80
 of product, 80
 tools, 65
Assimilators, 49
Audio tapes, 67
Aurora borealis, 232
Ausubel, D., 6
Autoeducation, 30
Automatism, 128
Automatistes, les, 128, 294
Automotion, 119
Autumn, 220–21, 253
Awards, 153, 211, *see also* Celebrations

Backdrops, in drama, 250
Background artists, in film making, 188
Baird, Rebecca Gloria-Jean, 289
Balance
 in art works, 98
 in collages, 136
 in composition, 92–93
Balla, Giacomo, 283
Ballachey, Barbara, 294
Banners, 211, 230
Barbier, Marie, 290
Barcelo, Miguel, 286
Barnes, H., 31
Baselitz, George, 286
Batik, 147–49
 crushed-paper, 134
Bayless, K., 244, 247
Beam, Carl, 289
Beamsville (Johnston), 291
Beane, James A., 4, 6, 7, 8–9, 205
Beer, A., 242, 244
Beesey, C., 80, 235, 237–38
Bellos, Jill, 286
Bench hooks, 140
Bercot, Paul, 255
Berger, Ron, 206
Birds, 226–27
Bisqueware, 168, 169, 171
Blackware, 172
Blind-contour drawings, 114
Block printing, 140, 143
Bloom, Benjamin, 6, 58, 68, 226
Blow painting, 133

Boardman, J., 280

Bobak, Molly Lamb, 100

Boccioni, Umberto, 283

Body, the, *see also* Figure
 adornment of, 23, 145, 152, 256
 art and, 219 fig., 220
 bodily intelligence, 54
 images of, 234

Boling, E., 190

Bolton, L., 153, 243, 254

Bone, R., 94

Bonfires, 172

Bookmaking, 180–82

Boorman, J., 253

Borduas, Paul-Émile. *Refus Global,* 294

Borich, G., 6, 11

Borland, J., 7

Boston Public Schools, 87, 242

Botticelli, Sandro, 281

Boxes, 237
 in space, 116, 117

Boyer, E., 204

Brady, M., 204

Brainstorming, 12–13, 63, 69–70

Braque, Georges, 135, 283

Brayer painting, 134, 140

Breton, André, 284

Brewster, Sir David, 137

Brinbaum, Dara, 286

Brittain, W.Lambert, 46, 48

Bronowski, J., 218

Brooker, Bertram, 292

Brookes, M., 107

Brooks, R., 50

Broude, N., 287

Broudy, H., 96

Brushes, paint, 130, 302

Buddhism, 276
 Zen, 277

Buildings, 206, 207–209, 256

Bunzel, R., 156

Buonarroti, Michelangelo, 254, 281

Burke, C., 11

Burnett, Brian, 286

Burnett, D., 291, 292

Burnishing, 171

Butterflies, 228

By a Lady (Tippett), 288

Calder, Alexander, 160, 161, 285

Calendars, 221

Calligraphy, 120, 180

Cameraless photography, 184

Camera obscura, 182, 183

Camerapersons, in film making, 188

Cameras, 182
 pinhole, 183–84
 video, 188

Camouflage, 226

Canadian Federation of Artists, 292

Canadian Society for Education Through Art
 (CSEA), 18

Caravaggio, Michelangelo, 281

Cardinal, Douglas, 209

Cardinal-Schubert, Joane, 289

Carmichael, Frank, 290, 291

Carr, Emily, 291, 296

Carra, Carlo, 283

Carrington, Leonora, 284

Cartoonists, 188

Cartoons, 119
 poetry and, 202

Cartoon strips, 202, 203 fig.

Cartwright, P., 75

Carving, 157

Cassatt, Mary, 100, 282

Cave paintings, 24, 274, 280

Celebrations, 17, 75, 79, 82, 153, 211

Cell animation, 186

Ceramics, 164–74, *see also* Pottery

Cézanne, Paul, 283

Chadwick, W., 284, 286, 287

Chagall, Marc, 111

Chalk painting, 134

Chambre d'Écoute (Magritte), 120

Characterization, in drawing, 119

Charcoal, 303

Chia, Sandro, 286

Chicken Soup with Rice (Sendak), 221

Children, *see also* Students
 development of art in, 42–48

China, art of, 276–77

Circus Polka (Stravinsky), 111

Clark, C., 30

Clark, Paraskeva, 129
Clarke, John, 7, 11, 14, 63, 64, 69, 70, 200, 204, 218
Classification, in integrated curricula, 235
Classroom
 arrangement of, 61
 as art gallery, 101
 climate of, 60
 design of, 208
 integrated, 28
 as learning environment, 60–61
 management, 28, 61
 student diversity in, 263
Clay, 164–65, 166–69, 170–73, 230, 271, 303
 digging, 172–73
 firing, 172
 musical instruments of, 247 fig.
 pottery, 246
 sculpture, 170–72, 173–74
Clemente, Francesco, 286
Clothing, 145, 210
Coil pots, 169
Coins, 235
Collaboration, in teaching, 60, 63, *see also* Team teaching
Collaborative drawings, 112
Collaborative learning, *see* Cooperative learning
Collages, 35, 135–36, 220, 227–28, 284
Collectibles, 61
Collographs, 144
Colour, 87–89, 96
 in art lessons, 29
 in collages, 136
 harmonies, 88–89
 intensity, 88
 media, 131
 in nature study, 123, 124
 poems, 202
 in posters, 179
 schemes, 88–89
 tones, 88, 123
 values, 88, 123
 wheel, 87–88
Colour field painting, 284
Colouring, 35, 45
Colours, 97

of autumn, 220
 complementary, 89
Comini, A., 287
Common sense learners, 52
Communication, 198
 art, 257
 art education and, 3–4
 the arts as, 22–24
 of teachers, 60
 visual, 92
Comparisons, in integrated curricula, 235–36
Composition, 87–96
 in collage, 135
 in music, 244
Computer-Assisted Design, 190
Computer graphics, 190
Computers
 in animation, 187
 in art, 189–91, 286
 information retrieval and, 191
 learning packages and, 191
 research and, 191
Concrete poetry, 201
Concrete random learners, 49
Concrete sequential learners, 49
Conference Board of Canada. *Employability Skills Profile,* 22
Conferences, parent–student–teacher, 80–81
Conner, J., 180–81
Constructing, in sculpture, 157
Constructivism, 14, 284
Conte, 303
Contour drawings, 114
Contour maps, 224
Contrast
 in collages, 136
 in composition, 93–94
 poetry, 202
Convergers (learners), 49
Converging lines, 115
Cooper, E., 164, 165, 166
Cooperative learning, 69–70
Copying, of art, 29, 121, 130
Cordeiro, P., 10, 11
Cortines, R., 242
Crayons, for fabric, 150

Crealock, C., 266–67, 268
Creative dance, 252–253
Creative thinking, 202–203, 266
Cross-contour drawings, 114
Cross-hatching, 89, 114–15
Cross-links, in drawing, 119
Crushed-paper batik, 134
CSEA (Canadian Society for Education
 Through Art), 18
Cubism, 283
Cucchi, Enzo, 286
Cultures, 205, 210–11
 art education and, 34
 art in, 20, 32, 65
 the arts in, 241–42
 dance and, 251
 imaginary, 214
 pottery in, 169–70
 sculpture within, 157
 stories from, 127
 study of, 14–17, 152, 162–63, 210–11,
 253–57
Curators, art, 100
Currency, 235
Curricula
 art integration into, 28–32
 generative, 10–11
 inquiry-based, 11–13
 integration of, 4–10, 15–17
 Kaleidoscope Curriculum Organizer, 9
 nonlinear, 5
 separate-subject, 4–5
Cutler, B., 30
Cutouts, 186

Dada, 162, 283, 286
Daguerre, Jacques Mandé, 183, 281
Daguerreotypes, 184
Dalcroze Eurhythmics, 242, 244
Dali, Salvador, 284
Dance
 art and, 251–53
 folk dancing, 252, 253
 masks and, 162
 newspapers and, 213
 painting and, 129

Darkrooms, 185
Davie, L., 80, 235, 237–38
Davies, Thomas, 290
DBAE (discipline-based art education), 26, 62
De Bono, Edward, 202
Decoupage, 136
Degas, Edgar, 100, 282
Degge, R., 109
Deighton, L., 74
De Kooning, Willem, 285
Delaunay, Robert, 283
Delaunay, Sonia, 283
De Maria, Nicola, 286
Dempsey, Shawna, 286
Depth, illusion of, 95–96, 98
Design, 35, 94–95, see also Redesign
 in advertising, 179
 of art works, 97
 of buildings, 206, 208
 in collages, 135
 of playgrounds, 207
Designers, of films, 188
Dessel, P., 6
Developing, in photography, 185
Dewey, John, 29–30
DiNapoli, Angie, 229
Dinosaurs, 229
Dioramas, 164, 165 fig., 171
Direct-teaching method, 6
Discipline-based art education (DBAE), 26, 62
Distortion, in drawing, 118
Divergers (learners), 49
Diversity, of students, 263, 267–70
Divisionism, 282
Dockrell, J., 263
Donna Russell's gingerbread cookies, 158
Dough, 158
Dow, Arthur, 29
Drake, S., 218
Drama, 163
 art and, 248–51
 newspapers and, 212
Draughtspeople, 188
Drawing, 107–25, 230–31
 of animals, 225
 animation, 186

on the computer, 189, 190
developmental stages in, 157
figure, 122
grid, 121
materials for, 109–10, 303
in monoprinting, 144
of shells, 227
teaching, 108–17
techniques of, 113–15
vertical, *see* Cross-hatching
with wire, 160
Drawings
blind-contour, 114
collaborative, 112
contour, 114
cross-contour, 114
gesture, 113
mass, 113
Dreher, D., 153
Drenters, Andreas, 162
Drums, 248
Dry-brush painting, 132
Dubuffet, Jean, 135
Duchamp, Marcel, 135, 161, 162, 283
Nude Descending a Staircase, 119
Dulongpré, Louis, 290
Dunn, K., 49–50
Dunn, R., 49–50
Dürer, Albrecht, 121, 281
Dyeing, 147, 148, 230, 306–309
Dynamic learners, 52
D'Zamko, M., 266

Eadie, S., 69, 70
Ecosystem, art education and, 3
Editions, in printmaking, 140
Editors, of films, 188
Edwards, Betty, 50–51
Egypt
architecture of, 209
art of, 276
Eisner, E., 6, 26, 28–29, 32, 74–75, 218–19
Elaboration, in drawing, 118
Embossing, 145
Embroidery, 150
Emotions
in art, 21

in language arts, 198
in painting, 128–29
Emphasis
in collages, 136
in composition, 94
Employability Skills Profile (Conference Board of
Canada), 22
Encoded images, in drawing, 120
Environment, 31, 224
art education and, 3
Environments (sculpture), 162, 171
Epics, 181
Ernst, Max, 135, 162, 283, 284
Escher, M.C., 236, 280
Escobar, Marisol, 285
E.S.L. students, 211, 267–70
Etching, 134, 142, 145
Ethnographic art, 255–56
Eurhythmics, 242, 244
Evaluation, *see* Assessment
Events, *see* Awards; Celebrations
Ewen, Paterson, 129
Exaggeration
in cartooning, 119, 202
in drawing, 118
Exhibitions, 16–17, 79, 82, 153
catalogues of, 100
Exiner, J., 251, 252
Experimentalism, 29–30
Expression
artistic, 34, 21
in music, 246
Expressionism, 48, 283–84, 287
Extroverts, 50
Eyck, Jan van, 281

Fables, 204
Fabric arts, 145–51
Fabrics
in painting, 131
in sculpture, 160–61
Fafard, Joe. *Pasture,* 156
Faircloth, C., 7
Fairley, Barker, 129
Falk, Gathie, 286
Fall, see Autumn
Fallen Birch (Fowler), 296

Family, 205, 271
Feeling types (learners), 50
Feldman, Edmund, 96
Fernald, Grace, 263
Fibres, for dyeing, 308–309
Field trips, 67, 99, 109, 122–24, 222–24
 for clay, 172
 newspaper offices, 212
 to zoos, 225
Figure, *see also* Body, the
 in drawing, 122
 in painting, 129
Film making, 188
Finger painting, 131, 133, 302
Fire Bird (Stravinsky), 111
Firing, of clay, 172
First Nations people, *see* Aboriginal people
Fishbowl sharing, 71
Fisher, B., 10, 11
Flags, 211, 230
Flight, interdisciplinary unit on, 226–27
Flip books, 186–87, 202
Flowers, 230
Fogarty, R., 910
Folk art, 255
Folk dancing, 241, 252, 253
Folklore, 180–81
Follett, Jean, 162
Footprints, animal, 225
Form
 in art, 91
 in music, 246
Formula poetry, 201–202
Found objects, 60–61, 67, 110, *see also*
 Field trips
Fowler, C., 242, 251, 252
Fowler, Daniel. *Fallen Birch,* 296
Fragmentation, in drawing, 119
Franck, F., 107
François, Claude (Frère Luc), 289–90
Frank, Frederick, 230
Frankenthaler, Helen, 285
Free association, 128
Free verse, 181
French language, newspapers and, 213
French Revolution, 281
Freud, Sigmund, 284

Frischl, Eric, 286
Frost, 221
Frottages, *see* Rubbings
Fry, Roger, 283
Functional art, 256
Future, as integrated unit of study, 205
Futurism, 283

Gabo, Naum, 284, 285
Galle, J., 222, 223, 224
Garcia Sevilla, Ferran, 286
Gardner, Howard, 52–54
Garrard, M., 287
Garritson, Jane Schmalholz, 5
Gates, J., 221, 230
Gatto, J., 92
Gauguin, Paul, 283
Gehrike, Nathalie J., 7
Gehrke, N., 6, 9
Generative curricula, 10–11
Geography, integration with art, 211–12
Géricault, Théodore. *Raft of the Medusa,* 281
Gesture drawings, 113
Gestures, 23
Ghost images, 143
Gifted children, 266–67
Giganti, P., 236
Gillespie, M., 180–81
Gimbutas, Marija, 274
Gingerbread, 158
Girling, Oliver, 286
Glazes, 169, 171
Glubok, S., 276, 279–80
Glue, 302
 potter's, 169
God's Eyes, 146, 147 fig.
Gombrich, E., 276
Goodlad, John, 41
Gordon, Hortense, 293
Gorky, Arshile, 285
Goya, Francisco, 281
Grauer, K., 198
Greece
 architecture of, 209
 art of, 280
 integrated unit on, 15–17
Greenhill, R., 183

Greenware, 168, 169, 171
Gregorc, Anthony, 49
Greh, D., 190, 191
Grid drawing, 121
Gris, Juan, 135, 283
Group of Seven, 290–92, 296
Groups
 brainstorming, 69–70
 home, 70
 informal, 69
 representative, 70
 small, 69–70
Gruener, M., 49, 50
Guest speakers, 100, 110, 212
Guilford, J.P., 9

Haiku, 202
Hale, Elizabeth Amherst, 290
Handicapped students, *see* Special needs students
Hanson, Duane, 162
Happenings, 286
Haptic learners, 48
Harmony, in composition, 94
Harper, J., 290
Harris, Lawren, 290, 291
Harter, P., 6, 9
Hartigan, Grace, 285
Hatching, in drawing, 89
Hats, 153, *see also* Headdresses
Hayes, P., 247
Hayward, S., 188
Headdresses, 153, 210
Headstart Program, 6
Health, 213, 220
Heavyshield, Faye, 289
Hedges, W., 266
Heriot, George, 290
Hess, K., 201, 202
Hesse, Eva, 285
High art, 254–55
Hinduism, 276
Hirsch, C., 236
History, *see also* Art history
 teaching of, 206, 210–11
Hobbits, 204
Hoerr, T., 232

Hoffman, K., 286
Hoffman, M., 242, 244
Hofmann, Hans, 285, 293
Holidays, 211
Hollins, Etta, 269–70
Holzer, Jenny, 286
Horizon line, 115
Houses, 207, 208
Howes, P., 221
Hubbard, G., 190, 191
Human commonalities, in social studies
 curriculum, 204
Humanities, teaching of, 32
Human resources, in science teaching, 218
Hunt, T., 250
Hurd, P., 218
Hurwitz, A., 42, 44, 47, 266

Ice, 221
Illustration, 121–22, 178–86
 painting in, 127–28
 of stories, 198–99
Images
 in communication, 23
 computer generation of, 191
 pre-drawn, 35
 preposterous, 120
Imagination, 66–67, 198
Immendorff, Jorg, 286
Immigrants, 211, 267
Impressionism, 130, 282
Independent study, 68
India, art of, 276
Individual study, 68
Industrial Revolution, 281
Infants, development of, 42
Information
 computers and, 60, 191
 recording of, 234–35
Inks, for printmaking, 141, 303
Innovative learners, 51
Inquiry-based curricula, 11–13
INSEA (International Society for Education
 Through Art), 18
Insects, 228
Installations, 162

Intaglio, 142
Integration, of curricula, *see under* Curricula
 and names of disciplines
Intelligence, 52–54
Interdisciplinary education, 48, 198
International Society for Education Through
 Art (INSEA), 18
Interpersonal intelligence, 54
Interviews, parent–student–teacher, 80–81
In Their Own Way (Armstrong), 52–54
Intrapersonal intelligence, 54
Introverts, 50
Intuitive types (learners), 50
Islam, art of, 280

Jackson, A.Y., 290, 291
 Terre Sauvage, 291, 296
Jacobs, Heidi Hayes, 226–27
Jainism, 276
Janson, H., 162
Japan, art of, 277–79
Jazz, 244–45
Jensen, C., 251, 253
Jensen, M., 251, 253
Jewellery, 23, 145, 151–52, 210
Johns, Jasper, 285
Johnson, Nancy, 286
Johnson, Rae, 286
Johnston, Franz, 290, 291
 Beamsville, 291
Johnston, G., 153, 243, 254
Journals, student, 79
Joyce, M., 252
Judd, Donald, 285
Judgement
 aesthetic, 22
 of art works, 99
Judging types (learners), 50
Junk art, 162

Kaleidoscope Curriculum Organizer, 9
Kaleidoscopes, 137
Kalia, P., 267–68
Kampen, N., 287
Kandinsky, Wassily, 284
Kantrowitz, B., 44

Kaufman, Larry, 286
Kauppinen, H., 206
Kazoos, 248
Keller, Helen, 264
Kellogg, Rhoda, 42
Kelly, Ellsworth, 285
Kennedy, Garry Neill, 294
Kenojuak Ashevak, 289
Kiefer, Anselm, 286
Kilmer, Joyce, 231
Kilns, 166, 172
Kinesthetic intelligence, 54
Kinetic art, 161, 285
Klee, Paul, 111
Kleiman, G., 233
Kline, Franz, 285
Knot tying, 151
Knowles, Dorothy, 294
Knowlton, Kenneth, 286
Kodaly method, 242, 244
Kolb, David, 49
Kollwitz, Käthe, 284, 287
Krasner, Lee, 285
Kraus, H., 287
Krieghoff, Cornelius, 290
Kurelek, William. *Ukrainian Pioneer #3,* 296

Landscape, in paintings, 100
Language
 art as, 32, 262, 265
 in dance, 253
Language arts
 integration with art, 198–204
 newspapers and, 212, 213
Languages, foreign, 213
Lascaux (France), 274
Laserdiscs, 190–91
Laybourne, K., 186
Leadbetter, J., 263, 264
Leadbetter, P., 263, 264
Learners, *see also* Students
 types of, 48–55
Learning
 atmosphere, 65
 centres, 69
 difficulties, *see* Special needs students

environment, 60–61
lifelong, 60
peak experiences in, 58
principles of, 54–55
self-directed, 30
styles of, 48–55
Learning packages, computers and, 191
Leaves, 220–21, 253
LeBrun, Christopher, 286
Leese, S., 248, 252
Legare, Joseph, 290
Legends, 210
Léger, Fernand, 283
Leonardo da Vinci, 182, 217, 281
Leonetti, R., 76
Le Parc, Julio, 285
Lesson planning, 60, 63–64, 71–74
Lettering, on posters, 179, 180
Lewis, M., 198
Lewis, Marien, 286
Lichtenstein, Roy, 285
Life skills, arts and, 21–22, 27
Light, in drawing, 113
Lindaman, M., 198
Lines, 89–90
 converging, 115
 in drawing, 110–12
 horizon, 115
 of perspective, 96, 115–17
Linguistic intelligence, 52
Lismer, Arthur, 290, 291
Lissitzky, El, 284
List, Lynne, 24
Lithographic printing, 142
Littlechild, George, 289
Live-action films, 188
Lloyd, P., 251, 252
Locomotor steps, 252
Logical intelligence, 52
Longo, Robert, 286
Looms, 146–47
Lord, B., 289, 290
Loring, Frances, 292
Loveless, R., 191
Lowenfeld, Viktor, 46, 48
Luckasson, R., 266–67, 268

Lueptow, L., 267
Luke, Alexandra, 293
Luomala, N., 287
Lupertz, Markus, 286
Lynton, N., 286

MacDonald, J.E.H., 290, 291
MacGregor, R., 26
MacLeod, Pegi Nicol, 293
Macramé, 151
Magnification, in drawing, 118
Magritte, René, 284
 La Chambre d'Écoute, 120
Mainstreaming, 263, 264
Maletsky, E., 236
Malevich, Kasimir, 284
Mandalas, 137
Manet, Édouard, 100, 282
Man Ray, 135, 283
Maps, 223–24
 contour, 224
 mind, 62, 63–64
Maracas, 247
Marble, simulations of, 160
Markham, Edwin, 231
Marschalek, D., 96, 190–91
Marshall, C., 153, 243, 254
Marshall, S., 201
Martin, Ron, 294
Masks, 162–63, 171, 211, 279
Mass
 art, 256
 in art, 91
 drawings, 113
Matching, of objects, 235–36
Materials, 301305, *see also* Media; Tools
 for masks, 163
 for painting, 130
Mathematical intelligence, 52
Mathematics
 integration with art, 232–38
 newspapers and, 212
Matisse, Henri, 255
4MAT Model of learning styles, 51–52
Matriart magazine, 288
McCarthy, Bernice, 49, 51–52

McCarthy, Doris, 294
McFee, J., 109
McLaren, Norman, 186
McLean, Bruce, 286
McShane, J., 263
Means, S., 6
Medallions, 153, 211
Medals, 152–53, 211
Media, 97, *see also* Materials
 colour, 131
 drawing, 110
 jewellery making, 152
 modelling, 158
 painting, 131
 sculpture, 157
Memory, 66, 129
Metamorphosis, in drawing, 118
Michelangelo, *see* Buonarroti, Michelangelo
Middle Ages, art of the, 280–81
Military art, 257
Millan, Lorri, 286
Miller, J., 31
Milne, David, 291–92
 Painting Place #3, 296
Mime, 248
Mind
 constructs of, 9
 mapping, 62, 63–64
 stimulation of, 248
Minification, in drawing, 118
Minimalism, 285
Miró, Joan, 284
Mirror images, 140, 236
 in drawing, 119
 in kaleidoscopes, 137
Mittler, G., 96
Mobiles, 161
Model animation, 186
Modelling, 157, *see also* Sculpture
 recipes for, 158
Modernism, 282
Modersohn-Becker, Paula, 284, 287
Molds, 169
Mondrian, Piet, 231
Monet, Claude, 282
Money, 235

Monoprinting, 142, 143–44
Montage, 136
Montessori, Maria, 30–31
Montessori schools, 30–31
Mordants, 230, 307–308
Morisot, Berthe, 100, 282
Moriyama, Raymond, 209
Mosaics, 136
Motherwell, Robert, 285
Moths, 228
Motivation, 22, 65, 66–71, 71
 for drawing, 109
 of gifted children, 266
 through language arts, 198
Movement, 251–53
 in composition, 93
 dramatic, 248
Multiculturalism, 211, *see also* Cultures
Multimedia art, 286
Multiplication, in drawing, 119
Multisensory experiences, 15, 17, 28, 58, 263
Munch, Edvard, 284
Munter, Gabriele, 287
Murals, 136, 220
Murray, L., 283, 285
Murray, P., 283, 285
Museums, 99
Music, 111, 241
 in Africa, 279
 art and, 242–48
 in illustration, 127–28
 newspapers and, 213
Musical instruments, 247–48
Musical intelligence, 54
Myths, 181, 204, 210

Nachmanovitch, S., 242
NAEA (National Art Education Association), 18
Naested, Irene, 15–17, 153, 243, 254
Narrations, 180
National Art Education Association (NAEA), 18
National Center for Improving Science
 Education, 218
Native people, *see* Aboriginal people
Nature study, 122–24
Needlework, 150

Neighbourhood, buildings in, 207
Neo-Expressionism, 286
Neo-Impressionism, 282
Newman, Barnett, 285
Newspaper, 159, 171
Newspapers, as integrated unit of study, 12–13
Newton, Isaac, 232
Ng, Phillip, 269
Nicolaides, K., 108
Nielsen, M. Elizabeth, 4, 6, 7, 9
Niepce, Joseph Nicéphore, 281–82
Nihonga, 277
Nochlin, L., 287
Noddings, N., 204
Noland, Kenneth, 285
Nonobjective compositions, 112
Nonrealistic rendering, 117–21
Northern lights, 232
Nude Descending a Staircase (Duchamp), 119
Numbers, 23, 235

Oat, R., 42, 44, 47
O'Brien, M., 182
Observation, 21
 activities for, 107
 of architecture, 206, 207–209
 checklists, 77
 in drawing, 109–10, 122
 on field trips, 124
 in nature study, 124
Oceans, 227–28
Ocvirk, O., 94
Ogletree, E., 31
Oldenburg, Claes, 285
One-point perspective, 115
Op Art, 285
Oppenheim, Meret, 90, 284
Optical illusions, 232
Orem, R., 30, 31
Orff approach, 242, 244
Organizing centres, 8
Outcome-based assessment, 76
Overheads, 183
Overprinting, 140
Oxymorons, in drawing, 119

Packer, M., 248, 252
Paint drip technique, 132
Painters Eleven, 293
Painting, 127–38
 blow, 133
 brayer, 134
 chalk, 134
 on clay, 171–72
 on the computer, 190
 dry-brush, 132
 finger, 133
 splatter, 133
 straw, 133
 sun, 183
 techniques, 132–34
 tissue, 134
 wet on wet, 132
Painting Place #3 (Milne), 296
Paintings
 cave, 24, 274, 280
 rock, 288
Paints, 301–302
 acrylic, 131, 150
 for clay, 171–72
 fabric, 150
 finger, 131
 home-made, 131
 in printmaking, 142
 soap-finger, 131
 starch, 131
Palmer, J., 5
Panaritis, P., 13, 64
Paper, 301
 blueprint, 186
 construction, 185
 diazo, 186
 for drawing, 108–109
 making, 212, 231–32
 for painting, 130
 photo, 184–85
 for sculpture, 157–59
 strips, 159
 weaving, 146
Paper-cuts, 120
Paper-stop-out, 144

Papier-mâché, 159, 164 fig., 303
Papyrus, 231
Parents
 reporting to, 80–81
 as supporters of arts education, 82
Parker, Rozsika, 284, 287
Pasture (Fafard), 156
Pateman, T., 282, 287
Patkau, John, 209
Patkau, Patricia, 209
Patriotic art, 256–57
Patterns, 236
 in collages, 136
 in composition, 94
Peer teaching, 68, 69
Pellan, Alfred, 293
Pencils, 108
Penck, A.R., 286
Perception, 266
Perceptive types (learners), 50
Performance art, 286
Perimeters, 237–38
Perkins, D., 5
Perspective, 95–96
 linear, 115–17
 one-point, 115
 two-point, 116–17
Petrovich-Mwaniki, L., 268, 270
Pevsner, Antoine, 284
Pfaff, Judy, 162
Photocopies, 35, 185
Photograms, 184–85
Photography, 182–85, 281–82
Photo-montages, 136
Physical education, 213
Physically challenged students, 263–64
Physics, integration with art, 232
Picabia, Francis, 162, 283
Picasso, Pablo, 111, 135, 160, 283
Picture wedges, 137
Piñatas, 159
Pinch pots, 169, 170, 171
Pinhole cameras, 183–84
Piper, Adrian, 286
Pissarro, Camille, 282

Pixels, 189
Planning
 for assessment, 74–80
 integrated programs, 28, 58–71
 lessons, 71–74
 units, 59, 71–74
Planographic printing, 142
Plants, 229–30
Plaster, 160, 225, 303
Plates, in printmaking, 140
Play, 42, 242, 248
Play dough, 158
Playgrounds, 207
Plays, *see* Drama
Plotek, Leopold, 294
Poetry, 181, 200–201
 creative dance and, 253
Pointillism, 130, 282
Points of view, in drawing, 117
Poitras, Edward, 289
Poitras, Jane Ash, 289
Poldaas, Jaan, 294
Polke, Sigmar, 286
Pollock, Griselda, 284, 287
Pollock, Jackson, 285
Polymerization, 146
Pommier, Hugues, 289–90
Pop Art, 285
Popular art, 256
Porter, A., 92
Portfolios, 78
Portraiture, 122, 129
Posters, 67, 179–80, 200, 220
Post-Impressionism, 282–83
Postmodernism, 282, 287
Pottery, 165–66, 169, 230, *see also* Ceramics
 of Africa, 279–80
 clay, 246
 in cultures study, 169–70
Poulin, Roland, 294
Powell, B., 200–201
Pratt, Mary, 100
Pre-adolescents, art development of, 45–47
Preble, D., 276, 280, 281–82
Preble, S., 276, 280, 281–82

Preschool children, development of, 42–43
Preteens, art development of, 45–47
Primitive art, 255–56
Printing
 block, 143
 embossed, 145
 lithographic, 142
 planographic, 142
 relief, 141, 142
 screen, *see* Silkscreen printing
 stamp, 143
 stencil, 142, 144, 150
Printmaking, 141–45
 inks for, 141, 303
 methods of, 141–42
 paints in, 142
 vocabulary of, 140
Problem solving, 21, 202–203
Progressive Education Movement, 29, 30
Proofs, in printmaking, 140
Propaganda, 256–57
Proportion
 in composition, 93
 in figure drawing, 122
 in integrated education, 234
 in portraiture, 122, 129
Props, in drama, 250
Prueitt, M., 189
Publicity, of art events, 82
Puki, 169
Pulling threads, 151
Puns, visual, 119
Puppets, 163, 164 fig., 249, 250

Questioning techniques, 68
Quilting, 150

Rabinowitch, David, 285, 294
Rabinowitch, Royden, 285, 294
Raft of the Medusa (Géricault), 281
Rainbows, 232
Raku firing, 172
Ramsey, M., 244, 247
Rauschenberg, Robert, 162, 285
Real-life learning, 5, 21, 67
Recorders, 248

Redesign, *see also* Design
 of problems, 202–203
Refus Global (Borduas), 294
Registration, in printmaking, 140
Reid, Dennis, 290
Reinsmith, W., 31
Relaxation exercises, 67
Relief, 87
 clay, 170–72
 printing, 141, 142
 sculpture, 157
Religious art, 254, 255
Rembrandt, 281
Renaissance, art of the, 281
Renfro, N., 250
Renoir, Pierre Auguste, 282
Repetition
 in composition, 93
 in posters, 179
Reporting, 80–81
Representational art, 47
Reptiles, 229
Response discussions, 70
Reversed images, see Mirror images
Reynolds, Catherine Margaret, 290
Rhythm
 in composition, 93
 in music, 246
Right–left brain theory, 50–51
Riley, Bridget, 285
Riopelle, Jean-Paul, 294
Risk taking, 21–22
Robertson, B., 117
Robinson, H., 287
Rock paintings, 288
Roerich, Nicholas, 267
Rome, art of, 280
Romey, W., 224
Rote learning, 206
Rothko, Mark, 285
Rouault, Georges, 255, 284
Roukes, N., 117
Rousseau, Henri, 290
Rowe, G., 42–43
Rubbings, 112, 143
 of coins, 235

wax, 132
Rubens, Peter Paul, 281
Russolo, Luigi, 283

Sage, Kay, 284
Salle, David, 286
Salt and flour dough, 158
Sanborn, John, 286
Sawchuck, George, 296
Sawdust, 158
Scenery, in drama, 250
Schiff, M., 292
Schnabel, Julian, 286
Schools, design of, 208
Schwartz, B., 190
Science
 integration with art, 217 fig., 218–32
 newspapers and, 212
Screen printing, *see* Silk-screen printing
Scribbling, 42–43
Scriptwriters, 188
Sculpture, 156–64, 211
 clay, 170–72, 173–74
 developmental stages in, 157
 fabric in, 160–61
 kinetic, 161
 materials for, 303
 paper for, 157–59
 relief, 157
 soft, 160–61
 wire in, 160
Sea life, 227–28
Seasons, 220–22
Seeing, *see* Observation
Segal, George, 162
Seitz, William C., 162
Self-assessment, 74, 80
Self-confidence
 of teachers, 59
 of teenagers, 47–48
Self-directed learning, 30
Self-esteem, 21
Self-identity, 200
 human body and, 220
 in social studies curriculum, 205
 of special needs students, 270–72

Self-portraits, 129, 220
Selleck, J., 92
Sendak, Maurice. *Chicken Soup with Rice,* 221
Sensing types (learners), 50
Separate subject curricula, 4–5
Serigraphy, 142
Seurat, Georges, 111, 130, 282
Severini, Gino, 283
Sgraffito, 171
Shading, 113, 115
Shapes, 90–91, 97, 253
 arrangement in painting, 134
 in collages, 135
 in drawing, 120
 geometric, 236–37
 in nature study, 124
 in posters, 179, 180
Sharing circles, 70–71
Shinto, 277
Shoe polish, 171
Short, K., 11
Sibley, N., 182
Signs, in drawing, 120
Silhouettes, 120, 237
Silk-screen printing, 142, 144, 150
Simplification, in drawing, 118
Sisley, Alfred, 282
Size, *see* Proportion
Sketching trips, 109, 225, *see also* Field trips
Slab pots, 169
Slides, 182–83
Slip, 169, 170, 171
Small groups, 69–70
Smith, D., 265–66, 266–67, 268
Smith, Frank. *To Think,* 55
Smith, Gordon, 294
Smith, John, 29
Snow, 221
Soap, in finger paint, 131
Social change, arts and, 24–25
Social studies
 integration with art, 204–14
 newspapers and, 213
Societies, *see* Cultures
Soil, 224, *see also* Clay
Songs, illustration and, 127

Sound-persons, in film making, 188
Sounds, 23
Soundtracks, 188
Space, in drawing, 120
Spatial intelligence, 52–53
Special needs students, 264–66
Spencer, D., 189
Spencer, S., 189
Splatter painting, 133
Sports art, 257
Spring (season), 221–22
St. Aygystubem School, 87
Stabiles, 161
Stage sets, 250–51
Stained glass windows, 237
Stamp printing, 143, 150
Stankiewicz, Richard, 162
Stanley-Baker, Joan, 277, 278
Starch paint, 131
Staton, B., 244
Steele, Lisa, 286
Steiner, Rudolf, 31
Stencil printing, 134, 142, 144, 150, 220–21
Sternberg, L., 263, 265, 266
Sternberg, R., 48
Still-life arrangements, 60, 67, 110
Stimulation, of mind, 248
Stinson, R., 94
Stitchery, 150, 151 fig.
Stone, simulations of, 160
Stone Road (Watson), 296
Stories, 198–200, 204
 illustration of, 127
Storyboards, 187, 202
Storytelling, 248–49
Stravinsky, Igor
 Circus Polka, 111
 The Fire Bird, 111
Straw painting, 133
String drip technique, 132
String-in-ink drawings, 112
Student record books, see Journals, student
Students, see also Children
 as advocates for the arts, 82
 behavioural problems of, 60
 diversity among, 263, 267–70

E.S.L., 211, 267–70
gifted, 266–67
handicapped, see Special needs students
motivation of, 22, 65, 66–71
participation in parent-teacher conferences, 80–81
physically challenged, 263–64
self-assessment, 80
self-evaluation, 74
with special learning needs, 264–66
Stuhr, P., 268, 270
Subjects, segregated, 4–5
Substitution, in drawing, 119
Summer, 221–22
Sun
 images, 185
 painting, 183
Surfaces
 for drawing, 108–109
 in painting, 130–31
Surrealism, 112, 118, 128, 284, 286
Swede, G., 200
Symbolic systems
 in the arts, 242
 in education, 22–24
 personal, 47
Symbols
 in communication systems, 22–24
 in drawing, 120
Synectics, in drawing, 120
Synthetic fibres, 146
Szekely, G., 73, 76, 79

Take a Line for a Walk, 133
Talbot, William Fox, 183
Talented children, 266–67
Talking circles, see Sharing circles
Tanner, D., 5
Tanner, L., 5
Tanning, Dorothea, 284
Tatlin, Vladimir, 284
Taylor, A., 182, 187
Taylor, R., 263, 265, 266
Teachers, characteristics of, 59–60
Teaching
 peer, 68, 69

team, 28, 63, 65, 68
 flexibility in, 60, 63
Team teaching, 63, 65, 68
 in classroom integration, 28
Technology, *see also* Computers
 art and, 189–91
 in art education, 67–68
 information access through, 60
Teenagers, art development of, 47
Teitelbaum, Matthew, 156
Tempera, 131, 301–302
Teneycke, Lori, 244
Ter Borg, L., 49, 50
Terre Sauvage (Jackson), 291, 296
Tessellations, 236
Textile arts, *see* Fabric arts
Texture, 90–91
 in collages, 136
 in music, 246
 in nature study, 123, 124
Thaumatropes, 187
Thinking
 divergent, 22
 symbolic, 242
Thinking types (learners), 50
Thompson, K., 96, 198
Thomson, Tom, 291
 West Wind, 296
Three-dimensional forms, 87, 156, 237, *see also*
 Sculpture
Tiedt, I., 270
Tiedt, P., 270
Tie-dying, 149–50
Tiepolo, Giambattista, 281
Time
 commitment in teaching, 63
 in integrated curricula, 234
Tippett, Maria, 290, 292
 By a Lady, 288
Tissue painting, 134
Tjanting, 148
Tone, of colour, 88
Tools, *see also* Materials
 for clay, 167–69
 for drawing, 108–109
 for painting, 130

Torrance, Paul, 266
 Test of Creative Thinking, 266
To Think (Smith), 55
Transformation, in drawing, 118
Trees, as integrated unit of study, 33, 34,
 220–21, 230–31, 294–96
Tregear, M., 277
Trophies, 153, 200, 211
Truckenbrod, J., 189
Two-dimensional images, 87
Two-point perspective, 116–17
Typographers, in film making, 188

Ukrainian Pioneer #3 (Kurelek), 296
Units, planning of, 71–74
Unity
 in art works, 98
 in collages, 136
 in composition, 93

VAKT system, 263
Valliere, T. Richard, 186
Value, of colour, 88
Van Dyck, Anthony, 281
Van Eyck, Jan, *see* Eyck, Jan van
Van Gogh, Vincent, 283–84
Vanishing points, 96, 115
Variety
 in composition, 93–94
 in drawing, 119
Varley, F.H., 290, 291
Varo, Remedios, 284
Vars, Gordon F., 7
Vasarely, Victor, 285
Velázquez, Diego Rodríguez de Silva y, 281
Vertical drawing, *see* Cross-hatching
Video
 cameras, 188
 discs, 190–91
Videos, 67, 100
 of students, 79
Villages, model, 207
Viola, Bill, 286
Visualization, 67
Visual learners, 48
Visual puns, 119

Waldorf Program, 31
Warhol, Andy, 285, 286
Warnock Report, 263
Warren, P., 222, 223, 224
Washes, 132
Wasson, R., 268, 270
Water colours, 131
Watson, Homer. *Stone Road,* 296
Watson-Newlin, K., 280
Wax
 in batik, 148
 crayons, 150
 resists, 132
 rubbings, 132
Weather, 212, 220, 221–22
Weaving, 145–47, 148, 152 fig.
Webs, thinking, 63
Wedges, picture, 137
Wedging, of clay, 168
Werden, Rodney, 286
Werner, P., 25
West Wind (Thomson), 296
Wet-on-wet painting, 132
Whinery, B., 7

White, Peter, 156
Whitehead, Alfred North, 218–19
Whitmore, Joanne, 66
Wideman, R., 69, 70
Wieland, Joyce, 129, 150, 288
Wigg, P., 94
Windows, in integrated curricula, 237
Wingert, P., 44
Winter, 221
Wire, in sculpture, 160
Women artists, 267, 282, 284, 287–88
Wood, Alan, 294
Wood, in sculpture, 303
Wood, R., 232
Wool, in weaving, 145, 146
Words, 23, 200
Wright, Frank Lloyd, 209
Writing, 198
Wyle, Florence, 292

Yarbrow, Teri, 286

Zen Buddhism, 277
Zoos, 67, 225

READER REPLY CARD

We are interested in your reaction to *Art in the Classroom: An Integrated Approach to Teaching Art in Canadian Elementary and Middle Schools*, by Irene Russell Naested. You can help us to improve this book in future editions by completing this questionnaire.

1. What was your reason for using this book?

- ☐ university course
- ☐ college course
- ☐ personal interest
- ☐ continuing education course
- ☐ professional development
- ☐ other _____

2. If you are a student, please identify your school and the course in which you used this book.

3. Which chapters or parts of this book did you use? Which did you omit?

4. What did you like best about this book?

5. What did you like least about this book?

6. Please identify any topics you think should be added to future editions.

7. Please add any comments or suggestions.

8. May we contact you for further information?

Name: _____

Address: _____

Phone: _____

(fold here and tape shut)

--

MAIL ➤ POSTE
Canada Post Corporation / Société canadienne des postes

Postage paid
If mailed in Canada

Port payé
si posté au Canada

**Business
Reply**

**Réponse
d'affaires**

0116870399 01

0116870399-M8Z4X6-BR01

Larry Gillevet
Director of Product Development
HARCOURT BRACE & COMPANY, CANADA
55 HORNER AVENUE
TORONTO, ONTARIO
M8Z 9Z9